Esther S Edgar - 1978 -

THE HIDDEN
MICHELANGELO

Rand McNally & Company

Chicago · New York · San Francisco

THE HIDDEN
MICHELANGELO

ROBERTO SALVINI

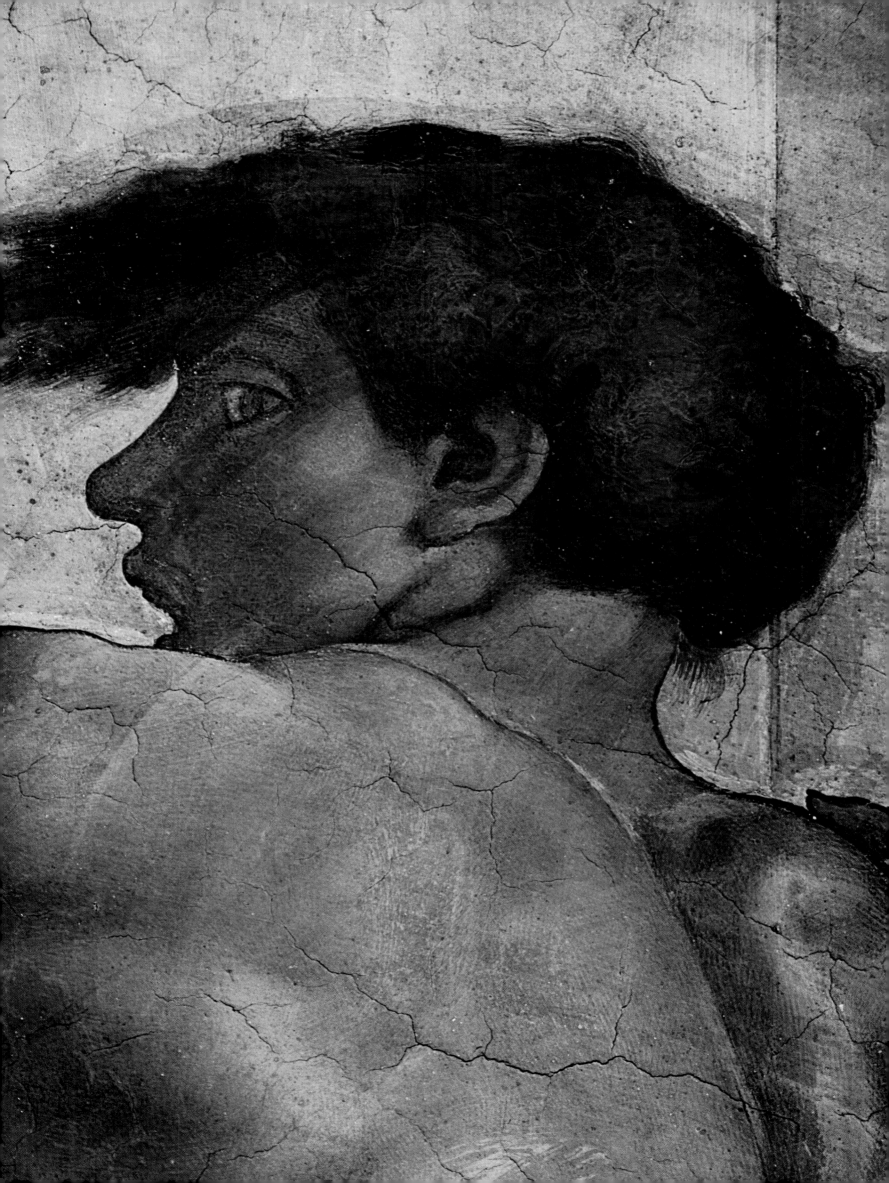

Frontispiece illustration:
IGNUDO
Detail
Fresco
1511–1512
The Vatican
Sistine Chapel
See page **75**

THE
HIDDEN
MICHELANGELO

BY ROBERTO SALVINI

EDITORS: MARIELLA DE BATTISTI, MARISA MELIS
EDITORIAL COLLABORATION: FABRIZIO D'AMICO
PAOLA LOVATO
GRAPHIC DESIGN: ENRICO SEGRÈ
TRANSLATED FROM THE GERMAN BY VIVIENNE MENKES

Published in U.S.A., 1978 by Rand McNally Co., Chicago, Ill.
Library of Congress Catalog Card No. 78-50815
ISBN: 528-81043-x

Printed in Italy by Officine Grafiche di
Arnoldo Mondadori Editore, Verona

Filmset by Keyspools Ltd, Golborne, Lancashire

Contents

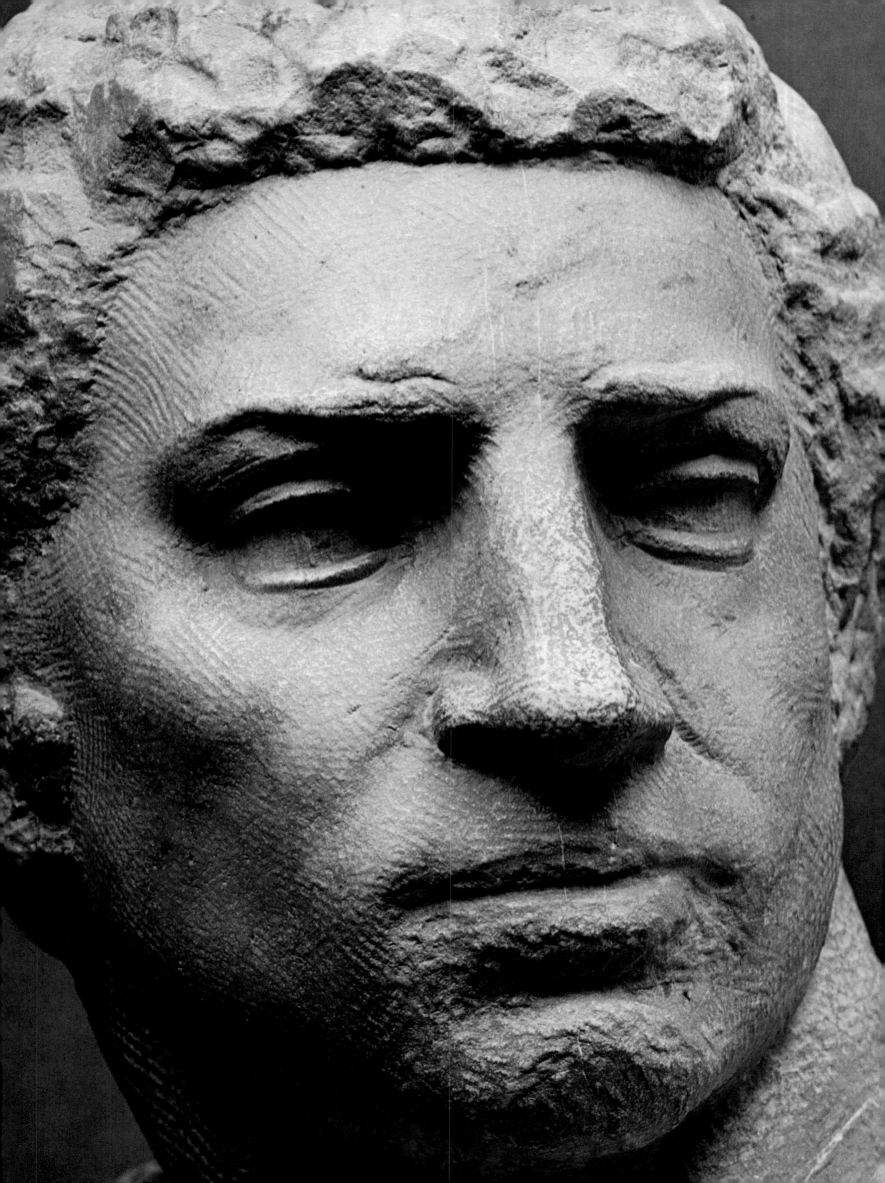

"Die Kunst ist lange bildend, eh' sie schön ist" (Art is figurative long before it is beautiful). Goethe's words, which stress that the creative function of art is to produce images that are not necessarily "beautiful," could be used to describe Michelangelo's art. The artist himself, in his prose writings and in his poetry, bears this out: in his phrase "far le figure" (to make figures), which he uses as a synonym for sculpture or painting in his letter to Varchi about the "comparison of the arts," or in his well-known lines:

Sì come per levar, Donna, si pone
in pietra alpestra e dura
una viva figura
Che là piú cresce, u' piú la petra scema.
(As when, Lady, one supposes a living figure to be in hard alpine stone, so as to draw it out, and it gradually grows as the stone falls away.)

Yet this concept contrasts with other just as important statements that the artist made, as in his famous verses:

Per fido esemplo alla mia vocazione
nel parto mi fu data la bellezza
che d'ambo l'arti m'è lucerna e specchio.
(As a faithful example to my vocation, beauty was given to me at birth, which is for me the lantern and the mirror of both arts.)

In Michelangelo's poetry, a conflict of ideas is apparent between the Aristotelian conception of the maker, who works laboriously to draw out the image that already exists potentially within matter, and the conception, derived from Plato and Plotinus, of the artist who operates in the light of a beauty that comes from God and who seizes the ray of divine universal beauty in the particular earthly object.

Né Dio, sua grazia, or mi si mostra altrove
più che in alcun legiadro e mortal velo
e quel sol amo perch'in lui si specchia.
(Nor does God in his grace reveal himself to me otherwise than in some lovely and mortal veil; and I love that alone, for it mirrors him.)

This conflict is not confined to Michelangelo's conception of art and cannot be explained away as a forgivable lack of clarity on the part of an artist who was, after all, not a philosopher. It should rather be seen as one of a complex of causes for tension and conflict that filled Michelangelo's whole personality and existence. By living through a time of transition, Michelangelo experienced the advantages and disadvantages of fundamental spiritual, social, and political changes: he suffered the upheavals of religious crisis and the Counter-Reformation; he experienced directly the change in the social position of the artist, which took place at the turn of the fifteenth century, and he saw his native city undergo a transformation from a city government to a regional state and the Italian peninsula caught up in the struggles for supremacy between the rulers of Europe.

BRUTUS: Detail
Marble
Height, 29½ in. (74 cm)
Circa 1538
Florence, Museo Nazionale del Bargello
Made for Cardinal Niccolò Ridolfi and later acquired by Francesco de' Medici. According to Vasari, Michelangelo and Tiberio Calcagni collaborated on this work, but critics believe that the latter's contribution was very limited.

During the late Middle Ages and for much of the fifteenth century, artists were bound by the corporate discipline of the guild. The corporation guaranteed the quality of the product to the customer, who was usually an ecclesiastical organization or an enterprising merchant or manufacturer. The artist was seen as an artisan, however highly skilled he might be. However, when the artist also began to study scientific problems and to identify art with the science of nature, he felt he should be recognized as an exponent of the liberal arts.

In the last decades of the century, the ruling class, which had been made up of pioneering private entrepreneurs, was now composed of rich men who had invested their considerable gains in land and real estate and wished to enjoy their wealth rather than add to it. Increasingly cultivated and refined, they gathered around them writers and philosophers and artists, who were now regarded as individual bearers of culture and raised to the rank of intellectuals. The artist was gradually released from his corporate constraints and had greater freedom. Soon however, as riches became concentrated in fewer hands, the artist's former middle-ranking patrons were replaced by more powerful figures, who had greater wealth at their disposal and who regarded patronage as a means of furthering their ambitions and political power. These richer patrons commissioned ever more magnificent projects, which were more risky for the artist because he was subjected more than ever before to financial uncertainties and the whims of the client.

Michelangelo suffered a great deal from this situation. Given the new status of the artist and his own youthful reputation, he was in a strong enough position to impose his own scheme for the frescoes of the Sistine Chapel ceiling on the pope. Julius II originally planned to limit the ceiling painting to architectural ornamentation and the figures of the twelve apostles. But as Michelangelo relates: "When I had made certain drawings, it seemed to me that it was a poor affair, so he [the pope] gave me another commission as far as the stories below; I was to do as I wanted on the ceiling." Even after winning this concession from the pope, he had to put up with his patron's changes of mood. Furthermore, he had to interrupt his great scheme for Julius II's tomb and his work as a sculptor, which was the activity most dear to him, in order to clamber up onto scaffolding to paint the chapel ceiling. He described his ill-humor and discomfort wittily in a famous sonnet:

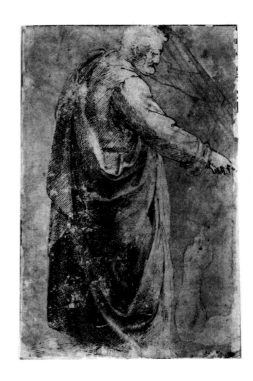

SAINT PETER
Pen and ink drawing on chalk
$15\frac{1}{2} \times 7\frac{3}{4}$ in. (39.5×19.7 cm)
1488 – 1490
Munich, Graphische Sammlungen
The drawing is a copy of Masaccio's fresco of the *Tribute Money* in the church of the Carmine, Florence. Saint Peter, who appears three times in Masaccio's work, is copied from the right-hand side of the fresco and is shown paying the tax collector.

I' ho già fatto un gozzo in questo stento
come fa l'acqua a' gatti in Lombardia
O ver d'altro paese che si sia
ch'a forza il ventre appiccà sotto il mento.
(I have already grown a goiter with this hard work, like the water in Lombardy—or wherever else it may be—causes in cats, so that my belly is forced up under my chin.)

Pope Julius's tomb, which it was the artist's greatest ambition to complete, became, with the continual reductions in scale demanded by the heirs, "the tragedy of the tomb," causing him, as Condivi relates, "infinite obstacles, griefs, and troubles."

Living in a new age, Michelangelo longed for the old. Working for popes, he was nostalgic for the patronage of a more modest figure, like Lorenzo il Magnifico, his former patron. Michelangelo established himself as an intellectual by composing verses in the Petrarchian tradition, but he still had a craftsman's love of his chisel and marble. Living and working in Rome, and a citizen of the world by virtue of his genius, he always felt himself to be a citizen of Florence and dreamed of returning to the banks of the Arno. To this end, he continually tried to improve his family's situation and

THREE MALE FIGURES
Pen and ink drawing on paper
$11\frac{1}{2} \times 7\frac{3}{4}$ in. $(29 \times 19.7\,\text{cm})$
Circa 1488–1490
Vienna, Graphische Sammlung
Albertina

The drawing is generally believed to be a copy of Masaccio's fresco of the *Sagra del Carmine* in Florence. In 1969, Creighton Gilbert proposed a theory that it is a reproduction of a lost work by Domenico Ghirlandaio, Michelangelo's master, and is reconstructed from later copies. However, this hypothesis is unconvincing.

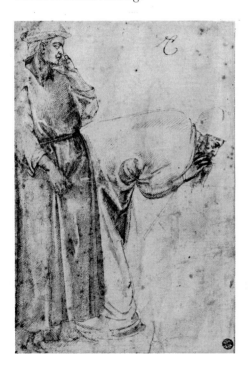

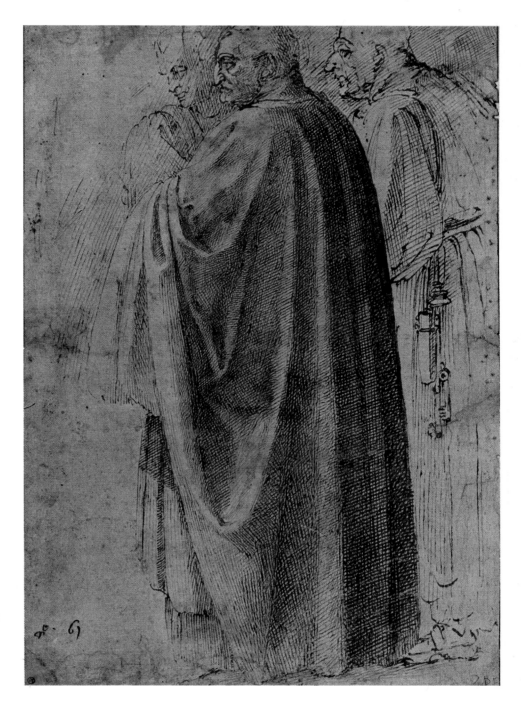

TWO MALE FIGURES
Pen and ink drawing on paper
$12\frac{1}{2} \times 8$ in. $(31.7 \times 20.4\,\text{cm})$
Circa 1488–1490
Paris, Musée du Louvre

The drawing is a copy of two figures from the left of Giotto's fresco of *The Assumption of Saint John the Evangelist* in the Peruzzi Chapel of Santa Croce, Florence. For a long time after Giotto's death, the frescoes of the Peruzzi and Bardi chapels were models that attracted many artists besides the Florentines.

strengthen their old but insecure position as citizens of Florence.

The same conflict between the old and the new can be seen in the development of his philosophy. As a member of Lorenzo il Magnifico's household, surrounded by classical sculpture, he was able to listen to Poliziano's humanist verses and Marsilio Ficino's subtle arguments. In this atmosphere, he was exposed to the humanist and Neoplatonist thinking of the most cultivated circle in Florence (and Italy) at that period. However, Michelangelo was also an assiduous reader of Dante, and he listened ardently to the fiery sermons and read the writings of Fra Gerolamo Savonarola, "for whom," according to Condivi, "he has always had great affection; the memory of his living voice remains in his mind." Condivi goes on to say that Michelangelo "has likewise with great study and attention read the holy scriptures, both of the Old Testament and of the New, and the works of those who have labored to explain them." While the verses of Michelangelo's *Rime* are full of Neoplatonist ideas, the influence of Savonarola is clear in the artist's tendency, often seen in his letters, to view adversity as divine punishment and to make sudden decisions under the influence of dreams, prophecies, or visions.

Thus, Michelangelo expressed the most advanced Renaissance thought but was attracted to a harshly moral and reactionary call back to the Middle Ages. Michelangelo's character, life, and work are interwoven with these contradictions, which he, with his unswerving moral sense, felt obliged to bring together to form a synthesis. For this reason, and not merely because of the special nature of his expression, Michelangelo was the most dramatic figure of Renaissance civilization.

Michelangelo, son of Ludovico di Lionardo di Buonarroti Simoni and of Francesca di Neri di Miniato del Sera, was born on March 6, 1475, at Caprese, a pleasant village overlooking the upper Val Tiberina. His father was the *podestà* (resident magistrate and mayor) of Caprese, which was situated midway between Casentino and Val Tiberina. Caprese and Chiusi della Verna were the centers of activity of this modest territory of the Florentine republic. Michelangelo thus belonged to a family of Florentine "citizens," which at that time meant not simply inhabitants of a city but those entitled by their position and by tradition to hold public office. The Buonarroti Simoni family had once been among the leading families of the city and were descendants of the counts of Canossa; but since the days of Michelangelo's grandfather, their fortunes had been at a low ebb. Ludovico, his father,

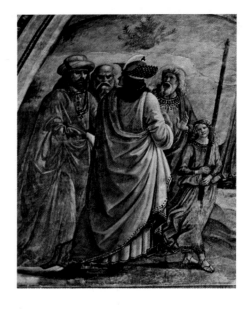

Domenico Ghirlandaio
ASSUMPTION OF THE VIRGIN
Detail, probably by Michelangelo
Wall fresco
1486–1490
Florence, Santa Maria Novella

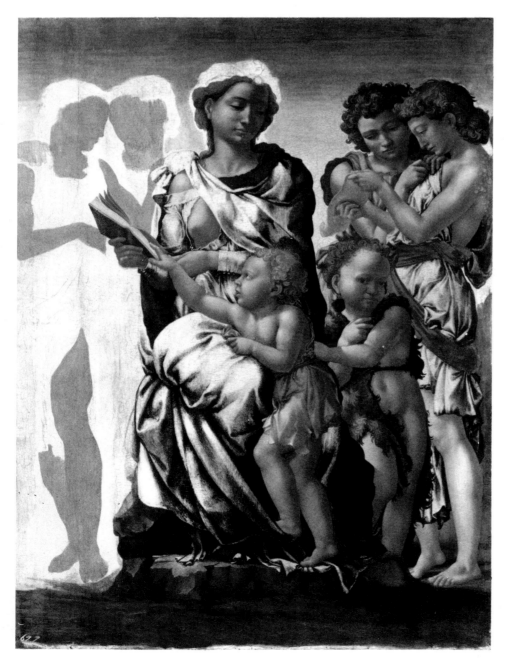

MADONNA AND CHILD WITH
SAINT JOHN AND ANGELS
Tempera on wood
40 × 30 in. (102 × 76 cm)
Circa 1510
London, National Gallery
Known as the "Manchester Madonna" because it was in Manchester that the work was first attributed to Michelangelo. There is not unanimous agreement about the panel's authorship and suggestions include the names of a number of Michelangelo's pupils or colleagues who might have worked from a drawing provided by Michelangelo or in collaboration with him.

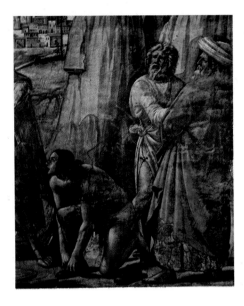

Domenico Ghirlandaio
BAPTISM OF CHRIST
Detail, probably by Michelangelo
Wall fresco
1486–1490
Florence, Santa Maria Novella

ENTOMBMENT
Tempera and oil on wood
$62\frac{3}{4} \times 58\frac{3}{4}$ in. (159×149 cm)
London, National Gallery
There is much uncertainty about the authorship of this work. It is generally attributed to the "Master of the 'Manchester Madonna'" who, with some form of involvement on the part of Michelangelo, is believed to have painted the two panels now in the National Gallery.

owned some property near Florence but had to supplement his meager income with the proceeds of his office as *podestà* and with customs work.

The impact of this family background, with the added sorrow of his mother's early death when he was only six years old, was apparent in Michelangelo's pride in his origins as a "free" citizen, a pride from which his love of liberty and republican sentiments sprang, and his constant concern for his family's fortunes, as seen in his sense of insecurity and anxiety. According to Condivi's biography, which was inspired, if not actually dictated, by Michelangelo himself in 1552–53, the child was entrusted to a nurse who lived at Settignano. She was the daughter of one stonemason and the wife of another. "Because of this," Condivi says, "Michelangelo used to say it was not surprising that he was so fond of the chisel—maybe as a joke or perhaps rightly knowing that the milk on which we are suckled has such effect and, changing the temperature of the body, introduces another

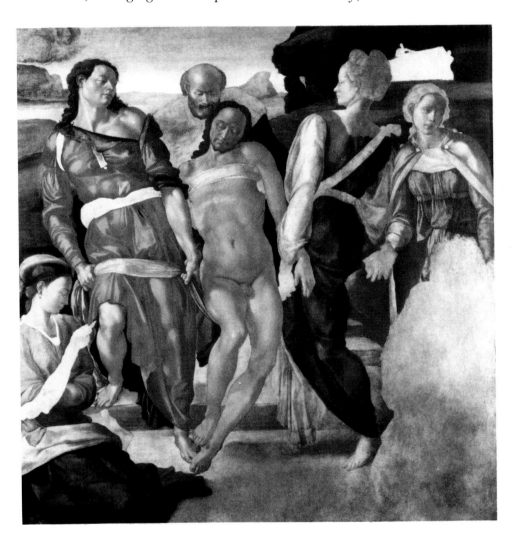

inclination very different from the natural one."

In early adolescence, Michelangelo attended the school of Francesco da Urbino, who taught Latin and, presumably, some form of literature. Although he made some progress in these studies, Michelangelo was strongly attracted to painting and, encouraged by his older friend Francesco Granacci, eagerly took to drawing in churches and visiting artists' workshops. His brothers and father, "a religious and good man of rather old-fashioned manners," apparently opposed the boy's vocation for a long time because "unused to the excellence and nobility of art, it seemed to them shameful that it should be in their family" (Condivi). Although by then artists had for several decades considered themselves to be intellectuals who understood geometry and perspective and although a member of the noble

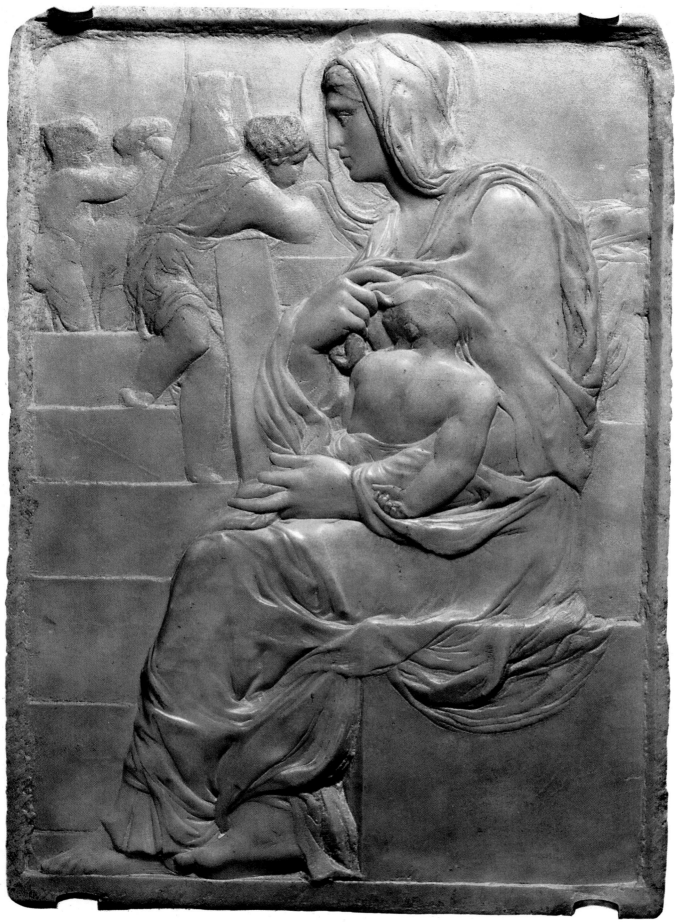

Alberti family had devoted himself to the theory and practice of the arts, Florentines of the old school obviously still regarded painting as a mechanical art unworthy of a young man from a good family. However, Michelangelo's obstinacy prevailed, and in April 1488, when he was just thirteen, he was accepted as an apprentice on a three-year contract in the workshop of the much-esteemed painter Domenico Ghirlandaio and his brother David.

What was the state of painting and the figurative arts generally in Florence at that time? Ghirlandaio had completed his frescoes in the Sassetti chapel of Santa Trinità and was now working on the fresco cycle in the choir of Santa Maria Novella. He painted easily, with a tendency to large compositions. Although Ghirlandaio preserved the sense of proportion and order that was characteristic of the Florentine tradition, he enriched the illustrative aspects of his work with a lively attention to landscape, surroundings, and manners. He deepened his range of color under the influence of Flemish painting, which at this time, with the arrival in Florence of Hugo van der Goes's great *Portinari Altarpiece* in 1483, was impressing established Florentine painters with its energy and warmth.

Sandro Botticelli had by now left his most humanist-inspired works behind him. In 1480, he had painted the *Madonna Between the Two Saint Johns* for Santo Spirito and the year before, probably, the tondo of the *Madonna of the Pomegranate* for the audience chamber of the Palazzo della Signoria. The San Barnaba *Altarpiece* probably dated from this time, too. Botticelli was also working on the *Annunciation* for the monks of Cestello and the great *Coronation of the Virgin* for the chapel of Saint Alò in San Marco. All of these works conveyed religious emotions poetically transfigured by means of dreamlike and nostalgic images seemingly drawn from a distant past or from the depths of ancestral memory.

On April 21, 1487, just one year before Michelangelo entered the Ghirlandaio workshop, Filippino Lippi had signed the contract for the frescoes of the Strozzi chapel in Santa Maria Novella. The young Michelangelo was not able to see him at work because the painter, sidetracked by other commitments, put off starting the work and left shortly for Rome to paint his frescoes in the church of Santa Maria Sopra Minerva. However, recent examples of his work that Michelangelo must certainly have seen were the *Scenes from the Life of Saint Peter* (which completed the cycle left unfinished by Masaccio over fifty years before) in the Brancacci chapel in the Carmine church in Florence; the delightful panel painting of

MADONNA OF THE STAIRS
Marble
$22 \times 15\frac{3}{4}$ in. (55.5×40 cm)
1489–1492
Florence, Casa Buonarroti
Lionardo Buonarroti presented this work to Cosimo I in 1566–1567. In 1617, Cosimo II gave it back to the Buonarroti family; since then it has been in the house (now a museum) that Michelangelo bought for his nephew Lionardo. Although sometimes dated 1494–1496, the most probable date for this work is about 1490.

BATTLE OF THE CENTAURS
Marble
$33\frac{1}{4} \times 35\frac{3}{4}$ in. (84.5×90.5 cm)
1492
Florence, Casa Buonarroti
According to Condivi, the work was already finished by the time of Lorenzo il Magnifico's death in April 1492. The date 1492, therefore, is generally accepted, although Longhi suggests it is a later work from the turn of the century.

Pages 14–15: Detail
This shows the middle section of the relief. The subject is not easily identifiable but is probably the rape of Hippodamia by the centaur Eurytus, an episode taken from Ovid's *Metamorphoses*. Vasari interprets it as a battle between Hercules and the centaurs, while Condivi speaks of it as the "rape of Deianira and the fight of the centaurs."

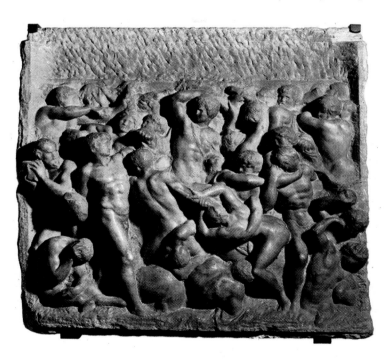

the *Vision of Saint Bernard*, then in a country chapel at the Convent of Campora; the great *Altarpiece* for the Sala degli Otto di Pratica, in the Palazzo Vecchio, painted in 1486; and the *Madonna with Saints* for the Rucellai chapel in San Pancrazio and another for the Nerli chapel in Santo Spirito in Florence.

The Carmine frescoes, despite the painter's genuine attempt to restrain

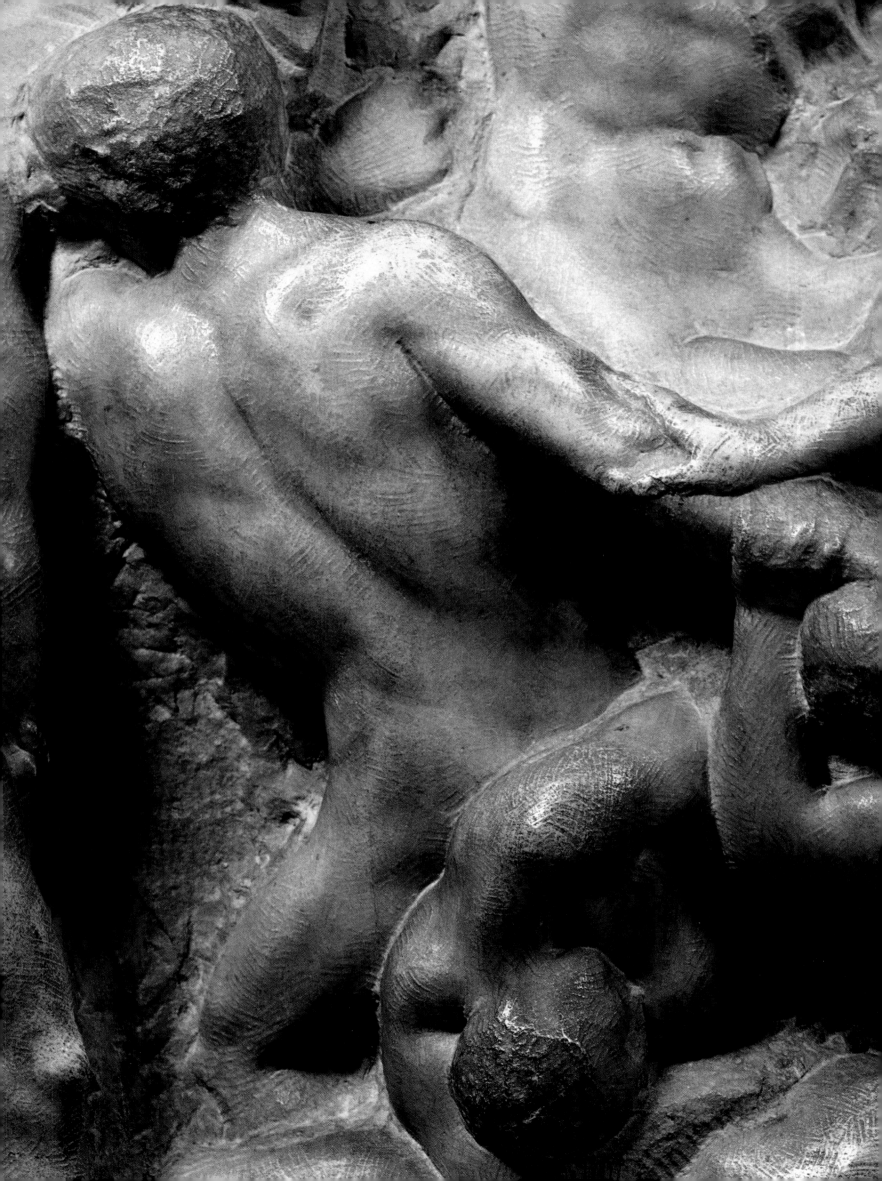

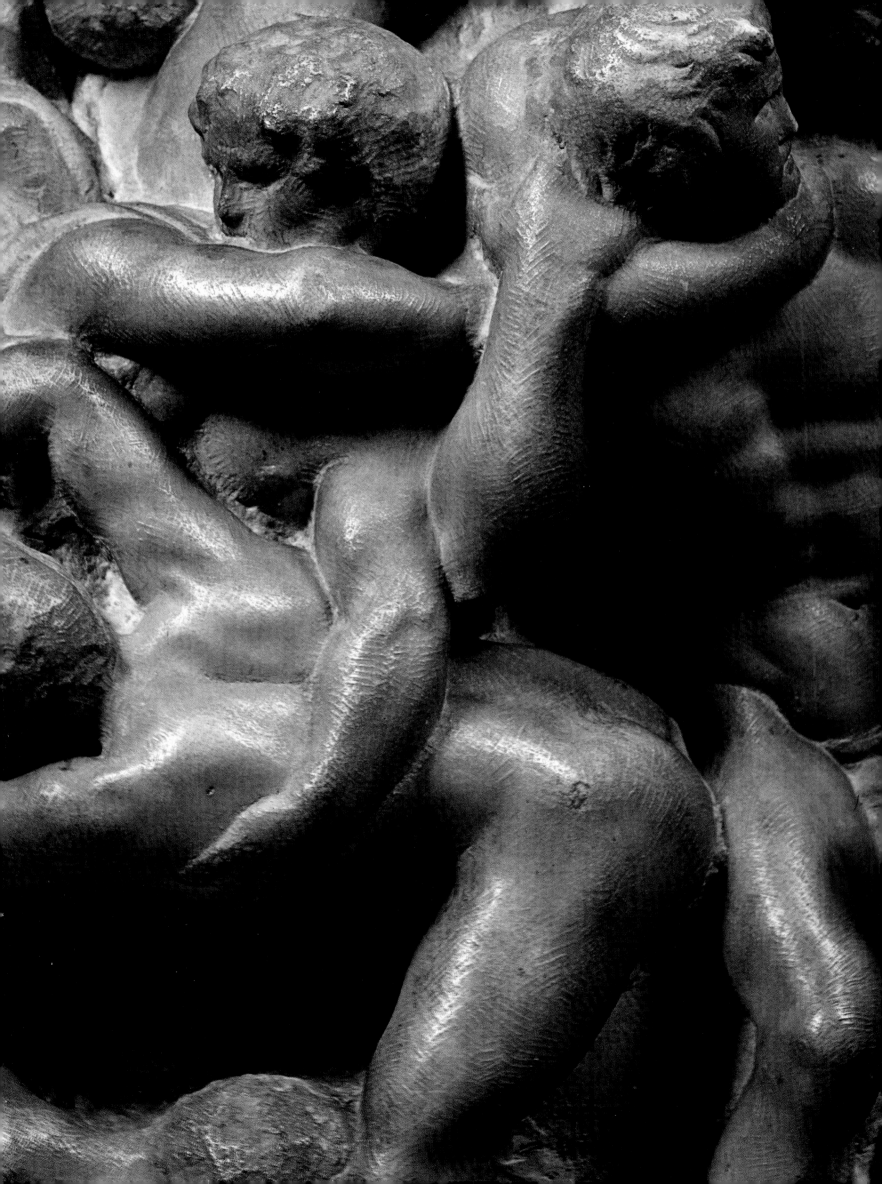

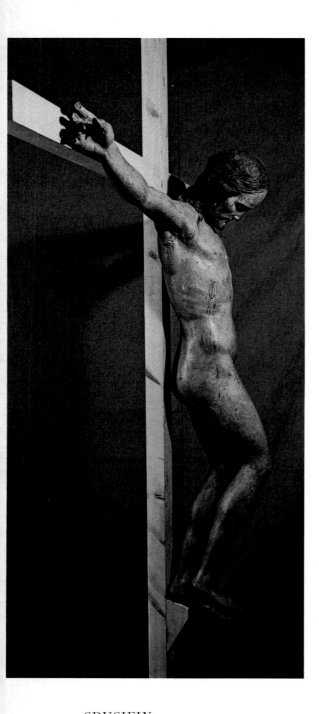

CRUCIFIX
Polychrome wood
53¼ × 53¼ in. (135 × 135 cm)
Circa 1495
Florence, Casa Buonarroti
This was made for the prior of Santo Spirito who had enabled Michelangelo to study anatomy. The work is mentioned by Condivi and Vasari among others and was believed lost until 1964, when Margrit Lisner recognized it beneath the thick layers of paint that masked it. The cross is a later element, probably added at the time of repainting, but the *titulus crucis* at the top, with its Greek, Hebrew, and Latin writings, is original.

his own taste for an episodic style, could not in Michelangelo's eyes have rivaled the noble, essential qualities of Masaccio. The panel painting of the *Vision of Saint Bernard* revealed a Botticelli-like sensibility, although more delicate and elusive, with more elongated figures, a greater relish for color in the Flemish manner, and greater attention, imaginative rather than fantastic, to the delights of landscape. All of these qualities appealed little to Michelangelo's adolescent temperament. Nor would he have been much attracted to the shadowy, aristocratic work of a painter like Alessio Baldovinetti.

Older artists who must have caught his attention included above all Antonio del Pollaiuolo, Verrocchio, and Benedetto da Maiano. Michelangelo already knew and admired Pollaiuolo's engraving, the *Battle of the Naked Men*, and probably also knew the *Martyrdom of Saint Sebastian*, painted for a chapel belonging to the Pucci family. He was to come across Pollaiuolo's three large *Labors of Hercules* a few years later in the Medici palace. Michelangelo was undoubtedly fascinated by the harsh tension of line and the use of *contrapposto* in Pollaiuolo's composition as well as more generally by his starkly dramatic qualities. Michelangelo must have been impressed by Verrocchio's range and the rich variety of stylistic devices his sculpture displayed and by Benedetto's solid, robust plasticity. (His meeting with Leonardo, who had left Florence seven years before, was to take place later.)

Michelangelo's first legendary brush works—his copy of Martin Schongauer's engraving of *Saint Anthony* and his copy of a portrait that he handed back to its owner in place of the original as a joke—have vanished. The earliest surviving examples of his pen drawings were eagerly executed copies of the works of Giotto and Masaccio. The fact that as a boy he was not satisfied by the highly skilled painting of Ghirlandaio signified quite simply his rejection of the delicate, nervous sensibility of Florentine art in the third generation of the century; his dislike of its characteristic spirit of episodic naturalism and ornamental elegance; and his desire to return to the larger, synthesizing spirit of the early fifteenth century. Given the development of Michelangelo's personality, it is safe to say that his motive for this turning back to an earlier stage was for moral, rather than for aesthetic, reasons: it was the search for a spirit of "truth."

I believe that the earliest of these drawings is the copy of Masaccio's *Saint Peter with the Tribute Money* (page 8), although some scholars date it as a later work. Although the sketch has a somewhat timid quality, revealing the hand of a beginner, it also shows an attempt to introduce elements not seen in the original. The artist has made the piece of material over the figure's shoulder wider, and it falls more freely; at the lower edge of the figure, he has added a little fold; and emphasizing what is a slight hint in the original, he has changed the last downward curving fold into a meeting of two separate folds. In Masaccio's figure, the clothing clings more obediently to the body, while Michelangelo has tried to give it a life of its own.

In the drawing in the Louvre after a detail from one of Giotto's frescoes in the Peruzzi chapel of Santa Croce , a new energy gives the figures greater relief and a more dynamic form than is seen in the original drawing. In the drawing in the Albertina Collection, Vienna (page 9), that shows some figures copied from a fresco by Masaccio of the Sagra del Carmine, the simple austere grandeur of the original (although now lost) seems to be transformed and enhanced with a new, dramatic intensity. In taking the works of Giotto and Masaccio as his models and bypassing everything in between, the young artist implicitly anticipated a critical judgment that was not explicitly formulated until the end of the nineteenth century.

Michelangelo did not complete the contracted three-year term of his apprenticeship with Ghirlandaio. Condivi, who refers rather vaguely and indirectly to the apprenticeship, states: "The boy drawing now this, now

that, and having no fixed place or course of study, happened one day to be taken by Granacci to the garden of the Medici at San Marco: this garden, Lorenzo il Magnifico ... had adorned with various antique statues and figures.'' Here his vocation for sculpture was born, and he decided to leave Ghirlandaio's workshop altogether. Since Condivi says that Michelangelo spent about two years in the Medici household, until Lorenzo's death in 1492, he must have worked with Ghirlandaio for just two years. This period of apprenticeship—from the spring of 1488 to the spring of 1490—was long enough to learn the techniques of fresco and panel painting. However, the first painting that can be attributed to Michelangelo with certainty—the tondo of the *Doni Madonna* (page 39)—is dated as 1503–1504. The question is whether Michelangelo, having abandoned his training as a painter under the guidance of Ghirlandaio, could really not have taken up his brush again until he reappeared as a highly accomplished painter fifteen years later. Various attempts have been made to fill this puzzling gap. One suggested solution is the attribution to the young Michelangelo of a group of Madonnas, centered around the *Holy Family with Saint John* in the National Gallery of Ireland, Dublin, often attributed to Granacci, and a tondo of the same subject in the Akademie, Vienna. However, the first picture contains a luxuriant landscape, an aspect that never appealed to Michelangelo; also, since it is in some respects similar to Leonardo's work and Raphael's Florentine Madonnas, the picture is dated as no earlier than 1505. So the painting must be attributed to Granacci and the Michelangelesque elements explained in terms of the young artist's influence over his older friend.

On the other hand, the Vienna tondo and other similar works have certain elements in common with late fifteenth-century Ferrarese painting, which Michelangelo could have come across during his stay in Bologna in 1494–95 (which will be discussed later). However, apart from the fact that these Ferrarese elements never reappear in Michelangelo's painting, the drawings already mentioned and later works clearly show that what the great Ferrarese artists—Francesco Cossa and Ercole de' Roberti—had to offer was of little interest to him. Ferrarese painting was dramatic, certainly, but it was also delicate and nervous, laden with a tremulous sensibility that Michelangelo rejected. Rather, he was attracted by the simple grandeur of Giotto and Masaccio and the measured dramatic spirit of classical sculpture.

Two other paintings—the *Madonna and Child with Saint John and Angels* (page 10) and the *Entombment* (page 11), both in the National Gallery, London—have been under discussion in this controversy. The similarities among individual features, especially in the Virgin's face, seem to indicate that the same hand was responsible for these two unfinished paintings, both exhibiting a high standard. The general conception of the paintings, especially the *Entombment*, suggests Michelangelo, but the quality of different parts of the two works varies. Most probably they are the work of an unknown artist who was a friend of Michelangelo and who worked under his influence and with his help (Zeri).

In the *Madonna and Child with Saint John and Angels*, the two angels are drawn from the *putti* of the Sistine Chapel. The Madonna and Child strongly recall Michelangelo's marble *Madonna* now in Bruges (page 32) and seems to be based on a design intended for a sculptured group: the shape of the marble block can be identified at the base. Yet it is hard to believe that Michelangelo, who was always so richly inventive, needed to make such slavish use of his own earlier themes. In the *Entombment*, however, Michelangelo was certainly responsible for the general design, dating from his early years in Rome at the end of the century when he had a certain interest in northern art. Just as the *Pietà* of Saint Peter's (page 21) takes up the idea of the German *Vesperbild*, so here Michelangelo refers to the ideas of composition in Van der Weyden's *Pietà* in the Uffizi. The imposing figure of Christ was certainly drawn by him and at least partly executed.

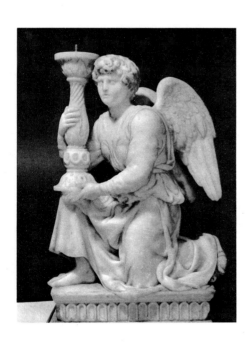

ANGEL WITH CANDLESTICK
Marble
Height with base, 20¼ in. (51.5 cm)
1494–1495
Bologna, Basilica of San Domenico
This small statue is a counterpart to another by Niccolò dell'Arca. When dell'Arca died in 1494, Francesco Aldovrandi arranged for Michelangelo to complete Saint Dominic's tomb in the basilica of the same name in Bologna; Michelangelo also made the statues of *Saint Petronius* and *Saint Proculus* for the tomb.

Michelangelo's hand is particularly evident in the lower portion of the figure, where the legs emerge powerfully from the picture to create a harsh and sorrowful tension. The figure of Saint John is so powerful and placed in such an exact relation to the figure of Christ that it may have been at least started by Michelangelo. However, the figures at the sides are too weak, and not simply because they are unfinished, to be attributed to Michelangelo. The appearance of the woman supporting Christ's body is fragile, and the figure of the woman beside her looks flat and awkward. Nor can Joseph of Arimathea's vaguely painted head provide proof of Michelangelo's authorship.

Another attempt to solve the problem consists of looking for signs of Michelangelo's youthful collaboration in the frescoes of the choir of Santa Maria Novella. Ghirlandaio and his school were working on these while Michelangelo was an apprentice; the contract did in fact stipulate that the boy was to paint as well as learn. Possible contributions by Michelangelo have been identified, by Marchini, in some figures in the *Assumption of the Virgin* and the *Baptism of Christ*. In the first composition, the man on the left with his back to the viewer is most likely to be a genuine example of Michelangelo's work (page 10). The imposing simplicity of the clothing, which seems to cover not just a well-rounded body but a lively and energetic character, too, and the solid folds of the toga give the figure a sculptural solidity. Here again Michelangelo draws his inspiration from Masaccio's austere simplicity, as in his copies of the Carmine frescoes of the same period.

In the *Baptism of Christ*, Michelangelo's hand may be seen in the nude youth and the two prophetic figures behind him (page 11). The first figure, with its simplicity and grandeur, is composed with a vigorous, unbroken outline that contains the solid, modeled form; its movement has a secret spiritual strength. The two standing figures, with their well-proportioned and contrasting masses, are shown in a relationship that suggests a silent dialogue of heavy moral import. The hard, almost stonelike clothing, with its sharply creased folds, worn by the man with his back to the viewer is a vivid reminder of the young Michelangelo's pen drawing in which he vigorously transformed Masaccio's conception of clothing into something new and intensely dramatic. The color in all of these figures is very clear and bright, with a tendency to dissonance that was to become more marked in the tondo of the *Doni Madonna*.

With his copies of Giotto and Masaccio and the few figures he completed on the walls of the choir of Santa Maria Novella (following in their broad outlines his master's designs and perhaps even his sinopia drawings), Michelangelo declared his opposition to a whole generation of Florentine artists—to Ghirlandaio's facility as an illustrator and his descriptive bent and to Filippino's refined and delicate episodic naturalism. He declared the need for a return to the simple heroic grandeur of his predecessor Masaccio and showed that the true imitation of Nature lay in the attempt to master large forms.

Given its similarities in style with these examples of Michelangelo's work in the Santa Maria Novella frescoes, I believe we should accept Longhi's suggested attribution to the young Michelangelo of the fragment of a panel showing *Saint John the Evangelist*, which was done by Ghirlandaio's workshop. Originally it was, as a modern copy shows, part of an altar frontal depicting Christ's lament. Most of the panel disappeared from the little country church of San Cristoforo at Canonica in about 1900. According to Longhi, the surviving fragment shows a system that, although based on the classicist Umbrian tradition (then very much alive in Florence with Perugino), strengthens the figure's modeled bulk with the billowing of the tunic at the waist and with the folded edge of a mantle next to it. This is a sculptor's idea. The hands with the firmly clasped fingers reveal a Michelangelo in search of a predecessor more violent than Perugino, such as

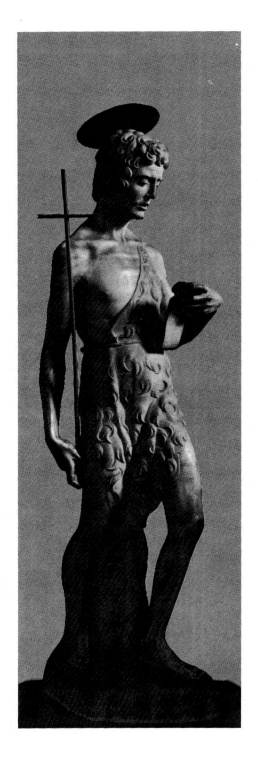

SAINT JOHN THE BAPTIST
Marble
Height with base, 68 in. (172.5 cm)
Circa 1495
Florence, Museo Nazionale del
Bargello
Sources refer to a young figure of *Saint John the Baptist* made for Lorenzo di Pierfrancesco de' Medici. Previously attributed to Donatello, the statue is now considered to be Michelangelo's work.

BACCHUS
Marble
Height, 72½ in. (184 cm); with base, 80 in. (203 cm)
1496–1497
Florence, Museo Nazionale del
Bargello
The work was acquired by the Roman banker and art collector Jacopo Galli after Cardinal Riario, who had commissioned the work, turned it down. In 1571–1572, it was bought by Francesco de' Medici and returned to Florence.

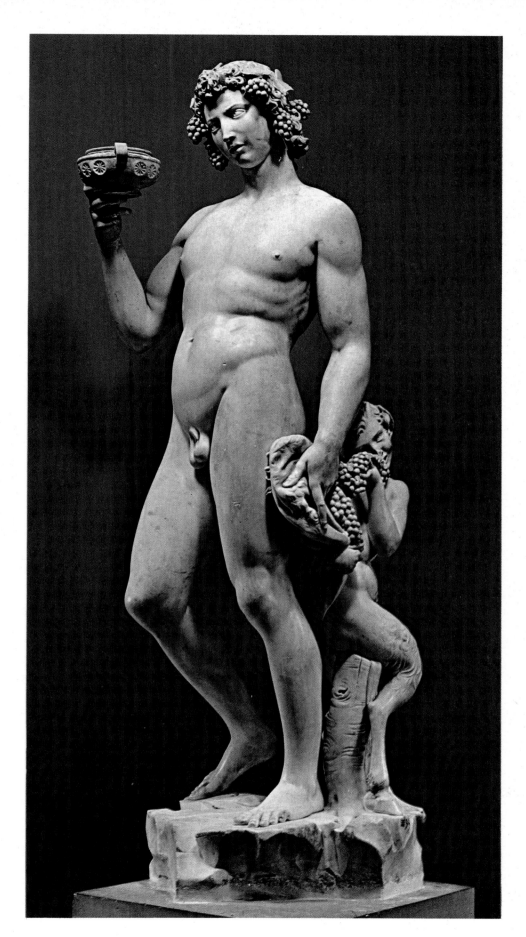

Signorelli, and, in the unprecedented foreshortening of the face, it is clear that, through his knowledge of Umbrian Sebastians, the artist anticipates by perhaps some ten years the contracted, elastic features found in the tondo of the *Doni Madonna*.

Probably in the spring of 1490, Michelangelo's vocation as a sculptor emerged. Seeing the antique statues collected in the Medici garden of San Marco, the boy, according to Condivi, "enjoyed the beauty of the works, and

from then on he went no more to Ghirlandaio's workshop, nor elsewhere, but spent the whole day here, in the best school for the subject, always doing something." On one occasion, he made a fine marble copy of a faun's head. This work so impressed Lorenzo il Magnifico that he asked Michelangelo's father if his son could live in his household. Ludovico, who had unwillingly agreed to let his son learn painting, could scarcely believe that he now wanted to take up the even humbler art of sculpture.

This view of sculpture as being a more manual art than painting must have been very common at the time. (In a well-known passage, Leonardo says that the painter's work is clean as compared with the toil, sweat, and dust the sculptor has to bear.) Ludovico Buonarroti complained to Michelangelo's somewhat older friend Francesco Granacci "that he was leading his son astray on this: that he would never allow his son to become a stonemason; it was no good Granacci explaining the difference between a sculptor and a stonemason" (Condivi). But he eventually gave in to

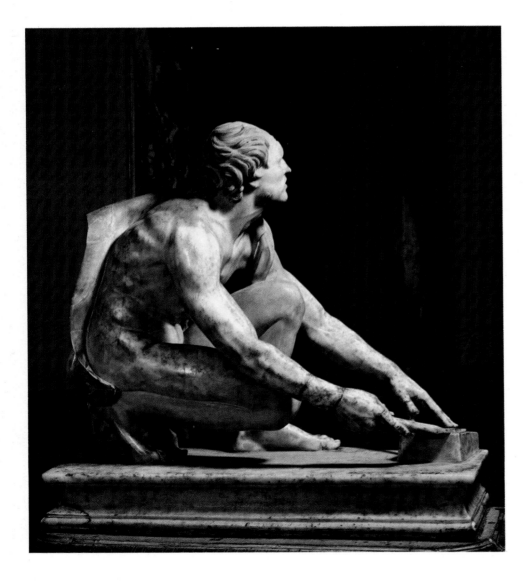

ARROTINO (KNIFE GRINDER)
Marble
Florence, Museo Nazionale del Bargello
The statue was moved from the garden of the Villa Medici in Rome to Florence in 1680. It may have been made for Cardinal Raffaele Riario but passed on to the Roman banker Jacopo Galli when Riario turned it down. Although generally believed to be a Hellenistic work, it was attributed to Michelangelo by Sandrart in 1675.

Lorenzo's request and was later rewarded with a customs job at eight scudi a month.

With the disappearance of the faun's head, which various scholars have unsuccessfully tried to rediscover, the earliest work of sculpture by Michelangelo is the relief the *Madonna of the Stairs* (page 12) in Casa Buonarroti. The iconographic concept of the composition, in which the staircase with angelic *putti* is an allusion to the Virgin's title "scala Dei," and

the Virgin gazes severely in front of her without paying attention to the Child she is suckling, is far removed from the typical humanized fifteenth-century concept of the nursing Madonna. The form is related to Donatello, with the use of very low relief and with its unfinished *putti* (small boys) in the background, who recall those on the singers' gallery in the cathedral. All sense of space is removed from the pictorial relief, so that the mass of the Madonna, poised motionless like an ancient goddess, emerges powerfully in the foreground. At the start of his work as a sculptor, Michelangelo again bypassed the refined art that had followed on from Donatello and returned directly to Donatello himself and his heroic austerity.

Next came the *Battle of the Centaurs* (page 13), illustrating the myth of the rape of Hippodamia, which, according to Condivi, was related to him "passage by passage" by Poliziano. With its high relief technique and the throng of figures, the work is modeled on Roman sarcophagi as well as on classicist reliefs by Bertoldo, Donatello's follower who frequented the

PIETÀ
Marble
Height, 69 in. (174 cm); width at base, 77 in. (195 cm); depth, 27 in. (69 cm)
1498–1499
Vatican City, Saint Peter's
This is the only work to bear Michelangelo's full signature; on the band across the Virgin's breast are the words, "Michael Angelus Bonarotus Florent Faciebat." The marble for this work was ordered from Carrara. In August 1498, Michelangelo, in the presence of the banker Jacopo Galli, who had bought the *Bacchus*, signed the contract with the French ambassador to the Holy See. The work, commissioned by Cardinal Jean Bilhères de Lagraulas in 1497, was placed in the chapel of Saint Petronilla, in the old Saint Peter's. The *Pietà* was then moved around several times inside Saint Peter's where it was first brought in 1517: it occupied the old sacristy, the old Sistine choir, the altar of Saints Simon and Jude, the choir, and finally was placed permanently in the first chapel on the right in 1749. After a madman's attack on the statue in 1972, the Virgin's nose, left eye, and left arm presented the most delicate problems of restoration to Redig de Campos, the director general of the Vatican Museum. Existing casts made it possible to skillfully repair the work, and it is now once again complete.
Pages 22–23, 25: Two details

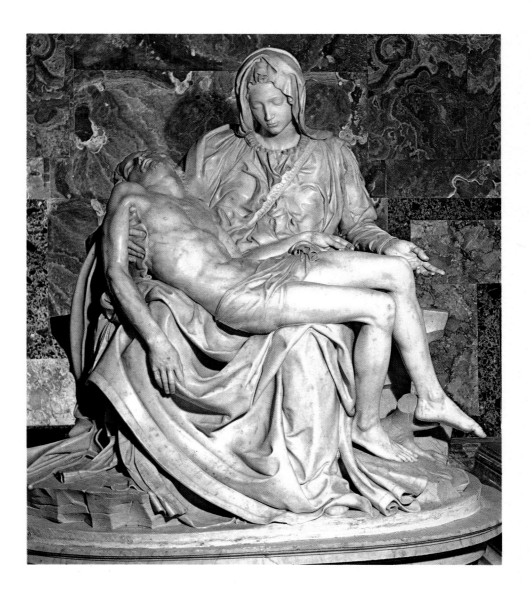

garden of San Marco. A further influence must have been a visit Michelangelo made to see Giovanni Pisano's pulpit at Pistoia. Just as in his early drawings for which Michelangelo took Masaccio and Giotto as his masters, so in this youthful attempt at sculpture, he looked back to Donatello and Giovanni Pisano. The sense of movement he saw in antique models and the emotional tension of the fourteenth-century artist were translated into a struggling tangle of powerful, contrasted masses — from the

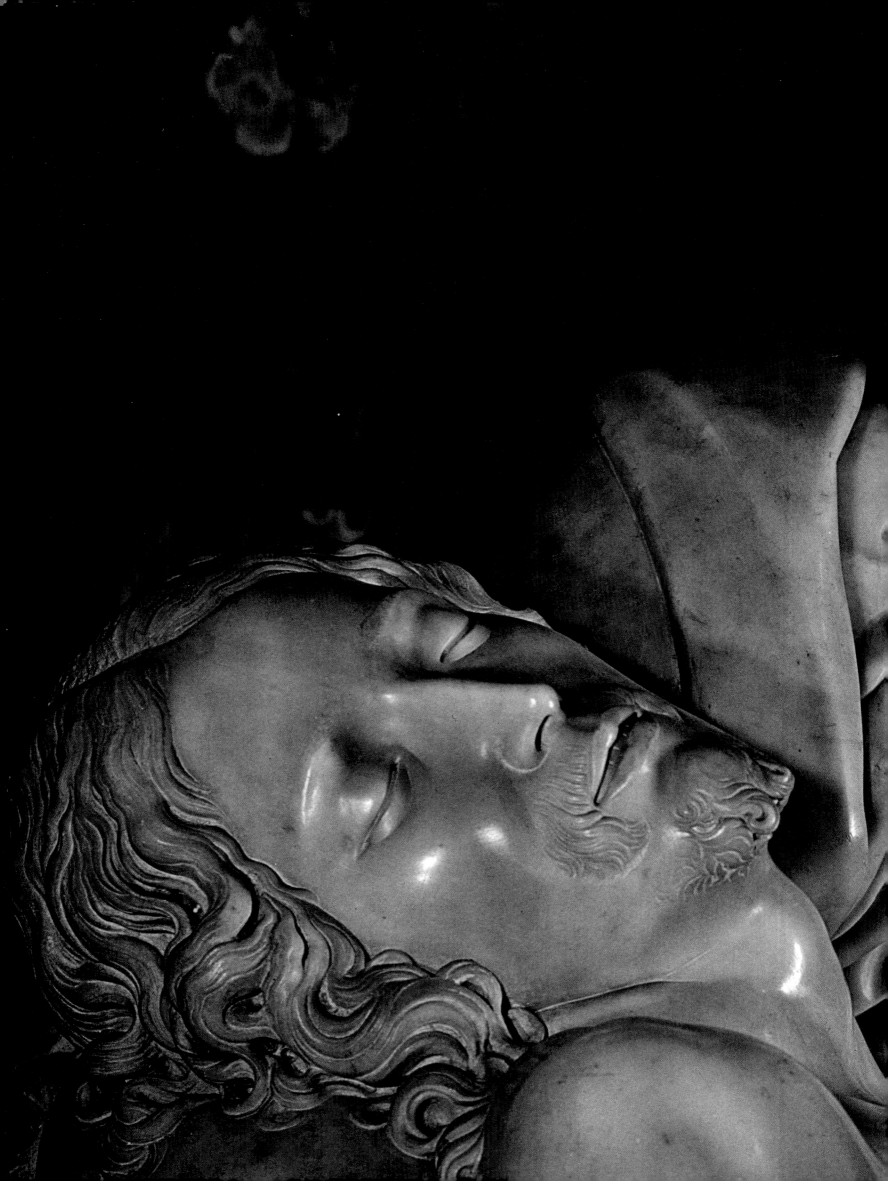

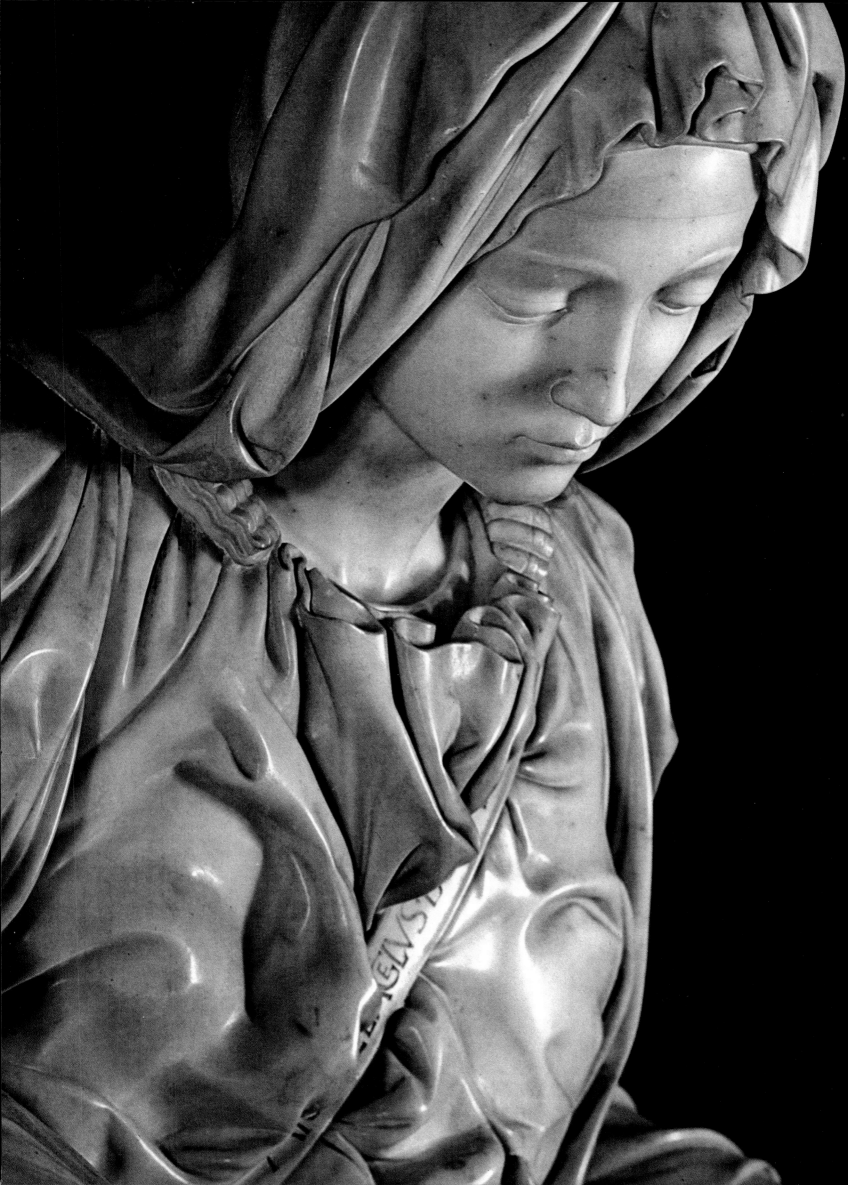

central group, an almost inextricable knot of bodies, to the more loosely spaced but equally vigorous and rhythmic figures at the sides. The result is an expression of sorrowful and enclosed drama. This work, which Michelangelo remained much attached to all through his life, seems so mature that it has been suggested that he may have worked on it again and improved it in later life.

According to Condivi, Michelangelo had only just finished the *Madonna of the Stairs* when his protector died in 1492. Grief-stricken, he returned to his family. The two years Michelangelo spent in the Medici household were very important to him: he had had an opportunity to study classical sculpture, to learn from Bertoldo (who died in 1491), and to become well acquainted not only with il Magnifico himself and his sons Piero, Giovanni (later Pope Leo X), and Giuliano (later duke of Urbino) but also with their tutors—Agnolo Poliziano, Marsilio Ficino, Pico della Mirandola, and Cristoforo Landino. Landino, who had compiled a commentary on the *Divine Comedy*, probably introduced Michelangelo to Dante's work; and from his conversations with the others, he must have absorbed ideas about classical civilization and Neoplatonist philosophy. It should not be forgotten that, for those who were not men of letters, learning was transmitted orally in conversation and discussion rather than in printed form. In Lorenzo's household, Michelangelo must have heard discussions and perhaps arguments about Savonarola's fiery sermons (these attracted such attention by 1490 that, in the following year, the large audiences had to be transferred from the church of San Marco to the cathedral). Instead of being confined to an artist's workshop, Michelangelo thus found himself at the center of the liveliest cultural circle of the day.

On Lorenzo's death, Condivi says, "Michelangelo returned to his father's house; he felt such grief at his death that for many days he could not do anything. But coming to himself again, he bought a large piece of marble that for many years had been exposed to rain and wind and made from it a *Hercules*, four *braccia* (yards) tall, which was later sent to France." He must have worked on this in 1493 and the beginning of 1494, if it is true that "while he was making this statue, much snow fell in Florence" (there is documentary evidence that a heavy snow fell on January 22, 1494) and that Piero de' Medici sent for Michelangelo to make him a snowman. The *Hercules* came into the possession of the Strozzi family and in 1530 was sent to Francis I, king of France, in an attempt to procure his help against the imperial troops then besieging Florence. It was later placed on a high pedestal in the Jardin de l'Etang at Fontainebleau and disappeared from there in 1713, when the garden was destroyed to enlarge the fountain courtyard. A rough record of the work seen from behind survives in a 1649 engraving and this, together with the description given in a 1707 inventory, is enough to refute Parronchi's attempted identification of the work with a nude statue; rather, these sources may indicate that in some respects the work was a forerunner of the *David*.

Unfortunately, there is no way of knowing what importance Michelangelo attached to the *Hercules*: was it a straightforward exercise in the imitation of the antique; a homage to Lorenzo's memory, likening him to the mythical hero as the benefactor of mankind; an allusion to Poliziano, who had provided his inspiration for the *Battle of the Centaurs* and whom Ficino called "Hercules," because with his philology he had slain the monsters that were destroying the territory of the Latin language; or a symbol of Florentine liberty, like his later *David* (page 27), perhaps with an allusion to Savonarola, who was already attacking Church corruption and making new plans for the republic? I prefer the last suggestion, if I am right in discerning Savonarola's clear influence in another work from this period that was also lost for several centuries (but was rediscovered just over ten years ago by Margrit Lisner).

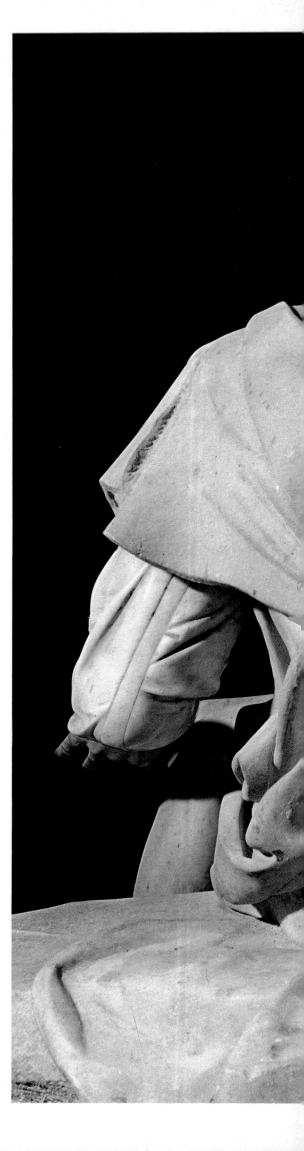

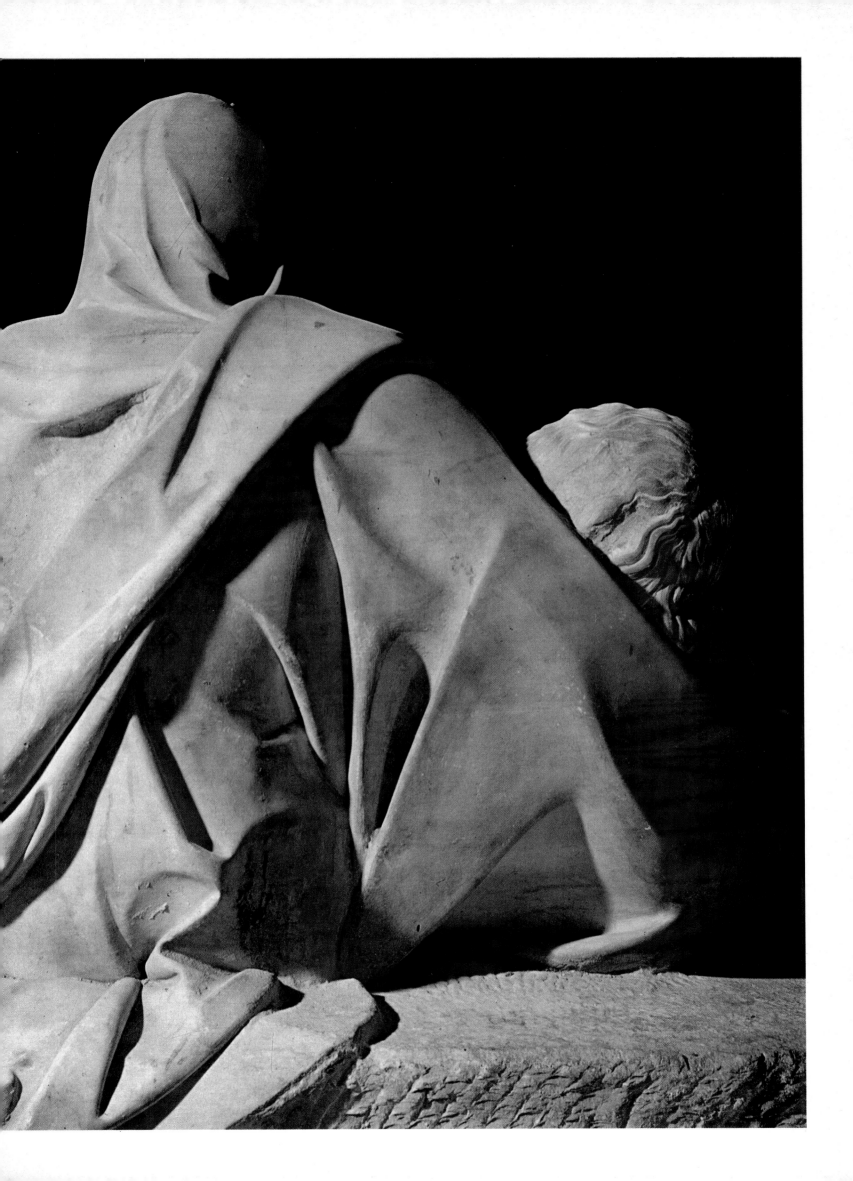

STUDIES FOR VICTORIOUS
DAVID
Pen and ink drawing on paper
$10\frac{1}{2} \times 7\frac{1}{4}$ in. (26.5 × 18.5 cm)
Circa 1501–1502
Paris, Musée du Louvre
On the right edge of the drawing are the words, "Davicte cholla Fromba e io chol larco," "Michelangelo," "Rocte lalta cholonna" (Petrarch, sonnet 229).

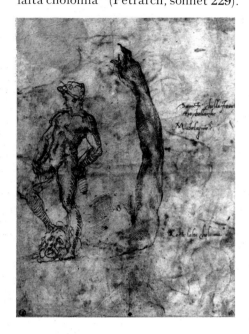

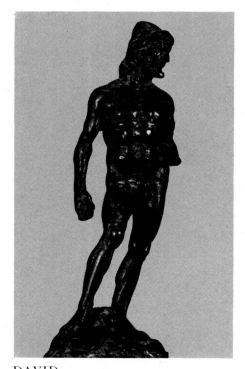

DAVID
Bronze
Height, 13 in. (33 cm)
Naples, Museo Nazionale di
Capodimonte
This bronze, owned by the Farnese family, came to Naples at the end of the last century. It is generally recognized as the work of Antonio del Pollaiuolo (1431–1498). The statue has recently been attributed to Michelangelo, but this theory is not widely accepted.

After the young sculptor had built the snowman in the courtyard of the Medici palace, Piero invited him to "stay in his house, as in his father's day, giving him the same room and keeping him always at his table as before." During this period, for the rest of the winter and the spring of 1494, "Michelangelo, for the pleasure of the prior of Santo Spirito, a much-venerated church in the city of Florence, made a wooden crucifix, a little less than life-size, that can still today be seen on the high altar of this church. He had many close dealings with the prior, receiving much courtesy from him and being provided by him with a room and corpses so that he could study anatomy" (Condivi). The Santo Spirito *Crucifix* (page 16), now displayed in the Casa Buonarroti Museum, is a very delicate, flesh-colored work that does not show any sign of Michelangelo's anatomical studies, which perhaps only began after it had been completed. The *Crucifix* gives a new torsion (which was to develop dramatically in later years) to the tranquil forms of the second period of the Florentine fifteenth century, particularly evidenced in the works of Benedetto da Maiano. It does not seem to me farfetched to find in this chaste and incorrupt image of the body of Christ an echo of Savonarola's *Operetta dell'Amor di Gesu (Little Work on the Love of Jesus)*, written in 1491–92. Some of the lines emphasize the "very holy and immaculate flesh" of "sweet Jesus" crucified.

Piero de' Medici, according to Condivi, had a character that was "insolent and overbearing"; so it is easy to believe that Michelangelo was not as happy in this household as he had been in Lorenzo's. On the night of September 28–29, 1494, Agnolo Poliziano, then barely forty, died suddenly. At about the same time, a court musician, Cardiere, a close friend of Michelangelo, dreamed repeatedly that Lorenzo was commanding him to "tell his son that soon he would be driven from his home and would never again return to it" (Condivi). Within two weeks, disturbed by Cardiere's visions and probably shaken by Savonarola's prophecy that "a new Cyrus" would descend on Italy, Michelangelo left Florence with two friends and set off for Bologna and Venice.

He soon started to make his way back to Florence, however, since he was short of money. But on reaching Bologna, at the end of October, it is thought, he was sentenced to pay a heavy fine because he had failed to receive the necessary seal of red wax on his thumbnail upon entering the city. He had to pay "fifty Bolognese lire; he had no means of paying, and while he was in the office, a certain Messer Gian Francesco Aldovrandini, a Bolognese gentleman who was then one of the *Sedici* (city councillors), saw him there, and when he heard about the situation had him released" (Condivi). He let Michelangelo stay in his house for about a year "and every evening made him read aloud to him from Dante or Petrarch or sometimes Boccaccio, until he fell asleep."

During this period, Charles VIII, the "new Cyrus" Savonarola had prophesied, occupied Florence. The Florentine people rose up and drove out the Medici, who took refuge in Bologna: "Thus Cardiere's vision, whether it was a devilish illusion, a divine prediction, or the result of a powerful imagination, came true—a truly wonderful event and worthy of record, which I [Condivi] have narrated as I heard it from Michelangelo."

Aldovrandini obtained a commission for Michelangelo to complete Saint Dominic's tomb, in the church of San Domenico, which had been begun during the thirteenth century by Nicola Pisano and his school and continued by Niccolò dell'Arca but left unfinished after his death. Michelangelo executed the small statues of *Saint Petronius* and *Saint Proculus*; the *Angel with Candlestick* (page 17), which faces Niccolò dell'Arca's angel; and, according to Parronchi, the cherubs' heads in the frieze.

The controlled strength and latent dynamism of the Bolognese reliefs of Jacopo della Quercia must have made a strong impression on the young Michelangelo. He must also have been attracted by the sober classicism of

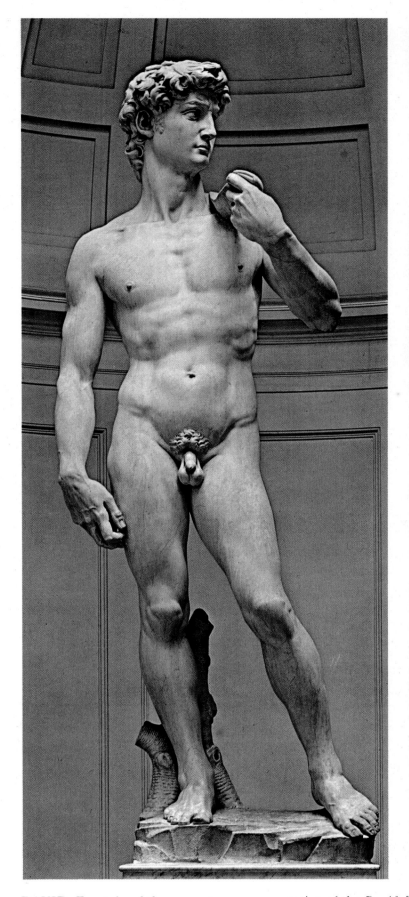
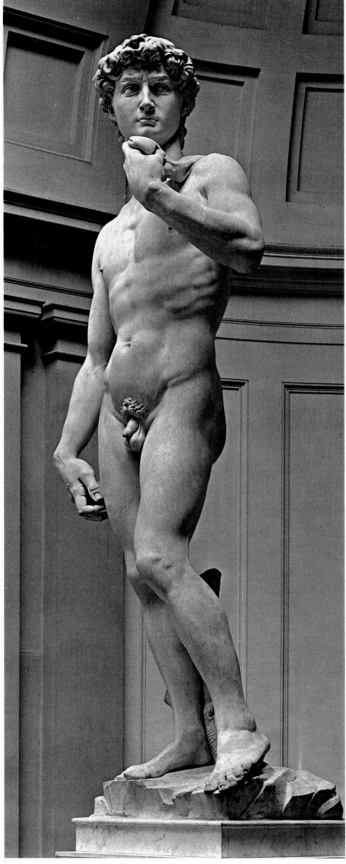

DAVID: Frontal and three-quarter view
Marble
Height, 13 ft. 6 in. (410 cm); with base, 14 ft. 3 in. (434 cm)
1501–1504
Florence, Galleria dell'Accademia
Because of Michelangelo's reputation and the magnitude of his task in making such a huge statue, there is an almost day-by-day account of the creation of the *David*. The huge block, which Agostino di Duccio and Antonio Rossellino had already worked on unsuccessfully and which was then left lying in the courtyard of the Opera del Duomo, was handed over to Michelangelo in August 1501. By September, he was working on the statue; in January 1504, it was more or less finished; and, in June, it was placed beside the entrance to the Palazzo Vecchio (replacing Donatello's *Judith*, which was moved to the Loggia). In September, the statue base, the work of Simone del Pollaiuolo and Antonio da Sangallo, was also complete. Since 1873, the *David*, replaced by a copy in Piazza della Signoria, has been in the Galleria dell'Accademia.
Pages 28–29: Detail

27

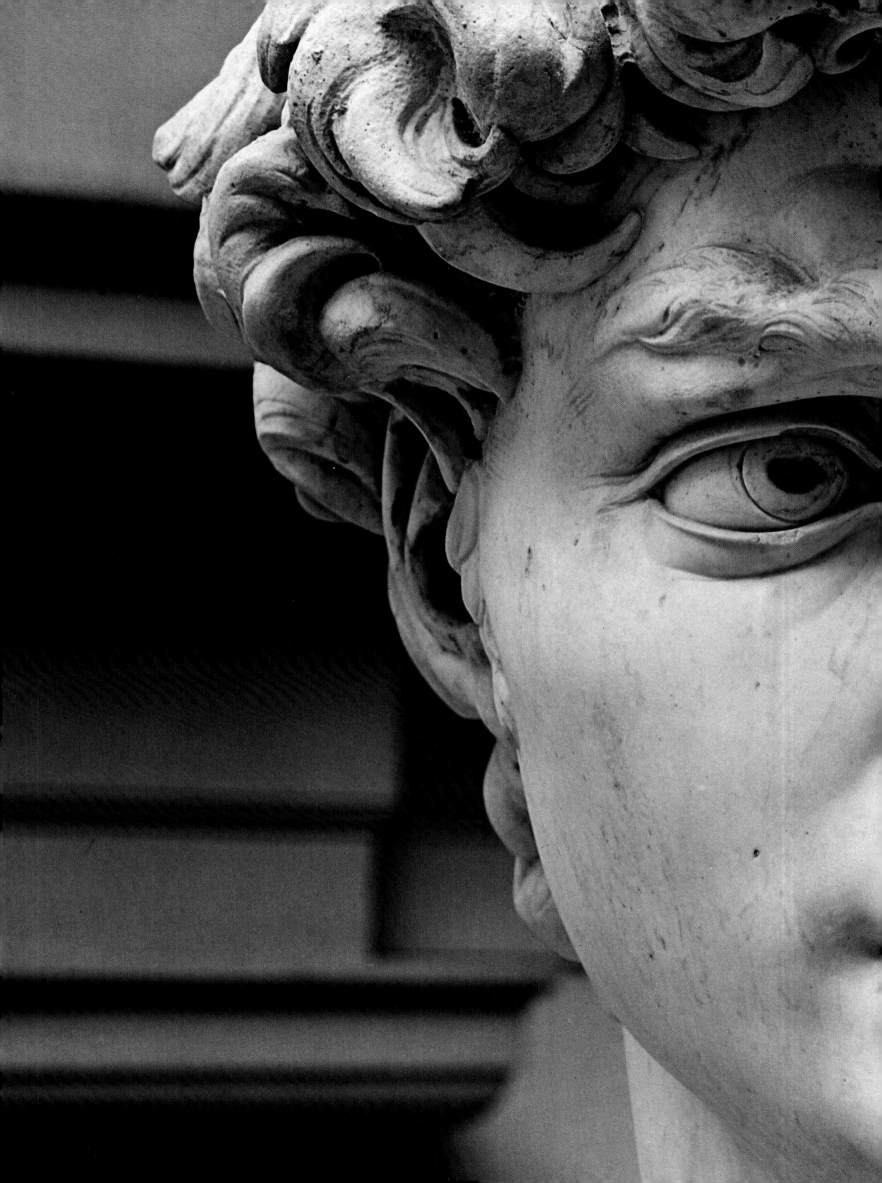

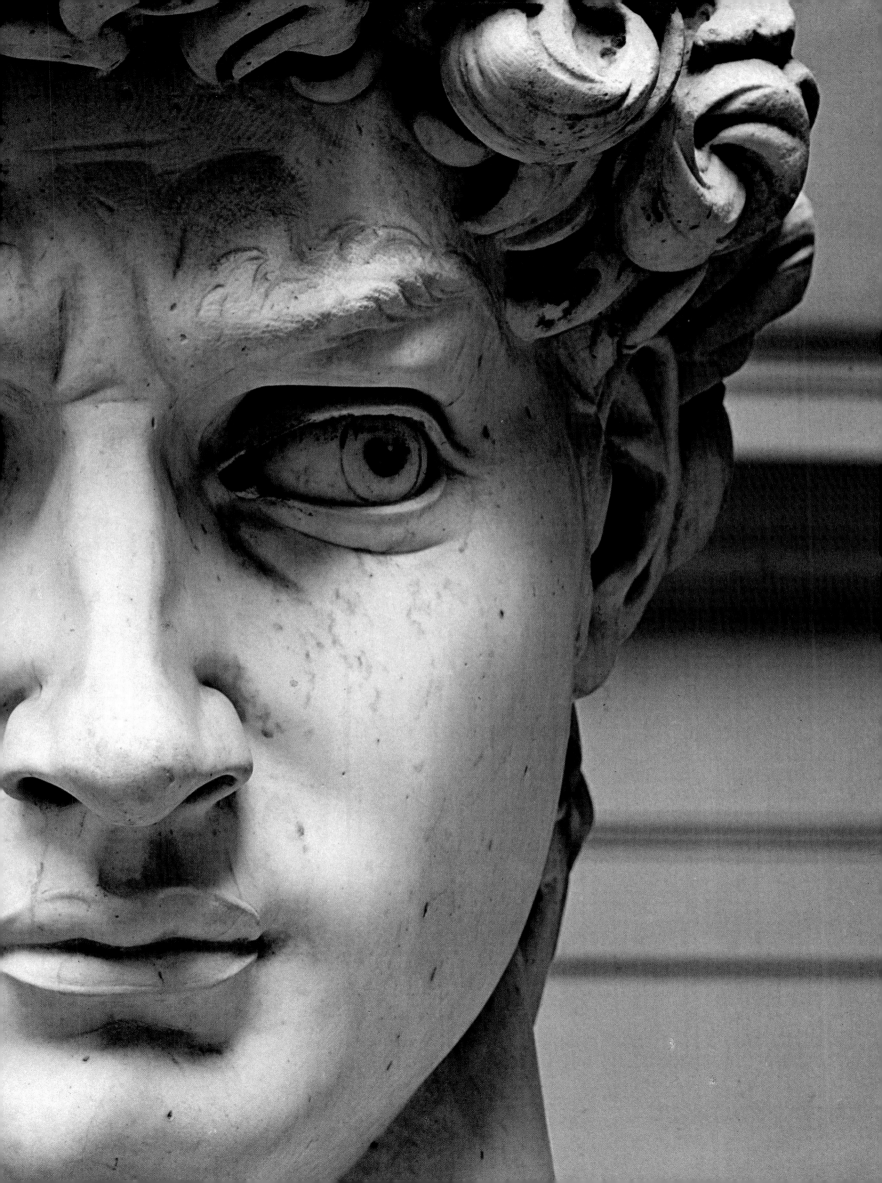

the Pisano sculptures of the tomb as well as by the harsh expressionism of the Ferrarese paintings by Tura, Cossa, and Roberti and the elements of that style which appeared in (or perhaps inspired) Niccolò dell'Arca's tomb in Santa Maria della Vita.

Influences of Verrocchio's equestrian statue, *Colleoni*, which the artist had recently seen in Venice, have also been identified, at least in *Saint Proculus's* head. The dense plastic mass of the angel makes the little figure look as if some inner energy were compelling it to rise and break the bounds of the block of marble, the form of which is still apparent in the general shape of the figure.

In these early works, a concentrated latent energy brings a new dimension to what Michelangelo learned from the predecessors who most appealed to him. In the angel's clothing, the vigorous, mobile folds, inspired by della Quercia, enliven the figure's tranquil outline, inspired by Luca della Robbia's angel in the sacristy of the cathedral at Florence. The model for *Saint Petronius* is della Quercia's statue of the saint on the portal of San Petronio. Tension of form and *contrapposto* are already hinted at in this statue but seem lost in the flowing Gothic rhythm of the figure. Michelangelo, in extracting these elements of contrast from the flowing lines and projecting them more forcefully, makes the image more dramatic with the lively plasticity of the clothing. The model for *Saint Proculus* is Donatello's *Saint George*, which goes beyond the echo of Verrocchio's

SAINT GREGORY; SAINT PAUL; SAINT PIUS; SAINT PETER
Marble
Respective heights, 53½ in. (136 cm), 50 in. (127 cm), 53 in. (134 cm), 49 in. (124 cm)
Circa 1501–1504
Siena, Cathedral
The four statues are part of the much larger project of decorating the Piccolomini altar in Siena Cathedral. Michelangelo undertook this task in two stages, in 1501 and 1504. The altar, built during the last decade of the fifteenth century by Andrea Bregno, was to have been decorated with sixteen figures by Pietro Torregiani,

 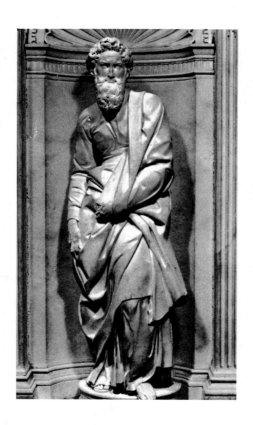 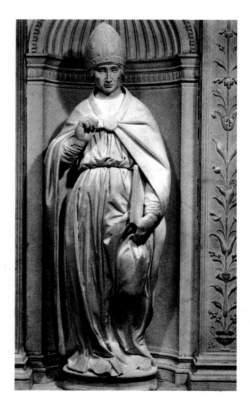

Colleoni in the frowning forehead to a dynamic unity of space and volume that is broken up into contrasting masses brought into the foremost plane and removed from the idealizing function of space. This produces a dramatic immediacy compared with the detached, heroic ideal of the fifteenth-century figure.

Even in these early works, Michelangelo clearly rejects the fifteenth-century concept of space and perspective that places each figure and each object in a space quite distinct from that of the onlooker and that produces,

consequently, detachment and distance even in the most dramatic representations. Rather, he tends to bring all his characters to the forefront in tragic solitude. This brings to mind some lines composed a few years later. They are among the first verses Michelangelo wrote:

Sol io ardendo all'ombra mi rimango,
Quand'el sol de' suo razzi el mondo spoglia:
ogni altro per piacere, e io per doglia,
prostrato in terra, mi lamento e piango.
(Only I remain burning in the shade when the sun strips the world with its rays: all others take pleasure, but I in sorrow, lying on the ground, mourn and weep.)

Michelangelo returned to Florence "when matters had become quieter and he could live safely at home." This was at the end of 1495, when Savonarola's republic was in full force. According to Condivi, he made two statues for Lorenzo di Pierfranceso de' Medici, known as "il Popolano" (the man of the people), because he had quarreled with Piero and posed as a republican, instead of fleeing into exile. These two works are a young *Saint John the Baptist* and a *Cupid*. Parronchi's identification of the *Saint John the Baptist* (page 18) with the statue in the Bargello traditionally attributed to Donatello seems to be a convincing hypothesis. More recent art historians, however, have rejected this view. The statue marks a return to Donatello but also reveals the inspiration of the Ferrarese school of painting, especially Ercole de' Roberti, with which Michelangelo became familiar in Bologna. The figure is ascetic and very austere, in keeping with the spiritual climate in Florence at the time, dominated as it was by Savonarola's stern admonitions; yet it has an extraordinary tension—an image ready for action but at the same time closed in on itself.

On the other hand, I believe that, despite various attempted identifications, the *Cupid*, the "God of love, between six and seven years of age, lying like a sleeping boy," is lost. This work, treated with earth to give it a patina of age, was sold in Rome as an antique to Raffaele Riario, Cardinal of San Giorgio in Velabro. The episode of the *Cupid*, which earned Michelangelo only thirty ducats, although it fetched a price of two hundred, was the reason the artist went to Rome on June 20, 1496, to the household of Cardinal di San Giorgio. (Probably another reason was that Savonarola's republic, while meeting Michelangelo's republican ideals, was an austere regime that did not provide many opportunities for work.) Michelangelo was disappointed by Cardinal Riario, who was not interested in keeping the *Cupid* once he discovered it was a modern work by Michelangelo rather than an antique. His disappointment is further reflected in Condivi's statement that the cardinal understood little about sculpture, since Michelangelo "all the time he was with him, which was about a year, was not commissioned to do any work for him."

In fact, the situation was rather different. A letter to Lorenzo di Pierfrancesco of July 2, 1496, and another to his father of July 1 the following year show that during the year between the two letters, Michelangelo was working on a life-size figure. This is generally thought to be the *Bacchus*, now in the Bargello (page 19), which originally stood in the garden of the learned Roman banker Jacopo Galli. If this is so, Galli must have bought the statue from the cardinal rather than commissioned it himself as Condivi claims, since according to the text of Michelangelo's letter to his father: "I have not yet been able to settle my affairs with the cardinal, and I do not want to leave until I am satisfied and rewarded for my labor." This has been taken to mean that Riario was unhappy with the work and passed the statue on to Galli.

It is worth considering, however, Parronchi's hypothesis that the figure

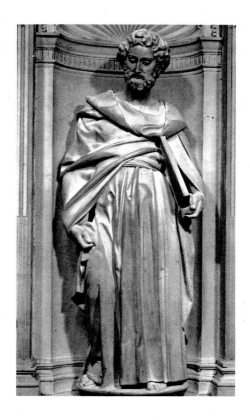

who in fact only began a *Saint Francis*. Michelangelo finished the *Saint Francis* and was to have completed the other fifteen statues. However, he only tackled a small part of his task and was later released from the contract. There is a recent tendency to regard them as at least partly authentic. *Saint Paul* and *Saint Peter* are believed to be mainly by Michelangelo; but apart from perhaps his small contribution to *Saint Pius* and *Saint Gregory*, the statues were executed by Baccio da Montelupo, who was probably provided with Michelangelo's designs. It is sometimes said that the face of *Saint Paul* is a self-portrait of the artist.

carved for the cardinal, in imitation of an antique work like the *Cupid* (which Riario had refused to keep because he was so angry at being deceived), should instead be identified with the famous Uffizi *Arrotino*, or *Knife Grinder* (page 20), formerly in the Villa Medici gardens in Rome and in Florence from 1680. This Scythian, shown sharpening the knife with which Apollo was to flay Marsyas, is usually thought to be a Hellenistic work; but Sandrart in 1675 described it in association with Michelangelo's name, and a number of older scholars, including the great Burckhardt, considered it the work of a modern sculptor. This superb figure is strongly influenced by the Hellenism of Rhodes—especially by the Belvedere torso that, according to sixteenth-century sources, Michelangelo greatly admired. It was clearly created as an attempt to compete with antique art, but it does not correspond to any known theme of classic iconography; instead, it traces back to a theme, prefigured by Giotto and Masaccio, reminiscent of Michelangelo's bowed figure of the neophyte in the fresco of the *Baptism of Christ* in Santa Maria Novella (page 11). It has already been mentioned that the young Michelangelo had assisted Ghirlandaio on this picture.

There are other reasons for associating the *Knife Grinder* with Michelangelo's hand. Many details—for example the way the beard is portrayed—recall Christ in the *Pietà* of Saint Peter's (page 21), while in the

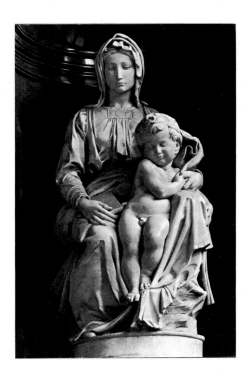

BRUGES MADONNA
Marble
Height, 37 in. (94 cm); with base,
50½ in. (128 cm)
1501-1502
Bruges, Church of Notre-Dame
This work was sent to Bruges during the first years of the sixteenth century and remained there (in the chapel of the Moscheroni, or Mouscron, family, who had bought the work for 4,000 florins in 1506) until the beginning of the nineteenth century, when Napoleon's agents removed it. It was returned to Bruges in 1815. Dürer refers to it enthusiastically in his travel diary.

back view of the Madonna from the same group (page 25), the regal way the clothing is arranged in broad, strong folds is closely foreshadowed by the cloak boldly thrown across the Scythian's shoulder. But the main reason for suggesting that this work is by Michelangelo and dates from the time of his first real encounter in Rome with the world of antique art is the latent tension contained in this block of alabaster marble. There is a highly dramatic dialectic between the curve of the figure, which appears bowed down under a crushing weight, and the movement implicit in the elasticity of the composition, as if the figure were about to raise himself in a rebellious outburst that seems to presage, however distantly, *Jonah*'s cry in the Sistine Chapel. The artist, Parronchi writes: "by isolating a figure like the *Knife Grinder*, raising it on a base perfectly calibrated on all sides, concentrates the attention on a subject that belongs to the perennial story of oppressed, enslaved humanity rather than to mythical antiquity."

In the *Bacchus* (page 19), however, Condivi remarks, "the form and aspect . . . correspond in every way to the intention of ancient writers." The lines and masses of the figure are animated by a tension (seen for example in the outward curve of the stomach), so that, through the contrasting emphatic rhythm of the composition, the classical serenity of the theme is overlaid with a dramatic sense of sadness and disquiet. It is a work of exceptionally rich plasticity, partly because it was meant to stand in a garden and be seen

STUDIES OF PUTTI
Black chalk drawing on paper
14¾ × 9 in. (37.5 × 23 cm)
Circa 1501
London, British Museum
The drawing is linked to the *Bruges Madonna* by two contemporary pen inscriptions that repeat the words "chostì di brugis." There is a note in Michelangelo's handwriting that contains the name "Lessandro manecti." On the *verso*, is a pen drawing of a male nude.

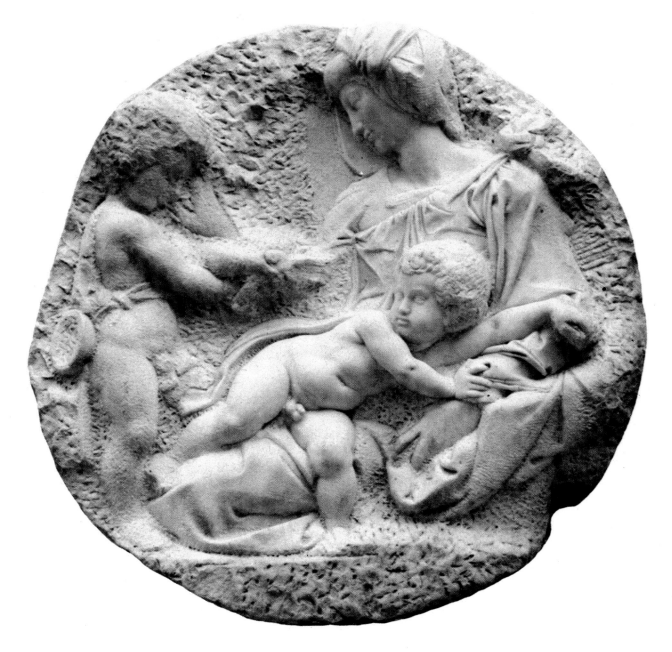

TADDEO TADDEI MADONNA
Marble
Diameter, 43 in. (109 cm)
1502–1504
London, Royal Academy of Arts
The tondo is named after its purchaser
Taddeo Taddei, and, according to
Vasari, it was made for him. In 1823, it
was bought by George Beaumont in
Rome and taken to London. The
authorship of the relief has been much
discussed: Wittkower, Tolnay, and
Arslan believe it is only partly, if at all,
by Michelangelo. The Leonardo-like
elements of the work and its chron-
ology (Venturi dates it much later)
have also been debated.

from all sides. From the side, the agile, intricate torsion of the little faun
seems to underline, like an ornamental run in music, the more sober torsion
of *Bacchus*, which is based on the interplay between Polyclitus's scheme of
weight distribution and the survival of a Gothic energy, reminiscent of
Jacopo della Quercia, that breaks that balance. According to von Einem, the
theme of the work is "the break in equilibrium—the tension between free
will and constraint." Condivi presents a different view of the theme: "On his
left arm, he has a tiger skin. . . . He made the skin rather than the animal to
show that whoever lets himself be so drawn by his taste and appetite for that
fruit and its juice will finally lose his life." This moralistic interpretation
may be correct in that the artist wished to represent dramatically the
struggle between man's moral sense and his abandonment to the sensual life.

About the same time that Michelangelo was, according to his letters,
working on a life-size figure, he obtained a commission for the famous
Pietà (pages 21–25). Now in Saint Peter's, it was carved at the request of
Cardinal di San Dionigi (called "Cardinal Rovano") and originally intended
for the cardinal's tomb in the church of Santa Petronilla (which was later
demolished). Jacopo Galli, as the contract drawn up on August 27, 1498,
shows, obtained this commission for Michelangelo in the autumn of 1497,
and the sculptor went to Carrara to choose his marble in October and
November of 1497.

The iconographic scheme derives from the typical German fourteenth- and fifteenth-century *Vesperbild*, which had reached Italy and had made an impression on Ferrarese painting. Evidence of this is seen in the *Pietà* of Ercole de' Roberti, now in Liverpool. But Michelangelo transforms the composition into a pyramidal scheme by enlarging the base and reducing the contrast between the vertical Madonna and Christ's horizontal body. This probably reflects Leonardo's Florentine works. There may be hints of Leonardo, too, in the new attention to the effects created by light that plays smoothly over Christ's body, creates rich effects of light and shade among the folds of the clothing (which might seem superfluous were they not so vigorously carved with a plastic energy of their own), and finally falls in a delicate half-shadow on the Virgin's face. The play of light that brings out Christ's body clearly against the surrounding darker dense mass of the Madonna is contained by the architectonic majesty of the composition that gathers together and encloses within its well-defined limits all the lively and tumultuous movement of light and shade and modeled surfaces. The work is a highly coherent expression of a sense of deep calm, imbued with grief and drama. The Neoplatonist atmosphere that Michelangelo breathed as a boy in Florence in the household of Lorenzo il Magnifico blossoms again here, allowing grief and drama to be contained within forms of delicate, ideal beauty.

According to the contract, Michelangelo should have handed over the *Pietà* in August 1499; but it seems likely that the work took much longer since not until May 1501 do we find him in Florence once again. Michelangelo's most relaxed and expansive works date from his first stay in Rome and the subsequent period in Florence. This suggests that he found himself less in conflict with his surroundings at this time. Back in Florence, he found the republic of Pier Soderini, gonfalonier for life, an aristocratic, conservative republic but one that still preserved the substance of Savonarola's constitution and that vehemently opposed the Medici. The short-lived institution of lifelong gonfalonieri was modeled on the Venetian dogeship and followed Savonarola's line of imitating the Venetian republic, which seemed to provide a model for a strong and peaceful state.

Probably Michelangelo felt that this regime was the incarnation of many of the civil virtues—moral austerity, the simple life, and dedication to the public good—that early fifteenth-century humanists attributed to republican Rome. Although Michelangelo had absorbed many Neoplatonist ideals, he still had a basic leaning towards Stoicism. This attitude, far more than any purely aesthetic motive, explains his eagerness to return to the artistic values of the early Renaissance and, as a boy, to study Giotto, Masaccio, and Donatello. Perhaps he remembered reading in Coluccio Salutati's *Vita Civile* that "of all human works, none is more excellent and more worthy than that which aims at the growth and safety of one's native land and the well-being of a well-ordered republic" while he worked between August 1501 and early 1504 to extract his *David* from the block of marble that had already been badly damaged by Agostino di Duccio thirty years before. He may have viewed this strong and powerful "giant," as his work at once became known among the people, as a symbol of the defense of Florentine liberty. The *David* (page 27) was originally intended for the cathedral but was later placed instead of Donatello's *Judith*, in front of the entrance to the Palazzo della Signoria.

The siting of the statue in front of the Palazzo della Signoria, where a copy now stands since the original was moved to the Galleria dell'Accademia in 1873, was decided by the signoria against the majority view of a commission of artists that included Cosimo Rosselli, Piero di Cosimo, Granacci, Davide Ghirlandaio, the two Sangallos, Cronaca, Andrea della Robbia, Sansovino, Perugino, Botticelli, Filippino, Lorenzo di Credi, and Leonardo da Vinci. The commission felt the statue should stand in the Loggia. Michelangelo's own

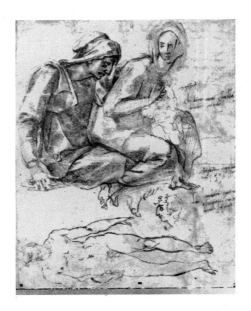

SAINT ANNE WITH THE VIRGIN AND CHILD
Pen drawing on paper
$12\frac{3}{4} \times 10\frac{1}{4}$ in. (32.5×26 cm)
Circa 1505
Paris, Musée du Louvre
Various dates during the first decade of the sixteenth century have been proposed for the Virgin and Child in this drawing. It has been suggested that Saint Anne may be a later addition (1523–1525), although this argument is not very convincing. The sketch of a male nude at the bottom of the sheet has been related to the *David*.

SAINT ANNE WITH THE VIRGIN AND CHILD
Pen drawing on paper
$10 \times 6\frac{3}{4}$ in. (25.7×17.5 cm)
Circa 1504
Oxford, Ashmolean Museum

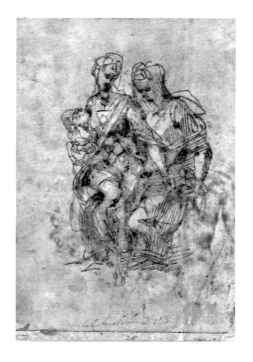

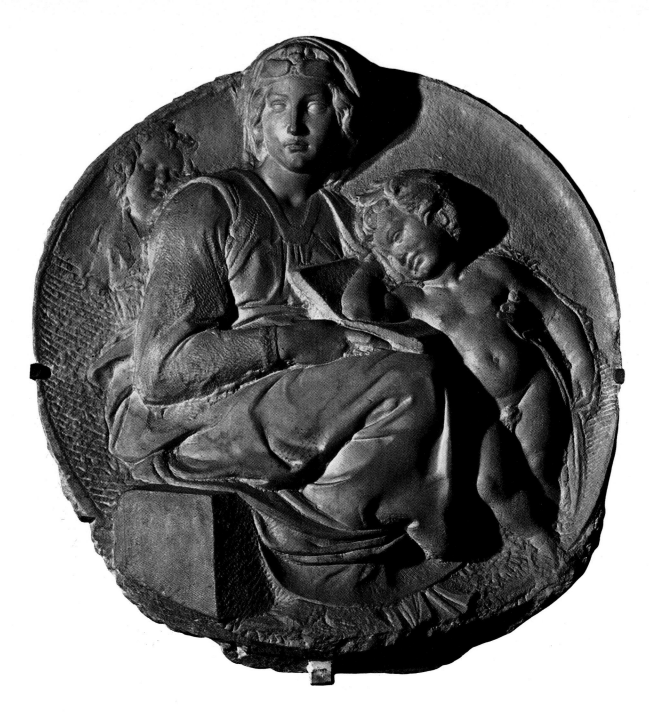

PITTI MADONNA
Marble
Height, 33½ in. (85.5 cm); width,
32½ in. (82 cm)
1503–1504
Florence, Museo Nazionale del
Bargello
The relief was made for Bartolomeo
Pitti and, according to Varchi, was in
Pietro Guicciardini's possession in
1564. It was bought by the Florentine
galleries in 1823 and placed in the
Bargello in 1873. Besides its links with
antique art, the work is clearly related
to the iconography of Jacopo della
Quercia's works and, more precisely,
to the figure of *Prudence* on the *Fonte Gaia*
in Siena. In 1972, Hartt suggested
that the *Pitti Madonna* should be dated
slightly later, about 1506. The cherub
on the Virgin's forehead symbolizes the
power of prophecy and is also a feature
of the *Madonna* of Donatello's altar in
the Santo in Padua.
Pages 36–37: Detail

request, which was perhaps influenced by his friendship with the
gonfalonier, was to place the statue at the palazzo, and the signoria probably
decided to follow his wishes. This confirms that the statue's political
significance is not a concept invented by posterity but an idea that was
already in the artist's mind when he conceived and executed his work.
Vasari also suggests this in the first edition of his *Lives*: "Therefore,
Michelangelo, having made a wax model, fashioned, as the insignia of the
palazzo, a young *David* with a sling in his hand to show that just as he had
defended his people and governed them with justice so whoever governed
the city should defend it bravely and govern it justly."

That this concept of the open defense (perhaps implied, too, by the figure's
nudity) of the city's liberty was an essential element of the work is made
clear by its novel iconography: it no longer shows, as Donatello's *David*
does, the hero after his task is done, with Goliath's head at his feet. Rather,
Michelangelo's *David* is shown gazing at the enemy and assessing the
imminent action. This is expressed in the dynamic, continuous tension of the
statue's contours, inspired particularly by Pollaiuolo; in the animated
surfaces and masses that give vibrant, intense energy to the anatomy; and in
the dialectic between the static pose that echoes the classical contrapposto
and the way in which the stance is altered between immobility and

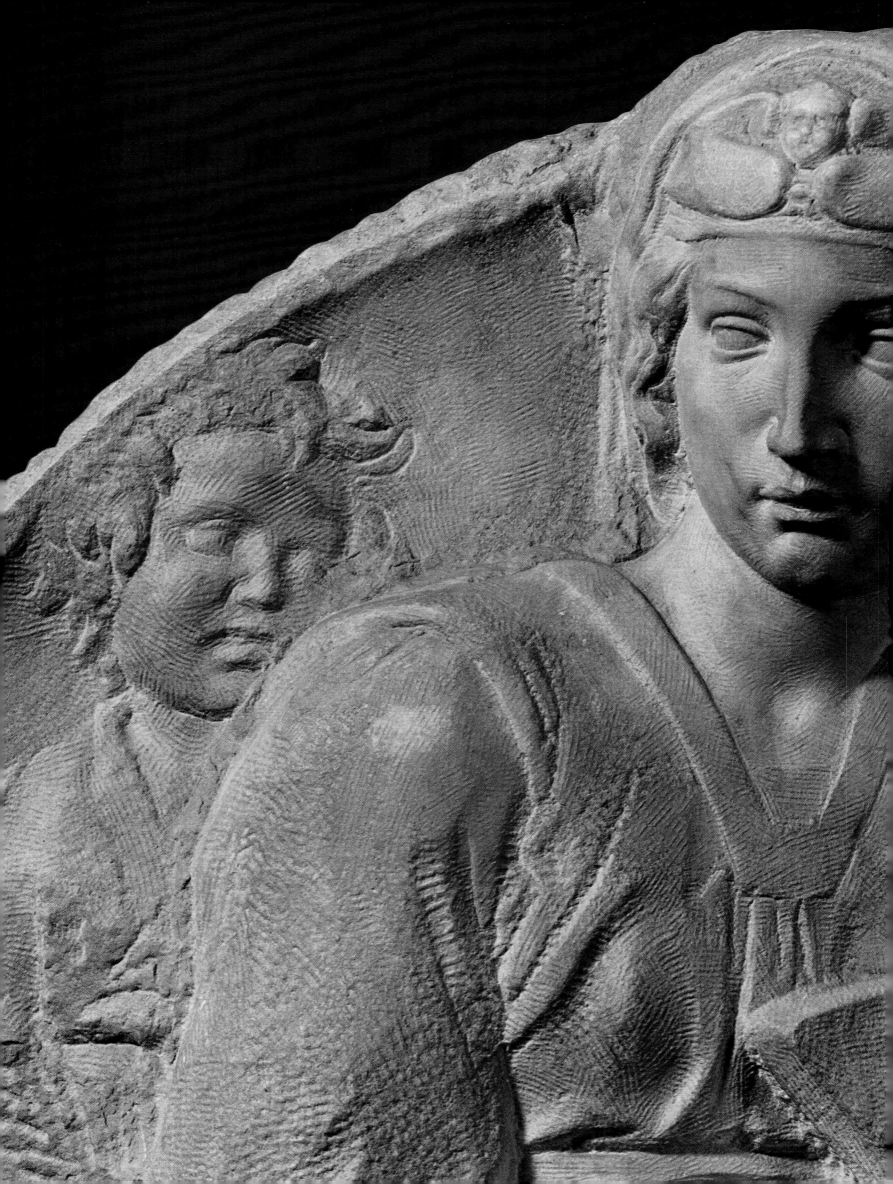

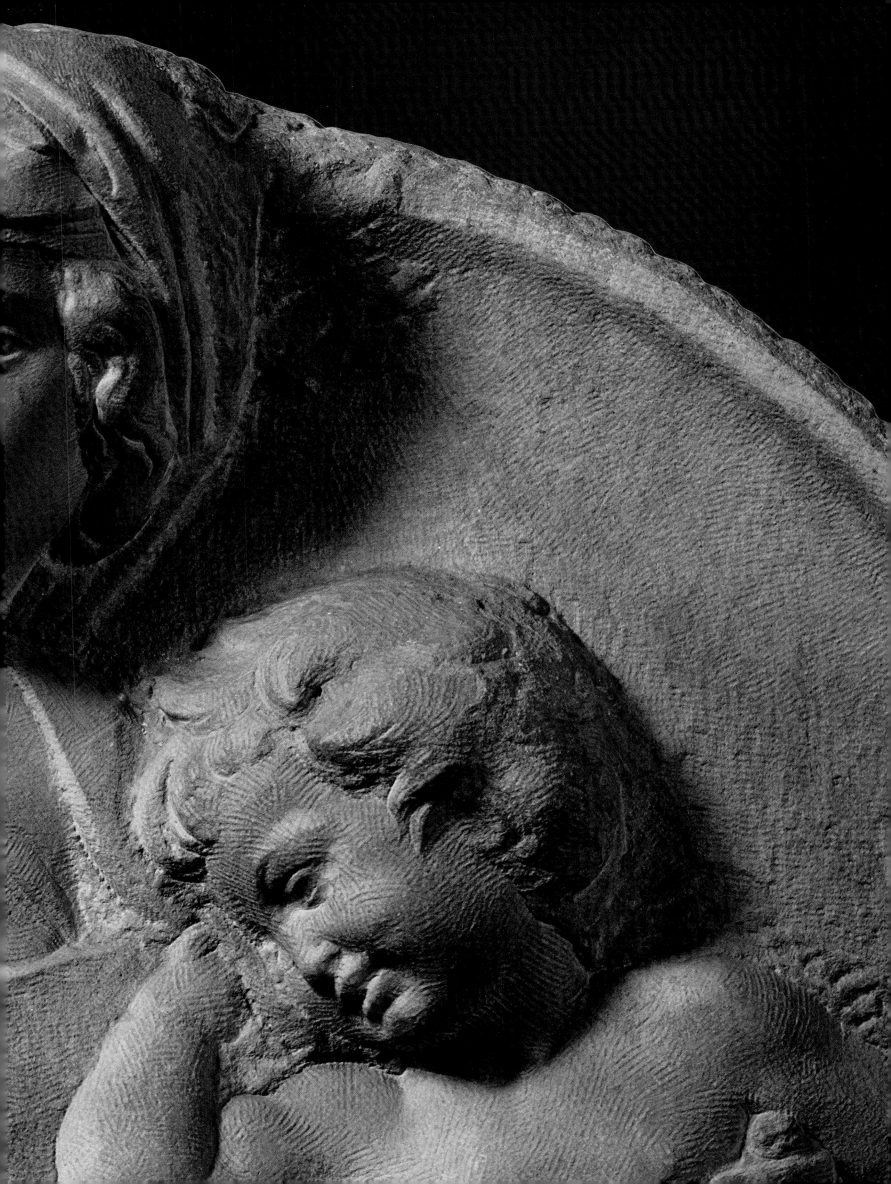

movement. The movement and action are potential rather than actual, but a narrow borderline divides the two qualities, and so the work is elevated to a symbol of perpetual vigilance and readiness.

It has been suggested that the *David* introduced classicism to Florence. However, the iconographic type of the "heroic nude" had a distinguished precedent in Donatello's bronze *David* and in Pollaiuolo's *Hercules and Antaeus*, which was already influenced in its iconography and style by small antique bronzes. Also, Michelangelo's *David* blends classicism with fifteenth-century Florentine naturalism, so that the work is less an imitation of the antique than the earlier *Bacchus*.

In the Louvre, there is a drawing of the marble *David*'s right arm (page 26) and a sketch for a bronze *David* that was made from 1502 to 1508 (and completed by Benedetto da Rovezzano) and that the signoria sent to France as a gift to a French diplomat (it disappeared after 1650). The same piece of paper also bears one of Michelangelo's earliest attempts at verse: "Davicte colla fromba e io coll'arco" (David with the sling and I with the bow).

Pierre de Rohan, Maréchal de Gié, who had requested the work, wanted the bronze *David* to be "like the one in the courtyard of the signoria," an imitation of Donatello's bronze *David*. But as early as 1564, Benedetto Varchi declared that it was made "not so much to imitate as to compete" with Donatello's work. Michelangelo's independence is confirmed by the drawing mentioned above and by a small bronze in Naples (page 26) that is similar in conception to the statue and may be a bronze version of some small model, perhaps in wax, by Michelangelo.

In October 1506, a chest containing a *Madonna* executed by Michelangelo was sent from Florence to Bruges. The figure was completed certainly before the summer of 1505, when it was packed up, and, probably, about 1502. The work was commissioned in Rome by the Mouscron cloth merchants, who then placed it in the church of Notre Dame in Bruges (where Dürer admired it during his travels in the Low Countries in 1521). Similar in style to the Rome *Pietà*, the *Madonna and Child* (page 32) accentuates the tension between the perfectly immobile frontal view of the Virgin and the torsion of the Child's naked body, anchored by his right leg to the axis of the main figure but then departing markedly from it. This creates a mood of secret drama, a sense of sorrowful, impending destiny further conveyed by the strong, full folds of the clothing.

Another Roman commission that was sponsored by Jacopo Galli came from the Piccolomini Cardinal Francesco (who later as Pius III became pope for less than a month in 1503). This commission resulted in the four slightly smaller than life-size statues that stand in niches of the Piccolomini altar in Siena Cathedral (pages 30–31). These four statues of the fifteen that were commissioned were completed sometime between 1501 and 1504 and with some help from collaborators, although art historians cannot agree on the extent of their intervention. *Saint Paul* and *Saint Peter* (sometimes referred to as *Saint James*) undoubtedly show the greatest evidence of Michelangelo's own work. They are stern, intense figures, with some of *David*'s energy but are thoughtful, too, like the Bruges *Madonna*. On the other hand, *Saint Pius*, apart from his powerful head, and *Saint Gregory* may have been conceived by Michelangelo but must have been mainly the work of collaborators.

In the spring of 1501, a few weeks before Michelangelo's return from Rome, Leonardo da Vinci, recently having returned from Milan, exhibited his *Saint Anne* cartoon, which aroused the lively interest of Florentine artists. Michelangelo was no exception, as is shown by two drawings apparently produced as a result of the impression Leonardo's cartoon made on him. The Oxford drawing (page 34), perhaps the earlier of the two, seems to be a violent reaction to the model. All Leonardo's softness and roundness is rejected in favor of the contrast between the self-contained statuelike

STUDY OF A HEAD
Red chalk drawing on paper
7¾ × 6¾ in. (19.9 × 17.2 cm)
Circa 1511–1512
Florence, Casa Buonarroti
It has been suggested that this drawing is a study for the Virgin's head in the *Doni Madonna* or is related to the prophet *Jonah* in the Sistine Chapel. On the *verso* there are some sketches not by Michelangelo.

DONI MADONNA (THE HOLY FAMILY)
Tempera on wood
Diameter, 47¼ in. (120 cm)
Circa 1504
Florence, Galleria degli Uffizi
Painted for Agnolo Doni, probably on the occasion of his marriage to Maddalena Strozzi, the tondo stayed in the Doni family until 1549. There is evidence that by 1635 it was already in the Uffizi, where it has remained ever since. A great many allegorical meanings have been attributed to this painting, including a suggestion that it is a reference to the purchaser's name, Doni. In 1909, Brockhaus claimed that the posture of the Virgin implies that she is in the act of asking Saint Joseph to give (*doni*) her the Child. The nudes in the background have been interpreted as prophetic figures, as angels, as symbols of paganism, or as referring to Baptism, to the primitive life or to humanity *ante legem*.
Pages 40–41: Detail

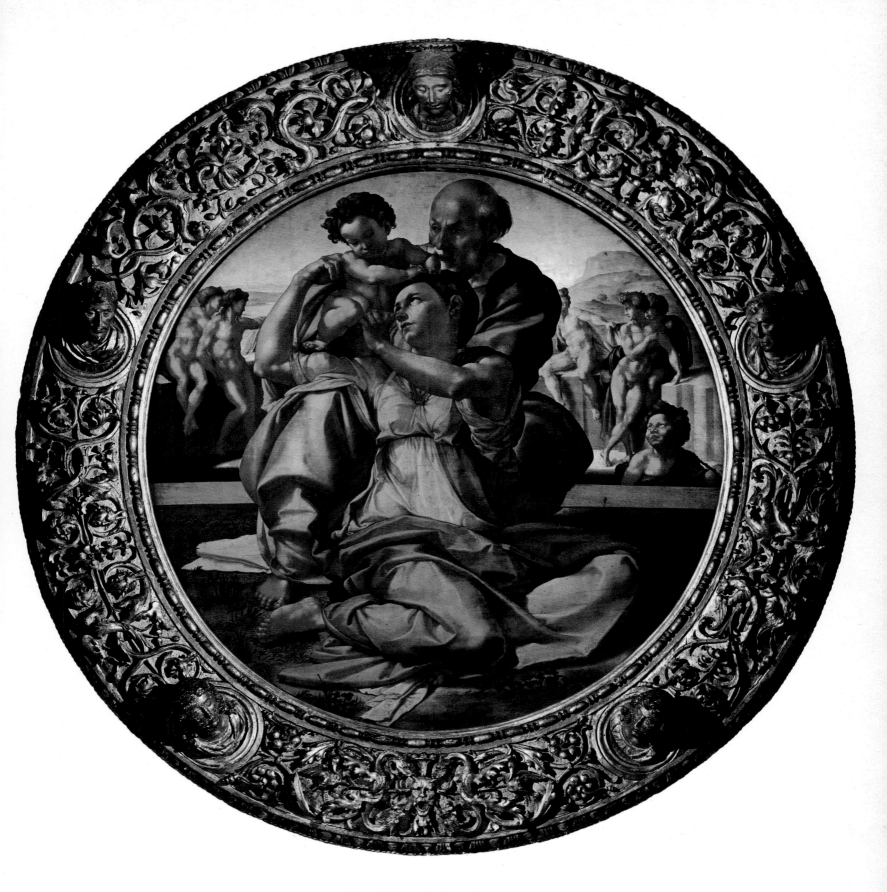

quality of the whole and the torsion of the bodies. This creates a dynamic tension between the group's closed unity and its tendency towards a spiral articulation.

In the Louvre drawing (page 34), probably made some time later, Michelangelo shows that he has understood the relationship between figures and space suggested by Leonardo's cartoon and has fully grasped the work's significance as an expression of total unity, almost as a mirror of the universe. The figures are large powerful masses that slant across the page and conquer space. Michelangelo realized that he had here identified himself with Leonardo's concept of space, for he noted in the margin: "Who would ever say it was by my hand."

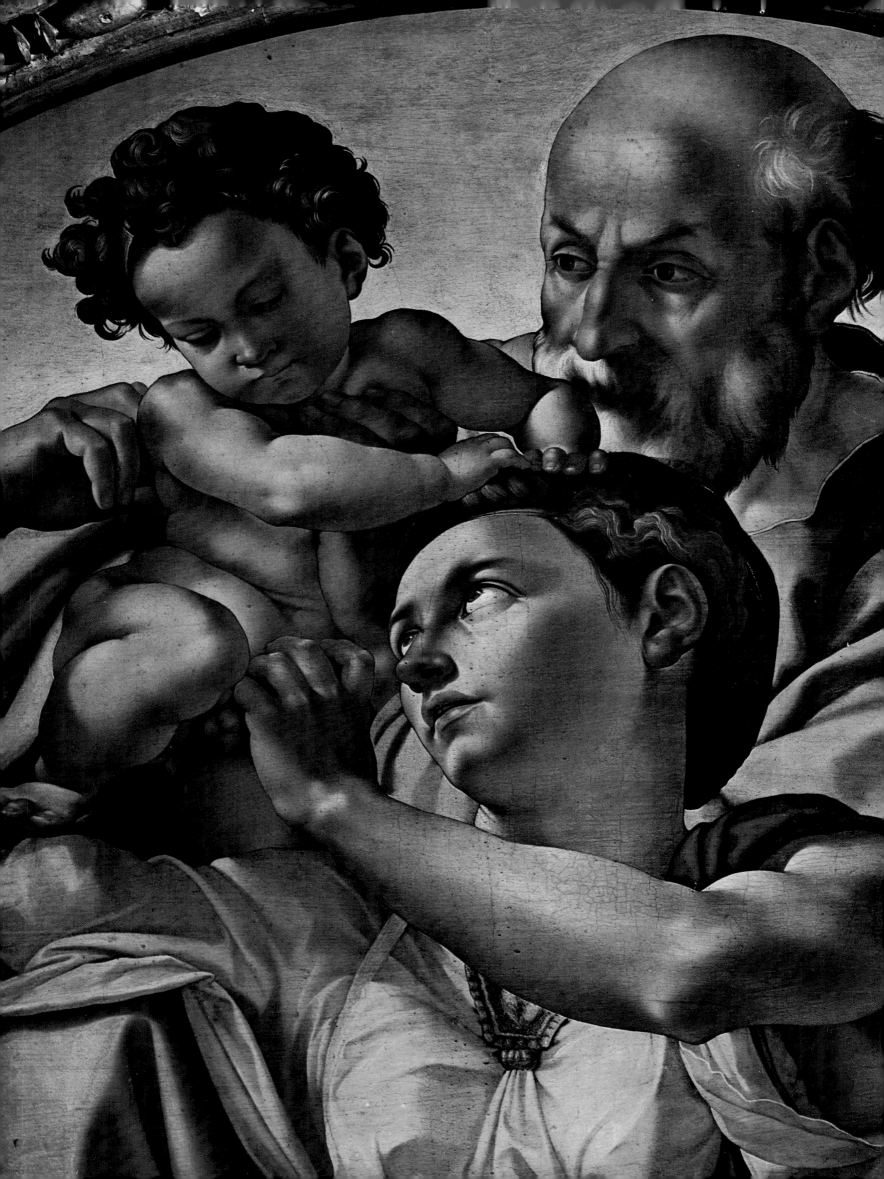

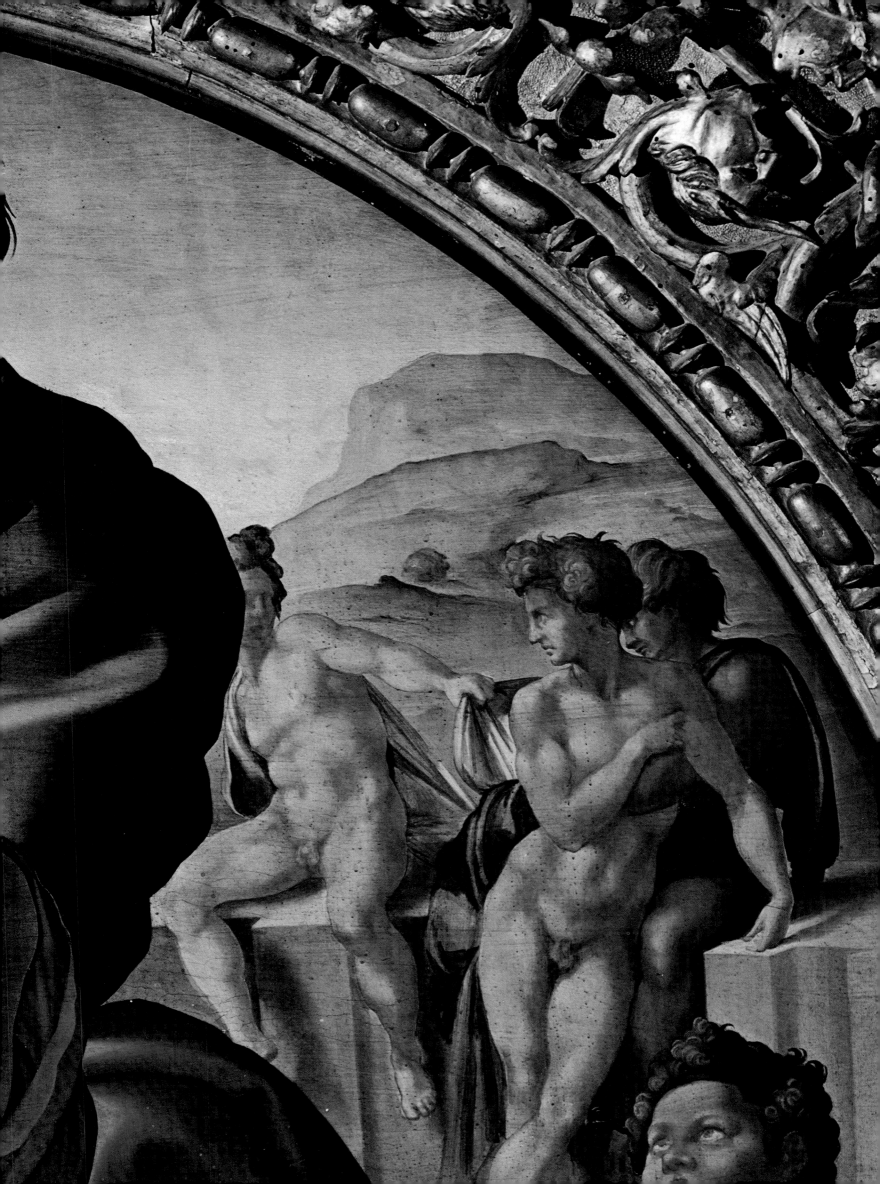

During these years, his contact with the art of his great colleague and rival gave rise to three works—two sculptures and one painting, all three of these are tondi. They are the tondo of the *Taddeo Taddei Madonna* (page 33), now in London; of the *Pitti Madonna* (pages 35–37), now in the Bargello museum, and of the *Doni Madonna* (pages 39–41), now in the Uffizi. The London and the Bargello tondi are marble sculptures; the Uffizi tondo is a panel painting. In the *Taddeo Taddei Madonna*, the planes of figures and background, set off by a partly intentional unfinished element, have a delicate vibrant quality. The images seem to float in space and air in the manner of Leonardo. In the *Pitti Madonna*, the circular form is more deliberately used for purposes of contrast. The figures' sturdy masses push against the circle, stirring within its narrow limits and curving slightly on themselves. The effect is enhanced by the uneven finish of the work. The figures seem to be surrounded by an undefined space, perhaps tending to a spherical form, as if drawn out of the same shapeless mass of chaotic matter from which the artist carved the images.

It has already been said that, while Michelangelo pursued nobility and austerity in antiquity and in the great figures of the early Florentine Renaissance, he from the start rejected the concept of space and perspective associated with the Florentines' moral severity. At first, this rejection led, as we have seen, to the exaltation of the solitary human image, dramatically brought to the fore, and without a background. Now, however, his encounter with Leonardo, his study of the *Saint Anne* cartoon, and his renewed interest in other works by the artist gave a fresh impetus to his imagination. His eagerness for universality, which had been apparent in the way he isolated the human figure from the bright but limited earthly setting defined by fifteenth-century perspective, now found an outlet in his investigation and conquest of universal cosmic space. The conquest is total in the tondo, now in the Uffizi, that Michelangelo painted for Agnolo Doni,

STUDY FOR THE BATTLE OF
CÀSCINA
Charcoal drawing on paper
$9\frac{1}{4} \times 14$ in. (23.5×35.5 cm)
Circa 1504
Florence, Galleria degli Uffizi
(folio 613E *recto*)
Barocchi, Mariani, Salvini, and Tolnay have recently proclaimed this fine drawing as Michelangelo's work. The present author believes that it is an early stage in the composition of the *Battle of Càscina* and that it shows the influence of Leonardo, who at this time was working side by side with Michelangelo on his *Battle of Anghiari*. It is inspired by a dynamic, impassioned vision and is intended to convey absolute terror and an all-pervading sense of flight. This is a very different vision from the far more rationalistic and pre-Mannerist final version of the cartoon as we know it from Sangallo's copy. On the *verso*, there are nude studies for the *Battle of Càscina*, again from this early stage, and the words "di Michelangelo," not in his handwriting.

42

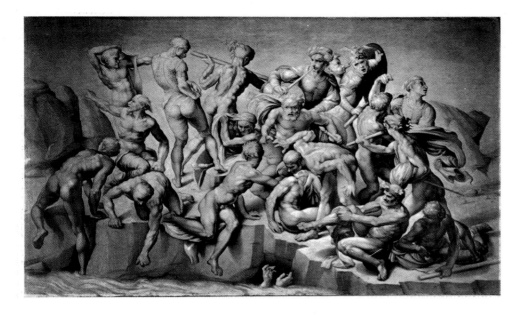

BATTLE OF CÀSCINA
Circa 1542
Holkham Hall, England, Earl of
Leicester Collection
Probably the work of Aristotile da
Sangallo, this is the most famous copy
of the lost cartoon that Michelangelo
prepared in about 1505 for a fresco to
be painted in the Sala del Gran
Consiglio in the Palazzo Vecchio,
Florence. The fresco may have been
started, but, if so, the work was soon
interrupted.

probably on the occasion of his marriage to Maddalena Strozzi at the end of 1503. In this painting, space does not stretch away behind the figures in a series of horizontal layers but is both created and enclosed by the wall of rock against which the young nudes are leaning languidly. The landscape behind them is largely hidden by these figures, and where it is visible, it consists merely of sketchy compact masses of color. The semicircular wall, echoing the picture's round shape, molds space into a spherical form. Space is not a measurable section separated from earthly space, as it was in the fifteenth century, but a synthesis of universal space.

Charles de Tolnay sees this painting as a transparent crystal sphere that contains a representation of the three eras of human history. He believes that the pagan images of the nude men represent humanity (the Creation and man's first acts); the Madonna and Saint Joseph portray Old Testament humanity, or mankind under the Mosaic law; and the Child Jesus, leaning on his parents and rising above them, incarnates New Testament humanity, or mankind under the law of Christ (according to a common medieval tradition of iconology, seen in certain cycles of Gothic sculpture in which the apostles are shown standing on the shoulders of the prophets, Jesus's position is meant to suggest that he supersedes those who went before him). Tolnay also believes that the infant Saint John, set slightly apart and behind the low wall that marks off the space filled by the Holy Family but in front of the group of nudes, represents the link between paganism and the Judeo-Christian world. This attractive interpretation would seem to be endorsed by Domenico del Tasso's carvings on the contemporary picture frame. These show the heads of two sibyls at the bottom; above them, the heads of two prophets; and, at the top, the head of Christ. However, there are weaknesses in this argument. In the first place, it is not clear how Saint John, who was of Hebrew origin, can provide a link between paganism and Christianity. Nor is it certain that the classical beauty of the nudes is meant to suggest the pagan world and its sensuality. They seem to be undressing or pulling off each other's clothes, and between the level on which they are standing and the low wall behind the Holy Family, there appears to be a gap. Therefore, it seems reasonable to accept Valerio Mariani's suggestion that they are neophytes preparing to plunge into the pool from which the half-figure of the infant Saint John is emerging. His presence confirms the allusion to the sacrament of baptism. In this case, the theme of the work must be the rebirth of humanity with the advent of Christianity. The little heads of sibyls and prophets around the frame symbolize the prophecies and preparation for Christianity of the classical pagan and Hebrew worlds. The frame thus provides a reference to the time before Christ's coming.

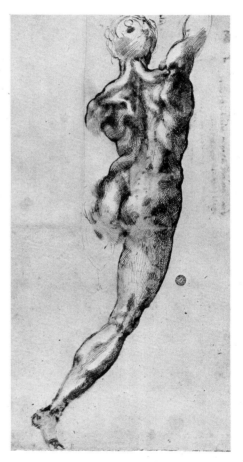

STUDY OF A MALE NUDE FROM
THE BACK
Pen and black chalk drawing on paper
$9\frac{3}{4} \times 6\frac{1}{4}$ in. (25 × 16 cm)
Circa 1505
Florence, Casa Buonarroti
For a long time this was thought to be a
copy of a drawing in Oxford, but Tolnay
has attributed it to Michelangelo and
tentatively linked it with the cartoon
for the *Battle of Càscina*. It is a first
study, followed by the Oxford drawing
and another in Vienna, for the figure of
the man with the lance (third from the
left in the back row) in the cartoon.

SAINT MATTHEW
Marble
Height, 7 ft. 1 in. (216 cm)
1505–1506
Florence, Galleria dell'Accademia
On April 24, 1503, Michelangelo signed
a contract with the Arte della Lana and
the Opera of Santa Maria del Fiore for
twelve apostles. But since Julius II
sent for him and employed him on more
grandiose schemes, he was released
from his obligation, and the unfinished
Saint Matthew is all that remains of the
project.

**STUDY FOR THE SISTINE
CHAPEL CEILING**
Pen and black chalk drawing
$10\frac{3}{4} \times 15\frac{1}{4}$ in. (27.5 × 38.6 cm)
1508
London, British Museum
This is a study for the first project for
the Sistine Chapel ceiling. Michelangelo
soon altered his plans, as he felt this
first solution was too simple.

Whichever interpretation is accepted, the traditional theme of the Holy Family is raised from a devotional motif to a symbol of human existence under the sign of Faith. Its complete ideological content is matched by the universal unity of form in its vision of cosmic space. However, within the confines of the composition, which contains universal rather than earthly space, there is a continual tension. In the main group, isolated from its surroundings as if it were carved from a weighty block of marble, the rich *contrapposto* (the dynamic and asymmetric poses) of the masses, articulated along a spiral curve, gives the figures and the group as a whole a sense of troubled, strongly contrasted movement. This expresses the drama that, for Michelangelo, is part of man's spiritual renewal. The heroic note of the harsh colors and the feeling of drama that governs the way the masses are placed are a powerful poetic expression of the belief that Faith is reborn only through a hard-won victory brought about by bitter and continual spiritual struggle. The main group, with the contrasts and complexity of its articulated forms, conveys a sense of unresolved sorrow and anxiety that will never end—like the continual, unresolved interweaving of lines and forces that make up the block. Even the young John the Baptist, whose open smile seems to be an almost intoxicated expression of spiritual joy, serves a specific function in the dynamics of the composition: he is an asymmetrical element acting as a catalyst for setting in motion the torsion in the upper part of the holy figures. The semicircle of nudes not only emphasizes the picture's spherical form by curving around it but also, with the *contrapposto* of the figures and fluid interplay of movements, provides an effective comment on the enclosed tension of the main group. These youths seem to be filled with restless exaltation, creating a sense of joyful anticipation and drama to come with the opening of the new age.

Even this brief and incomplete analysis shows that Michelangelo made fundamental changes in both types of tondos that were typical of the fifteenth-century Florentine tradition. One of the modes, represented by

Masaccio's *Birth Plate*, Filippo Lippi's *Nativity* in the Pitti, and Domenico Veneziano's *Adoration of the Magi* in Berlin, used the round frame as a porthole through which the spectator was invited to watch whatever was taking place in an interior or a bright countryside. The view was depicted in the same perspective as in an ordinary square or rectangular panel or fresco. The Botticellian type, on the other hand, brought all the images to

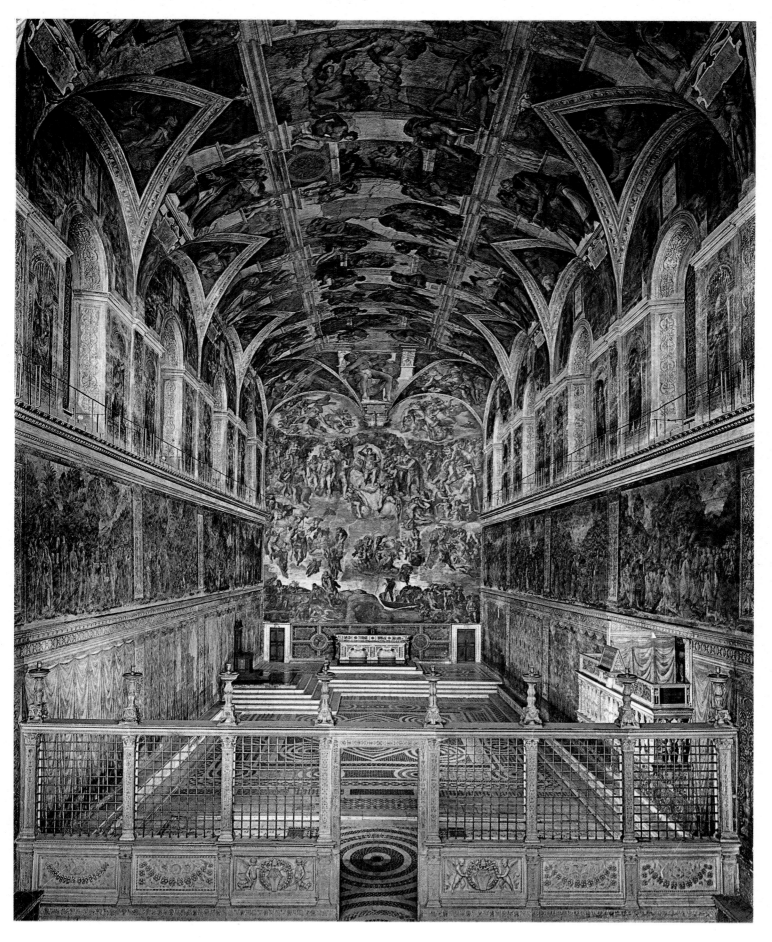

THE SISTINE CHAPEL
Vatican City, Vatican Palace
General view of the Sistine Chapel. At the back is the altar wall with the *Last Judgment*. The chapel, built by Sixtus IV in **1473–1484** includes frescoes by Michelangelo, Botticelli, Ghirlandaio, Signorelli, Perugino, and Pinturicchio.

the foreground in a rhythmic relation to the circular frame, which is either contrapuntal—as in the Berlin tondo or the *Madonna of the Pomegranate*—or in melodic harmony—as in the *Magnificat*.

Michelangelo arranged his main group around a vertical axis in marked contrast to the painting's circular shape. In this respect and in his use of *contrapposto* in the figure of the Virgin, Michelangelo was foreshadowed by

45

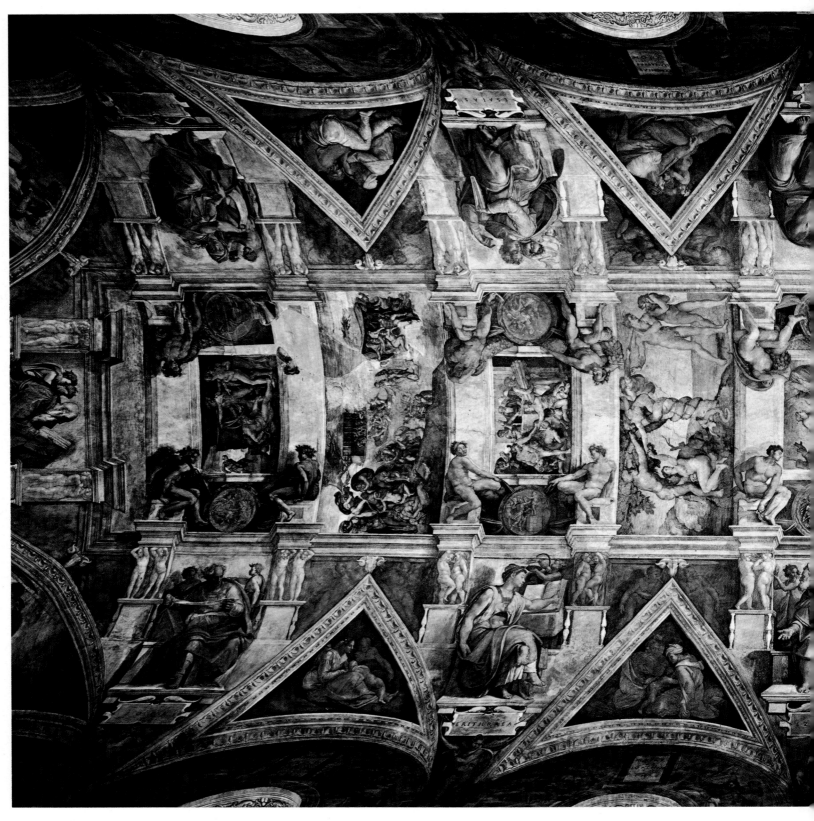

Luca Signorelli in the *Madonna* (now in the Uffizi) he painted in about 1490 for Lorenzo di Pierfrancesco, whose house Michelangelo frequented. The background in this work is peopled with nudes that, although they are only the shepherds of the nativity, take the noble form of ancient heroes. In Signorelli's tondo for the Guelph party (now in the Uffizi), the imposing presence of the Holy Family in the foreground and the tension and contrast in the composition of large plastic masses are fully established. In his Ginori tondo (Alte Pinakothek, Munich), which dates from around 1498, we again find powerful *contrapposto* in the way the Madonna is constructed, while the nude in the background is a neophyte removing his sandals before entering

THE SISTINE CHAPEL CEILING
Wall fresco **43** × **118** ft. (**13** × **36** m)
Vatican City, Vatican Palace
Julius II della Rovere commissioned Michelangelo to repaint the ceiling of the Sistine Chapel. Piermatteo d'Amelia had previously painted it in imitation of a starry sky. Michelangelo's original project was to have consisted of twelve apostles between the spandrels and geometrical decorations in the middle of the ceiling, but he soon decided that this was un-

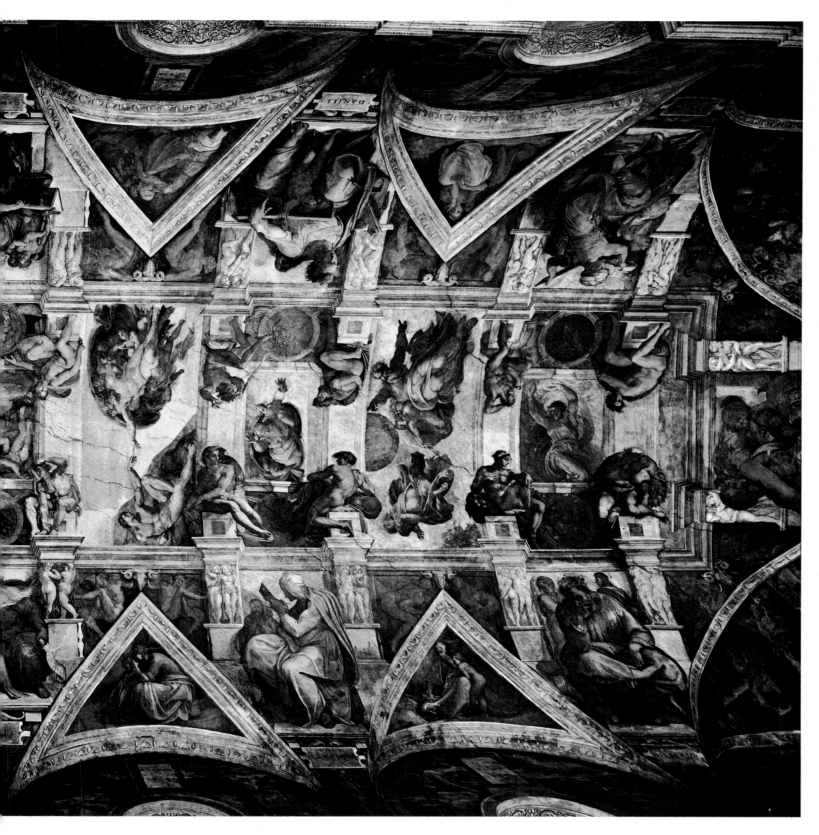

satisfactory and obtained the pope's permission to alter it as he wished. He planned to use assistants, including Granacci, Giuliano Bugiardini, and Aristotile da Sangallo, but soon dismissed them and completed the gigantic undertaking more or less single-handedly. He started the project in August 1508 and finished by October 31, 1512. He began painting at the entrance end and worked towards the altar.

the river. But these considerations, together with all that is known about his admiration and affection for Signorelli, in no way detract from Michelangelo's originality. The Florentine painting that creates something completely new—a representation that goes beyond the limits of its subject matter to become the symbol and dramatic expression of the supreme fulfillment of human destiny in a Christianity that embraces and exalts the perfection of antiquity—could only have come from the genius of Michelangelo.

From the autumn of 1504 to early March 1505, when Pope Julius called the sculptor to Rome to entrust him with the commission for his tomb, and

perhaps from May to October 1506 (the evidence is open to various interpretations), Michelangelo worked on a major painting project that was never carried out—the fresco of the *Battle of Càscina* for the Sala del Maggior Consiglio in the Palazzo della Signoria. From the autumn of 1503, the signoria had appointed Leonardo da Vinci to paint a huge fresco in the great chamber that was built in 1495, by Cronaca, to house the "parliament" of Savonarola's republic. The chamber was increased in height and

THE DRUNKENNESS
OF NOAH
Fresco
5 ft. 7 in. × 8 ft. 6 in.
(170 × 260 cm)
Circa 1508
Vatican City, Vatican
Palace, Sistine Chapel
The interpretation of the
scene is as follows: the
patriarch is overcome by
the effects of wine; Ham,
with his back turned, is
mocking Noah's drunken
ness; Shem (on the right)
expresses his disapprov -
al; and the third son
covers their father. By
the time Michelangelo
had painted this panel,
probably the second to
be completed, he must
have been working
without any assistance
worth mentioning.

decorated by Vasari from 1560 onwards. The fresco was to show the *Battle of Anghiari*, a splendid military action that took place in 1440, when the Florentine army defeated the Duke of Milan's mercenary troops led by Niccolo Piccinino.

A year later, probably concerned that Leonardo alone would not be able to complete the huge task of painting the chamber, Michelangelo was given part of the project. As Vasari relates and as other documents confirm:

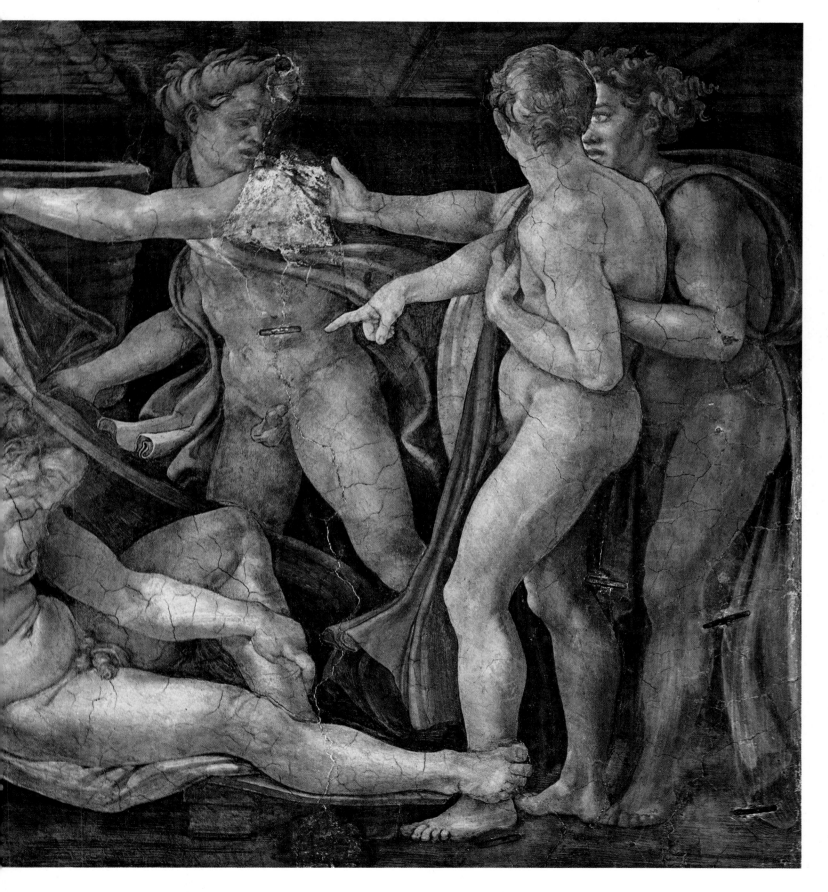

"Piero Soderini, then gonfalonier, because of the great talent that he saw in Michelangelo, made over part of the chamber to him; the reason being that he should in competition with Leonardo do the other wall, for which he took as his subject the war with Pisa" (more specifically, the decisive encounter of the war, the battle of Càscina, when on July 30, 1364, the Florentines defeated the Pisan army under their commander Sir John Hawkwood). The scheme was left unfinished, and they never got beyond completing their respective cartoons—the full-size drawings to be transferred to the wall before painting. At one point, Leonardo was given permission to start painting before the cartoon was completely finished; but after unsuccessful attempts to revive the old encaustic technique, he abandoned the painting, which did not hold (Vasari later had to remove the last remnants of it).

It seems that Michelangelo never even started to paint his wall. Although Vasari and Varchi clearly state that Michelangelo was given the other wall—that is, the long wall opposite the one Leonardo was working on—and

THE GREAT FLOOD
Fresco
9 ft. 2 in. × 18 ft. 8 in. (280 × 570 cm)
1508–1509
Vatican City, Vatican Palace, Sistine Chapel
This is probably the first of the nine Biblical scenes that Michelangelo painted. Notwithstanding that there exist some uncertainties about the fresco technique, there is evidence of the work of Bugiardini and Granacci, who may have been assisting him at this time.

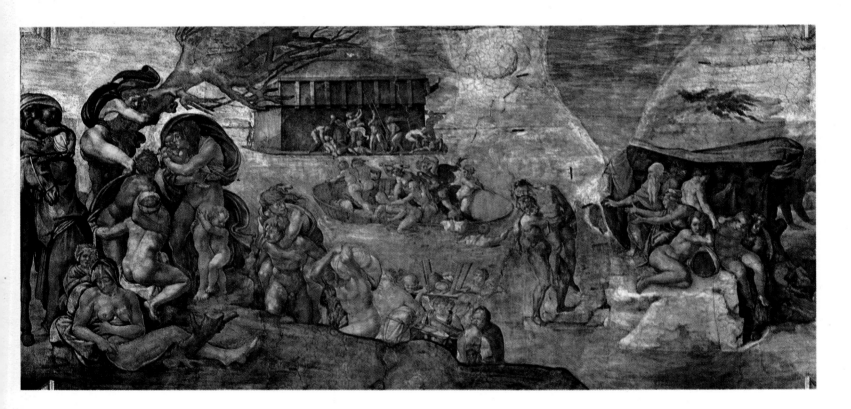

although Michelangelo himself later wrote that he had "taken half the chamber to do," scholars have tended to believe that, because of the vast expanse each of the two painters would have to fill with a single episode, the two areas to be painted were both on the same east wall, on either side of the "most eminent residence" of the gonfalonier and the signoria. This section, like the government bench in modern parliaments, occupied the central position. But it is probable, as Grohn and Isermeyer claim, that the plan was for three stories on each wall, at the top below the ceiling, arranged more or less like the existing frescoes by Vasari.

The two artists' cartoons, which were studied and admired by crowds of artists, were soon cut up and dispersed, so that now only a fragment of Leonardo's cartoon survives, in Oxford, and that has been completely reworked. From preparatory sketches, source material, and drawings, we know that the theme of Leonardo's cartoon was "the struggle for the standard," while Michelangelo's showed the episode of the soldiers surprised by a false alarm while bathing in the Arno, according to Villani's account. In both cases, the subjects chosen seem unsuitable for the proper celebration of the two victorious battles. This is particularly true of Michelangelo's theme

Facing page: Detail
In this particular part of the fresco, the collaboration of Granacci and, to a lesser degree, Bugiardini, has been identified.
Pages 52–53: Another detail
This shows the group of people taking refuge under the tent on the mountaintop, who afterwards were to be struck by a thunderbolt sent by God. This last episode is no longer visible because part of the fresco has been lost. The whole group is universally recognized as Michelangelo's work.

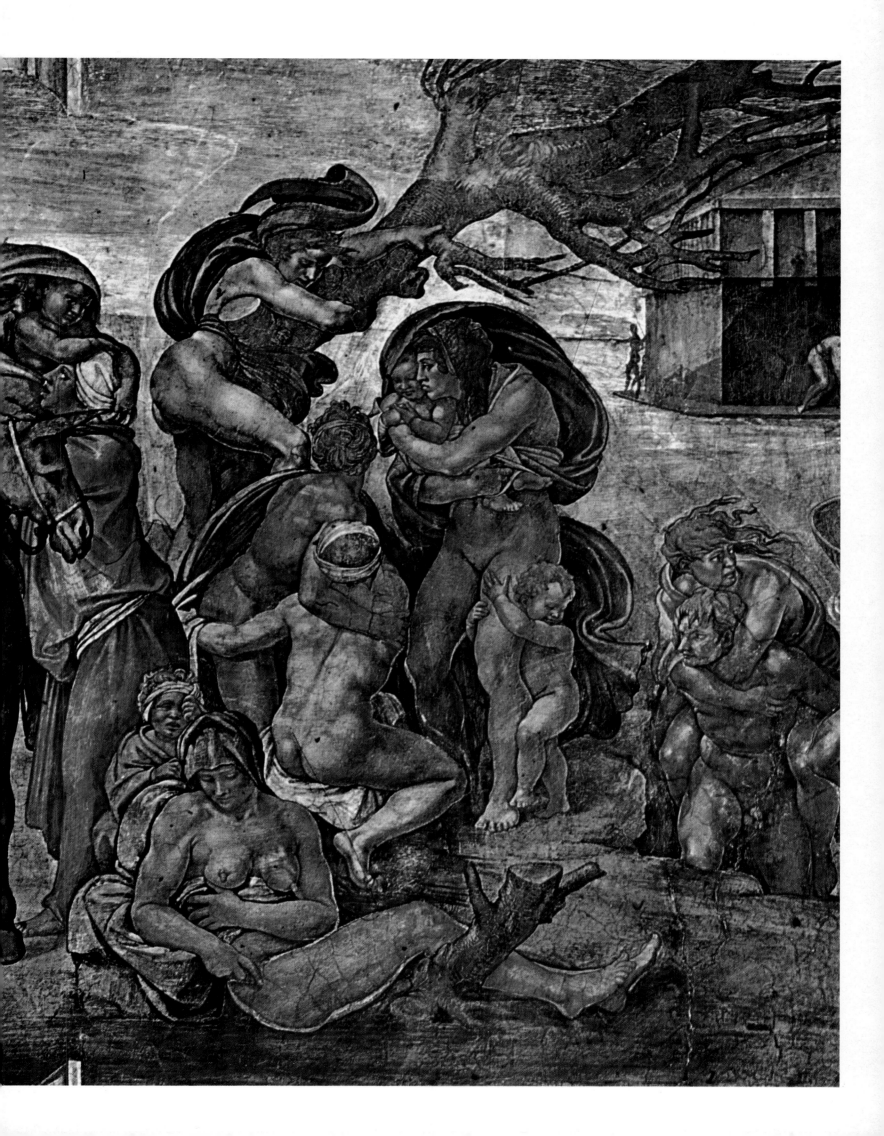

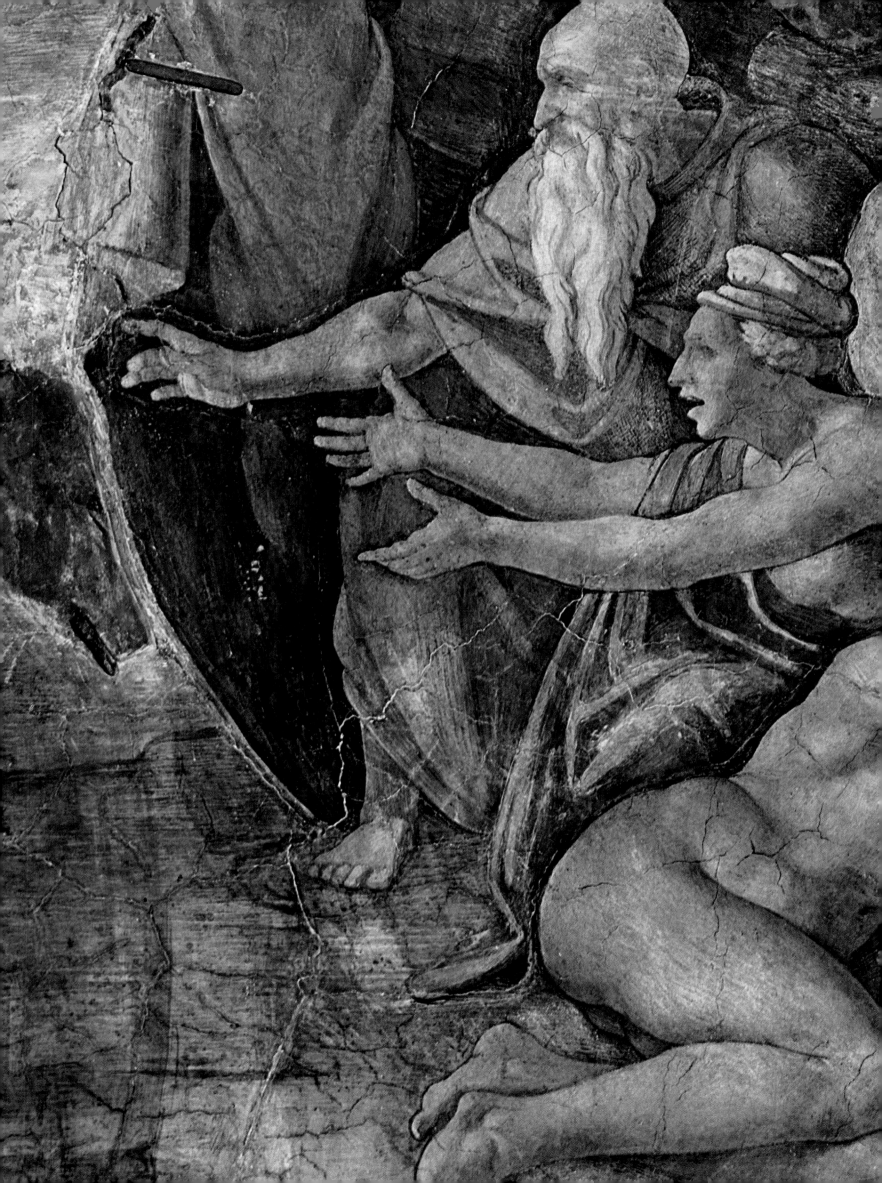

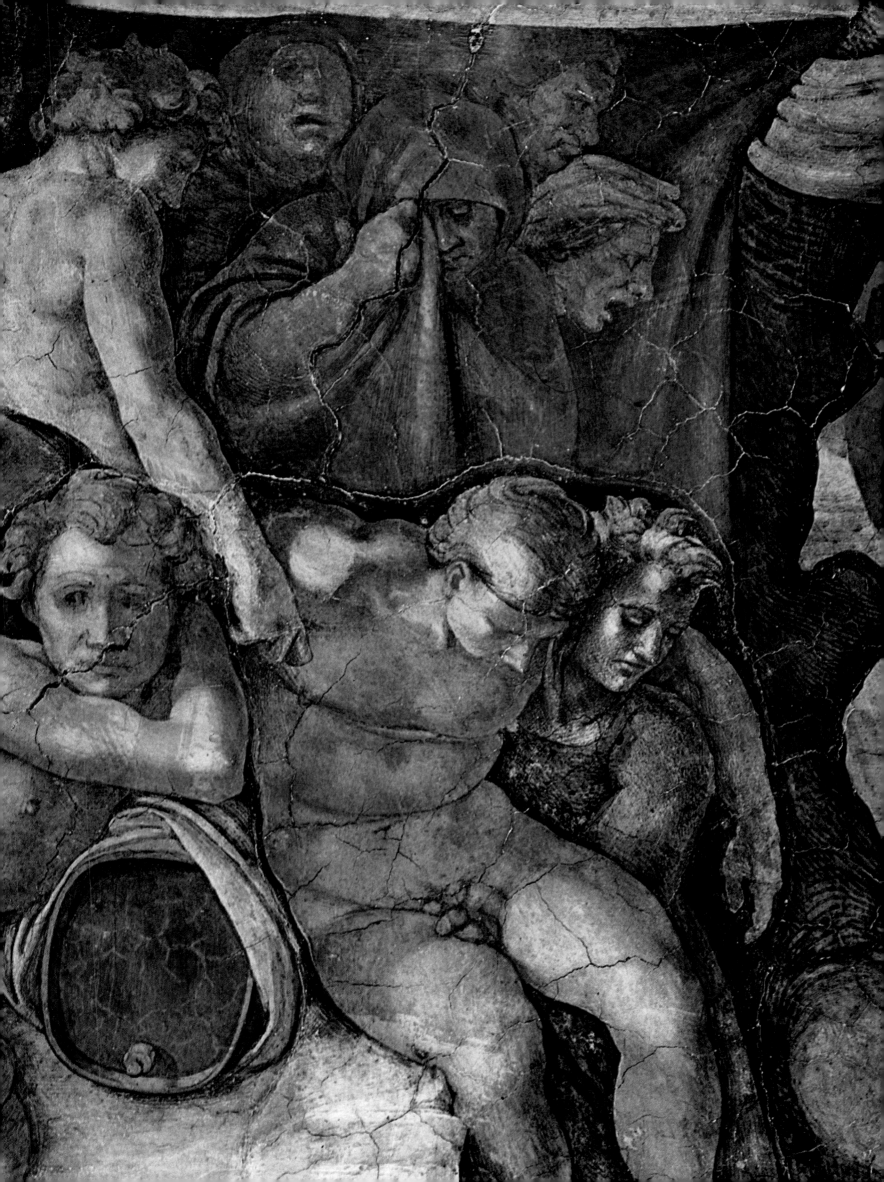

concerning an episode that occurred the day before the Pisan attack. Even if the artist meant the false alarm (given by an officer to call the soldiers to order and prepare them for the next day's battle) to be taken for the real alarm given at the enemy's approach, the fresco would still show only a preliminary event. For this reason, I think it is probable that each cartoon showed only one of three episodes the artist had meant to portray, and that Leonardo's cartoon probably showed the middle scene, whereas Michelangelo's depicted the first episode.

Michelangelo's cartoon survives only in a *grisaille* made by Aristotile da Sangallo, in 1542, from his own drawing (now lost) of the cartoon (page 43). However, there is a series of sketches and drawings, of varying degrees of completeness, for individual figures and a sketch for the general composition. The sketch differs somewhat from Sangallo's *grisaille* in the number of figures and the attitude of some of them and is very different in its stylistic intentions. This is the Uffizi folio 613E recto (page 42) that some scholars quite wrongly refuse to recognize as Michelangelo's own work. In my view, it records, under Leonardo's influence, an early idea for the painting.

The composition centers around two directrixes that converge towards the captain's head but point beyond it. The captain is the pivot of the composition: the torsion of the body makes it part of the overall dynamism, while its prominent, isolated position, cutting it off from the main flow of forceful movement, makes it a stable point of reference. The movement of flight, nonetheless, continues beyond it in the direction indicated by the outstretched arm of the figure on the captain's left. The backward pull of the two figures on the left, the figure of the vaulting man oriented towards the right, and the vertical, downward movement of the "weary man" (almost like the figure of Christ in a deposition scene) in the center provide elements of counterpoint that make the general movement of flight more dramatic. The scene is certainly a poetic expression of flight, although, historically, it

NOAH'S OFFERING
Fresco
5 ft. 7 in. × 8 ft. 6 in. (170 × 260 cm)
1509
Vatican City, Vatican Palace, Sistine Chapel

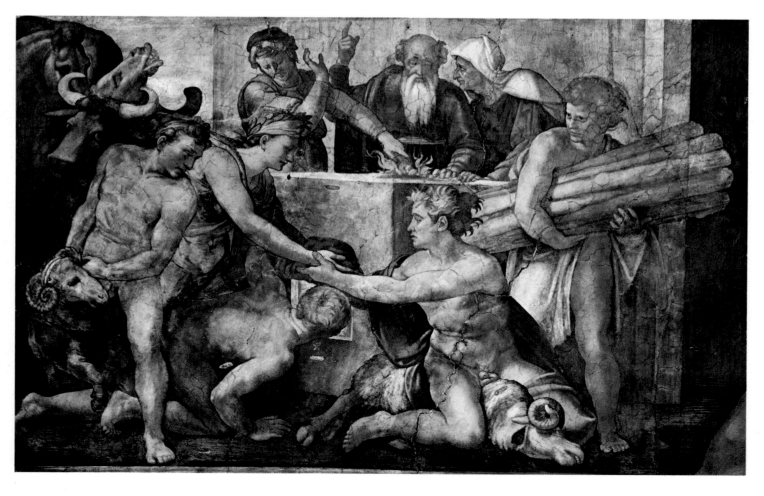

should be an agitated rush to arms. The continuity of composition is matched by the swift continuity of design, creating a perfectly compact and coherent scheme of modeled forms. As a result, the masses themselves carve out space, a space that even in this very indefinite sketch conveys (like the *Great Flood* of the Sistine Chapel) a sense of turmoil and distress. As later in the *Great Flood*, the emotion expressed in this sketch is an overwhelming, desperate longing to be saved.

At this stage of its conception, there was a significant relationship between the *Battle of Càscina* and the *Battle of Anghiari* for the other wall of the chamber that Leonardo was then working on. In conceiving this "group of horses fighting for a flag" (as Vasari graphically described it), Leonardo emphasized the tangle of forms and the interplay of figures dissolving into one another. This depiction is executed with extreme fluidity, expressing his poetic sense of continual transmutation, the irresistible and mysterious flux of all things and all events. Michelangelo's vision was certainly more anthropocentric and his figuration was more plastic, so that even in his rough drawing, his figures act as masses creating a sense of space on the white paper. But some perpetual, independent impulse compels their unceasing running, their "transcendental" flight, which is no less cosmic than Leonardo's universal transmutation.

A number of other partial sketches reflect this early stage in the development of the work, and there are also some sketches in Oxford and London for episodes other than the bathers—a tangled battle of nudes, an encounter between riders, galloping horses, and fighting foot-soldiers and horsemen. These must have been preliminary sketches for the second of the three stories. The artist may have completed part of the cartoon for the second scene—the battle itself—since Vasari's description of the cartoon includes "numerous cavalry soldiers starting the affray."

A quite different series of sketches, including the Casa Buonarroti work (page 43) reproduced here, tends towards the more static forms in the

ZECHARIAH; JUDITH AND
HOLOFERNES; DAVID'S
VICTORY OVER GOLIATH
Fresco
11 ft. 10 in. × 12 ft. 10 in.
(360 × 390 cm)
1509
Vatican City, Vatican Palace, Sistine
Chapel

Pages 56–57: IGNUDO, Detail
Fresco
1509
Vatican City, Vatican Palace, Sistine
Chapel
This *ignudo* appears between the *Great Flood* and *Noah's Offering*, next to the medallion showing the *Destruction of the Statue of Baal*, and above the *Erythraean Sibyl*.

antique manner of the cartoon as we know it from Sangallo's copy, revealing the study of classical models. In the composition of the cartoon, the continuous flow of movement is lost. The figures are balanced against one another in a series of studied relationships that the early Mannerist painters observed closely as a rich source of inspiration. This creates an impression that, perhaps led on by the theme of the nude itself, Michelangelo felt impelled to pursue formal problems beyond the demands of expression. It also seems possible that at a certain moment he made a deliberate effort to

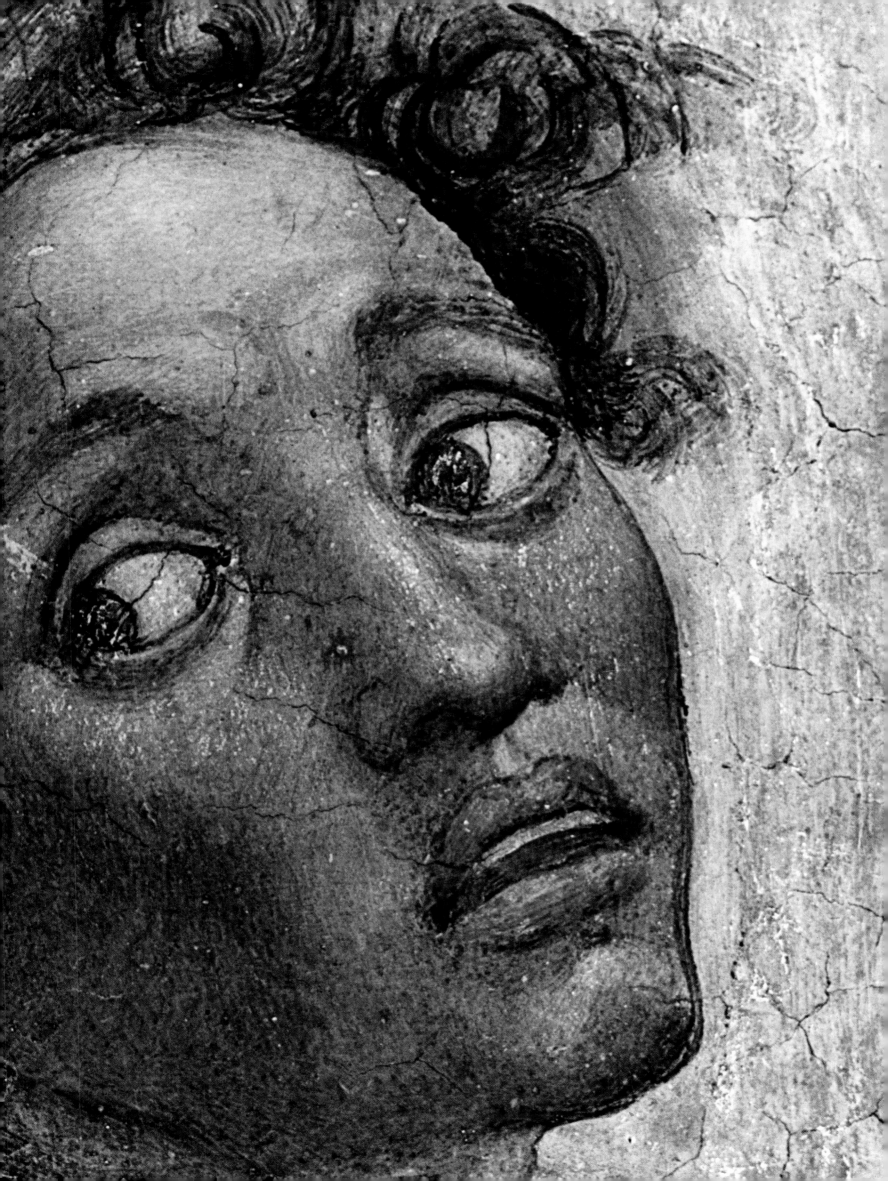

free himself from Leonardo's spell. He may have felt compelled to make his own style as different as possible from his rival's, which he perhaps reluctantly recognized as great. Of course, since only a copy survives and since the true artistic spark may shine out from the minutest nuances of expression, there is no way of knowing how much of the extremely academic effect created by the *grisaille* is due to Michelangelo and how much to the copyist. Even so, this first mature statement of Michelangelo's poetic view of the heroic nude as the repository of dramatic and universal forces is a necessary prelude to the Sistine Chapel ceiling.

This Florentine spell of untiring artistic activity, which led from *David*'s frank heroism to the strained drama and insistent *contrapposto* of the nudes in the *Battle of Cáscina*, ended with the *Saint Matthew* (page 44). This was the first of a series of large-sized figures of the apostles. The work, which was immediately interrupted, was intended, according to a contract drawn up in 1503, for the inside of the cathedral. It appears that it was begun before Michelangelo's departure for Rome in March 1505 and resumed in 1506. In this highly original work, critics have found traces of different works — Donatello's *Abraham and Isaac*, the *Laocoön* (discovered in Rome and seen by Michelangelo in January 1506), or the evocative fragment of Hellenistic sculpture still popularly known in Rome as "Pasquino." These sources are probably not mutually exclusive; what is significant is that Michelangelo was no longer turning to antique, classical forms but to the passionate, anticlassical approach of Hellenism and the ardor of Donatello. Donatello's group and the "Pasquino" provided Michelangelo with a starting point for the torsion of the figure's plastic planes, the strained *contrapposto* of the right arm and left leg that correspond to one another, and the planes of chest and head that face different directions.

The statue was left unfinished, and the figure now appears to be emerging laboriously from the block of stone. The unfinished element here is certainly not intentional, since there is ample evidence that Michelangelo had many other commitments. Yet one has a feeling that the artist did not abandon his task at random but when an expressive and significant stage in the dialectic

TWO IGNUDI
Fresco
6 ft. 3 in. × 12 ft. 8 in. (190 × 385 cm)
1509
Vatican City, Vatican Palace, Sistine Chapel
These two *ignudi* are next to the panel of the *Drunkenness of Noah*, on the side of the painting showing Noah planting the vine, and above *Joel*. The medallion in between them shows the death of Joram, with Jehu throwing Joram's body from the chariot.

between figure and block had been reached. The fascination of these unfinished pieces lies not only in the opportunity for close observation of the labor of artistic creation but also in the explicit relationship between the immobile architectural form of the block of marble and the vital movement of the chiseled part of the figure.

Many critics have emphasized a note of triumph and victory in the *Saint Matthew*, expressing the struggle of the enlightened spirit against the dark

JOEL
Fresco
11 ft. × 12 ft. 6 in. (335 × 380 cm)
1509
Vatican City, Vatican Palace, Sistine
Chapel

shades of matter. But the composition, in the slow rhythms of the *contrapposto*, is also imbued with a sense of suffering and strain, as if aware of a destiny that might make struggle futile and drive the image back into the shadows from which it is striving to free itself.

During these years, Michelangelo wrote his first verse within the Petrarchian tradition to express a note of universal grief that perhaps looks forward to Leopardi: "Cosa mobil non è che sotto el sole/non vinca morte e

THE DELPHIC SIBYL
Fresco
Circa 1509
Vatican City, Vatican Palace, Sistine
Chapel

THE ERYTHRAEAN SIBYL
Fresco
Circa 1509
Vatican City, Vatican Palace, Sistine
Chapel
Pages 62–63: Detail
The *putto* lighting the lamp has been
interpreted as a symbol of the power of
divination.

cangi la fortuna" (There is nothing moving under the sun that death does
not conquer and fortune change). This closing couplet follows a quatrain on
the inconstancy of Fate. The lines seem to express in a bitter, sorrowful tone
(and indeed by a process of antithesis or *contrapposto*) the melancholy of a
verse by Pico that Michelangelo had probably read or heard in Lorenzo de'
Medici's house: "Cosa ferma non è sotto la luna" (There is nothing firm
beneath the moon).

In March 1505, Michelangelo left these tasks unfinished and went to Rome
in response to Julius II's pressing invitation. He was commissioned by the
pope to construct a monumental tomb for him in Saint Peter's and devoted
himself to this work until he came up with a design for a complex
architectural structure that met with the pope's approval. According to
Condivi, it consisted of a very high rectangular base, with four freestanding
faces surrounded with niches and projecting plinths, both bearing allegorical
statues, surmounted by a cornice, above which stood four large statues
(one a *Moses*). Above that came the tomb in a *tempietto* supported by

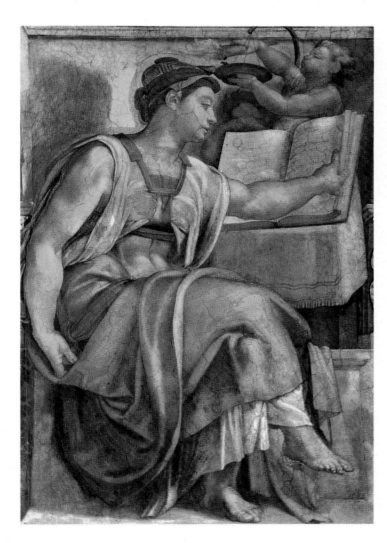
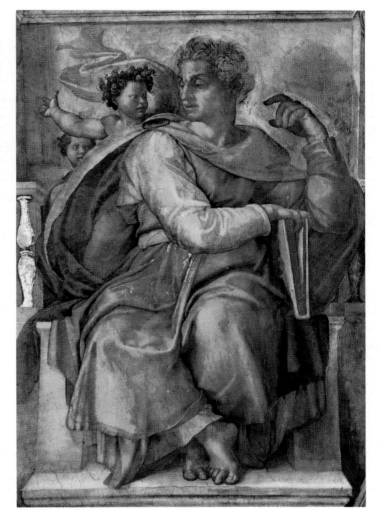

ISAIAH
Fresco
Circa 1509
Vatican City, Vatican Palace, Sistine
Chapel

two angels, one laughing and one weeping (or, in Vasari's version, by the
Earth weeping and Heaven rejoicing). "In brief, in the entire work, there
were to be more than forty statues, not counting the bronze reliefs of stories
all related to the general scheme and illustrating the pope's deeds"
(Condivi).

The figures standing in the niches were to represent the virtues and those
attached to the projecting plinths the liberal arts and "likewise painting,
sculpture, and architecture" in the guise of *Captives* (the figurative arts were
thus put on an equal footing with the traditional arts of grammar, rhetoric,
logic, arithmetic, geometry, astronomy, and music; this was, no doubt, in

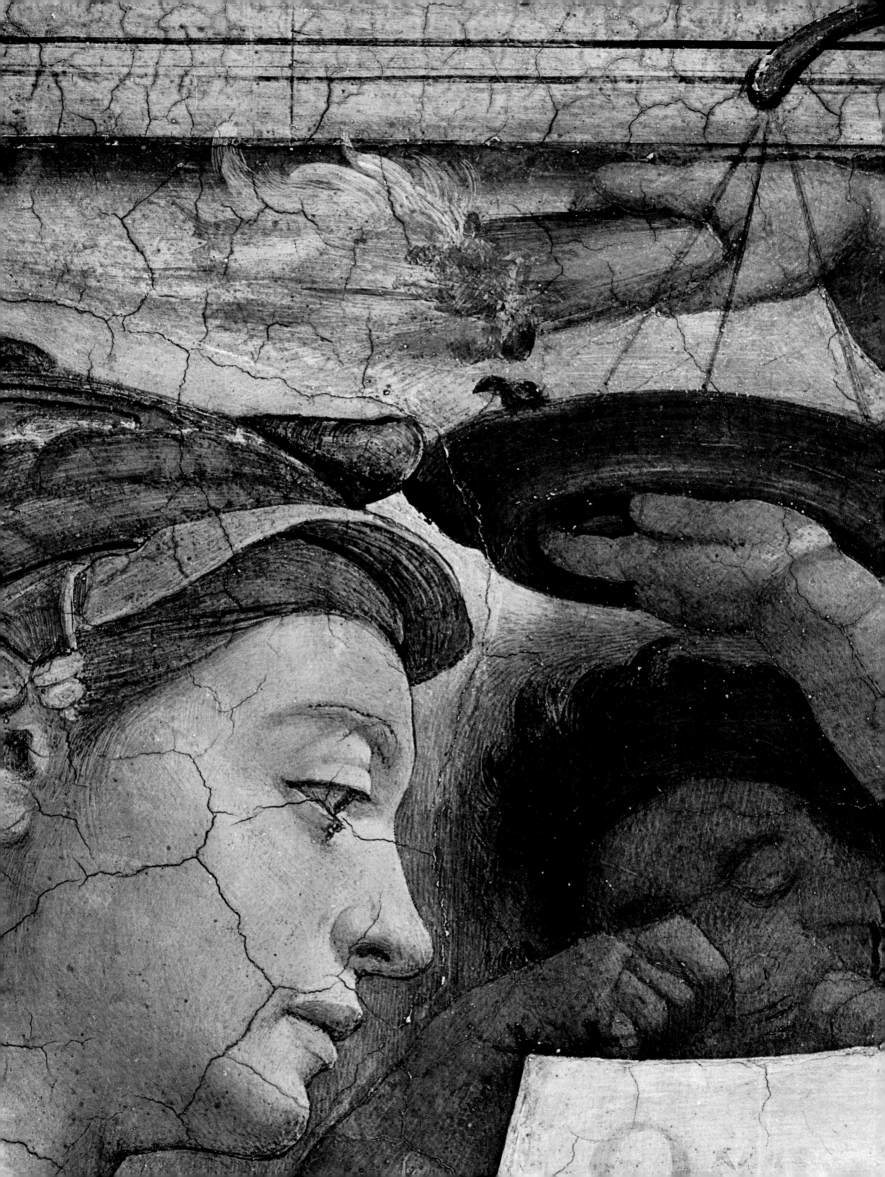

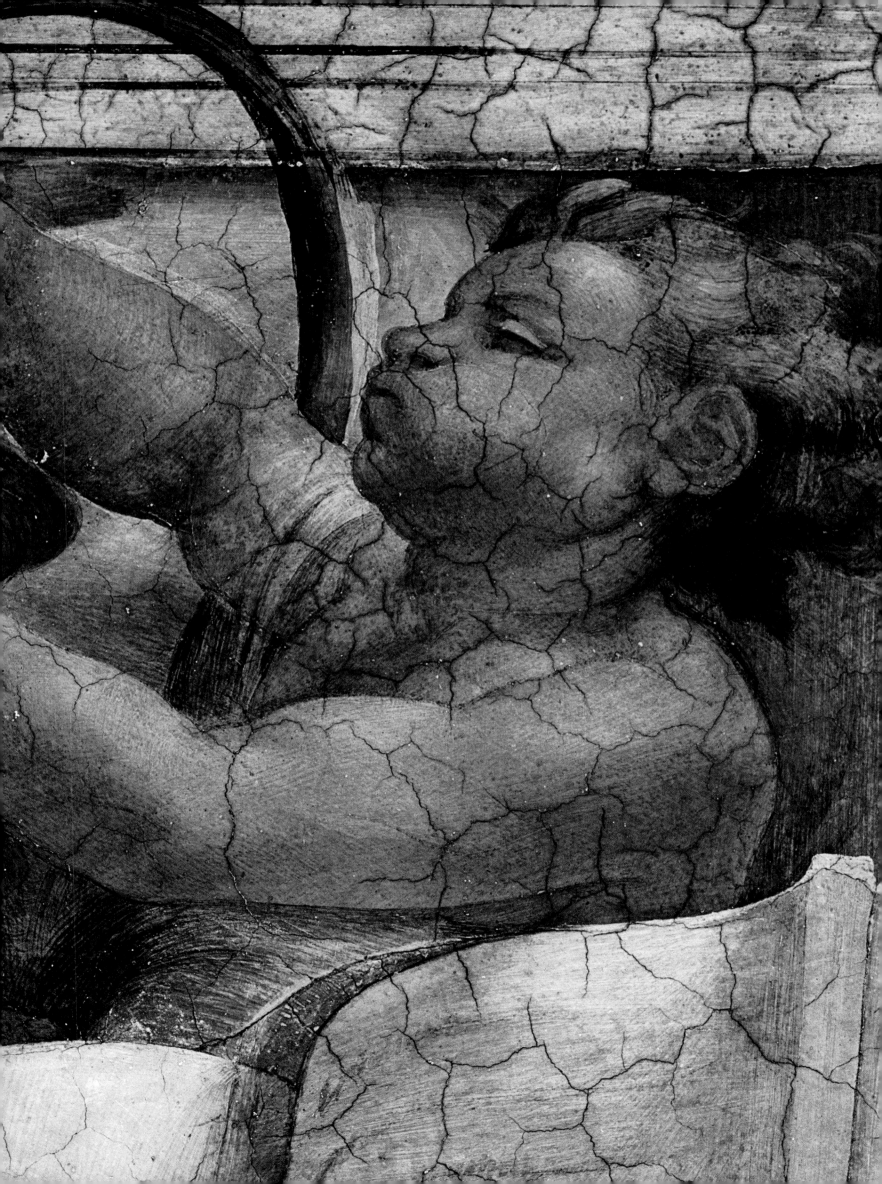

accordance with Michelangelo's own wishes). He was "showing by these figures that all the virtues [in the sense of human talents], like Pope Julius, were prisoners of death since they would never find anyone to favor and encourage them like him" (Condivi). The magnificent monument was to stand in the unfinished tribune of the new Saint Peter's that had been begun over fifty years before by Rossellino at the time of Nicholas V. The pope appointed Giuliano da Sangallo and Bramante to work on the designs, but "during these discussions," continues Condivi, "the pope decided he wanted the whole church rebuilt. He ordered a number of designs to be prepared and accepted Bramante's as being finer and more successful than the others." Bramante's scheme was never carried out, and it was Michelangelo's task to resume the work many years later and to complete it according to his entirely new interpretation.

The major plans for renovating the basilica meant that the erection of the tomb took second place in Julius's program. Michelangelo had meanwhile spent over eight months in Carrara overseeing the quarrying, choosing and rough-hewing his marble, and arranging its transportation.

On his return to Rome, when the last of the marble had been unloaded and "wishing to pay for the freight, unloading, and transport, he came to ask the pope for money." He was turned away from the palace on Julius's orders. Disgusted, the artist left Rome on horseback that evening. The pope's messengers caught up with him at Poggibonsi, in Florentine territory, "where they could not harm him." He sent word by them to the pope that "he would never return; that he did not deserve this change of mind after his good and faithful service—to be driven away like a rogue; and as His Holiness no longer wished to attend to the tomb, he was free of his obligations and did not wish to take on more obligations" (Condivi). And so, in April 1506, the "tragedy of the tomb" began and was to overshadow Michelangelo's life and darken his spirit for many decades to come.

Other factors may have contributed to the artist's rage and "great despair": presumably the malicious gossip of his colleagues, especially Bramante, or the considerations mentioned in his letter of May 2, 1506, to Sangallo in Rome. After an account of his flight from Rome, he writes: "But this was not the only reason for my departure; there was another, which I do not wish to write; suffice it to say that it made me think that if I stayed in Rome my tomb would be made before the pope's. This was the reason for my sudden departure." I think there is further evidence in a sonnet, usually dated about 1511 but better suited to this earlier period, that contains these verses addressed to Julius II:

Tu hai creduto a favole e parole
e premiato chi è del ver nimico.
Io sono e fui già tuo buon servo antico,
a te son dato come e' raggi al sole,
a del mio tempo non ti increse o dole,
e men ti piaccio se più m'affatico.
(You have believed tales and talk and rewarded him who is a true enemy. I am and was before your old faithful servant and gave myself to you as to the sun its rays; you do not regret or grieve at my time, and the more I toil, the less it pleases you.)

The pope did his utmost to get Michelangelo back and made his friends in Rome write to him. But the artist sent his reply that he was quite willing to work on the tomb—but in Florence, not in Rome.

A letter dated May 10, from Piero Rosselli to Michelangelo, reports a conversation in which the pope indicates to Bramante that he wanted Michelangelo to paint the ceiling of the Sistine Chapel. (Bramante hinted that Michelangelo did not have enough experience in painting, "particularly

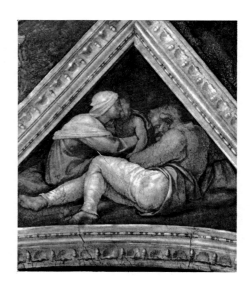

THE CHILD JOSIAS WITH HIS MOTHER AND FATHER AMON
Fresco
8 ft. × 11 ft. 2 in. (245 × 340 cm)
Circa 1508–1510
Vatican City, Vatican Palace, Sistine Chapel

THE FALL; THE EXPULSION FROM EDEN; THE CREATION OF EVE
Fresco
Upper panel, 9 ft. 2 in. × 18 ft. 8 in. (280 × 570 cm); lower panel, 5 ft. 7 in. × 8 ft. 6 in. (170 × 260 cm)
Circa 1509–1510
Vatican City, Vatican Palace, Sistine Chapel
These panels belong to the second phase of the timetable suggested by Tolnay. This period covered the last months of 1509 and the first eight months of 1510. The upper part of the fresco combines the two themes of the temptation of Eve and the expulsion from the earthly paradise; the tree in the middle separates the two scenes, which are usually shown as two distinct episodes.

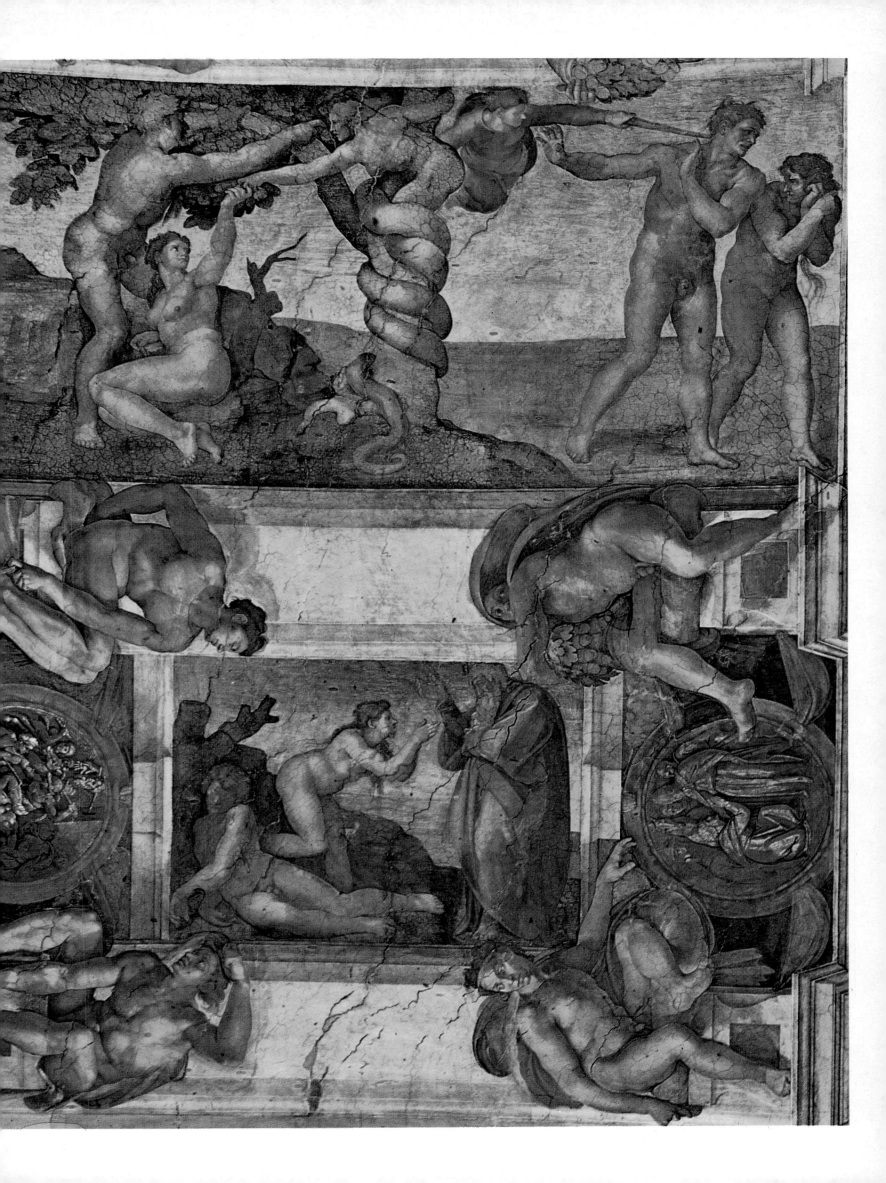

as the figures are high and in foreshortening, and this is quite different from painting on the ground.'') Meeting the artist's refusal and silence, the pope sent three briefs in succession to the signoria of the Florentine republic. Eventually, the gonfalonier Pier Soderini "called Michelangelo and said to him: 'You have tried a bout with the pope that a king of France would not have dared; therefore, you must no longer make him beg. We do not wish to quarrel with him on your account and put our state at risk; therefore, prepare yourself to return'" (Condivi). (According to Condivi, Michelangelo would more willingly have accepted the invitation of the Turk—Sultan Bajazet II—to go to Constantinople in order to build a bridge between Pera and Istanbul.) Soderini eventually persuaded Michelangelo to go to Bologna, which the pope had entered victoriously on November 10, after defeating the Bentivoglio signoria.

In Bologna, Michelangelo had to perform the difficult technical task of modeling and casting a huge bronze statue of Pope Julius for the façade of San Petronio. The statue was set in place in February 1508. The statue, about three times life-size, showed the pope, with his right hand raised in benediction and his left hand holding a key as a symbol of power, in a seated position. The sculptor had first asked the pope whether he should be shown with a book in his left hand. Julius apparently replied: "What book? a sword! for I know nothing about letters" (Condivi). The statue was later destroyed on December 30, 1511, after the Bentivoglio had reconquered Bologna with the help of the French.

Some idea of what the statue was like can be gleaned from Bandinelli's drawing in the Louvre. The sketch was intended as a design for a monument to Clement VII but was certainly inspired by Michelangelo's lost statue. From this, it can be seen that, although the sword as a symbol of war was in the end replaced by the key as a symbol of authority, the fierce, powerful gesture of the arm raised in benediction justified both the pope's lighthearted question, "This statue of yours, is it blessing or cursing?" and the artist's reply, "Holy Father, it is threatening this people if they are not wise."

In March 1508, Michelangelo returned to Florence fully intending to finish the works he had left incomplete almost two years before. These were the *Saint Matthew* and perhaps the other apostles in the series, the cartoons for the other episodes of the *Battle of Càscina* in the Sala del Maggior Consiglio, and perhaps the fresco itself. But towards the end of April, or in early May at the latest, Pope Julius called him urgently to Rome to entrust him with the task of painting the Sistine Chapel ceiling. A note made by the artist shows that after receiving a payment on account, on May 10, he began work and started to prepare schemes and drawings for the ceiling. On May 27, he received payment for the scaffolding and the preparation of the *arriccio*. The work was completed in October 1512. The procurator Paride de' Grassi states in his diary that the chapel (page 45) was now free of scaffolding and was reopened on All Saints' Day eve.

The work was carried out in two or perhaps three phases. The work was begun at the door end and proceeded towards the altar, in a direction opposite to the chronology of events shown. When he had completed a good half of the ceiling, up to and including the *Creation of Eve*, with the *ignudi* (nude male figures), sibyls, and prophets below, the work was interrupted by the pope. Julius, then absent from Rome, was keeping a tight hold on the purse strings, although Michelangelo made two trips to Bologna to appeal to him. Sources vary regarding the dates when portions of the work were completed. Michelangelo may have completed half of the ceiling between August 1508 and the autumn of 1510 but did not unveil it until August 1511. He may have waited because he had not received the payment due to him nor an advance to pay for more scaffolding. He then painted the remainder between the end of August 1511 and October 1512. On the other hand, he

THE CUMAEAN SIBYL
Fresco
About 12 ft. 4 in. × 12 ft. 6 in.
(375 × 380 cm)
Circa 1510
Vatican City, Vatican Palace, Sistine Chapel

may have unveiled the first half when he finished it in the autumn of 1510 and, after a long break, completed the second half, except for the lunettes, between spring and mid-August 1511. He finally painted the lunettes at the top of the walls between September 1511 and October 1512.

A letter that the artist wrote to Giovanni Fattucci many years later in 1524, in which he bitterly goes over his stormy relations with Julius, indicates the pope's intentions. Julius at first wanted the ceiling painting to be confined to the figures of the twelve apostles in the lunettes, with between them "a certain space filled in with ornamentation in the usual manner." Some idea of this original scheme is shown in two partial sketches, one in London and the other in Detroit (the authenticity of the sketch in Detroit is sometimes questioned). Both drawings show that the pope's first scheme was to relate the figures' architectonic thrones to a complex framework of trompe-l'oeil architecture superimposed on the vault to create a strong unity of form. However, Michelangelo writes: "Having begun this work [or, as he specified in another letter of the same period, 'having done certain drawings'], it seemed to me that this would be a poor affair. . . . Then he gave me a new commission to do what I wanted and what pleased me, and I was to paint down as far as the stories below [and in the other letter, 'to do whatever I wanted on the ceiling']."

The great freedom that the pope allowed the painter in the formal organization of the decoration and the subsequent selection of subject matter was undoubtedly due to the esteem Michelangelo had earned for himself while still a young man. However, this does not rule out the possibility that Michelangelo may have turned for guidance to theological texts (since he was, according to Condivi, an assiduous reader of the Bible and commentaries on it) or even to some learned churchmen. But there is no doubt that he was responsible for the general idea and final choices; he selected themes that he thought best lent themselves to figurative representation.

A formal analysis of this masterpiece cannot provide an adequate explanation of it; but to understand its importance —its expressive content contained in the clear, formal language—we must ask what message Michelangelo wanted to convey to his contemporaries and to posterity. We must try to discover the author's secret intentions, so secret that there is little or no hint of them in available source material. Only then can we assess the work as the expression of a spiritual content that the artist pondered deeply.

In recent research, this search has taken two directions. Some critics have looked to the ideological systems characteristic of the medieval tradition. For example, they interpret the ceiling painting as a "Tree of Jesse," associated with the thoughts of the Dominican theologian Sante Pagnini.

Hartt proposes as inspiration the "Tree of Life," according to Saint Bonaventura and the Franciscan theologian Marco Vigerio, who in 1507 wrote *Decachordum Christianum* and dedicated it to Julius II. On the other hand, some critics have turned to Platonist theories favored by the Medici circle in Florence. Tolnay, for example, believes that the work as a whole is inspired by the Neoplatonist theory of *emanatio* and *remanatio*—the divine origin of the soul and its return to God by degrees. From what we know of Michelangelo's background, either of these alternatives is possible, but if we accept that the artist played a decisive part in developing the "program," then the only interpretations acceptable are those that reveal a concept inspired by powerful thought and moral fervor, certainly, but of a clear and simple magnificence in keeping with Michelangelo's artistic vision.

The interpretations based on Dominican and Franciscan theology have only weak arguments to support them. More significantly, this source of inspiration seems too subtle and lacking in clear moral conviction to have appealed to Michelangelo. It seems more likely that the basis for the Sistine

ACHAZ WITH THE CHILD
EZECHIAS
Fresco
Circa 1508–1510
Vatican City, Vatican Palace, Sistine
Chapel

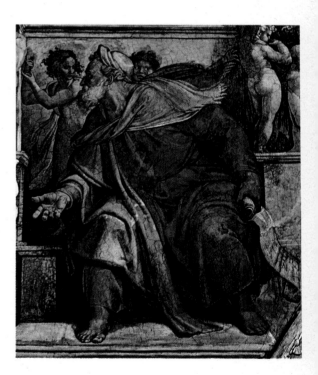

EZECHIEL
Fresco
Circa 1510
Vatican City, Vatican Palace, Sistine
Chapel
The figure on the left who seems to be guiding the prophet's glance has been interpreted as a young girl or, more often, as an angel.
Pages 68–69: Detail

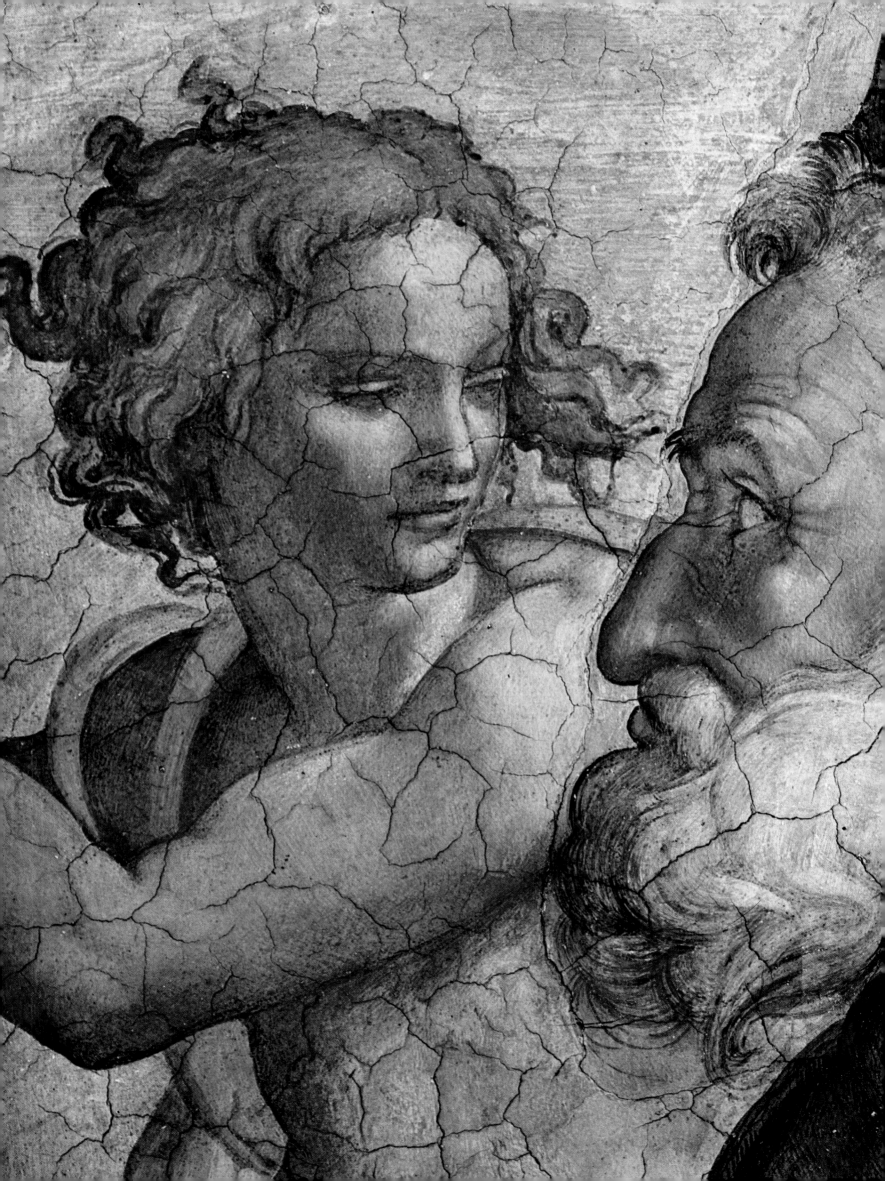

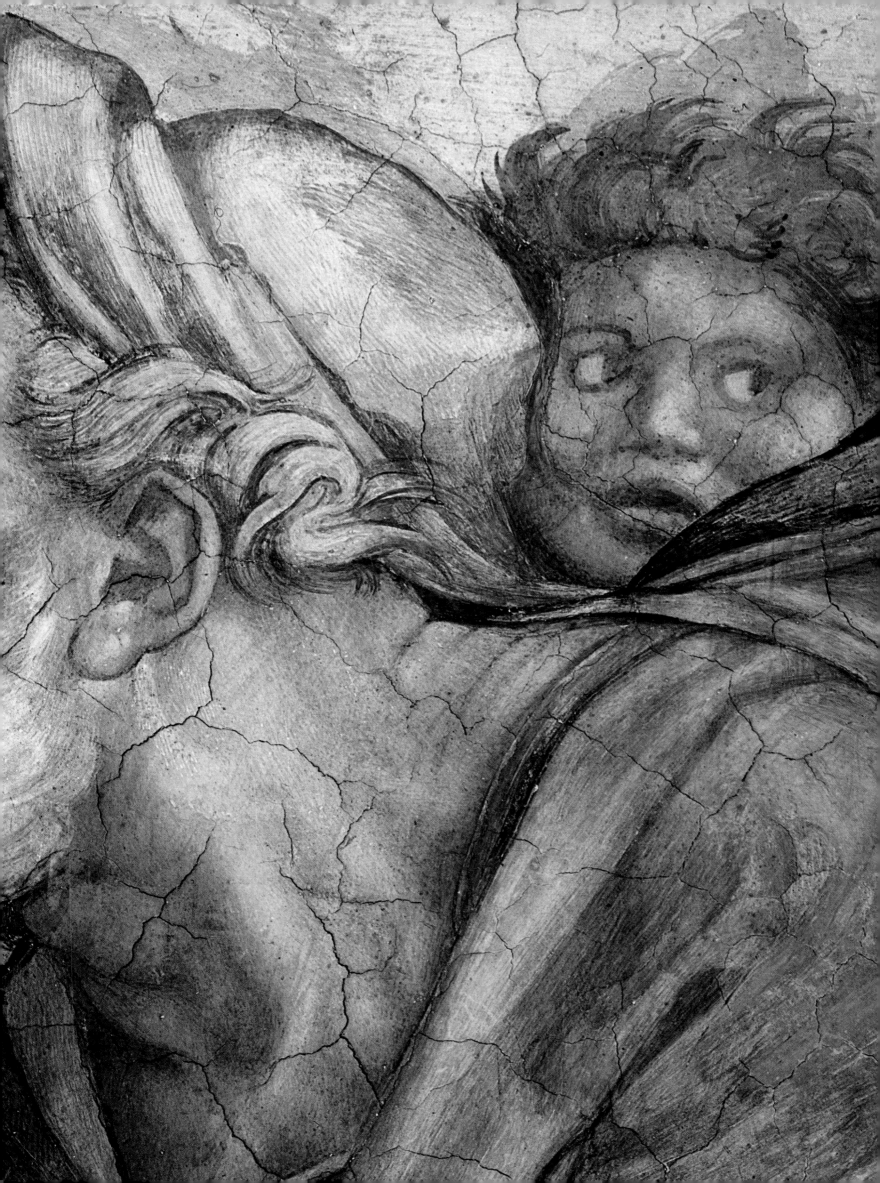

Chapel ceiling was the idea that God is reflected in man in varying degrees. This would draw on Neoplatonist ideas—that virtue and beauty are one and that the light of God shines through the soul and the light of the soul through the body. (These thoughts recur throughout the *Rime*, almost from the first line to the last.) This follows Tolnay's interpretation, though without many of its more subtle details and additions that seem incompatible with Michelangelo's mentality.

The artist's fundamental idea was, I believe, the same as in the tondo of the *Doni Madonna*: the regeneration of humanity by virtue of Christian Redemption. The fifteenth-century frescoes around the chapel walls already portrayed parallel episodes of humanity under the Mosaic law and under the law of Christ. It thus seemed clear that the ceiling should be devoted to the Creation and man's first acts. But just as on the walls below each Old Testament story had a New Testament equivalent, so on the ceiling at least some allusions to the future coming of Christianity, the final goal of

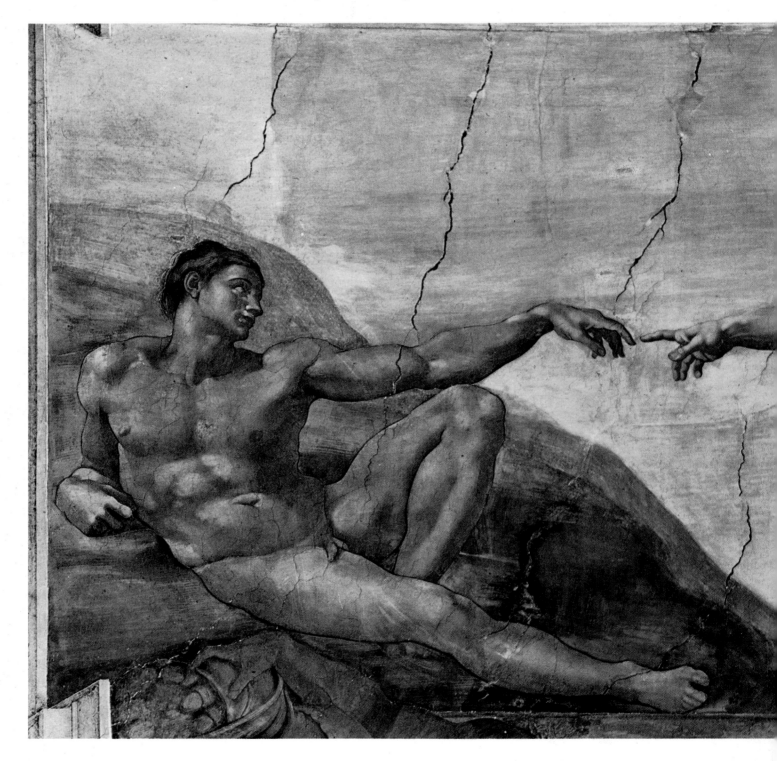

THE CREATION OF MAN
Fresco
9 ft. 2 in. × 18 ft. 8 in. (280 × 570 cm)
1511 or 1511–1512
Vatican City, Vatican Palace, Sistine Chapel
In this scene, taken from Genesis, the figure (probably female) nestling in God's left arm has been closely studied, and it has been suggested that it represents Eve, Wisdom, the human soul, Dante's Beatrice, or even the Madonna.

mankind's spiritual history, were necessary. This is the purpose of the four salvations of Israel, always considered in theology as prefiguring the Redemption, in the four corner spandrels; the stories from the Books of Kings, also interpreted as *types* of New Testament events, in the bronze-colored medallions; and above all, the figures of the great seers, the Hebrew prophets who foresaw the Redemption, and the ancient sibyls, who, imprisoned in pagan darkness, also had an obscure presentiment of the rebirth, according to a view expressed by Saint Augustine.

Michelangelo, who had had a chance to admire powerful figures of sibyls on Giovanni Pisano's pulpit at Pistoia, here took up the theme again on an unusually large scale to include both the classical world and the Hebrew world in his synthesizing account of human destiny. The mysterious figures of the *ignudi* (pagans), or nude youths, are probably an allusion to the Gentiles—to the Greek and Roman world seen as the repository of an unsurpassed ideal of beauty, identified in Platonic terms with virtue. In this

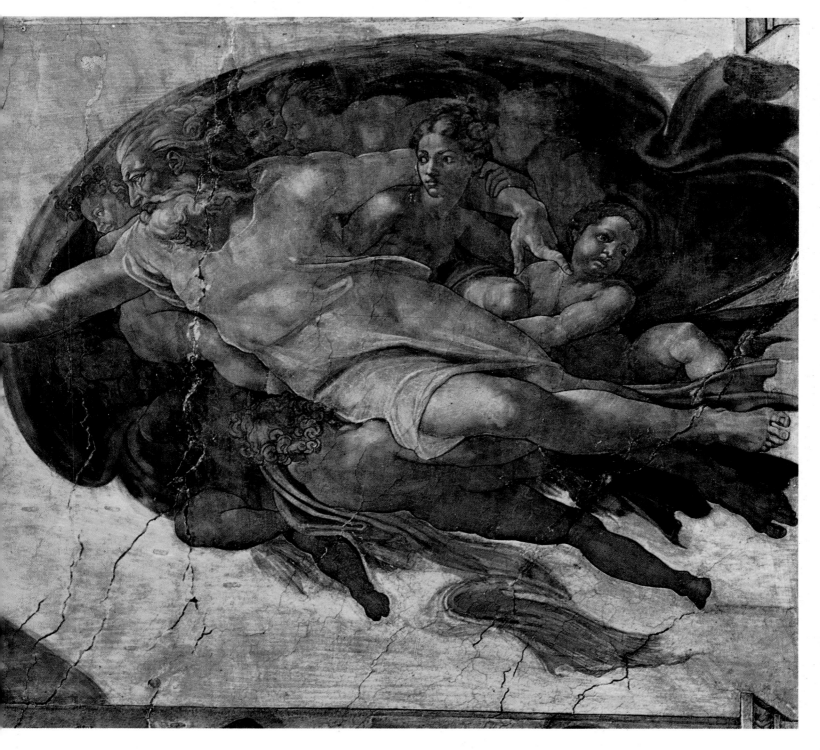

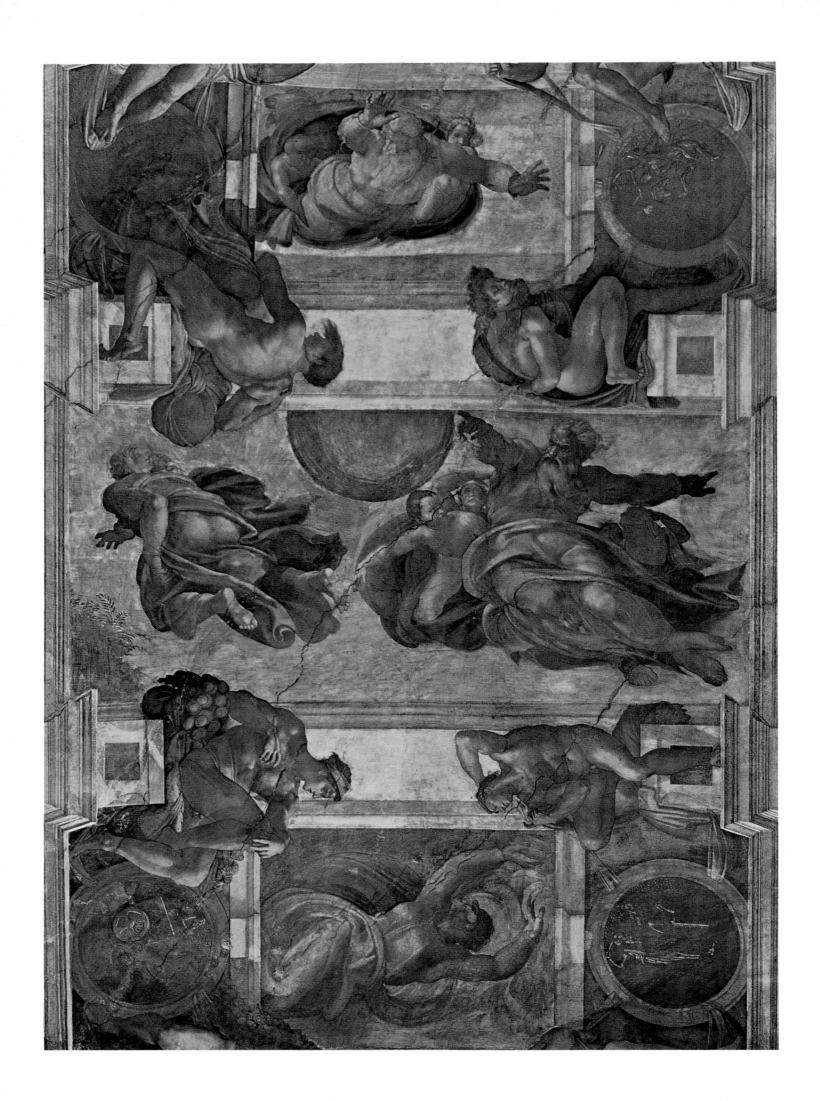

way, the artist not only includes the whole of humanity in prehistory and the wait for Redemption but also ennobles antiquity, in accordance with the spirit of the Renaissance. On the other hand, the series of the ancestors of Christ in the lunettes refers to bodily preparation for the Redemption, while the seers represent spiritual preparation.

In conclusion, given that the central episodes cover the period from the Creation to the Fall and from the reconciliation after the Flood to man's new fall into sin, with the ridiculing of Noah, the basic concept of the ceiling must clearly be man's yearning for Redemption. This striving is accompanied and supported by the gradually revealed light of God: from its full revelation in the stories of Creation and early humanity at the highest point of the vault to the seers' indirect spiritual enlightenment to the feebly dawning light of the ancestors of Christ. Michelangelo does not express this concept in strict ecclesiastical terms; instead, he creates a majestic vision of history that combines the religious and moral ideals of the Judeo–Christian tradition with the ethical and aesthetic values of classical antiquity. Michelangelo's recognition of this relationship between Jewish and Christian moral values and the aesthetic values of the classical world, expressed through the medium of Neoplatonist thought, explains the apparent contrast that immediately strikes anyone seeing the Sistine Chapel ceiling for the first time. The viewer senses not only the unceasing drama and agitation, the extraordinary animation of forms and images, but also the noble beauty, the solidity and order, contained in this sublime work.

Michelangelo divided up the barrel vault, which rests on a series of lunettes and was previously painted in imitation of a starry sky, by an imposing fictive architectural framework, consisting of sturdy pilasters that form the arms and sides of the seers' monumental thrones and continue into the higher central part as broad pilaster strips marking off the alternate wide and narrow panels that contain the episodes of Creation and man's first deeds. It is generally agreed that he translated into painted form many of the real architectural divisions he had conceived for Julius II's tomb; but this has misled many scholars into thinking that episodes should be regarded as imitation paintings or pictures, or perhaps as tapestries or hangings, inside marble frames. The weakness of this interpretation is that it assumes an illusionistic, virtuoso approach to the work, which would have been quite alien to Michelangelo's character.

The same criticism applies to a theory that is based on a remark Condivi made in his conscientious description of the ceiling's scheme of decoration: he says that the center of the ceiling opens "from top to bottom like an open sky." This comment gave rise to the erroneous interpretation that the histories are windows open to the sky and that the chapel is a roofless temple curtained off from the sky by painted awnings. If this had been the artist's intentions, he would have had to use illusionistic methods of perspective. But the perspective is not illusionistic or related to a single viewpoint for the whole surface, (as in the later ceilings of Andrea Pozzo and the Baroque quadraturists); each division has its own viewpoint and its own never-very-pronounced perspective. Vasari remarks that the painter "in the divisions has not used perspective foreshortenings, and there is no fixed viewpoint, but he has accommodated the division to the figures rather than the figures to the division."

Another aspect that needs to be discussed before studying the groups of figures on the ceiling is the question of how "real" each element is. In most interpretations, only the figures of the prophets and sibyls are regarded as truly "real"—the episodes of the Creation and Fall, as well as the four salvations of Israel in the corner spandrels, are considered to be the seers' visions and the posed figures of the *ignudi* to be a reflection of these visions. This confirms that the central scenes are, as they do indeed appear to be, mystical rather than historical in character; but it does not mean that they

GOD DIVIDING THE WATERS FROM THE EARTH; THE CREATION OF THE SUN AND THE MOON; GOD DIVIDING THE LIGHT FROM THE DARKNESS; IGNUDI
Fresco
Respective sizes, 5 ft. 1 in. × 8 ft. 10 in. (155 × 270 cm); 9 ft. 2 in. × 18 ft. 8 in. (280 × 570 cm), 5 ft. 11 in. × 8 ft. 6 in. (180 × 260 cm)
1511 or 1511– 1512
Vatican City, Vatican Palace, Sistine Chapel
These frescoes belong to the third of the four phases of Tolnay's widely accepted timetable for Michelangelo's work on the Sistine Chapel ceiling. Tolnay believes that the works of this phase were painted between January and August 1511. However, the theory in this book proposes a slightly later date for the second half of the ceiling, that begins with the *Creation of Man*. Vasari suggests that the subject of the seventh biblical scene to be painted is *God Dividing the Waters from the Earth*. This is the most accepted view, although others interpret it as the creation of the aquatic creatures. In the next panel, God appears twice; in a frontal view, he is shown creating the sun and the moon and in a foreshortened back view, he is creating the plants.

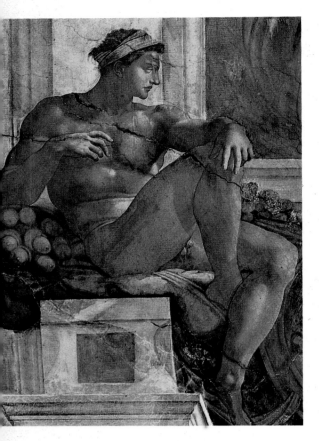

Above: IGNUDO
Fresco
1511–1512
This *ignudo* comes between the *Creation of the Sun and the Moon* and *God Dividing the Light from the Darkness*, next to the medallion showing the ascension of Elijah, and above *Jeremiah*.

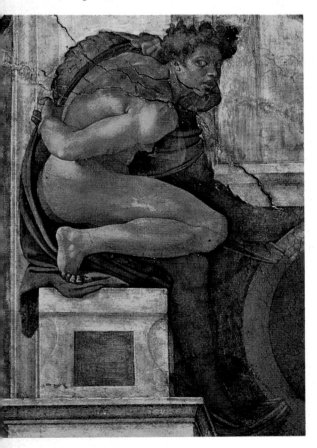

are less real and to be regarded as visions. And as the prophets and sibyls are known for their powers of seeing into the future, it would be odd if here they were endowed with the gift of hindsight, unless their retrospective visions are regarded as prophetic in the sense that Old Testament events prefigure the New Testament.

A study of the biblical episodes as types is superfluous here, since the idea of waiting for Redemption is implicit in the seers and the salvations of Israel, as well as in the series of spandrels and lunettes showing the ancestors of Christ. Indeed, the Old Testament histories are bounded on either side by scenes illustrating the preparation and waiting for Redemption: the physical preparation for the Redeemer's birth in the ancestors, the prefiguration of the Redemption of the human race in the salvations of the chosen people, and the spiritual preparation for Christianity in the seers' prophecies. Instead, taking as a starting point the observation that Michelangelo transferred the proposed scheme for Julius II's tomb to the architectural framework of the ceiling, the histories should be regarded as reliefs; the prophets, sibyls, and *ignudi* as stone statues, and the *putti* in the shadows above the spandrels containing the ancestors as bronze figures, particularly since the faded colors still bear some relation to the tones of marble, hard stones, bronze, or other metals.

If the ceiling decoration as a whole gives the impression of an imposing architectural structure decorated with sculptures (pages 46–47), the figures themselves acquire a higher degree of reality when considered separately. Situated in a no-man's-land between truth and fiction that emphasizes their autonomy and detachment, they possess a metaphysical aura quite in keeping with an allegorical and mystical, rather than historical, tone. The *putti*-caryatids (the figures of small boys that are used as pillars) on the thrones that appear to be sculptural details of the throne architecture are no less alive than the large *ignudi*. The other *putti*-caryatids holding up the cartouches that bear the prophets' and the sibyls' names may be performing this task as living figures or as statues. Even if the figures are regarded as imitation sculptures against the chapel's architecture, the artist has, by a happy paradox, made their three-dimensional forms seem wholly real. All the images on the ceiling are equally vital and have the same sculptural three-dimensional qualities, so that it makes little sense to regard the histories as less real than the other groups of figures.

Sources show that Michelangelo began painting at the entrance end and worked towards the altar, in a direction opposite to the chronological order of events portrayed. This is confirmed by the style that, after the first three histories at the west end, becomes more imposing and on a scale more suited to the onlooker on the ground. The *Drunkenness of Noah* (pages 48–49), mocked by Ham, marked the beginning of Michelangelo's task but showing man's fall once again into sin, was the last episode in the cycle of mankind's early deeds. This picture shows the artist's admiration for the great fifteenth-century Florentine painters. The composition seems to be inspired by Paolo Uccello's fresco on the same subject in the Green Cloister of Santa Maria Novella. The perspective assumes a near viewpoint and takes no account of the distant eye of the onlooker, since otherwise the figures would have been minute and practically invisible from the ground. More

Left: IGNUDO
Fresco
1511–1512
Between the *Creation of the Sun and the Moon* and *God Dividing the Waters from the Earth*, next to the medallion showing the death of Absalom, and above the prophet Daniel.

Facing page: IGNUDO
Fresco
1511–1512
Between the *Creation of the Sun and the Moon* and *God Dividing the Waters from the Earth* and above the *Persian Sibyl*; the medallion near the *ignudo* does not contain a scene.

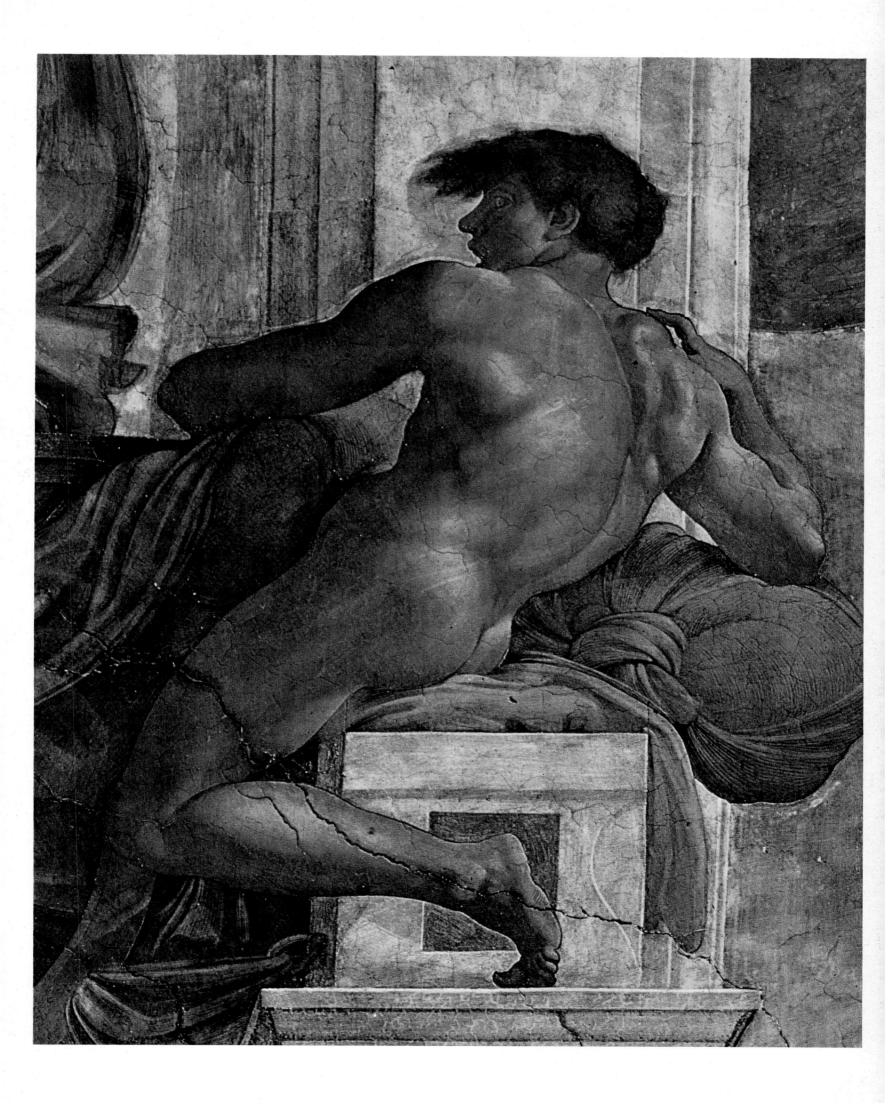

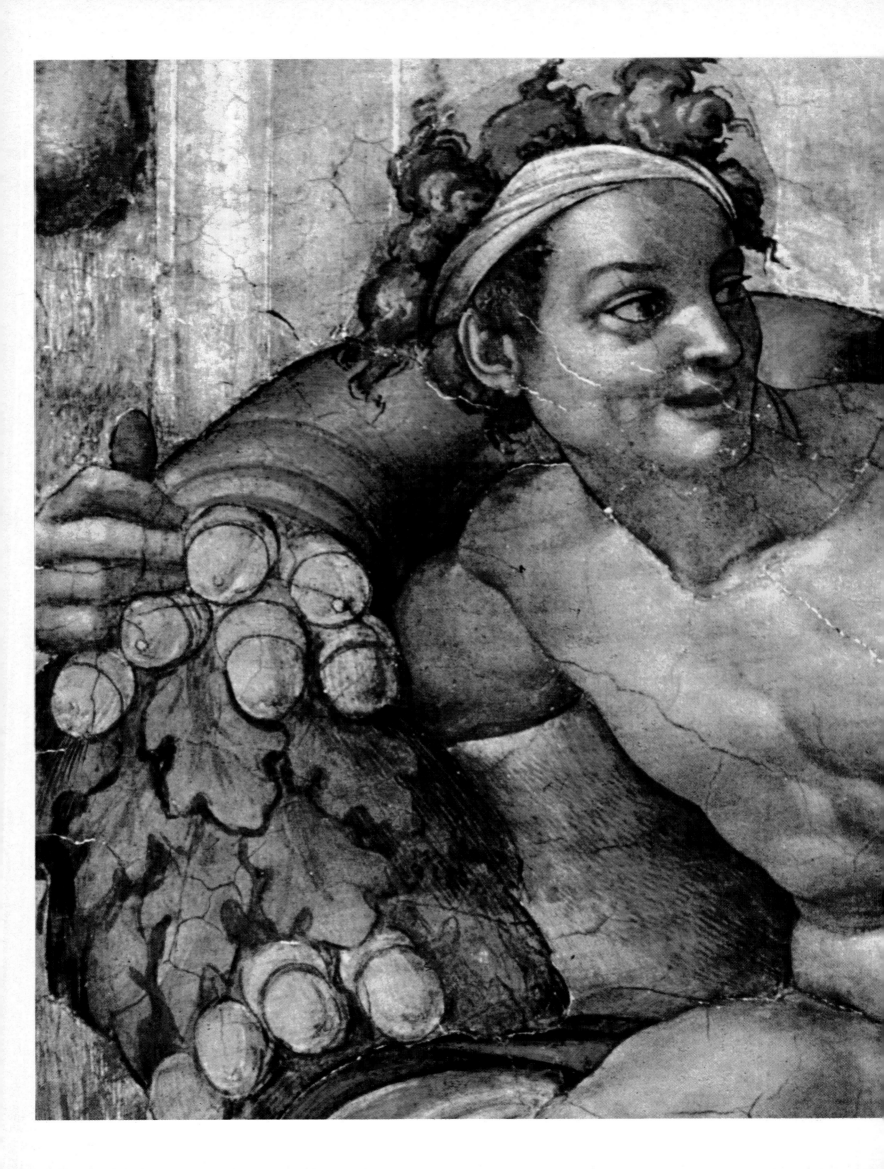

importantly, Michelangelo could not have cramped his own vision into the iron cage of Alberti's rules of perspective, which were quite inadequate for the representation of space on a cosmic scale. With the rapidly converging lines of the ceiling beams, dictated by the near viewpoint, and the large mass of the vat, the general composition of the scene follows the rules of classical relief. The painter was able to enlarge the figures in the foreground, giving the episode a sober eloquence that clearly conveys the episode's moral significance. This is underlined by Noah's noble, heavy, inert form, reclining like an ancient river god, so that he seems to belong to the earth, while the active figures of his sons have the lively animation of a full spiritual life. The sons, who are naked themselves, are not shocked by their father's nakedness so much as by his drunkenness, which Tolnay believes symbolizes in Neoplatonist terms the imprisonment of the soul in the body. Behind on the left, Noah is shown digging in order to plant the vine, a scene that prefigures the founding of the Christian faith and provides an image of industrious activity faintly reminiscent of Jacopo della Quercia's Adam at work.

Noah's Offering (page 54), which, in the correct order of events, should come after the Great Flood, is here moved to form a companion piece to the Drunkenness of Noah. This placement was made for harmony of composition and because the crowd scenes of the Great Flood required one of the larger panels; the reason was not, as has been suggested, to place it next to the prophet Isaiah, whose lips, according to Vigerio's Decachordum, were purified by a burning ember taken from the altar (although in Noah's Offering, a woman is in fact shown poking a piece of wood into the fire on the altar).

In the Drunkenness of Noah, Michelangelo broke the fifteenth-century rules of perspective with regard to distance. In the Great Flood (pages 50–53), the sense of spatial depth is achieved not by the traditional use of perspective but by the three-dimensional interplay of masses in a deliberately unbalanced and asymmetrical composition and in the groups that unwind and stretch out in a kind of sequence, now interrupted, now beginning afresh. Space emerges and grows as the composition of figures develops, so that it is no longer the theater where the drama is enacted but is itself part of the drama. This creates the sense of the universal tragedy and universal grief of humanity here portrayed as suffering rather than punished. The contorted, powerful nude forms, the intricate, tangled limbs, the crescendo of tension in the figures climbing the mountain, even the storm-wrenched bare branches of the tree convey in unsurpassed poetic terms the sense of a destiny of endless, hopeless suffering. The theme of slavery, which man may resist but cannot escape (which was to inspire the Captives for Julius's tomb) can already be seen in this imposing composition that goes far beyond the biblical subject of a terrible, unforeseen calamity and the thunderbolt of the Lord's wrath.

Michelangelo's bold formal study of the nude in laborious movement, which was part of his work for the cartoon of the Battle of Càscina, here bears fruit, creating a more intense form of expression freed from the somewhat contrived qualities of his earlier explorations. The assortment of hard-won solutions to formal problems shown in the cartoon here becomes an organized composition, in which the relationships among the straining, fearful figures convey the message of painful, wasted effort. However, there is some relief from the sense of desperate flight that had totally pervaded the first scheme for the Battle of Càscina. This comes mainly from the oblique sequence of the men fighting over the lifeboat or the figures seeking safety on the ark platform. Noah's Offering is similar in composition to the Drunkenness of Noah, so that the tumultuous scene of the Great Flood is framed on either side by two calm, solemn compositions.

In Noah's Offering, the perspective is composed with a near viewpoint, and the altar is shown as a sharp edge to measure space. But the figures are

IGNUDO: Detail
Fresco
Circa 1509
Vatican City, Vatican Palace, Sistine Chapel
This *ignudo* appears between *Noah's Offering* and the *Fall*, above the prophet *Isaiah*, and next to the medallion showing the death of Uriah. It is not in a perfect state of preservation.

THE LIBYAN SIBYL
Fresco
1511–1512
Vatican City, Vatican Palace, Sistine Chapel
The book that appears with both the *Erythraean Sibyl* and the *Libyan Sibyl* has been interpreted in various ways: it has been suggested that the *Erythraean Sibyl* is using the book to help her reply to *Ezechiel,* who is placed opposite her and who appears to be questioning her; with the *Libyan Sibyl,* the question is whether she is laying down her book after writing in it or, as more recent interpretations have suggested, picking it up.

Pages 80–81: STUDY FOR THE LIBYAN SIBYL, Detail
Red chalk drawing on paper
$11\frac{1}{2} \times 8\frac{1}{2}$ in. (29 × 21.5 cm)
1511–1512
New York, Metropolitan Museum

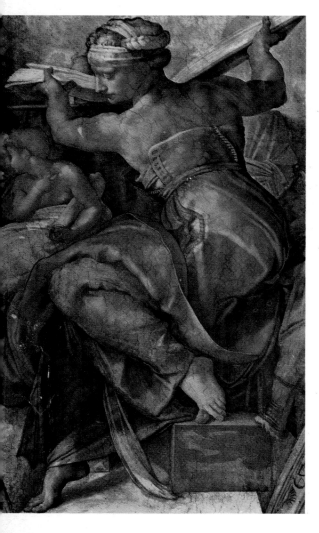

arranged in a self-contained group made autonomous, too, by the range of color used; and this destroys the perspective relationship with the onlooker. The way the fine three-dimensional forms are linked in an unbroken chain gives the work the quality of a classical relief and creates a solemn yet lively rhythm that gives the ritual act depicted a sense of noble detachment and moral grandeur.

After the first three histories, Michelangelo painted the two corner spandrels showing the salvations of Israel — *Judith and Holofernes* and *David's Victory over Goliath,* two episodes that theologians had for centuries interpreted as prefiguring Christianity. According to the *Speculum,* Judith's victory over Holofernes corresponded to Mary's triumph over the devil, and Saint Augustine held that David killing Goliath prefigured Christ vanquishing the devil. The influence of details derived from Signorelli's work does not make *Judith and Holofernes* any less original. The heroine and her maid are leaving Holofernes' tent, where his headless body is in its last throes. The artist has captured a single moment of the action as if in a snapshot; but that moment encapsulates the episode's total significance, and the tension of line draws the entire mass into movement. To create this effect, the painter opens up an expanse of empty space that conveys the idea that the action is unfolding in time but then immediately closes it off with the side wall of the hut behind Judith and her maid. This barrier isolates them from the background and gives prominence to their vigorous forms.

A similar device is used in *David's Victory over Goliath.* This new treatment of the subject matter shows the fight in its last stages: the hero is about to behead the giant, whom he has already felled with his sling. Here, even more than in *Judith and Holofernes,* there is a sense of space stretching away, suggesting the passing of time; but the artist immediately closes it off by placing the conical pavilion behind the figures. In both scenes, Michelangelo achieves a dialectical synthesis between the thesis of space and the antithesis of three-dimensional form: he hints at the significance of the action in time but brings it back to its culminating moment. In this way, the event ceases to be a mere episode and takes on a universal dimension.

Michelangelo probably next moved on to the eight *ignudi,* the three prophets and the two sibyls around the first histories, and the corresponding spandrels showing the ancestors of Christ. The first four *ignudi* around the *Drunkenness of Noah* are arranged in symmetrical pairs of statuelike figures, curved forward or leaning back. This pose is consistent with their action of holding up the bronze medallions, which portray the minor biblical scenes of Joab killing Abner and Jehu killing Joram. These beautiful figures convey a sense of quiet, collected energy beneath their sad expressions. They are sad because the scene above them shows man's further fall into sin and because the two scenes of murder, one by a usurper (the death of Joram, Kings II) and the other for revenge (the death of Joab, Samuel II).

The other four *ignudi* around *Noah's Offering* are more complex in position and structure and are more animated and vital. Perhaps this is a comment on the scenes shown in the medallions (the destruction of the idol of Baal from Kings II and Uriah's death in battle from Samuel II). Probably, however, the artist, perhaps departing here from the intentions of his learned advisers, meant them to embody the radiant dramatic beauty he perceived in the historical synthesis of man's first deeds as a portent of future Christian regeneration.

Zechariah (page 55) was perhaps the first prophet to be painted. The imposing, weighty, but basically facile mass of the figure is executed rather summarily, and some recent scholars have found it too bulky and inert. However, Vasari understood that the image was alive in the "eagerness with which he seeks [in the book] something which he cannot find." The tension implicit in his concentration on his book is accentuated by the *contrapposto* between the profile view of his head, with his arm reaching forward

horizontally, and his legs, with their heavy clothing, which emerge in a three-quarter view.

Joel (page 59), perhaps the next to be completed, gazing steadily and intently at the end of his unrolled scroll, is given life by the magnificent sweep of his cloak and by the two vivacious *putti*. On the whole, however, the figure is rather static and cannot conceal Signorelli's influence.

The *Delphic Sibyl* (page 60) is undoubtedly the first truly great figure among the seers. Like the Madonna of the Doni tondo (pages 39–41), whom she in some respects resembles, she seems to be quite distinct from her throne. She floats in the sphere, clearly suggested by her curving outline that encloses and unites the *contrapposto* of her form. This makes the image seem even more self-contained—removed from earthly space and poised instead in a sphere of universal space. The firm lines of her head set a seal to the restless curves of her body, underlining in style the fear and surprise of her open gaze. It seems likely that Michelangelo's imagination was fired by the tone of mystery and wonder that fills the verses concerning the Delphic Oracle in *Oracula Sibyllina*: "tacita sed mente tenendum" (when the seer reveals the secret, to be kept in silence), "qui virgineo conceptus ab alvo prodibit sine contactu maris" (of the coming of One who would be born from a Virgin without contact with a man), "omnia vincit hoc naturae opera; at fecit qui cuncta gubernat" (a miracle which by the will of the supreme Ruler breaks the laws of nature).

The *Erythraean Sibyl* (pages 61, 62–63), too, is a superb figure, despite the influence of the central nude in Signorelli's fresco of the *Testament and Death of Moses*. She is totally absorbed in turning the pages of her great book, perhaps seeking an explanation of the mystery. She, too, is isolated in the large boxlike space of the throne. In relation to the child who is lighting

JEREMIAH
Fresco
1511
Vatican City, Vatican Palace, Sistine Chapel
Jeremiah is sometimes believed to be the self-portrait of a sorrowful Michelangelo.

JONAH
Fresco
13 ft. 2 in. × 12 ft. 6 in. (400 × 380 cm)
1511
Vatican City, Vatican Palace, Sistine Chapel
Jonah, the last seer on the ceiling, completes the series. The great fish beside him represents the whale in whose belly he spent three days.

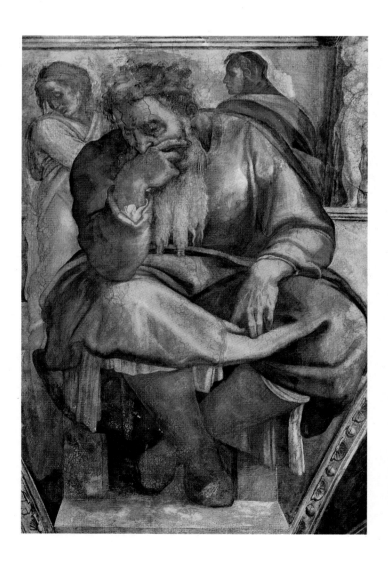
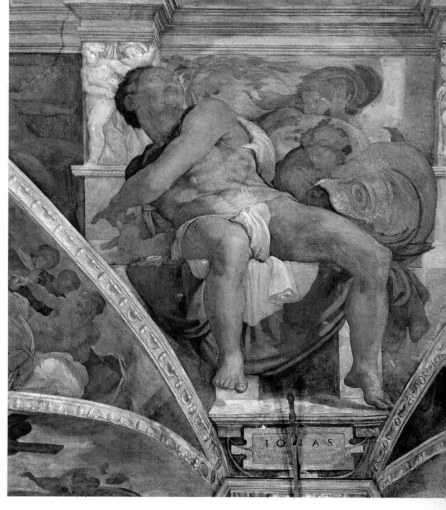

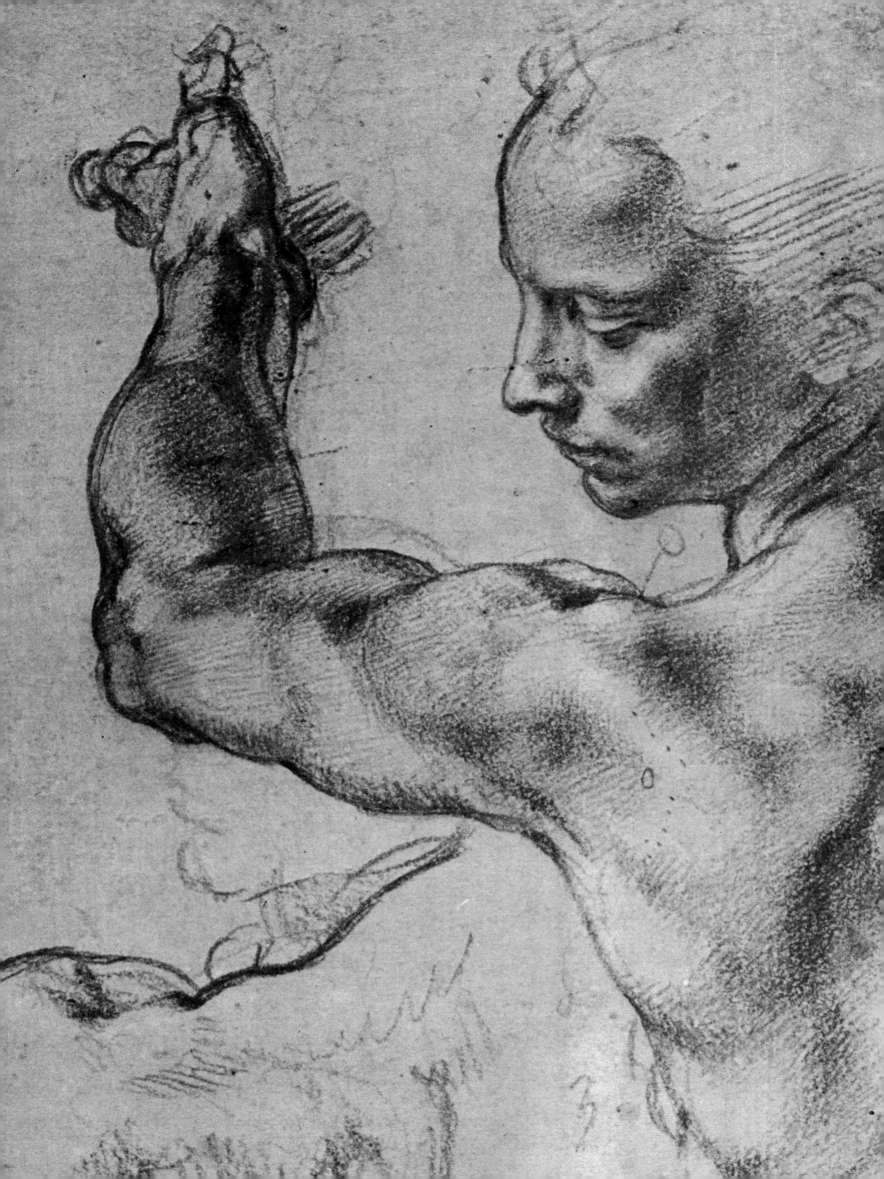

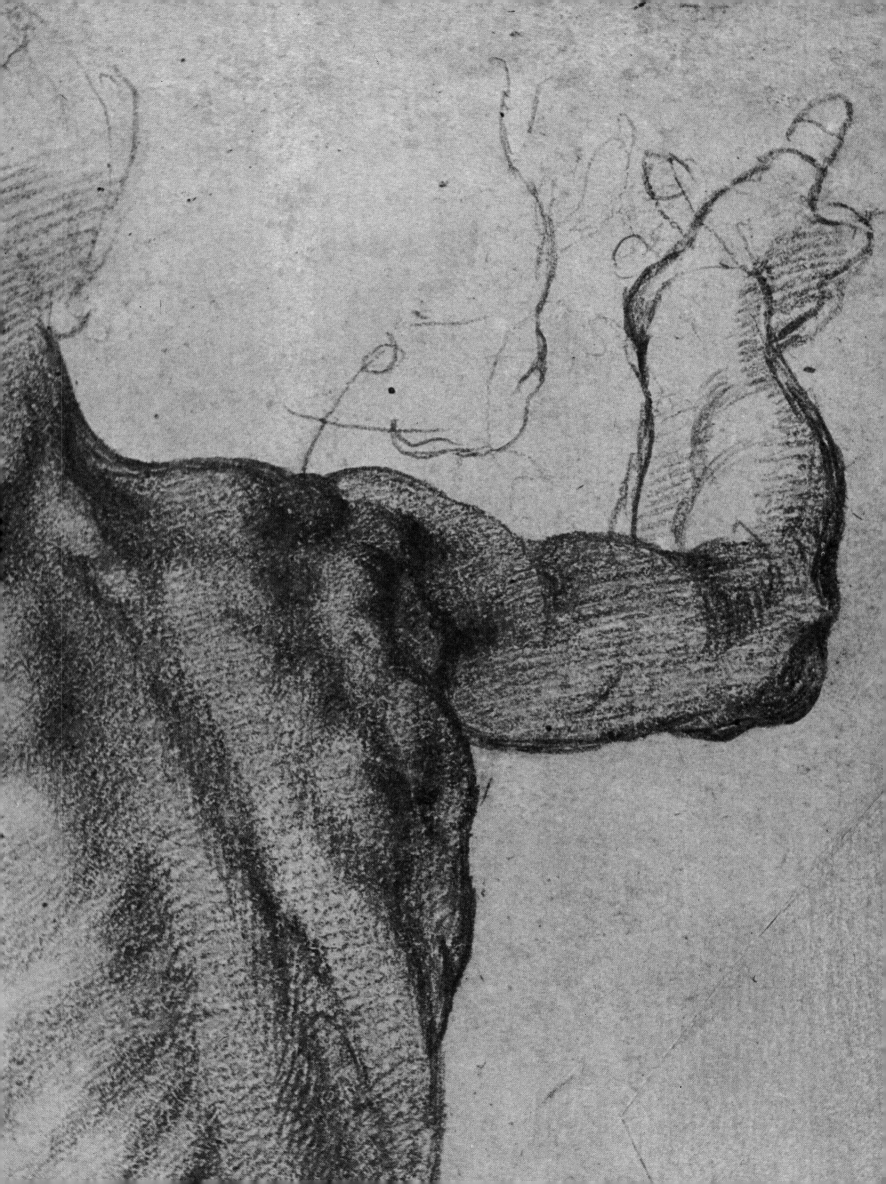

the lamp of prophecy, she takes on a powerful rotating motion that is a visual expression of intense prophetic emotion; it even seems to reach the *putti* on the throne who face each other in a wrestler's pose.

In *Isaiah* (page 61), the details of the closed book with the finger between the pages to keep the place and the head turning at the call of a voice from above (which the hand raised to the ear, as if obeying the little genius's call, is undoubtedly meant to convey) support the general view that this figure illustrates the onset of prophetic inspiration. But with perfect unity of content and form, these illustrative details harmonize with the figure's formal structure. The round shape of the figure is created by the billowing curves of the cloak; and the bent arm, cutting the figure off from the perspective space of the throne, gives it a rotating motion, emphasized by the strong, dappled colors.

As part of this first stage of the work, Michelangelo also painted the two families of the ancestors of Christ in the spandrels between the thrones of the *Delphic Sibyl* and *Isaiah* and between *Joel* and the *Erythraean Sibyl*. Shown as men, women, and children resting on a long journey, these groups are more muted in color. Their tight composition of balanced masses fits neatly into the confined triangular space inside the heavy frame. This suggests a secret and lonely existence. The bronze-colored nudes above the two spandrels are restless, twisting figures. They underline the idea of slavery of the flesh, which is implicit in the iconology of these unwitting precursors of the Word Incarnate. In this little-studied area of the Sistine Chapel ceiling, there is already a glimmering of the great ideas that were to be realized twenty years later with the theme of time halted by death in the Medici tombs.

When these first histories and figures were finished, Michelangelo

HAMAN CRUCIFIED
Fresco
19 ft. 3 in. × 32 ft. 4 in. (585 × 985 cm)
1511–1512
Vatican City, Vatican Palace, Sistine Chapel
The corner spandrels show the miraculous salvations of Israel. The scene here records the massacre of the Hebrews that was ordered by the vizier Haman but that Esther was able to prevent by her intervention, which resulted in Haman's condemnation. The crucified Haman (the Bible in fact says he was hanged from the gallows) has been regarded as prefiguring the Redeemer.

THE BRAZEN SERPENT
Fresco
About 19 ft. 3 in. × 32 ft. 4 in.
(585 × 985 cm)
Circa 1512
Vatican City, Vatican Palace, Sistine Chapel
This is the corner spandrel to the left of the altar wall. God sent a swarm of poisonous serpents to punish the Hebrews who were disheartened by their long wanderings and had begun to turn against him and Moses. Moved by his people's suffering, Moses had erected a brazen serpent that had the power of healing and saving from frightful death anyone who looked towards it.

dismantled part of the scaffolding. He then obviously realized that he had misjudged the size of the figures when seen from a distance, since from the next episode onwards, the scenes are less crowded and the figures are larger and much easier to see from below. It seems amazing, given the tremendous artistic impact of even these first groups of figures, that Michelangelo should have complained, six months after he started work, of "the difficulty of the work and that it is not even my profession." He declared in his sonnet to Giovanni da Pistoia that "the place is wrong, and I am no painter." These outbursts of ill-humor were provoked partly by the appearance of mold on the *Great Flood*. This occurred, apparently, because the lime base used in applying the *intonaco* was too wet. His ill temper may also have been caused by his initial miscalculation of the size of his figures and his fury over his inability to get going on Pope Julius's tomb after all his work and dreams.

The *Fall* and the *Expulsion from Eden* (page 65) balance each other on either side of the same composition and are separated by the axis of the tree trunk around which is coiled the serpent with the torso of a woman. The balance between the two sides of the composition is dynamic and full of tension, because the *contrapposto* of the two twisted figures in the *Fall* and their solid, three-dimensional construction melt into the ampler, looser treatment of the bodies in the *Expulsion from Eden*. In visual terms, the *Fall* prepares the way for the *Expulsion from Eden*. This gives the composition as a whole its overwhelming sense of fatality: the torsion of Adam and Eve as they pluck the fruit acts as a spring; the tree with its bough spreading to the left and the serpent's coils act as a brake. But the angel, flying in from the distance towards the surface of the painting and stretching out his arm and sword to the right, is the impetus for further movement, which is transmitted to the elastic nude figures of the two outcasts, driving them to their fatal descent.

These figures are usually compared with Masaccio's treatment of the same scene, and Michelangelo obviously intended an allusion to the work of his fifteenth-century predecessor whom he so much admired. However, Michelangelo's figures are fuller and more rounded, with more emphatically curving outlines. The drama is more painful and the suffering more rebellious: in the ashamed weeping of Masaccio's Adam and Eve's despairing cry, there is an element of heroic acceptance of their hard destiny; but the cry of Michelangelo's couple echoes pathetically through the bleak world. In the *Creation of Eve* (page 65), there is a further homage to Masaccio: the figure of God is enveloped in stiff, stonelike clothing, like the apostles in the *Tribute Money*, and Michelangelo here makes use of one of his early drawings of the Brancacci chapel. But Masaccio's heroic humanity here becomes superhuman *terribilità*. Such tremendous power emanates from the solid, massive figure of God that Eve springing from Adam's side seems to be drawn forth by the magnetic energy of the Father's gesture. The composition, with its solid, compact structure, based around a parallelogram, seems to anticipate by four centuries the theory of gravitation.

From this scene onward the *ignudi* become larger and more imposing, and the couples are increasingly contrasted, almost alternating in style. Around this panel, two figures are in calmer, more compact poses, while the pair opposite them "break loose," twisting their powerful bodies around into an almost frontal view, where movement ceases with the astonished, staring eyes. This second pair is holding up the medallion that shows David doing penance (before Nathan) for his adultery with Bathsheba and Uriah's death. The first pair's medallion depicts the destruction of the tribe of Achab, a worshipper of Baal. There seems to be an inverse relationship between the subject shown on the medallions and the attitude of the *ignudi*: the scene of violence offset by a tranquil pose and the calm penitential scene by prophetic or visionary agitation.

The *Cumaean Sibyl* (page 66) is reading in her great book about the return

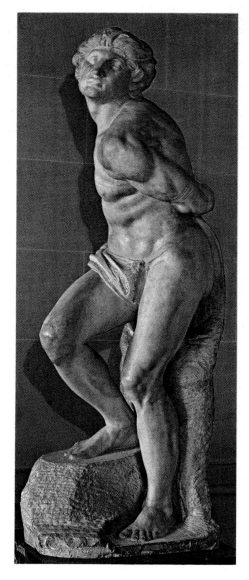

THE HEROIC CAPTIVE
Marble
Height, 85 in. (215 cm)
Circa 1513
Paris, Musée du Louvre

THE DYING CAPTIVE
Marble
Height, 90 in. (229 cm)
Circa 1513
Paris, Musée du Louvre
The two statues were certainly begun in 1513 for the second version of the scheme for Julius II's tomb. They were not included in the final project and were given to Roberto Strozzi by Michelangelo. In 1550, the two works were with Strozzi in France, then came into the possession of the Connétable de Bourbon, and later were in the hands of Richelieu. Finally, in 1793, they were acquired by the French government and placed in the Louvre collections. Vasari and Condivi each gave a different allegorical interpretation of the two *Captives*: Vasari believed they represented the provinces that Julius II acquired and that were annexed to Church domains, while Condivi regarded them as an allusion to the liberal arts.

of the golden age, which, according to the *Oracula Sibyllina*, would be when the Magi offered the Child gold, frankincense, and myrrh. The masses are loosely composed with the usual *contrapposto* that is justified in terms of illustration. The sibyl, holding the page away from her, is reading farsightedly, and this, together with the bronzy sheen of her cloak over the pale blue dress and the sunburned tinge of her skin, creates an image of an elderly virgin emanating a sense of calm and mature spiritual power.

In the two groups of ancestors in the spandrels on either side of the *Fall* and the *Expulsion from Eden*, the masses are in a closer relation, while the bronze-colored nudes above them present new variations on the theme. The two figures above the spandrel of the family of Achaz with the child Ezechias (page 67) closely prefigure the statues of *Dawn* and *Evening* in the Sagrestia Nuova.

The prophet *Ezechiel* (pages 67, 68–69), struck by a vision (presumably, the vision of the four animals and the four wheels prefiguring the evangelists), springs from his feet, swings around to the right, and stretches out his hand in puzzled amazement. The scroll sent him by the Lord hangs partly unrolled from his left hand. It is close to his side and follows the arc formed by the figure as a whole. His sacred frenzy is emphasized by the contrasting colors of his scarlet, velvet robe set off by the pale blue scarf around his neck and the bright violet folds of his cloak. Even the *putti* on the armrests of the throne, far from being lifeless statues, look as if they were about to begin wrestling.

Michelangelo apparently completed these episodes and figures (just over half the entire ceiling) between August 1508 and September 1510. At the beginning of September, he was anxiously awaiting funds in order to erect scaffolding for the second half of the ceiling. In a letter to his father dated September 7, 1510, Michelangelo says, "I am waiting for 500 ducats, from the pope, that I have earned, and he should give me a similar sum to build the scaffolding and proceed with the rest of my work; he has gone away and left me no orders. I have written a letter to him, but I do not know what will happen."

The pope had gone to Bologna and, although the artist twice visited him there, Julius had no intention of providing funds, or so it seems from Michelangelo's account in a letter to Fattucci of 1524. Even after the pope's return to Rome in January 1511, the artist received nothing for several more months and spent his time "drawing cartoons for the Chapel of Sixtus, hoping to get money and finish the work." Finally he received 2,000 ducats and was able to start work again.

On August 14, 1511, Paride de' Grassi records that the pope visited the chapel "vel ut picturas novas ibidem noviter detectas videret, vel quia ex devozione ductus fuit" (either to see the latest pictures recently unveiled or drawn there by devotion). Since we do not know exactly when Michelangelo received the 2,000 ducats, it is not certain whether he waited until August before dismantling the scaffolding and uncovering the first half of the ceiling, or whether between spring and summer he managed to paint all the rest, apart from the lunettes at the top of the walls, which he would then have completed between the end of August 1511 and October 1512. The entire work was revealed to the public on All Saints' Day. The frescoes we are about to discuss, therefore, belong either to the first half of 1511 or to the second half of the same year and slightly beyond.

This stage of the work began with the panel of the *Creation of Man* (pages 70–71). Before Michelangelo, the Creation of Adam was depicted either as the work of a Maker who fashioned man's form out of mud or as God instilling the spirit into the formed figure of Adam by sending forth rays of light or by stretching his all-powerful right hand over Adam's head. But here, as in the *Creation of Eve*,

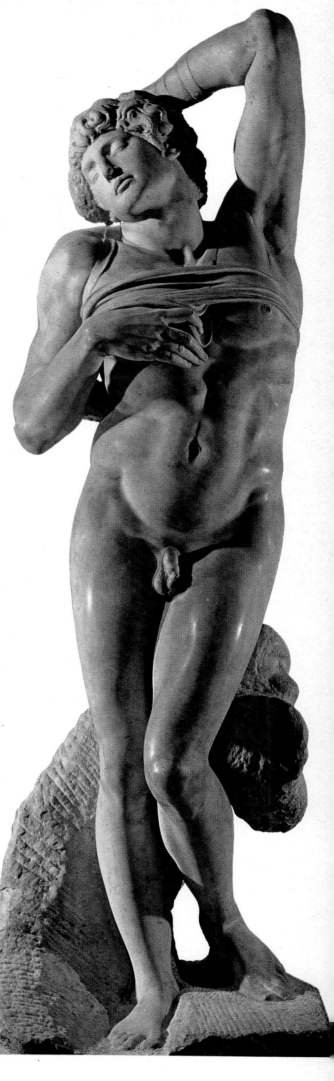

Michelangelo had Jacopo della Quercia's panels in the church of San Petronio in mind. It was he who first conceived the Creator as a primal force of nature, although he did not dispute his portrayal in human form, In della Quercia's work, Eve is drawn from Adam's rib by the Lord's hand, and Adam is given life by his gesture of benediction; but on the Sistine Chapel ceiling, Eve springs from Adam's side at the command of the Creator's right hand, and Adam is aroused from his sluggish, dormant state by what can only be described as an electric impulse that God's finger discharges without actually touching Adam's finger.

The composition is based on the balanced contrast between the bare earth on which Adam is lying and the wind-filled cloak that encircles the Lord and his host of angels. The strip of land is conceived both as a naturalistic sloping hillside and as a cosmic section of the earthly globe edged by a sea. Michelangelo, in a magnificent poetic and cosmic vision, expresses the awesome solemnity of the newly created world and the idea of God as vital energy. In the dialectical contrast between the round shape of the cloak and the extended line of the body, the image of the Eternal takes on a human grandeur and conveys the sense of swift flight (almost like the *Donnergang* of Goethe's sun). The balanced composition of Adam's robust body creates a wonderfully beautiful figure, in which harmony of form matches the harmonious, slow, timid movement of his limbs. The concept of the spark of life created by the contact of the fingers, a felicitous invention, is given prominence as an image. More than any other, this composition of figures illustrates the harmony between the invention of motifs and the creation of forms, between iconography and style.

The powerful cosmic inspiration of the Creation cycle, in which Creation is for the first time represented rather than symbolized, derives from Michelangelo's outstanding invention of the person of God. He is not just a towering figure of indomitable strength but an incarnation of all the primitive irresistible forces of the world. Through artistic insight, a new myth of Creation is born. The idea goes far beyond faithful adherence to the Bible and seems to anticipate by several centuries a modern secular and scientific view of the formation of the universe.

If one follows this quick succession of four scenes as one would a film sequence, starting with *God Dividing the Light from the Darkness* (page 72), the last episode to be painted but the first theme, one immediately has a strong sense of the vast amount of energy that the acts of Creation demanded from the All-powerful. This mighty, superhuman effort on a cosmic scale shows the birth of the world and of mankind in a dramatic light. In one subtle interpretation, God's gesture in creating light and darkness has been identified with the priest's characteristic gesture accompanying the elevation of the host; but this merely shows that iconology is of little help in understanding the artistic substance of works, except in conjunction with an interpretation of the expressive values of form. This gesture is not a solemn, ritual action but the first of a series that build up and become increasingly commanding and charged with energy. Michelangelo's God creates sun and moon by opening his arms imperiously. On the left of the same panel, he calls forth the plants by simply reaching out his hand and opening his fingers as he flies across the earth. The complex *contrapposto* in the composition of the scene and the admirable foreshortening of the figure on the left create through movement a sense of infinite space.

In the next panel, the thunderous face of the powerful old man is framed by the eloquent gesture of his outstretched arms, which bring order to the sublunar world as they divide the earth from the waters. With his new image of God, Michelangelo did not intend simply to portray a strong old man; through this venerable and awesome image, he hoped to convey the idea of pure and absolute force. Yet God is in every way an anthropomorphic figure, drawn from the biblical account and reinforced by Michelangelo's

experience of antiquity. It is this biblical and classical anthropomorphism that allows God as a natural force to be portrayed in such an incomparably dramatic manner.

In this section of four scenes, the *ignudi* share in the increasingly exalted and vital spirit of the episodes of Creation. Around *God Dividing the Waters from the Earth*, two of the *ignudi* are figures of controlled strength and firm contours. The other two move more freely and dramatically; they twist so that one has his back to the onlooker and the other his front (pages 2–3, 72, 74, 75). Around the last picture, or the first chronologically, the contrast is no longer between couple and couple but between the two figures in each couple. In one of the *ignudi* (page 74, above), the balanced three-dimensional masses are composed in classical harmony (prefiguring more than ever the great statues of the Sagrestia Nuova) and are completed by a pure and

MOSES
Marble
Height, 93 in. (235 cm)
1513–1515
Rome, Church of San Pietro in Vincoli
The theory that this statue dates from 1505, the year of Michelangelo's first project for Julius II's tomb, has been discarded. The work is now unanimously placed between 1513, the date of the second project, and 1515, when Michelangelo wrote a letter referring to the work as being unfinished. *Moses* was made specifically for Julius II's tomb but was not originally intended for its present central and important position; it was meant to go in a niche in the middle story of the tomb, so that the patriarch would have been seen from below and from farther away. There have been many interpretations of the underlying significance of this work, which is one of Michelangelo's most finished pieces. Burckhardt and others believe the figure of *Moses* is contemplating the Hebrews' betrayal; but according to Tolnay, the statue is an idealized self-portrait of the artist's soul, showing a superior being's disdain of the moral depravity of the world.
Page 89: Detail

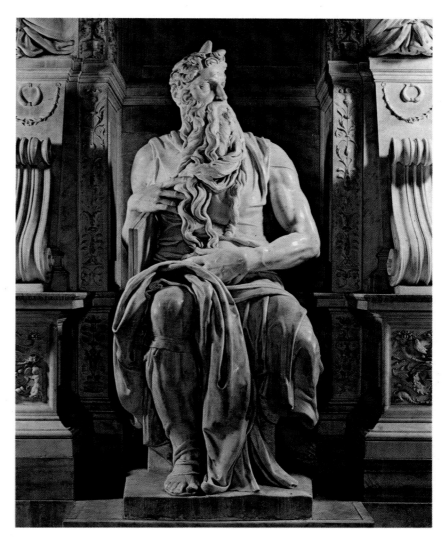

inspiring profile view of the head. His companion is laboriously shifting the load on his back in a *contrapposto* that is made more dramatic because, since the figure is seen from the front, it is achieved almost entirely in the third dimension. The two figures on the other side convert the poses of the two facing them into a frontal and profile view respectively. This makes the relationship between the two couples both a direct correspondence and a cross symmetry.

At this point, it may be easier to understand the role of these figures in the composition as a whole. Although some of them are related in their attitudes to the subject matter of the medallions, either directly or as a contrast, their main relationship is obviously with the stories of Creation. They embody the tremendous energies released by the acts of Creation and by the dramatic fortunes of early humanity. The *contrapposto* composition of their body

movements provides a rhythmic accompaniment to the solemn events of the histories and forms a rich counterpoint to their development. Yet the emphasis is not only on the release of energy but also on the blossoming of the most limpid and radiant beauty. The stories of Creation are revealed truth, but truth is identified in Platonic terms with beauty. The *ignudi* are thus to be seen as a stylistic and expressive symbol of the Sistine Chapel ceiling's miraculous fusion of biblical *terribilità* and classical serenity. They are both the symbol and the expression of the work's central theme—the whole of mankind's anxious wait for Redemption, epitomized in the contrasting civilizations of the Hebrew world and the classical world.

The seers, too, grow in stature and might. A calm, yet irresistible force breathes from the *Persian Sibyl*, who peers nearsightedly at her book and sideways to the onlooker. Her powerful legs, covered with heavy clothing, almost protrude beyond the throne. *Daniel* seems to be possessed by a more powerful prophetic spirit; leaning to the left, at the call of the divine voice, he looks away from his enormous volume, which has to be supported by a *putto* as a telamon.

In the fine figure of the *Libyan Sibyl* (page 78) that, as a well-known drawing (pages 80–81) shows, was studied in the nude on a male model, the springy, elastic movement is coupled with a radiant sense of youthful beauty and strength that are enhanced by the bright colors, especially the dominant golden yellow of the skirt, and the vigorous, blooming uncovered shoulders and opened arms. This figure contrasts with the venerable, old *Jeremiah* (page 79) opposite it. *Jeremiah* is a compact figure bowed down under the weight of his lamentations. The solid balanced masses give the stern figure an exceptional three-dimensional quality. This is set off by the jewellike brightness and moving figures of the two sad virgins of Israel and Judah in the background, instead of the usual *putti*.

The series of seers ends above the altar wall with the youthful image of *Jonah* (page 79) wearing a short sailor's tunic. The monstrous head of a great fish on his left is a reference to the whale that kept him inside its body for three days, making him a symbol of Christ's Resurrection. But, as the castor-oil plant in the background confirms, the artist's subject is not the whale episode but Jonah's argument with the Lord, who forgave the sinful city of Nineveh after he had condemned it to destruction. Michelangelo thus ends the series in a lofty, dramatic atmosphere, again underlining his motivating belief that Faith is a hard-won conquest. In the figure of Jonah, the masses are arranged around a very oblique axis, drawn into a swirling circular motion, a furious rotation that is continuously enriched by contrasting notes of counterpoint. This forms a tempestuous finale, in which the energy accumulated through the whole sequence of seers is released.

There is a similar dramatic frenzy in the two salvations of Israel—*Haman Crucified* (page 82) and the *Brazen Serpent* (page 83)—on either side of *Jonah*, in the corner spandrels of the ceiling. One element here is a distant echo of the impression created by the Hellenistic group of *Laocoön,* found in 1506. The dynamic structure of the compositions utterly transforms space and breaks all the bounds of classical propriety; but this does not, as has been suggested, mean that Michelangelo has left the spirit of the Renaissance behind him and adopted a full-blooded Mannerist style. Certainly these two compositions reflect the Mannerist style of later decades, but they themselves cannot be described as Manneristic because of their spontaneous, passionate expression. Mannerism, even in its most original and noble form, always has a secondhand quality: it is art born from art. This is shown by the fact that the Mannerists found another rich source of inspiration in the last spandrels of the ancestors, which in form and expression are the exact opposite of the two corner spandrels.

It has often been suggested that by this stage the artist was worn out by his exertions and made less of an imaginative effort. This is not so, since the

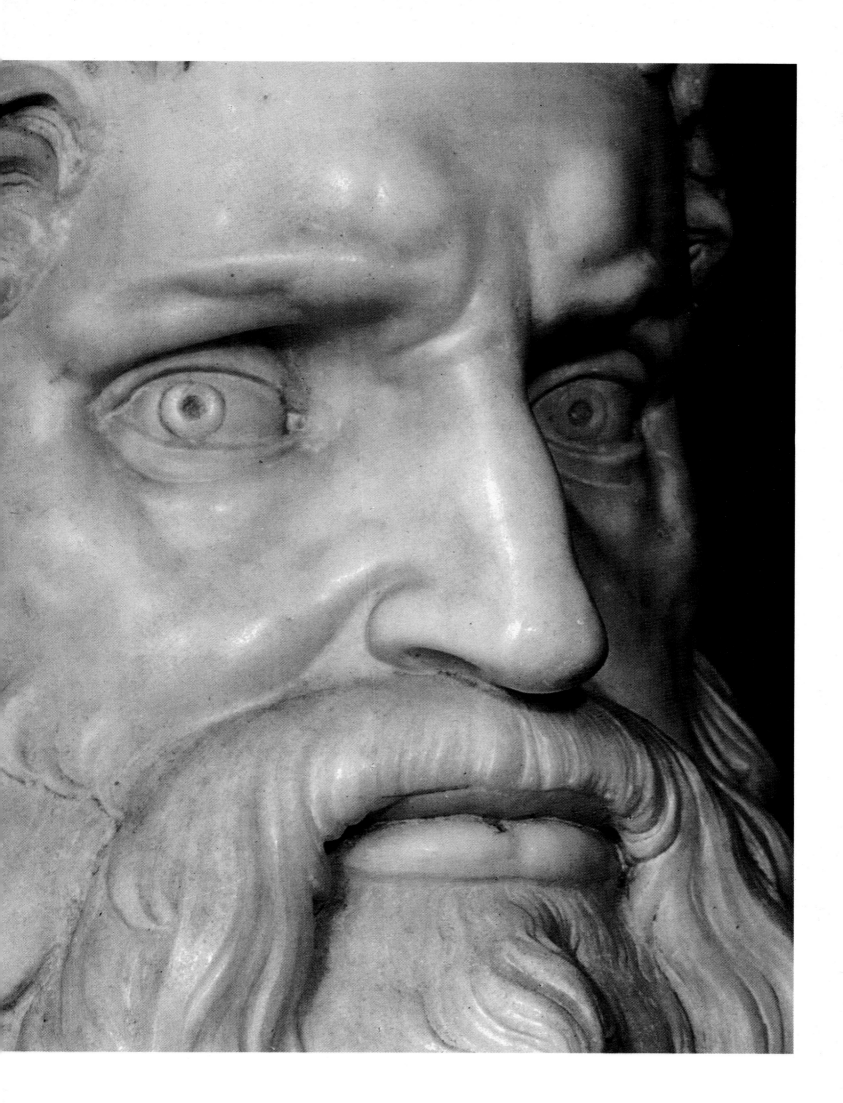

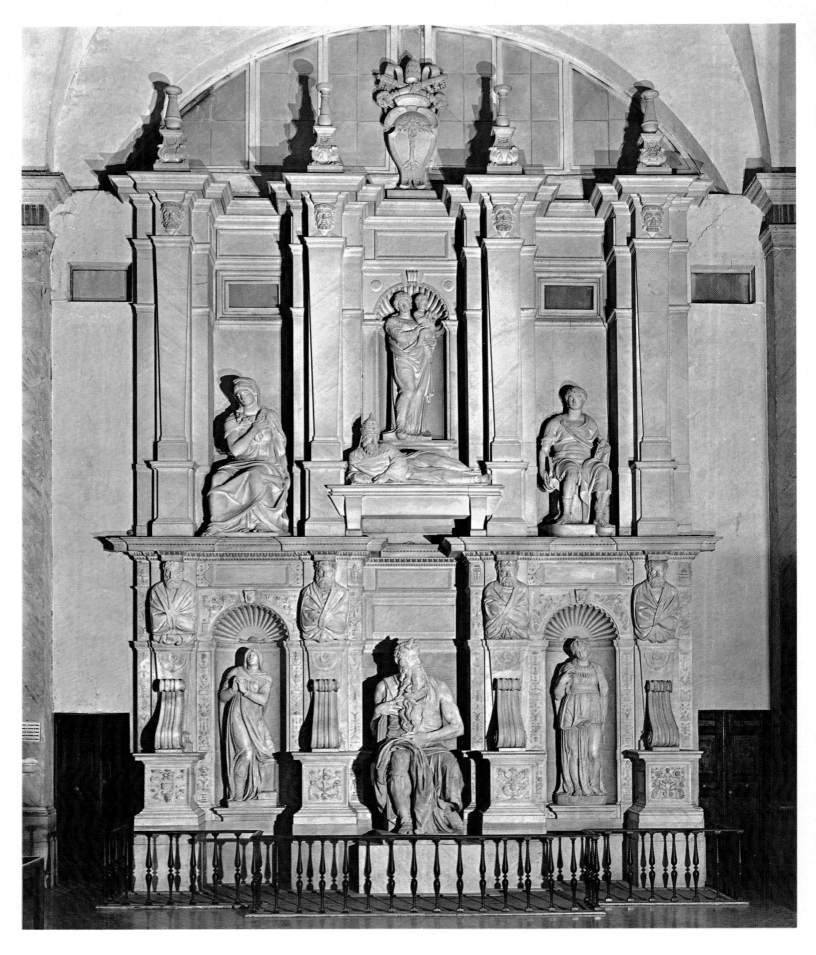

tensions of these figures compared with those of the larger groups of figures on the vault are resolved in a compressed energy of reduced, sometimes flattened forms. This creates a new kind of *terribilità*, expressed both in the solemn silence of the figures whose faces are hidden and in the dazed fixed stare or somber glances of the others. Compared with the early spandrels, the generations of Israel from this section of the ceiling convey a stronger sense

of solitary, ghostly images, frightened and sad, which was to continue, with far more variety, in the lunettes below. This suggests that the painter did not devote the whole period from August 1511 to October 1512 to the execution of the lunettes, as is generally believed nowadays. Instead, the whole second half of the ceiling and the lunettes below date from this period; that is to say, from July 1508 to the unveiling on August 15, 1511, Michelangelo worked on the first part of the ceiling (just over half) and concentrated on the rest of the work in the next thirteen or fourteen months.

That Michelangelo worked at different rates of speed, with the slower pace during the first period, can easily be explained by the initial difficulties of the work, the appearance of mold, and the pope's refusal to provide funds.

The last four spandrels, in particular, are in the same style as the lunettes below that continue the series of generations of ancestors. They thus date from the same period as both the lunettes and the last episodes of the Creation—the last seers and the last *ignudi*, groups of figures which appear to be quite different in form and spirit. This is further evidence of Michelangelo's highly complex mind and imagination, of the contrasts that could occur in his art, and of the importance he attached to the subject matter—or rather to the whole range of moral and philosophical themes that he had helped to formulate.

Michelangelo regarded art not as a simple exercise in form but as a means of expressing an abstract moral message, and he allowed himself to be freely inspired by the meaning of the images he had presented figuratively. This is the only possible explanation for his ability, in such a short span of time, to give shape to the tremendous figures of the seers, the Creation of the world, and the two last salvations, as well as to the humble, shadowy figures of the ancestors in the last spandrels and the lunettes.

The gradual lessening of tension from the highest point of the vault to the sides was anticipated from the start in terms of the subject matter of different groups of figures. The Creation—the origin of mankind's spiritual history as narrated in the Old Testament—demanded the highest degree of formal tension and a supreme display of force. The same was true of the *ignudi*, whose ritualized movements were intended to comment on those events, and of the seers and the salvations of the chosen people, which alluded to the conscious wait for Redemption. But for the ancestors, who waited unenlightened and unaware, the theme demanded a more restrained treatment to express their more somber, self-engrossed dramatic quality. In the last spandrels and the lunettes, the *contrapposto* of the masses in the individual figures and their linking are as accomplished as ever, but the tension has slackened, the rhythm is broader, and the modeled three-dimensional quality of the volumes and the rendering of the clothing have a solemn simplicity that again recalls Masaccio.

A sentence from a letter of July 1512 has been wrongly interpreted as a sign of incredible weariness: "I am working harder than anyone ever has, in poor health and greatly fatigued; yet I have the endurance to reach the end I desire." This if anything shows, besides physical fatigue, the artist's psychological identification with the groups of figures he was painting: twilight images, crouched on the ground, weary and thoughtful, worn out by the interminable march from generation to generation—the artist's way of expressing in concrete form their long unconscious wait for Redemption.

The range of styles used in the painting of the Sistine Chapel ceiling is thus extraordinarily wide, harmonizing in very different ways with the profound and disturbing sense of drama. But the order that contains them is firm and clear—"classical" in Renaissance terms. The iconological significance of the groups of figures is expressed both by the shading of color from the paler tones of the central episodes to the more intense, vibrant tones of the seers to the dark, somber, deeply shaded colors of the spandrels and lunettes and by the solid architectural framework of the whole, which is quite free of

TOMB OF JULIUS II
1542–1545
Rome, Church of San Pietro in Vincoli
This is the completed version of Michelangelo's sixth project for the tomb of the Della Rovere pope. Before the final project was realized, there were five superseded versions, each of which was more complex in design than the one preceding it. The original project dated from 1505, the second from 1513, the third from 1516, the fourth from 1526, and the fifth from 1532. The last contract is dated August 20, 1542, and in 1545 Michelangelo, who provided the designs for his numerous assistants, finally managed to complete what had come to be known as the "tragedy of the tomb."

illusionistic tricks and encloses the tumultuous population of figures in a complex but definite geometrical order.

The enormous pain and discomfort that Michelangelo suffered while painting the Sistine Chapel ceiling were caused by his awkward position on the scaffolding. He describes this with bitter irony in the sonnet to Giovanni da Pistoia already quoted. Late in life, Michelangelo still remembered. Condivi recounts that "When this work was finished, because he had kept his eyes raised to the vault so long while painting, he could see little when he looked down afterwards; if he had to read a letter or look at some other small thing, he had to hold it with his arms above his head. But he then gradually again became used to reading when looking down." But the ceiling was much admired and Michelangelo's fame as a painter was officially recognized. On All Saints' Day, the newly uncovered ceiling "was seen with great satisfaction by the pope [who went to the Chapel that day], and all Rome flocked there to admire it." Forgetting their earlier quarrels, Julius "loved him ardently and cared for him more and was more jealous of him than of anyone else he had near him." But Michelangelo's spirit of powerful, honest independence and his faith are again demonstrated by the famous sonnet signed "Your Michelagniolo in Turkey," in which he gives vent to his scorn for Julius II's warlike politics:

Qua si fa elmi di calici, e spade
E'l sangue di Cristo si vende a giumelle
E croce e spine son lance e rotelle,
E pur da Cristo pazienza cade.
(Here helmets and swords are made from chalices and Christ's blood is sold by the cupful. And cross and thorns are lances and bucklers. And even Christ loses patience.)

Soon after, on February 21, 1513, Pope Julius died. According to Condivi, "he not only wanted to employ [Michelangelo] in life but even when he was dead; so when he was nearing death, he ordered that the tomb he had started should be finished for him, entrusting the task to the old Cardinal Santi Quattro [Lorenzo Pucci] and Cardinal Aginense, his nephew [Leonardo Grosso della Rovere, bishop of Agen], who had a new design prepared because the first seemed to them too large an undertaking. Thus, Michelangelo entered a second time into the tragedy of the tomb; he did not succeed more easily with it than at first but much worse, and it brought him endless problems, sorrows, and troubles."

Although the mausoleum idea had been dropped, the tomb, which was to be visible from three sides, was still a grandiose scheme. A very worn autograph drawing and a copy of it by Jacomo Rocchetti, both in the Kupferstichkabinett, East Berlin, give some idea of the scheme, as does a deed dated May 6, 1513, in which the artist specifies what was agreed in the contract: "And the composition of the said tomb is to be in this form: a rectangle visible on three sides, the fourth side of which is attached to the wall and cannot be seen. . . . On each of these three sides, there are two tabernacles that rest on a base running right around the said rectangle and are adorned with pilasters, architrave, frieze, and cornice. . . . In each of the said six tabernacles, there is a figure of similar size: as there are twelve pilasters, there will be twelve figures; on the platform above the said rectangle, there is a sarcophagus with four feet, as can be seen in the model, upon which will be Pope Julius, his head between two figures supporting him, his feet between two others; this makes five figures on the sarcophagus, all larger than life-size, about twice life-size. Around the said sarcophagus, there are six dadoes bearing six figures of the same size, all seated. On the same platform as these six figures, above the side of the tomb that is attached to the wall, rises a little chapel about thirty-five palms

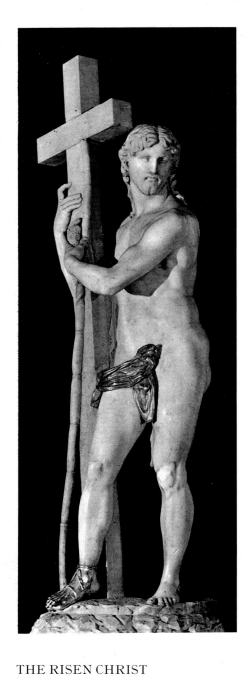

THE RISEN CHRIST
Marble
Height, 81 in. (205 cm)
Circa 1518–1520
Rome, Church of Santa Maria sopra Minerva
The statue is partly the work of Pietro Urbano. Later, Federico Frizzi helped to finish it. The work was not at all to Michelangelo's satisfaction, and he offered to make another of the same subject for the purchaser. However, his offer was refused, and in December 1521 the work was placed in the church in Rome, where it still stands.

(approximately twenty-five and a half feet) high, in which stand five figures larger than all the others because they are further from the eye. There are also three histories either of bronze or of marble . . . on each face of the said tomb between one tabernacle and another."

This was a magnificent project, indeed, which would have included thirty-four life-size or larger-than-life-size figures, the reliefs and *putti,* and the thrones on the upper story that would be a sculptural translation of the fictive three-dimensional painted figures of the Sistine Chapel ceiling. The artist undertook to finish the work in seven years.

There is evidence that, during the same year, Michelangelo worked on the statue known as the *Heroic Captive,* or the *Rebellious Slave* (page 84), now in the Louvre, and probably at the same time on the other Louvre statue of the *Dying Captive* (page 85). The two images are complementary, or as Enzo Carli puts it, "two different conditions of the same sentiment. . . . In the *Heroic Captive,* an indomitable energy violently animates the masses, which are balanced against one another in boldly diverse planes: in their convulsive effort to break the shackles that bind them, the limbs become hard and tense, the muscles emerge through a close web of fleeting shadows." Von Einem believes that there is an echo of the *Laocoön* here, but the grief and despair are given a Christian dimension by the allusion to the theme of Saint Sebastian. A secret note of resignation lies beneath the impulse to revolt. The figure is straining with all his strength, but he knows that liberation (Michelangelo must have been thinking here of the slavery of the flesh and of sin) can never be achieved. He turns his head to heaven, like a Sebastian, with a movement that in nature would conflict with his effort to break his bonds with his powerful arms and shoulders. In the *Dying Captive,* the longer forms are drawn out in a tension that begins but is never resolved. The interplay of balanced masses that dissolve in the continuity of line expresses a torment fading into weary languor. This expression is crowned by the angle of the head, leaning back into the diamond-shaped space formed by the crooked arm. Very much in the pre-Mannerist taste, this is a new invention. It is necessary here for sealing the ambiguity of the sentiment —extreme grief and sweet surrender to death—that animates this work.

Moses (pages 87, 89), begun in 1513 and not quite finished in 1515, according to one of Michelangelo's letters, was not intended to occupy such a totally dominant position in the scheme as it now does. According to the final and definitive plan (page 90), the monument was completed in 1545. The statue, along with a seated female counterpart, perhaps a sibyl, or, as Tolnay suggests, an allegory of the contemplative life, was intended for the right-hand corner of the upper story. In the original plan, the statue would have been seen from a suitable distance below. The oppressive physical presence of this twice life-size statue (which now overwhelms the onlooker) would have made the spiritual impact even more commanding. There is a distant echo of the figure of *Saint John the Evangelist* that the young Donatello made for the cathedral at Florence: in the torso, which catches the light and rises above the rich, moving folds of the clothing over the legs and knees; in the position of the arms; and in the vigorous strands of the flowing beard.

Most important are the magnificent sculptural qualities. As mentioned previously, *Moses* expresses in marble the motif of the prophets of the Sistine Chapel ceiling. The architectonic composition of balanced masses is concentrated in each part and detail into a powerful, dynamic impulse: the rolled clothing around the right leg and the famous unruly, flowing beard are only the most obvious examples; but no tiny part of the surface is inert or unaffected by the vibrant quality of the modeled surfaces. On the other hand, the enormous weight of the mass and the firm logic of the *contrapposto* contain the powerful motion of the figure, which is caught between

STUDY FOR THE MEDICI TOMBS
Black chalk drawing on paper
11¾ × 8¼ in. (29.7 × 21 cm)
Circa 1521
London, British Museum
This is one of the most interesting studies for the Medici tombs and probably belongs to a late stage of work on the design for the Sagrestia Nuova of San Lorenzo.

movement and immobility in the dialectic between its solemn, permanent, dominant position on the throne and its sudden movement as the head turns sharply and the left leg is drawn back. The highly finished workmanship of this statue is often commented on; it was certainly later retouched and finished when placed in its position on the tomb in San Pietro in Vincoli in 1545.

Enzo Carli writes: "Light plays over this smooth, soft, highly finished surface, and as it vibrates against the sharp folds of the draperies, the interplay of muscles and sinews, the flowing beard, it increases the sense of perpetual yet controlled movement that is already apparent even in the composition of the block." Compared with the Sistine prophets, lost in deep meditation or in the grip of some spiritual frenzy, this image has a stronger

SAGRESTIA NUOVA, SAN LORENZO: View of the tomb of Lorenzo de' Medici, duke of Urbino, on the left and of the altar on the right.
1520–1534
Florence, Church of San Lorenzo
Work began on the chapel in March 1520, after the demolition of old houses built against the church transept.

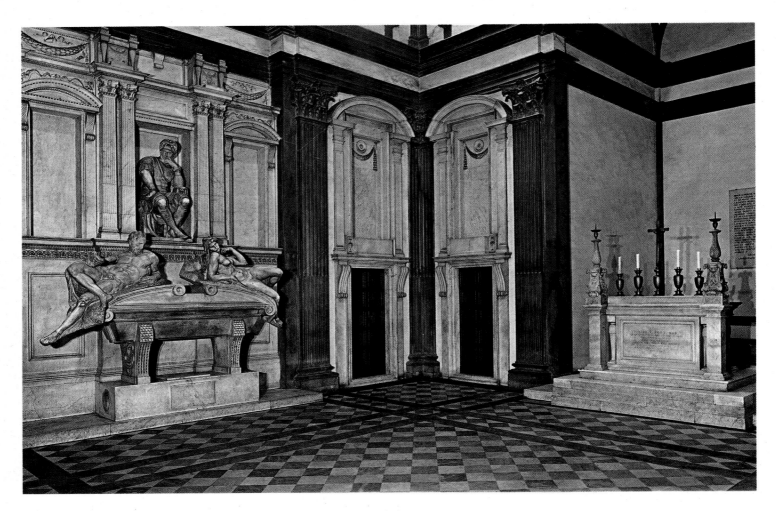

presence, a more powerful existential quality that is skillfully captured at the moment when thought, inspired by relentless moral passion, gives way to action.

From 1513, Michelangelo rented a house in Via del Macel de' Corvi and had the marble for Pope Julius's tomb brought there. He lived modestly and worked unstintingly in spite of his problems. His assistant had a long illness, and the boy he had sent for from Florence to carry out domestic duties and to learn about art in his spare time spent the whole time drawing and would not perform his domestic tasks. Michelangelo worried continually about the family fortunes. He sent money to the Banco dello Spedale di Santa Maria Nuova and lent or gave his father and brothers considerable sums to buy farms and shops.

He warned his family against becoming involved in politics, and, after the Medici's return to Florence with the help of the Spanish mercenaries who savagely sacked the city of Prato, he denied the rumor that he had ever spoken badly of them. However, in an undated letter of October or

SAGRESTIA NUOVA, SAN LORENZO: View of the tomb of Giuliano de' Medici, duke of Nemours, on the left and of the sarcophagus of Lorenzo il Magnifico
1520–1534
Florence, Church of San Lorenzo
Cardinal Giulio de' Medici and Pope Leo X invited Michelangelo to work on a chapel that was to be built as a counterpart to Brunelleschi's Sagrestia Vecchia. The chapel was to contain the four tombs of Giuliano, of his brother Lorenzo il Magnifico, and of Lorenzo's son Giuliano di Nemours and of his nephew Lorenzo di Urbino. However, Michelangelo only completed the last two tombs.

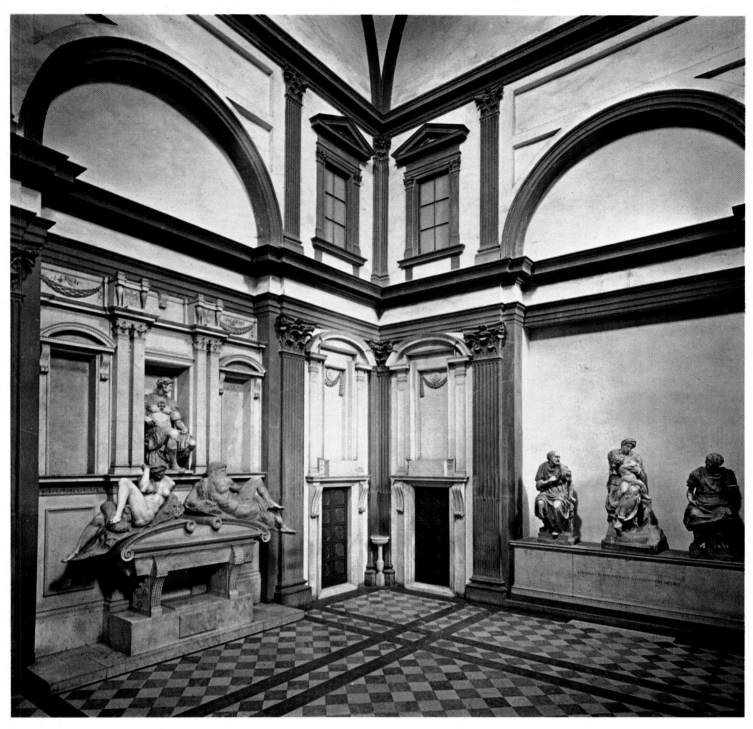

Pages 96–97: SAGRESTIA NUOVA,
SAN LORENZO, View from above
1520–1534
Florence, Church of San Lorenzo
After Michelangelo took charge of the
works in 1520 and visited Carrara to
oversee the quarrying of the marble in
1521, he probably did not start on the
sculptures until 1524, when work was
resumed more energetically after the
election of Giulio de' Medici as Pope
Clement VII.

November 1512 to his father, his righteous indignation did draw one
admission from him: "With regard to the Medici, I have never said anything
against them, except in the way that everyone talks, as in the case of Prato:
if the stones could have spoken, they would have spoken about that." On the
other hand, shortly before (on September 18), he had written: "Live in peace
and do not make friends or intimates of anyone except God." Soon
afterwards, he wrote: "One must have patience and trust in God and right
one's errors, as these adversities are sent for this reason only, especially
because of pride and ingratitude; I have never known a more ungrateful or
prouder people than the Florentines. Therefore, if justice comes, it is with
reason." These lines reflect Savonarola's warnings that public adversities
were God's punishment.

Michelangelo's high moral sense and noble, haughty temperament did not
find an outlet in political action. His deep religious feeling, heightened by
the impact Fra Gerolamo's sermons had made on him as a young man, may
have inclined him to accept calamities as divine punishments, or he may have

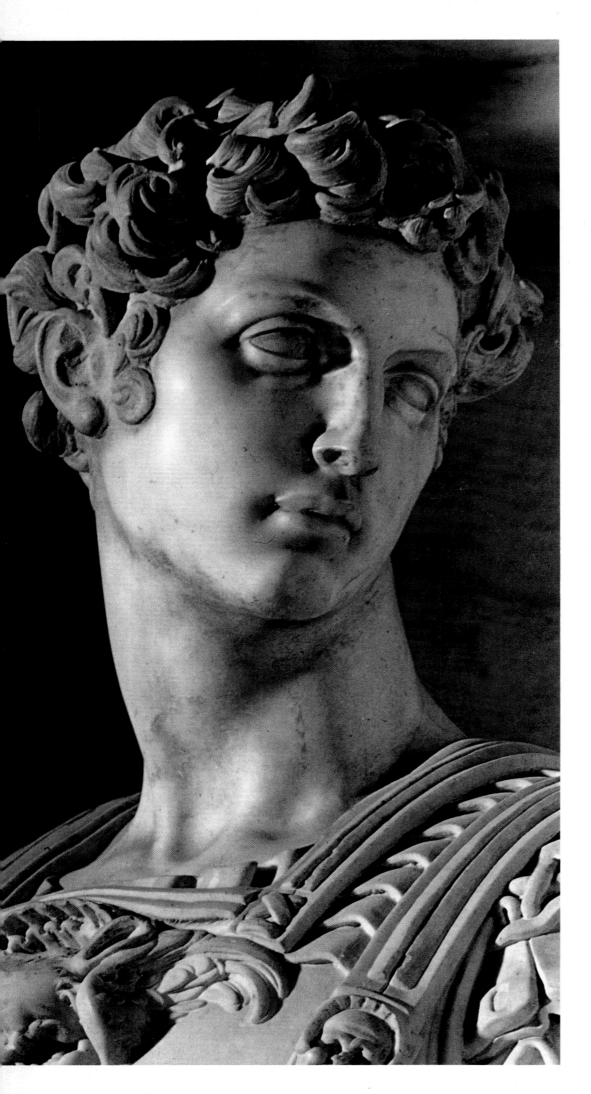

GIULIANO DE' MEDICI, DUKE OF NEMOURS: Detail
Marble
Height, 68 in. (173 cm)
1526–1534
Florence, Sagrestia Nuova, San Lorenzo
Giuliano is seen as an incarnation of the active life or as a despot. He is holding the baton of command, sometimes interpreted as the baton of the Church; in the other hand, he has a coin, which perhaps signifies his generosity.

TOMB OF GIULIANO DE' MEDICI
1526–1534
Florence, Sagrestia Nuova, San Lorenzo
Day and *Night* were begun in 1526 and finished by 1531. The statue of Giuliano was completed later. Montorsoli made some contributions to the work in 1533–1534, but they are probably of little importance.

thought that in order to improve the lot of his family, he could never take sides. He wrote: "If you cannot have earthly honors like other citizens, it is enough to have bread and live well in poverty with Christ, as I do here, for I live frugally and care nothing for life or honor in this world; I have great problems and a thousand worries." The conflict between his genuine moral impulses and external conditions that frustrated them was the underlying

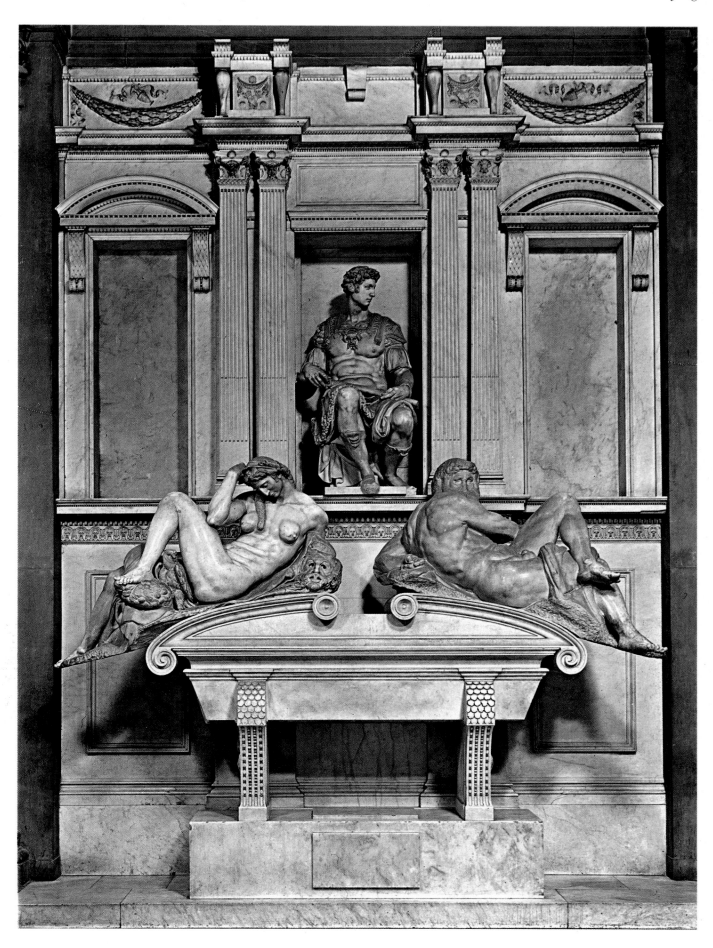

cause of the harshness and resentment of Michelangelo's life. But these same sentiments, which he suppressed in day-to-day life, pervade his artistic vision, as seen in *Moses's* moral *terribilità* or in the *Captives*. Both of these works convey that even the most courageous struggle to achieve spiritual liberation is doomed.

Michelangelo would have made a lasting impression in the field of architecture, even if he had then never completed anything other than the decoration of the Sistine Chapel and the designs for Pope Julius's tomb. However, the great popes of the early sixteenth century, so eager to call on his exceptional talents as painter and sculptor, were hesitant about giving him architectural commissions. This attitude may have been due to Bramante's supremacy in the Roman milieu and to the popes' not wholly confident feeling that Michelangelo could or would apply the venerable rules of the classical style to architecture.

His first work as an architect dates from 1514, when the Chapel of Saints Cosmas and Damian was built in the Cortile delle Palle of Castel Sant'Angelo for Pope Leo X (Giovanni de' Medici, son of Lorenzo il Magnifico and the artist's contemporary and friend since adolescence). Antonio da Sangallo the Younger directed the project, but a drawing from the sketch book of Bastiano (known as "Aristotile") and Giambattista da Sangallo from about 1540 reproduces, with some differences the view of the right side, and

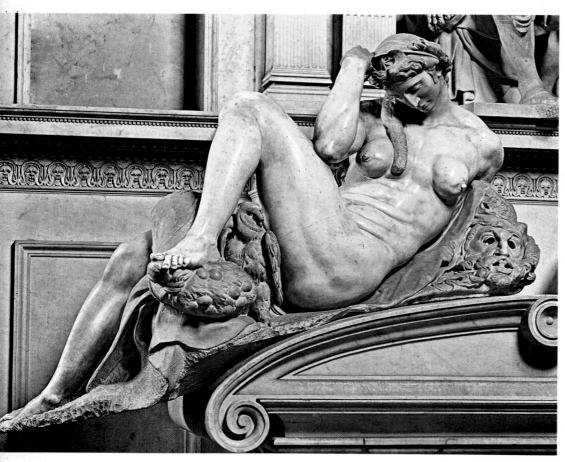

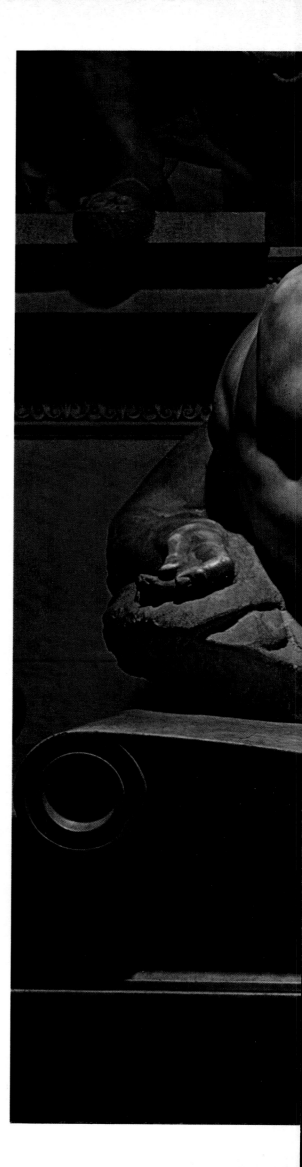

NIGHT
Marble
Length, 76 in. (194 cm)
1526–1534
Florence, Sagrestia Nuova, San Lorenzo
The owl, the mask, the poppies, and the starry diadem on the figure's head symbolize sleep and darkness that come with night.

DAY
Marble
Length, 73 in. (185 cm)
1526–1534
Florence, Sagrestia Nuova, San Lorenzo
Among the many theories on the symbolic value of this image is the suggestion that it personifies the revolt against slavery.

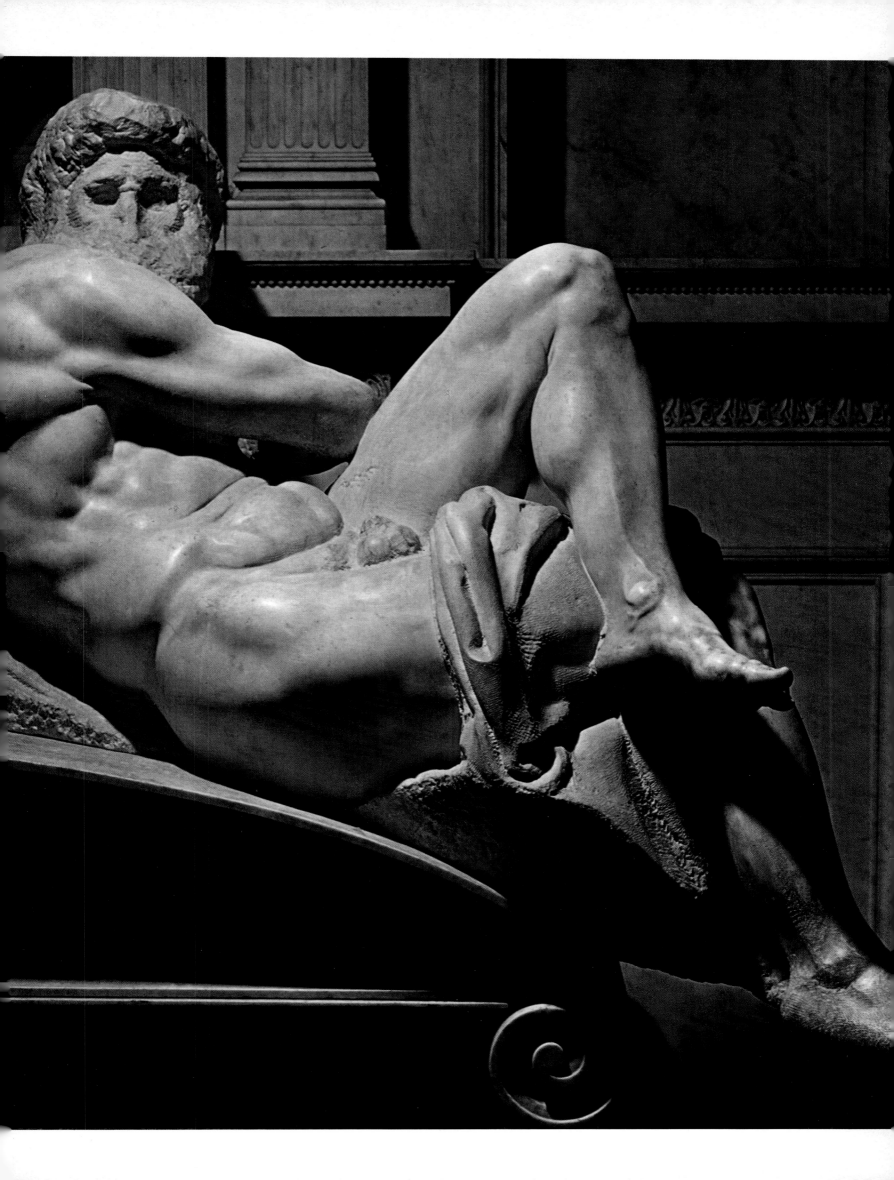

attributes it to Michelangelo. There is no reason to doubt that he was at least responsible for designing that front.

A tympanum, interrupted by a recessed trabeation, rises above a projecting central bay, between two half-columns, that opens into a large cross window. On either side of the central bay, there are two narrow lateral bays almost completely filled by a niche. The central opening is based on the type of cross window seen in Rome in the fifteenth century; but the two small upper windows are half the depth of the lower, and the central pilaster has a projecting volute at the top. The tympanum is in the form of a flattened triangle, with a base that extends beyond the edge of the central section. The half-columns taper quite markedly. In this little work as a whole, there is a lively and fluid interplay of tensions that makes all the details, whether classical or Renaissance in origin, more dramatic.

In July 1516, Michelangelo had just signed a new contract for Julius's tomb (a scheme on a smaller scale than the one agreed three years previously) when Pope Leo X commissioned him, along with Baccio d'Agnolo as his assistant and subordinate, to design the façade for Brunelleschi's church of San Lorenzo in Florence. From the rather confused and contradictory accounts of Condivi and Vasari, it appears that Pope Leo X had had this idea a year before; but because at that time Michelangelo was reluctant to stop work on Julius's tomb, a competition, entered by many architects of the day—Baccio d'Agnolo, Antonio da Sangallo, Andrea and Jacopo Sansovino, Raphael, and Giuliano da Sangallo—was held. But ultimately, the pope insisted on having Michelangelo, presumably because he wanted the artist to work for the glory of the Medici family, while at the same time delaying progress on his great work in memory of the Della Rovere pope.

Michelangelo went to Florence and, with the help of Baccio and others, began preparing designs and making terra-cotta and wooden models. He went several times to Carrara and, on the orders of the pope who did not want to be subject to the prince of Carrara, also to Pietrasanta and Serravezza (which were in Florentine territory) to quarry marble and arrange transport for it; he also had a new road built in the mountains.

After he had shown several drawings and two models to the pope, a contract was drawn up in 1518. But very soon, in early 1520, Pope Leo changed his mind and canceled the contract. Michelangelo was bitterly disappointed to see so much work and effort wasted. He wrote to a friend at the beginning of March 1520: "I have not yet reckoned in his [the pope's] account the wooden model for the said façade that I sent him in Rome; I have not reckoned the three years I have wasted on this affair; I have not reckoned the fact that I have been ruined by the said work of San Lorenzo; I have not reckoned the great disgrace to me of bringing me here to do the said work and then taking it away from me; I do not yet know why."

In the drawings and the surviving wooden model (page 148), sometimes identified as the one made by Baccio d'Agnolo and sometimes by Pietro Urbano, one can see the transition from the fifteenth-century conception of the façade as a collection of parts to a new, more united, three-dimensional idea. The façade was not intended to be attached directly to the unfinished wall but was to be the front face of a narthex that was to project out from Brunelleschi's naves. This would provide greater scope for creating a three-dimensional effect. In the final drawing, the lateral bays are narrower; the center bay projects more emphatically than in the wooden model; and a dramatic movement of contrasted masses runs through the whole façade. This organization would provide a fitting frame for the statues and reliefs that were to decorate the surfaces, as if gathering and concentrating the tension of the modeled architectural membering. There were to have been eighteen statues, six in bronze and nineteen reliefs, making the work, as the artist proposed, "the mirror of architecture and sculpture for all Italy."

TOMB OF LORENZO DE' MEDICI
1524–1534
Florence, Sagrestia Nuova, San Lorenzo
On the left is *Evening*; on the right, *Dawn*; in the middle in the niche, *Lorenzo, Duke of Urbino. Evening* (length, 77 in.; 195 cm) is the last of the statues to be completed, while the other two were almost finished before work was interrupted in 1527. Vasari says that Giovanni Montorsoli collaborated on the *Lorenzo*.

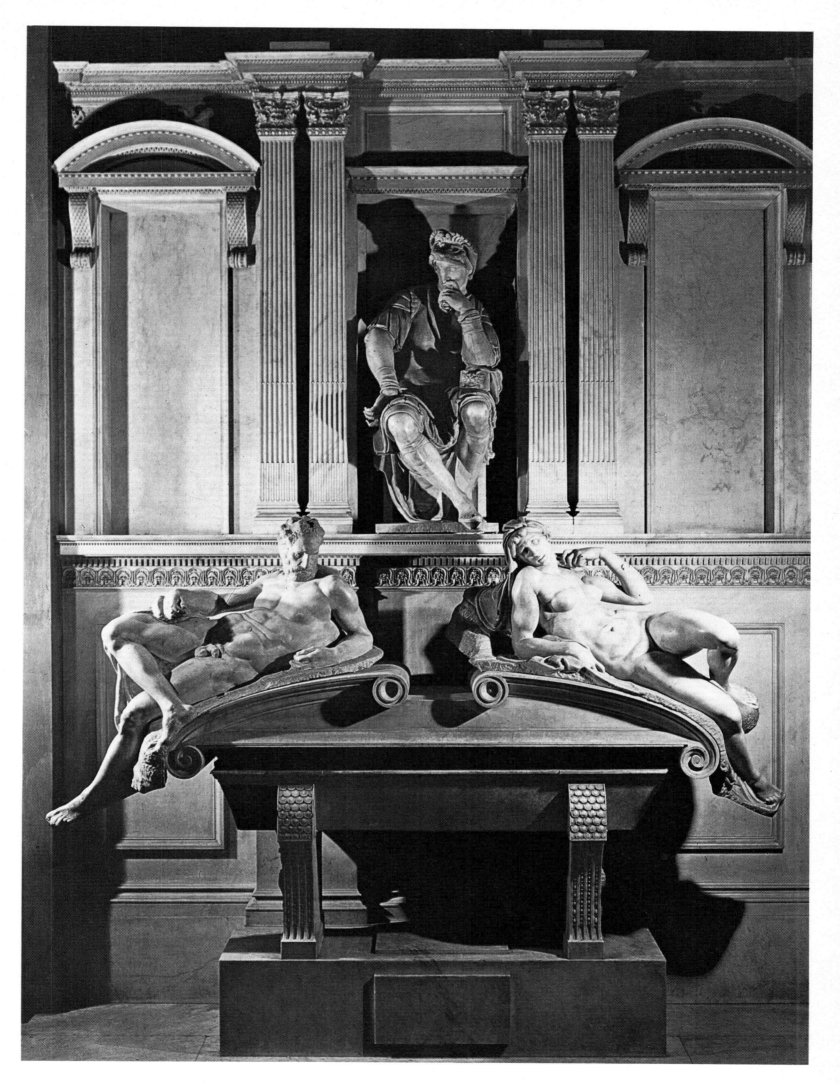

In 1514, Michelangelo had agreed to produce a life-size, nude *Risen Christ* for Metello Vari for the Dominican church of Santa Maria sopra Minerva in Rome. But because of a flaw in the marble, a vein that ran right across the figure's face, he abandoned the statue before leaving for Florence in 1516.

In 1518–19 in Florence, at Vari's insistence, he began again with a new block of marble ordered from Carrara. The work (page 92) was sent to Rome and unveiled in 1521, after it had been clumsily retouched by an apprentice Pietro Urbano and then, to make amends, by Federico Frizzi and Michelangelo himself. Michelangelo was still not satisfied with the work and offered to redo the figure a third time for his client. However, Vari was quite happy, and the statue was highly praised by Sebastiano del Piombo and others. Vari also asked for the first, incomplete statue for his garden which contained a whole collection of antiques, but it later disappeared (unless Parronchi is correct in identifying it as Niccolò Cordier's Saint Sebastian in the Aldobrandini Chapel of the same church of Santa Maria sopra Minerva).

The statue, which illustrated a eucharistic theme and was to have stood in a tabernacle, follows, as von Einem points out, the same tradition as Vecchietta's *Risen Christ* in Siena cathedral. According to von Einem, Michelangelo set out to resolve the problem of an art "with a mystical, Christian content that also affirmed the values and laws of nature and, in addition, followed antiquity." The importance that the artist attached to his theme explains the work's stylistic complexity. The anatomy of the figure is studied from life and has a heroic and classical stamp. But at the same time, the torsion of the body in a *contrapposto* position helps to soften the image and is, as some scholars have already pointed out, reminiscent of Leonardo's *Leda and the Swan*. In my opinion, this is almost the only work by the mature Michelangelo that has any relation to his youthful Santo Spirito *Crucifix*. In the tenderness of his treatment of the delicate, nude Christ, memories of Savonarola's ideas and sentiments reappear.

While involved in preparing the designs and selecting the marble for the façade of San Lorenzo, Michelangelo tried not to neglect Pope Julius's tomb. In February 1519, as a letter from Leonardo Sellaio in Rome to Michelangelo in Florence shows, the artist had promised Cardinal Aginense, the executor of the Della Rovere pope's will, that by the summer he would complete four figures. These were later seen by Francesco Pallavicini and in 1542 were still to be found with other rough-hewn works in the sculptor's house in Via Mozza (now Via San Zanobi). However, Michelangelo records in a famous letter of 1542: "Seeing this, that I was working for the said tomb, Medici [Cardinal Giulio de' Medici, son of Giuliano and archbishop of Florence], who was in Florence and who later became Pope Clement, did not let me continue." These four figures are undoubtedly the four *Captives* that his nephew Lionardo gave to Duke Cosimo I and which Buontalenti placed in the grotto in the Boboli gardens, where they remained until they were transferred to the Galleria dell'Accademia in 1908. Therefore, they date from about 1519–20 and not, as many scholars claim, ten or more years later. The artist, however, may have continued to work on them from time to time before he finally left Florence in 1534. Although unfinished, or rather because they are unfinished, the Academy *Captives* are among the works that illustrate most vividly Michelangelo's definition of sculpture as "that which is made by the effort of cutting away," in a laborious struggle with the hard marble. Later he wrote in a poem:

Non ha l'ottimo artista alcun concetto
Ch'un marmo solo in se non circoscriva
Col suo soperchio, et solo a quello arriva
La man, che ubbidisce all'intelletto.
(The greatest artist has no conception that a marble block does not contain within itself, and only the hand that obeys the intellect can reach it.)

LORENZO DE' MEDICI, DUKE OF
URBINO: Detail
Marble
Height, 70 in. (178 cm)
1524–1534
Florence, Sagrestia Nuova, San
Lorenzo
The helmet with the lion's mask
perhaps symbolizes the duke's
strength, and he is in fact classically
represented as wearing armor.
However, the more frequent interpre-
tation of the image, based on Vasari's
description of Lorenzo as "the
thinker," is that it represents the
contemplative life (while Giuliano
is the symbol of the active life).

DAWN
Detail
Marble
Length, 81 in. (206 cm)
Circa 1524–1527
Florence, Sagrestia Nuova, San
Lorenzo
Of the four allegorical images of time,
Dawn perhaps best illustrates one of
the many suggested interpretations of
the significance of the Medici Chapel as
a whole: the sad fate of man, who must
succumb to the all-consuming passage
of time.
Pages 106–107: Detail

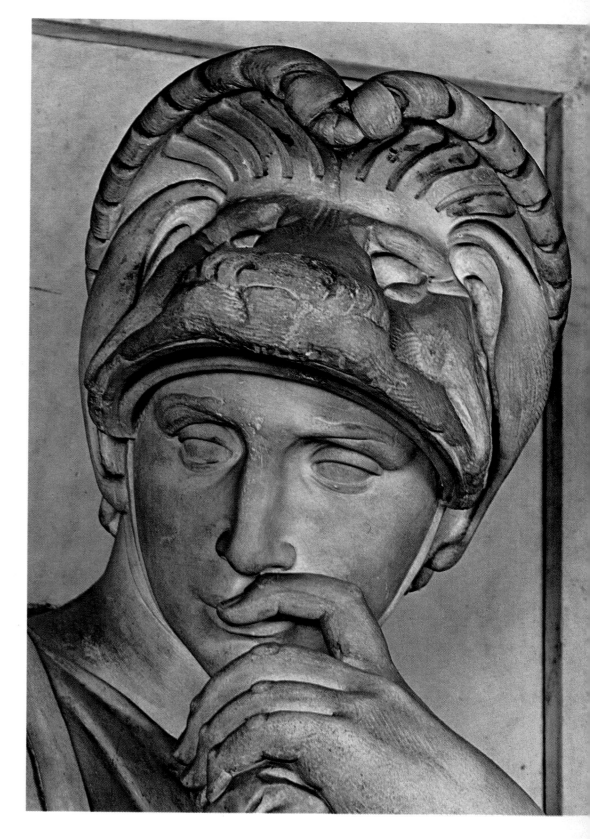

This seems to reflect the Aristotelian idea that the artist's job is to make
actual what is already potential in the material. According to Aristotle, the
form of a statue of Mercury is contained potentially within the marble block.
On the other hand, the Neoplatonists believed that the intellect that guides
the hand in this operation shares in the divine intellect from which is
ultimately derived the image contained in the stone for the artist to reveal.
To these Aristotelian ideas, filtered through the Neoplatonism of Plotinus
and Ficino's version of it, Michelangelo adds a vivid sense of the craftsman's
effort, in his unequal struggle with the hard stone: the expression "in pietra
alpestra e dura" (in hard alpine stone) is more than once rhymed with

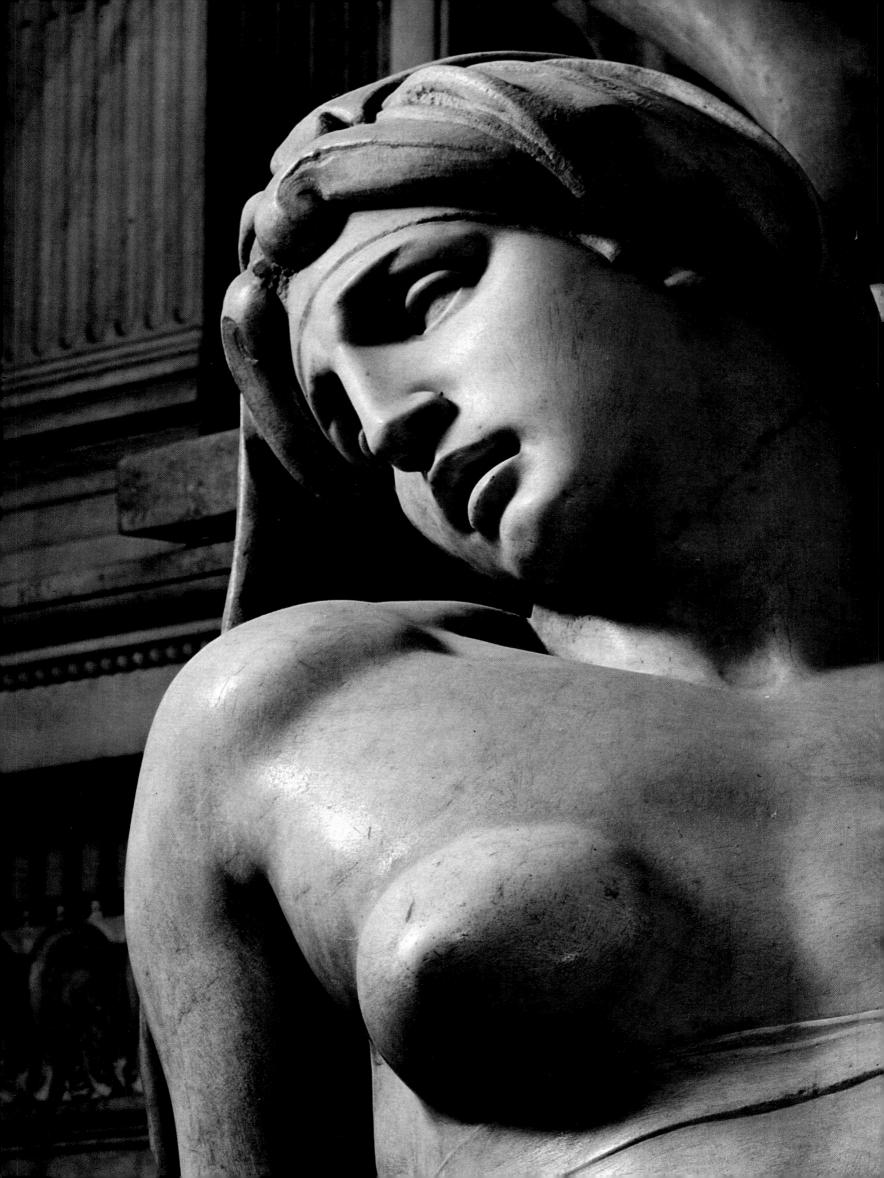

"figura" in his verse, just as "pietra viva" (living stone) rhymes with "l'arte intera e diva" (entire and divine art) and the "martello" (mallet) with what it must reveal "tal concetto bello/che'l suo etterno non è chi'l prescriva" (a concept so beautiful that none can limit its eternity).

As Clements has shown, at times Michelangelo suggests that the marble itself is unwilling to be quarried from the mountain and worked. A block of marble cut down to provide a headstone for a tomb speaks thus:

Dagli alti monti e d'una gran ruina
Ascoso e circumscritto d'un gran sasso
Discesi a discoprirmi in questo basso
Contra mie voglie, in tal lapicidina.
(From the high mountains and a great ruin, hidden and surrounded by a great stone, I came down against my will to be revealed in this low place in such a headstone.)

It is clear that Michelangelo, who has been described as insensitive to nature (certainly he did not have a naturalistic approach in the modern sense or a romantic feeling for landscape), was powerfully aware of its majesty and power in contrast to his own eagerness to reduce it by force to human shape (hence his plan to carve a giant from one of the peaks of the Apuanian mountains). The work of the artist in his effort to free the beautiful image from the marble block is compared, in the famous sonnet to Vittoria Colonna quoted above, to the work of Love that seeks in the beloved "il ben ch'io mi prometto" (the good I promise myself) and rejects "il mal ch'io fuggo" (the evil I flee), because it may happen that

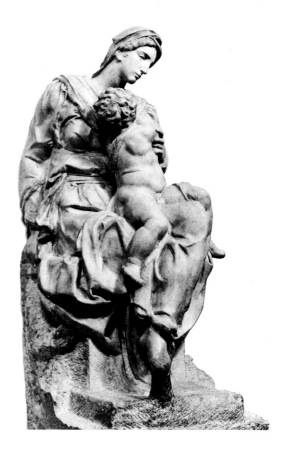

Se dentro del tuo cor morte e pietade
Porti in un tempo, che mio basso ingegno
Non sappia, ardendo, trarne altro che morte.
(If within your heart you bear at one time pity and death, and my lowly understanding aflame can only draw death from it.)

The man guided by love must use his understanding to find what is good in the object of his love, just as the artist's understanding, guided by the intellect that comes from God, must guide his hand to draw out the beautiful image from the marble. This thought is described in a slightly earlier poem for Tommaso de' Cavalieri:

Si come nella penna e nell'inchiostro
E l'alto, il basso ed il mediocre stile
E ne' marmi l'immagin ricca e vile,
Secondo che 'l sa trar l'ingegno nostro.
(Just as in pen and ink, there is high or low or intermediate style, so in marble, there are rich or base images according to how our understanding knows how to draw them out.)

The physical and mental effort that the artist must make in order to draw out the beautiful image is like the effort the soul must make in life to distinguish good and evil, which coexist like the beautiful image and the base image in marble. Art and morality are thus closely linked. The impassioned striving of the artist to achieve beauty, which leaves its imprint both on the marble to be fashioned and the poetic language of sixteenth-century Petrarchism that Michelangelo forced to new heights of expression, is the same as the soul's striving to attain the good.

To appreciate what the four *Captives* express, and in their incomplete state leave unexpressed, these basic principles of Michelangelo's poetic theory and moral belief must be understood. But in considering them as

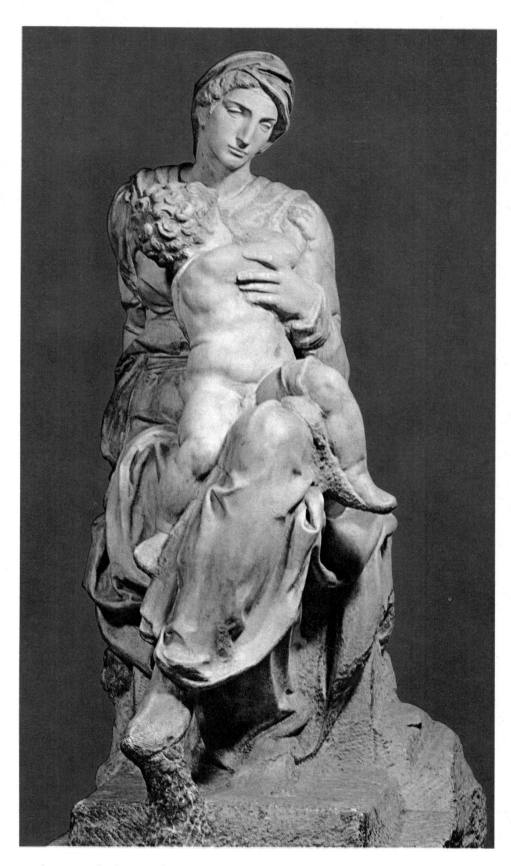

MEDICI MADONNA
Marble
Height, 89 in. (226 cm)
1521–1534
Florence, Sagrestia Nuova, San
Lorenzo
The *Madonna* was left in its present
incomplete state when work on the
chapel ended in 1534. The figure is the
center towards which the two dukes
direct their gaze, as if seeking to be
saved from the outrages of time.
Facing page: Side view

sculptures, it is worth quoting Valerio Mariani: "In some of them in
particular, Michelangelo arrives at formal expressions that seem to share
something of the nature of the original block from which the images take
life: instead of eliminating the rough appearance of the stone block's form,
he makes it part of the artistic experience, in moments of supreme lyric
tension creating the figure at the very heart of the mass that thus becomes
for the artist an integral part of the work: he 'sees' the image to be sculpted
in the mass, because to his imagination the marble is not inert matter but a
living form, rich with three-dimensional possibilities. For this special way of

contemplating the marble block in the light of his imagination, he simply created a few sketches or small, rough clay or wax models before setting to work on the marble; often he drove his chisel straight into the mass, certain that the chance form of the raw material would suggest to him solutions for the image pressing from within. This highly personal approach is thus far removed from a sculptor's rough sketch in which the work remains in an unformulated state but is not 'seen' in terms of a particular block of marble. When an artist carves out of stone a composition for which he has already prepared a complete model as a first draft, he does not 'place' his figure in the marble or see the block as containing the infinite number of ideas that he might convey, but he instead creates in marble a larger version of a model independent of the form of the block itself that has nothing to do with the artist, except as a technical medium from which he draws his work.''

Thus, in the least finished of all, the so-called *Atlas*, the stone giant's gesture is powerfully expressive as he struggles apparently to free his head from the grip of the brute matter that still hides him. But this does not mean that the artist would have ruined the work by going on with it. It is the coherence of style in the finished parts that makes completion seem unnecessary and that guides the imagination in a certain way.

In others, like the *Bearded Giant*, where work is further advanced, the twisting of the limbs in the effort to break the chains conveys in the painful but noble interplay of masses the image's mysterious, expressive power. An expression of grief and mourning, rather than revolt, is seen particularly in the *Young Giant*, whose limbs twist and stretch the opposite way to the figure of the *Bearded Giant*, whom he would have stood opposite on the tomb.

The *Awakening Giant* is in a less complete stage. He was given this traditional name because he appears to be lying down, especially when viewed horizontally, while turning slowly on his stone bed. I prefer to consider this *Captive* as a parallel, a new, more massive and more tragic version of the *Dying Captive* of the Louvre. I see the movements of the arms, which here again are bending to form a diamond at an angle to the head, the stiffly bent right leg, and the slow tension of the body as the *Captive*'s last movements in his long, futile, now-waning struggle to free himself. If this is so, this figure and the so-called *Atlas* correspond as a pair to the *Dying*

NUDES WRESTLING
Red chalk drawing on paper
$9 \times 7\frac{1}{2}$ in. (23×19 cm)
Circa 1524
Paris, Musée du Louvre
Some doubts have been expressed about the authenticity of this drawing, which has been related to the counterpart to the *David* that Michelangelo was asked to produce on two occasions and that was finally commissioned from Baccio Bandinelli. The drawing must refer to Michelangelo's second idea for the group and has been dated about 1524. However, it has also been suggested that the subject may be *Jacob and the Angel*, dating it much later, about the middle of the century.

Captive and the *Heroic Captive* in the Louvre. Some verses that the artist wrote at about this time may well be applied to this *Captive*.

Quand'il servo il signor d'aspra catena
Senz'altra speme in carcer tien legato,
Volge in tal uso el suo misero stato
Che libertà domanderebbe appena.
(When the lord keeps the slave bound by a cruel chain in prison without hope, he becomes so used to his pitiful state that he scarcely demands freedom.)

RIVER GOD
Wood, clay, wool, and oakum
Length, 71 in. (180 cm)
Circa 1524
Florence, Casa Buonarroti
The model should perhaps be related to the Medici Chapel in San Lorenzo, where it was apparently placed with other *River Gods* for a short period, or less probably to the Academy *Captives*. It passed from Cosimo I de' Medici to the artist Ammannati, who gave the statue to the Florence Academy in 1583.

The sculptor and art critic Adolf von Hildebrandt claims that the four *Captives* were rough-hewn by apprentices and that Michelangelo only added a few touches. This hypothesis is supported only by Kriegbaum and very few others, since not only the general conception (which would, in any case, have been based on Michelangelo's models) but the modeling, too, has a sureness and a strength that could only have come from the hand of Michelangelo himself. The work of his pupils is very apparent in the so-called *Fifth Captive* (page 120), which for many years was abandoned in a brick store in a courtyard of the Pitti Palace. Fortunately, Tolnay recognized it as belonging to Julius's tomb, and it is now in the Casa Buonarroti. Because this statue, as Tolnay has shown, is clearly related to figures in the *Last Judgment*, Michelangelo must have conceived and partly executed it later than the other four *Captives*. As part of a new design for the tomb agreed on that year, he must have worked on it during or after 1532. In 1568, Vasari recorded that for the tomb, the sculptor "rough-hewed eight statues in Rome, and in Florence, he rough-hewed five and finished a *Victory.*" Four of these five figures were at an advanced stage in 1519. Since there is no mention of other figures, this fifth unfinished *Captive* and the *Victory* group of the Palazzo Vecchio (page 123) must belong to the 1532 scheme.

Inspired by Hellenistic sculpture in the figure of the vanquished, painfully bowed beneath the hero's knee (the group of *Wrestlers* in the Tribuna of the Uffizi has been mentioned in this context), the *Victory* sounds a Manneristic note in its interpretation of antiquity. The harsh yet elastic torsion of the victor's body introduces an expressive element of sadness in triumph. In fact, the group of Virtue subduing Vice, conceived and carved by Giambologna, was later regarded as a counterpart to this work.

Returning to 1519, the year of the four *Captives*, we now know with certainty (thanks to a memoir kept by the prior of San Lorenzo, Battista Figiovanni) that when Lorenzo, duke of Urbino, died, three years after his brother Giuliano duke of Nemours (both sons of Lorenzo il Magnifico), Cardinal Giulio de' Medici (shortly to become Pope Clement VII) asked Michelangelo, with Figiovanni acting as agent and paymaster, to build the Sagrestia Nuova as a counterpart to Brunelleschi's Sagrestia Vecchia. This would include a burial chapel for the two dukes and for their father and uncle, Lorenzo and Giuliano, who were provisionally buried in the old sacristy. He was also to build the Biblioteca Laurenziana. Although he did not start designing the library until 1524, work immediately began on the chapel.

Michelangelo grew irritable; he was, we know, a difficult and touchy man. Figiovanni wrote: "the master architect, the one and only Michelangelo Simoni, with whom Job could not have been patient for one day." Even Pope Leo, who claimed to love him like a brother, once wrote of him: "It is impossible to deal with Michelangelo; he is so terrible that he even frightens popes."

Figiovanni must have been a scrupulous, fussy administrator involved in continual quarrels with the artist. Michelangelo could not bear all the inspections, and in 1526 Figiovanni's appointment was canceled. In his memoir, he records that Michelangelo "in the end replied [to Pope Clement, who had urged him to keep on good terms with Figiovanni] that he did not want a window over his roof [he did not want to be spied on] and that I wanted to know as much as him; in short, if I did not remove myself, he would leave. I was obliged to leave." This memoir and Parronchi's useful comments on it show that work began in November 1519 with the demolition of several houses built against the church transept. This shows that, contrary to some views, the Sagrestia Nuova was Michelangelo's work from the very foundations (pages 96–97).

It is, therefore, all the more significant, given that the scheme was not already determined by Brunelleschi, that Michelangelo as an architect

HERCULES AND CACUS
Clay
Height, 16½ in. (41 cm)
Florence, Casa Buonarroti
Perhaps a clay model for a statue for Julius II's tomb; more probably, it is related to the planned counterpart to the *David*.

related to his early Renaissance predecessors in the same way that as a painter he had turned to Masaccio and as a sculptor to Donatello. He planned the chapel as an expression in terms of three-dimensional contrasts of the geometric spatial harmonies of Brunelleschi's sacristy. The slender *pietra serena* membering, which Brunelleschi used as the surface expression of a harmonious ideal division of space, here takes the form of wider, more emphatic projections that scarcely leave room for the doors and fictive windows between them. They not only stand out against the wall but form a kind of frame emphasized in the middle by the enclosing arch of the central bay, while at the sides, separated by pilaster strips, the windows repeat and develop the form of the niches below. Above this intermediate story come the lunettes and pendentives that support a dome very different from Brunelleschi's. The coffering, which was undoubtedly inspired by the Pantheon, appears, as Ackerman remarks: "unusually small, and the ingenious pattern of recessions around the oculus helps to accentuate the grid between the coffers, introducing a lively dialogue between circular and radial accents, in which the latter come to appear as structural ribs."

In short, Michelangelo, while following the general lines of Brunelleschi's composition, enlivened the space of the chapel with continuous horizontal and vertical tensions. He transformed the serene, static quality of Brunelleschian space into something dramatic and dynamic. This sense of drama springs from the contrast between the powerful, restless forms striving to expand and the strictly confined space. In architecture, this reproduces the dialectic between the solid marble block and the powerful figure living within and struggling to get out. To achieve this effect, Michelangelo abandoned both fifteenth-century canons and the rules of classical architecture that were set down by Vitruvius and that Italian architects were diligently interpreting in the first decades of the sixteenth century. Giorgio Vasari, with his perceptive critical intuition noticed this and recognized in the architecture of the Sagrestia Nuova a break with tradition that was to lead to Mannerism in architecture. In 1550, Vasari wrote: "In the innovations of such beautiful cornices, capitals and bases, doors, tabernacles and tombs, he acts quite differently as regards proportion, composition, and rules from others who followed Vitruvius and antiquity and did not want to add anything. This freedom much encouraged those who saw what he did to start imitating him, and new fantasies appeared more grotesque than rational or ordered in their ornaments; so artists are infinitely and perpetually obliged to him, because he broke the bonds and chains that made them to follow a single common path."

The outside of the chapel is not as distinctive in style and, with its blind arcades, repeats the facing of the church's Brunelleschian transept. This is probably because building began in March 1520 under other architects or master builders who are not named in contemporary accounts. Michelangelo, furious at "the very great insult" he had suffered when the commission to build the church façade was taken away from him after all the work he had put in, refused the new commission. He accepted it later, in October of the same year, when the general shape of the building was well established. In any case, he was primarily concerned with the tombs and their statues. He probably agreed that for a building placed symmetrically to balance the Sagrestia Vecchia, it was best to keep to the style and forms of his great fifteenth-century predecessor. On the outside, Michelangelo's only important contribution was the lantern. This was inspired by Brunelleschi's lantern for the cathedral dome only in its use of linking volutes between the top of the columns and the "lid" of the aedicula. The expressive effect derives entirely from the contrast between the slender, agile columns and the "lid," which seems to be pressed down as if its weight, passing through the volutes, made the cornices project so emphatically over the tops of the columns.

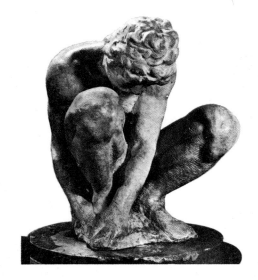

THE CROUCHING BOY
Marble
Height, 22 in. (54 cm)
Circa 1524
Leningrad, Hermitage Museum
Critics do not agree about the authenticity of this work, which has also been attributed to Tribolo and Pierino da Vinci. It has been assigned various dates between 1500 and 1530. It has also been suggested that the statue may have been intended for the tomb of Julius II or of Lorenzo, duke of Urbino. If this is so, it must date from about 1524.

112

As already mentioned, the chapel was meant to contain not only the tombs of Giuliano and Lorenzo but also those of their father, Lorenzo il Magnifico, and their uncle, Giuliano de' Medici. The usual upheavals and changes of plan prevented the implementation of the scheme as a whole; so like all Michelangelo's major sculptural projects, the chapel remained unfinished. The tombs of Lorenzo and Giuliano were never even designed in detail, let alone executed, although in the final scheme they were to have been combined in a single monument. Even the tombs of the two dukes have survived in an incomplete state. The four River Gods, which were to have stood in pairs at the foot of each of the two tombs are missing as are the four statues—two representing Heaven and Earth and two of unspecified subjects—which were to have been placed in the niches now left empty on either side of the two dukes. Also missing and never painted are the frescoes that were to have decorated the lunettes above the three tombs. Above the Magnifici's tomb, there was to have been a fresco of the Resurrection; above Giuliano of Nemours was to be placed the Attack by Serpents; while the scene above Lorenzo of Urbino's tomb might, it has been suggested, have shown either the Healing by the Brazen Serpent or Judith. These suggestions are based solely on hints contained in letters, on some sketches by the artist (pages 114–15); and, for the River Gods, on some models of debatable authenticity (page 110).

The progress and timing of the work and its separate parts pose some problems that cannot be discussed fully here, but in general the timetable can be reconstructed as follows. Up until and including 1523, construction work on the chapel must have been going on while Michelangelo, according to the evidence of an incomplete series of sketches, studied the form and arrangement of the tombs. He hesitated over having freestanding tombs at the center of the chapel or single or double tombs against the walls. In the spring of 1524, he was working on clay models for the dukes' tombs and related figures. By the end of the year, he already had on site marble that he had had quarried and sent from Carrara. He first completed the architectural parts of Duke Lorenzo's tomb, in 1526, but he appears to have worked on more than one statue at a time. A letter of June 17, 1526, relates that the statue of one of the two dukes (which one?) is finished and "within fifteen days, I will begin the other Captain, then of important works, only the four River Gods will remain. The four figures on the sarcophagi, the four figures on the ground that are the River Gods, the two Captains, and Our Lady, who goes on the tomb at the head, are the figures I would like to make with my own hand: and of these, six have been begun."

The expulsion of the Medici in 1527 may have slowed down the work but did not bring it to a complete halt. In 1529, in preparation for the siege, Michelangelo devoted himself to the work of fortification and abandoned the chapel. There followed his famous flight, the siege, and a period when he was forced into hiding, while the victors searched for him in order to arrest and perhaps kill him. Then, through Pope Clement VII's intervention, Michelangelo was able to start work again in April 1531. He made the statue of Duke Lorenzo; completed the Giuliano, except for a few finishing touches entrusted to Montorsoli; and prepared the models for the figures of Heaven and Earth. It was at this time, in 1534, that the artist left Florence for Rome to paint the fresco of the *Last Judgment* in the Sistine Chapel.

Scholars cannot agree on an interpretation of the iconology of this series of statues. Tolnay proposes a Neoplatonist interpretation based on the *Phaedo* and Ficino's commentary on Plato's dialogues. The chapel was dedicated to the Resurrection, which was to have been shown in the fresco planned for the lunette above the Magnifici's tomb. The central theme of the chapel was to be the soul's destiny after death: its resurrection (like Christ's) from the darkness of Hades (as expressed by the four River Gods) to the light of the contemplation of the Idea, which here takes the Christian form of the

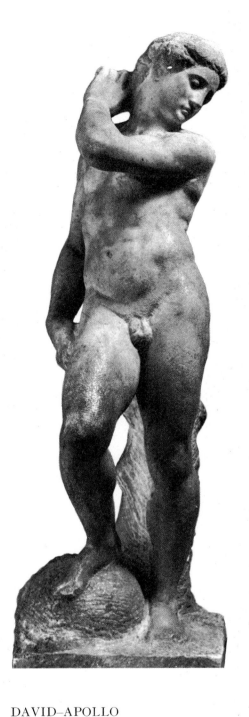

DAVID–APOLLO
Marble
Height, $57\frac{1}{2}$ in. (146 cm)
1525–1526 and 1530–1531
Florence, Museo Nazionale del Bargello
Michelangelo probably made this statue for Baccio Valori in 1530–1531. He turned the figure, which was begun as a *David* in 1525–1526, into an *Apollo*. In the sixteenth century, it was recorded as belonging to the Medici family.

Madonna towards whom the two dukes are turning (they are represented as living figures rather than lying on the sarcophagus, as in traditional iconography).

The figures of *Day* and *Night*, and *Dawn* and *Evening* symbolize this world and human life, subject to the laws of time. The upper level, with the dukes who have risen again to the spiritual and contemplative life and the frescoes (planned but never painted) dealing with Redemption and Resurrection, represents the world of the afterlife. The soul frees itself from the body, which is the prisoner of Hades, and rises to the heavenly sphere through the central opening in the sarcophagus, which is produced by the weight of the two figures representing the passing of time. Tolnay finds support for this interpretation in the way the light falls from the highest point of the building and gradually fades as it gets lower, suggesting the shining brightness of heaven, the half-light of earth, and the darkness of the underworld. He finds further confirmation in the fact that, in keeping with the Platonic theory of the generation of opposites, Michelangelo has placed the figures of time, not chronologically, but in pairs of opposites, *Day* with *Night*, *Dawn* with *Evening*.

This explanation is certainly ingenious, and given the Neoplatonist aspects of Michelangelo's thought and the frequent appearance of Platonist conceits in the *Rime*, it must be counted as a possibility. However, it seems to conflict with an idea about Duke Giuliano's tomb that Michelangelo noted on a page of drawings for the tombs: "*Day* and *Night* speak and say: we with our rapid course have caused Duke Giuliano's death, so it is just that he should revenge himself as he does. His revenge is this, that we having caused his death, he in death has taken light away from us and with his closed eyes has shut ours, which no longer shine upon the earth." Interpreted literally, the sentiment expressed in these lines may seem too courtly to be a true indication of the artist's innermost thoughts. But on further consideration, Michelangelo may have been expressing the idea, in terms intelligible and acceptable to his patron, that time has stopped and day no longer lights the earth since the duke's death. It is not difficult to discern in these lines the universal ideas that time not only passes inexorably and leads to death but also stops with death and that earthly life is identified with the passing of time and the life beyond is associated with motionless eternity. A short poem composed during these years begins "Chiunque nasce a morte arriva/nel fuggire del tempo" (whoever is born arrives at death with the flight of time).

The dramatic contrasts that animate the chapel's architecture are repeated in the figures but in a different key. The figures of the dukes themselves follow the general scheme of composition of the Sistine prophets but on a less commanding, perhaps more hesitant note. The contrasting *contrapposto* masses of the prophets here become richer, yet at the same time more subdued, through a more sensitive and complex articulation of the forms, which are more slender and elongated in their individual parts. In the treatment of surfaces, too, there is a note of ambiguity, for example, in the way the torso is presented. Although the body is shown as covered by a cuirass, its surfaces are represented in carefully observed anatomical detail as if it were naked. There is the same ambiguity in the pose of the two statues. The hands of *Giuliano* (pages 98, 99) are resting on the marshal's baton. He has swung his head around, while lowering one knee and drawing back his left leg as if he were about to stand up. These movements are performed with a relaxed air that gives them little sense of immediacy or readiness, so that the image seems to be caught between the will to action and the doubt that checks and puts off action. With *Lorenzo* (pages 103, 105), the bowed angle of the head, the chin resting on his hand, and the rather unnatural position of the right arm, with the back of the hand lying against the leg, have earned the figure its popular name the "Thinker," but the tension of the figure's outline and the gestures illustrating his relaxed state introduce a sense of potential action.

114

STUDIES FOR GROUPS OF NUDES
Red chalk drawing on paper
9¾ ×13¼ in. (24.5 × 33.5 cm)
Circa 1530
Oxford, Ashmolean Museum
The drawing is believed to be a study for the two frescoes Michelangelo planned to paint in the lunettes above the tombs of the two dukes in the Sagrestia Nuova of San Lorenzo in Florence. The top group on the left shows the nudes attacked by the fiery serpents. Below, those afflicted look towards the brazen serpent and are healed.

One should, therefore, beware of judging the two figures in the usual way—accepting the illustrative side as the substance of the style and confusing the semantic datum with the expressive effect. The sculptor has made a subtle play between illustrative and stylistic values, both of which are equally essential to poetic expression: the relaxed style softens *Giuliano*'s attitude, which is directed, its illustrative aspects suggest, towards action, while the unbroken, taut contours of *Lorenzo* inject a secret will to action into his attitude, which appears to illustrate profound meditation.

The figures, which symbolize the continual passing of time as figurative representations of ideas, also have forerunners in some of the imitation bronze nudes of the Sistine Chapel ceiling, but *Dawn* and *Evening* (pages 103, 106–107), as has been observed, are more like the two figures of the

115

River Gods from the Arch of Septimius Severus. It may be significant that Michelangelo looked for inspiration to the heavily emotional art of late Roman sculpture rather than to the classical art of the first century. But it should be noted that he only regarded his Roman model as a starting point for his composition, and it is difficult to imagine two more original figures, particularly in their relationship to the plane on which they are resting. They are lying on the volutes of the sarcophagus, and in their general composition they repeat its curve in the opposite direction, providing an element of contrast. But this contrast is then diminished by the way one leg lies easily along the volute, underlining its gradual curve and extending it beyond its end. Thus, two contrasting formal principles coexist in the same figure. In this way, the dramatic contrast is translated into a much more self-contained, subtle, complex sense of sadness and unease.

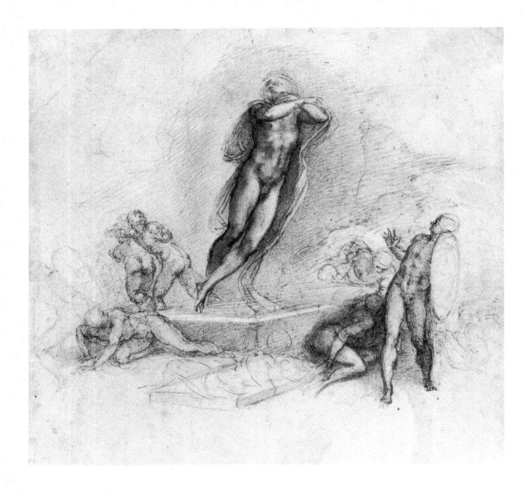

RESURRECTION OF CHRIST
Black chalk drawing on paper
$12\frac{3}{4} \times 11\frac{1}{4}$ in. (32.6 × 28.6 cm)
Circa 1533
London, British Museum
This is one of Michelangelo's most finished drawings on this theme.

STUDY FOR THE RISEN CHRIST
Black pencil drawing on paper
$13 \times 7\frac{3}{4}$ in. (33.1 × 19.8 cm)
1532–1533
Florence, Casa Buonarroti
Berenson and a few other scholars have doubted the authenticity of this drawing, although it is generally accepted as being by Michelangelo. It has been suggested that it is related to the *Last Judgment* in the Sistine Chapel or more often to an earlier phase that includes a series of other studies of the Resurrection.

Although the two powerful athletic figures dominate the small space of the chapel, they in turn seem to be subject to the action of mysterious external forces. Tolnay rightly remarks that "whereas Michelangelo's forms had previously evolved from an interior centrifugal force, which was, however, still contained within them, they have now become vehicles for the force flowing through them." This explains the lengthening of the forms, the way they are organized in slender modules, and their unusual position in relation to their couches. In illustrative terms, they look like people trying unsuccessfully to find a restful position: *Dawn* is turning restlessly as if awaking from heavy, troubled sleep, while *Evening*'s classic reclining pose blends into a more relaxed, abandoned state. This complex and precise formulation of the image is enhanced by the very studied and subtle use of "imperfect *contrapposti*." For example, note how in *Dawn* the right arm, bent to form a right angle, corresponds both to the left leg, which is bent the other way but at the same angle, and to the left arm, which is bent to form an

Right: STUDY FOR THE RISEN
CHRIST
Black chalk drawing on paper
16¼ × 10¾ in. (41.4 × 27.4 cm)
Circa 1536
London, British Museum
It has been pointed out that Christ's
attitude is almost identical (although
shown in the reverse) to that of the
Christ of the *Last Judgment* in the
Sistine Chapel. In his left hand, he is
holding a standard, which is lightly
sketched in. The *verso* shows an animal,
a study for a torso, and a nude figure
holding a plate.

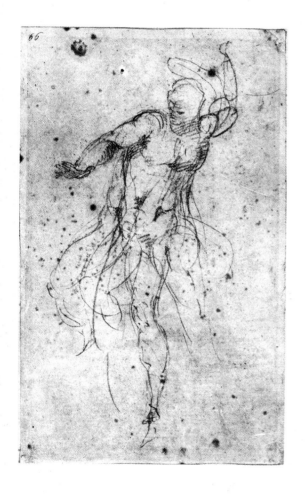

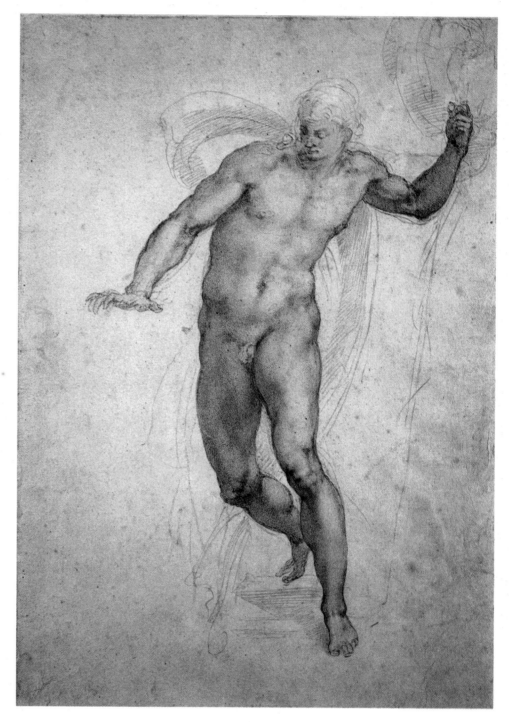

acute angle, which also finds an inverse but more relaxed correspondence in
the right leg gently resting against the volute. In *Evening*, the cross patterns
of the *contrapposti* are more distinct in the clear correspondence between left
arm and right leg, although there are other subtle, imperfect cor-
respondences that create a network of relations between the two arms and
the two legs. The same could be said of the balanced but imperfect symmetry
of the two figures in relation to one another. The complex relations in terms
of composition are matched by the subtle working of the surfaces of the
nude, with a lighter, more pliable anatomy than usual.

Anatomy and the treatment of the nude's modeled planes become firmer
and closer to accepted canons in the figures of *Day* and *Night* (pages 99,
100–101). Here, too, there is a perfect harmony between illustrative and
stylistic motifs. *Night*'s deeply bowed head indicates heavy sleep; but the
figure as a whole, defined by the sharp outlines of the face and the bent leg
and by the squared planes of bust and body, is stylistically enclosed in a

117

separate, cutoff world. The voluptuous pose of Leda, taken from the decoration on an ancient sarcophagus, expresses something quite different. The close, complex use of *contrapposto* is again a prime factor in determining the image's mysterious, hermetic quality. *Day* balances *Night*'s symmetry; the composition, with the heavy anatomy of the nude, contains contrasting elements and a potentially explosive force within the compact scheme.

The grandiose project was never completed, and even the statues lack the finishing touches. However, as Condivi realized, "They have reached a stage where the excellence of the artist may very well be seen; their unfinished state does not spoil the perfection and beauty of the work." The biographer who wrote if not at Michelangelo's dictation, then certainly under his inspiration, here soberly poses the problem of the *nonfinito*, about which so much has since been written. I think he suggests the right answer: the sculptor would certainly have liked to complete his work but consoled himself with the positive impression it would make even in an unfinished state. It seems likely that Michelangelo intended, or at any rate accepted willingly the *nonfinito* of *Day*'s head. The contrast between the rough surfaces of the head and the very smooth, rounded, light-catching texture of the shoulders, creates a feeling of unbounded space. The old man's face seems to emerge from some dark, distant abyss. It is a concrete poetic image, expressing a sense of incalculable ages past, rather than a mere symbol.

The *Madonna* (pages 108, 109) rises almost ghostlike against the wall facing the altar. Judging from the rough base, it was carved from a tall narrow block, which the sculptor had deliberately cut down to the desired dimensions. The shape of the original block became the conditioning factor of the figure's vertical form. The only contrast is successfully provided by the long oblique line of the left leg, which crosses over the other leg and merges into the mass, and by the parallel angle of the head and neck. The compression of the modeled planes, emphasized by the way the Child's body clings so closely to his mother, is matched by the almost transparent clothes that cling to the Virgin's body. The image thus seems sorrowful and inward-looking. The bold torsion of the Child's body implies not a baby's eager movement to suckle at his mother's breast but a sudden burst of convulsive, irrational, childish fear. This profoundly and dramatically sorrowful image is the culmination of the deeply melancholic, elegiac vision of human destiny that emerges with symphonic fullness from the insistent rhythms of the architecture and the restless forms of the figures in the sealed space of the chapel.

In 1527, while the artist was working on the Sagrestia Nuova and the Medici tombs, the barbaric sack of Rome took place. The Medici were again expelled from Florence, and the republic was restored. Michelangelo did not abandon his work, which had far greater significance for him than a glorification of Florence's rulers, but he did place himself at the new government's disposal. In the autumn of 1528, he offered his services, free of charge, as military architect and fortifications expert. For the city gates, he designed new bastions, which are richly curved in form. Many of the drawings of these bastions are now in the Casa Buonarroti. Gonfalonier Niccolò Capponi of the conservative party, which was initially in control, did not, however, implement Michelangelo's schemes, either because of the expense or because he was planning a compromise with the Medici faction.

Michelangelo had more success with the next government, led by Gonfalonier Francesco Carducci of the popular party, a political group totally opposed to any agreement with the Medici and determined to defend the republic to the end. During 1529, Michelangelo was appointed a member of the Nove della Milizia and then president of the Dieci della Guerra as well as governor and procurator general of fortifications. He was also sent on a mission to Ferrara during the summer to study the famous fortifications there. On this visit, at the request of the duke, he prepared the cartoon of the

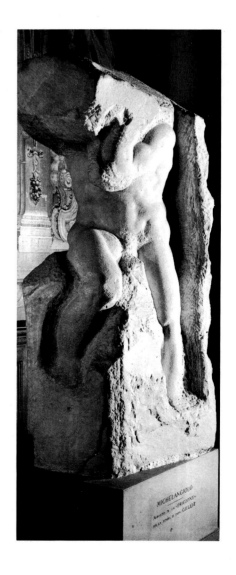

CAPTIVE: THE SO-CALLED
ATLAS
Marble
Height, 109 in. (277 cm)
Circa 1519–1520
Florence, Galleria dell'Accademia
Michelangelo's four unfinished *Captives*, or *Slaves* are probably the four statues that the artist promised to Cardinal Aginense (executor of Julius II's will), who had asked him to continue work on the pope's tomb.
Left: Front view

Leda, which he later painted and gave to his pupil Antonio Mini; it disappeared and is now known only from a series of painted and engraved copies.

In September 1529, Michelangelo heard rumors about the treacherous nature of Malatesta Baglioni, the commander in charge of the city. (Baglioni

THE BEARDED GIANT
Marble
Height, 104 in. (263 cm)
Circa 1519–1520
Florence, Galleria dell'Accademia
The four *Captives* remained in Michelangelo's workshop in Florence for some time and were then given by his nephew Lionardo to Cosimo de' Medici, who placed them among artificial stalactites in a grotto in the Boboli Gardens. They remained there until 1908, when they were moved indoors to the Accademia.

THE FIFTH CAPTIVE
Marble
Height including base, 92 in. (234 cm)
Circa 1532
Florence, Casa Buonarroti
Largely the work of pupils, this is one of the *Captives* intended for Pope Julius II's tomb. For a long time, the unfinished work was abandoned in a courtyard of the Pitti Palace before being moved to the museum of Casa Buonarroti.

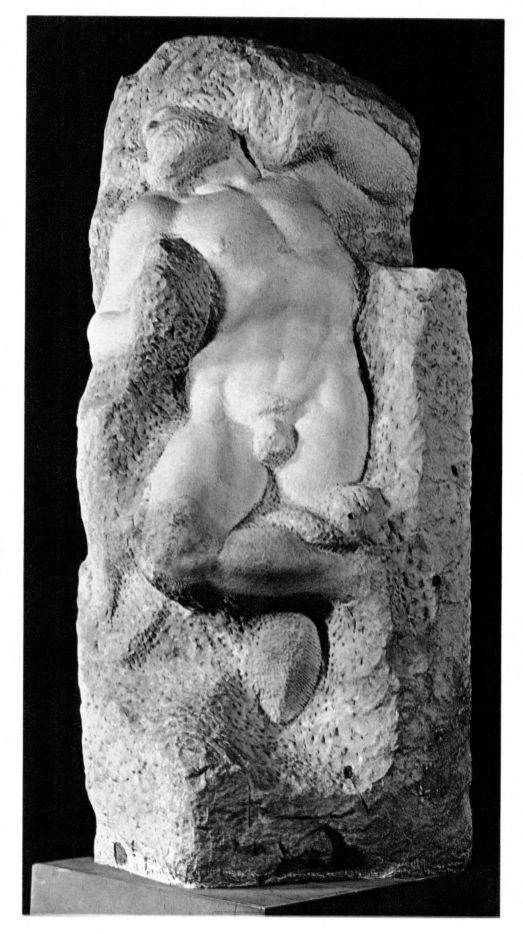

Right:
THE AWAKENING GIANT
Marble
Height, 105 in. (267 cm)
Circa 1519–1520
Florence, Galleria dell'Accademia
Critics have pointed out that these unfinished statues, more than the completed works, show the meaning of Michelangelo's conception of sculpture as what is made "by the effort of cutting away" until the image contained potentially in the marble is drawn out.

THE YOUNG GIANT
Marble
Height, 101 in. (256 cm)
Circa 1519–1520
Florence, Galleria dell'Accademia
The unfinished state of these four statues has been much discussed but no agreement has been reached concerning whether or not they were deliberately left unfinished.

would betray the city only a few months later.) Therefore, Michelangelo, as Condivi relates, "partly because of his own observations, partly on the advice of certain officers who were his friends, went to the signoria and told them what he had heard and seen. . . . But instead of thanking him, they abused him and reproved him for being so timid and suspicious." His furious

121

reaction can easily be imagined. Michelangelo continues the account in a letter to Battista della Palla. The passage, as Walter Binni has pointed out, has a highly poetic effect: "Tuesday morning, the twenty-first day of September, a man came out of the gate at San Niccolò where I was at the bastions and whispered in my ear that, if I wanted to save my life, I should not stay there any longer: he came with me to my house, dined there, brought me horses, and did not leave me ever until he had got me out of Florence, telling me what was for my good. God, or the devil, I do not know who he was." This was Michelangelo's most famous, and indeed ill-famed, flight, although it is too simplistic to explain it as mere cowardice; it was more an example of his sacred dread of the supernatural, which had been nourished in his youth by Fra Gerolamo Savonarola's sermons.

Michelangelo went to Venice and considered emigrating to France. Meanwhile, the government of the republic, which had declared him a rebel, had, since October 10, been besieged by the Milanese forces and implored him to return, promising him amnesty. The artist obeyed and then worked energetically to strengthen the city's defenses. When the surrender came, he hid, not in the bell tower of San Niccolò as legend has it, but "in the house of a great friend of his," according to Condivi. Parronchi has now identified this friend as the same Figiovanni, procurator of San Lorenzo, with whom Michelangelo had quarreled so fiercely years before. Meanwhile, again according to Condivi, "Many citizens were taken and killed, and officers were sent to Michelangelo's house to arrest him; and all the rooms and chests were opened and even the chimney and the closet." Then Pope Clement ordered that "if he [Michelangelo] wanted to continue the work of the tombs he had already begun, he should be set free and treated with courtesy." Michelangelo went back to work, but he would have nothing to do with the new tyrant, Duke Alessandro, "a young man, as everyone knows, fierce and vengeful," and refused to build for him the Fortezza da Basso to keep the Florentine people under control.

During the last two years of his stay in Florence, Michelangelo went back to work on the tombs and also completed the figure of the Virgin. At the request of Pope Clement's representative Baccio Valori, he altered a statue of *David*, which he had begun in about 1525, into an *Apollo*. He finalized the plans for the Biblioteca Laurenziana, which he had been working on since 1523–24 and started building. The *David-Apollo* (page 113), now in the Bargello, has neither the youthful assurance of Goliath's conqueror nor the radiant serenity of the sun god. It is a tormented image, the *contrapposto* of its composition contained within the strained torsion of the whole body. The energy that flows through the figure seems to be turned in on itself, finding no outlet and weighing the image down with a sense of sorrowful meditation.

The Biblioteca Laurenziana (pages 149–151) is one of Michelangelo's finest and most original architectural masterpieces, although he was only in charge of the building works during the early stages. After 1550, important features, such as the stairway in the vestibule, were completed strictly in accordance with his plans and specifications by Vasari and particularly Ammanati. The upper sections, also completed according to Michelangelo's ideas, were not completed until the end of the nineteenth century. Even more than the Sagrestia Nuova, the library vestibule, which is very high and is lit from its highest point, introduces an architectural concept that goes beyond the human scale confirmed by Brunelleschi and always respected by fifteenth-century architects, especially those in Florence. Space, freed of any precise proportional relationship with man, can become the field of action for superhuman forces. The dramatically contrasted forces embodied in the dominant motif of the huge pairs of recessed wall columns, which widen towards the bottom, seem to discharge all their suppressed energy into the volutes below the cornice at their base. Between each pair of columns, interest is provided by the projection and recession of two orders of fictive

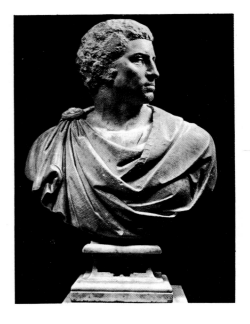

BRUTUS
Marble
Height, 29½ in. (74 cm)
Circa 1538
Florence, Museo Nazionale del Bargello
This statue, one of Michelangelo's masterpieces, as a sculptor, seems to contain clear references to Roman statuary, particularly busts of Caracalla. Michelangelo finished this work for Cardinal Ridolfi (a republican driven into exile) sometime before 1545. It seems to reveal a heightened political awareness.

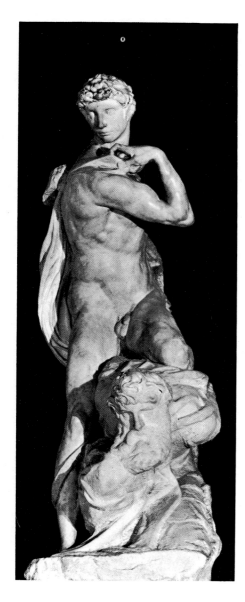

THE VICTORY
Marble
Height, 103 in. (261 cm)
Circa 1532
Florence, Palazzo Vecchio
This is one of the most difficult of
Michelangelo's works to place chro-
nologically. It is usually believed to
have been intended for Julius II's
mausoleum and has been related to five
different projects for the tomb that
dated from 1505 to 1532. However, if,
as has been suggested, the main figure
really is Tommaso dei Cavalieri, the
group must date from after 1532, when
Michelangelo met the young man.
Among the many interpretations pro-
posed is that of Tolnay, who suggests
that the group symbolizes the victory
of youth over old age.

windows—upright and rectangular in the lower order, square in the upper—
flanked by pilaster strips and crowned by triangular or rounded pediments
that project sharply in profile.

The doorway to the reading room is crowned by a broken pediment at a
certain height above it. On either side of the doorway, there is a pair of
recessed columns, pressing so closely against it that the ends of the
tympanum seem almost to be pushed out.

The stairway, which runs down from the doorway to the center of the
vestibule, has steps curving outwards, as if they were pushed out by some
internal force that made the stone give way. After a first short flight, the
stairway expands dynamically into two side wings on either side of the
central flight, creating a burst of movement emphasized by the elastic
volutes at the top of the two wings. The controlled energy with which walls
and space are charged seems finally to explode in the stairway.

The reading room is sometimes said to be a deliberate contrast to the
vestibule, expressing in its tranquil forms a peaceful atmosphere suited to
study and meditation. In fact, its space is just as dramatic, with the same
tensions, except that the forces that in the vestibule were compressed are
here freely expressed in the rapid, insistent rhythm of the pilaster strips,
which contain the two orders of windows. The insistent and urgent rhythm
that is created is apparent in a more sober version on the outside of the
building.

Before we come to the magnificent, awe-inspiring fresco of the *Last
Judgment*, painted on the end wall of the Sistine Chapel, we must examine
briefly the importance of Michelangelo's experiments during his untiring
work in sculpture and architecture between the time when he completed the
Sistine Chapel ceiling and his return to painting with the *Last Judgment*. The
note of dark, resigned sadness characteristic of his last ceiling paintings,
those portraying the ancestors of Christ, is developed in the Louvre and
Accademia *Captives* for Pope Julius's tomb. Despite the atmosphere of
Apollonian beauty, the *Captives* express a sense of torment abating into
weariness and languor or into a sad, resigned, introspective meditation.
However, in the Medici tombs, which caused Michelangelo so much trouble
and which he was working on until the time came to plan the *Last Judgment*,
the theme of time stopping in the presence of death becomes, as we have
seen, a dramatic, universal elegy, a deeply painful, melancholy vision of life,
which develops the basic theme of the ancestors of Christ and gives it a new
cosmic inspiration.

Between the dark, hopeless, existential melancholy of the ancestors of
Christ at the bottom of the vault, the Sagrestia Nuova and the Medici tombs,
and the dramatic architecture of the Biblioteca Laurenziana, there is a
gradual return to beauty and vital tension, although always against a
background of sad, silent meditation and accompanied by a constant
inclination towards visions on a cosmic scale. The *Last Judgment* is,
therefore, not an unforeseen explosion but the culmination of a long, gradual
process of spiritual development. This great burst of imaginative activity
was certainly sparked by Michelangelo's unsettling and painful public and
private experiences during those years. The main events have already been
mentioned, but then, too, there were his fears, as expressed in his letters, for
the life of members of his family during the plague of 1527; the death the
next year of his beloved brother Buonarroto, a hard-working honest man on
whom Michelangelo had depended in his efforts to revive the fortunes of his
unlucky family; and the death in 1534 of his honest, yet mediocre, father,
whom he had unfailingly treated with affection and respect. Michelangelo
wrote the following about his father's death.

Nel tuo morire el mio morir imparo
padre mio caro, e nel pensier ti veggio

dove'l mondo passar ne fa di raro.
(In your dying, I learn of my death, dear father, and in my mind, I see you where the world rarely reaches.)

Regarding the misfortunes of Florence and the failure of the ethical and political ideal of an austere republic, Michelangelo, remembering Savonarola's stern prophecies, felt that these reversals of fortune were inescapable divine punishments: "One must have patience and trust in God and right one's errors, as these adversities are sent for this reason only, especially because of pride and ingratitude; I have never known a more ungrateful or prouder people than the Florentines. Therefore, if justice comes, it is with reason." In the upheavals and uncertainties of the time, the artist saw the signs of divine rage, and in an increasingly sinful world, he could see no other remedy than to call for Grace:

Spoglia di me me stesso e col tuo scudo
colla pieta e tue vere e dolci arme
difendimi di me ...
Mentre ch'al corpo l'alma non è tolta
Signor che l'universo può far nulla
Fattor, Governator, Re d'ogni cosa
poco ti fie avere dentro a me loco.
(Defend me, the remains of myself, from myself, with your shield, your pity and your true, gentle weapons. ... While the soul is still in the body, Lord, the world can do nothing: Maker, Ruler, King of All, it would be little to you to find a place in me.)

These thoughts and feelings are part of the spiritual preparation for the tremendous sense of implacable fate that is created by the *Last Judgment* (pages 125–36).

The first commission for the *Last Judgment* dated from autumn 1533, while Michelangelo was still trying to complete the Medici tombs in Florence. A *ricordo* of the artist describes a meeting with Pope Clement at San Miniato al Tedesco on September 22. By October, Michelangelo was in Rome, and he began preparing the first sketches for his great composition as well as starting work again on his favorite scheme, Julius II's tomb. As Condivi explains: "Michelangelo, who knew the obligation he was under with the duke of Urbino, did his utmost to escape this commission [the fresco of the *Last Judgment*]; but as he could not rid himself of it, he delayed it; pretending to apply himself to the cartoon, as he partly did, he secretly worked on the statues for the tomb." However, in February of the following year, scaffolding was already erected in the chapel so that the wall could be prepared.

For the last time in his life, Michelangelo visited Florence and spent three months there working on the Biblioteca Laurenziana. He had only just returned to Rome in September when Clement VII died. His successor, the Farnese pope, Paul III, confirmed the commission, and a brief of November 1536 stipulated that the work should follow the cartoons already prepared at Pope Clement's request. The first conception of the work thus developed between 1534 and 1536. From the end of 1536 until 1541, Michelangelo worked on the immense wall from his scaffolding without much interruption.

A short account of Michelangelo's circle of acquaintances in Rome is appropriate here, not only to complete the biographical details of his life but to understand more fully his state of mind during the years when he was planning and painting his tremendous work. As a native of Florence, he always felt in exile when away from home, like his great predecessor Dante, although like him he was always ready to attack the Florentines for their

THE LAST JUDGMENT
Wall fresco
45 × 40 ft. (13.7 × 12.2 m)
1536–1541
Vatican City, Vatican Palace, Sistine Chapel
As early as 1534, Clement VII asked Michelangelo to complete the decoration of the Sistine Chapel. Again in 1534 Clement's successor, Paul III, commissioned the *Last Judgment* for the altar wall and another fresco (which was never executed) for the entrance wall. Between 1534 and 1535, on Michelangelo's orders and instructions, two windows in the altar wall were blocked up and the wall was made to overhang slightly, sacrificing Perugino's frescoes and Michelangelo's own frescoes in the two lunettes that he had painted at the same time as the ceiling. Once the scaffolding was erected, work began in the middle of 1536 and was completed in October 1541, when the wall was unveiled before the pope, who was impressed and terrified by the vision.

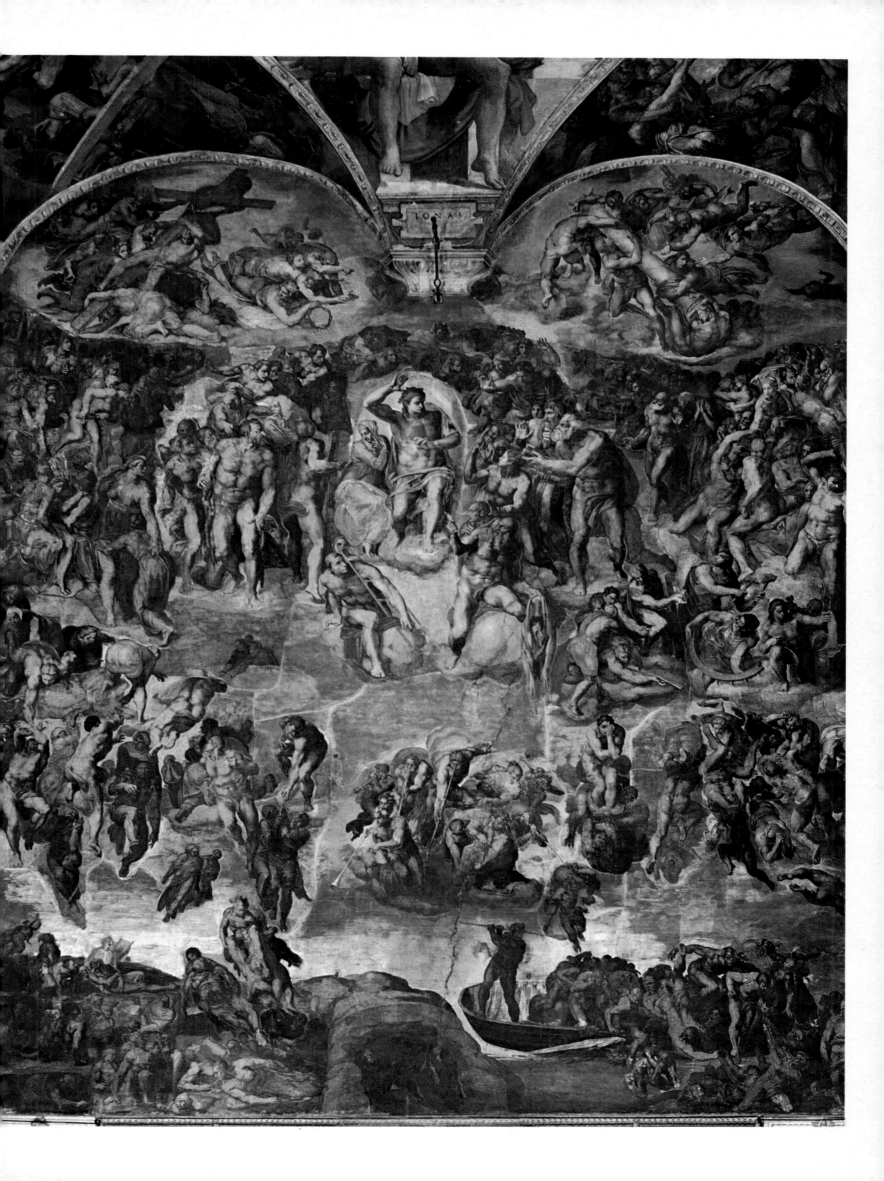

vices. He mainly frequented the circle of Florentine exiles, such as Donato Giannotti, Cardinal Ridolfi, Roberto Strozzi, and Luigi del Riccio. Shortly after Alessandro de' Medici's assassination at the hand of Lorenzino, the bust of *Brutus* (pages 6, 122), now in the Bargello, was carved for Ridolfi at the request of Giannotti, and it was certainly meant to honor the tyrannicide. This at least is what emerges from the importance attached to the moral problem of tyrannicide in Giannotti's *Dialogues* and from Michelangelo's alleged remarks about Brutus and Cassius that they should be absolved from sin as he who kills a tyrant kills not a man but a wild beast.

Clearly inspired by the portraiture of imperial Rome, the *Brutus* is a powerful image: in the tension that is contained by the stern profile of the head composed as an acute-angle triangle with the vertex at the bottom; in the simple, yet disdainful, modeled features; and in the pools of shadow under the eyebrows, which seem to suggest a growing doubt in contrast to the fierce expression of the eyes. The *nonfinito* is a positive element of the expression, and its pictorial touch gives the image something in common with certain figures in the *Last Judgment*.

Michelangelo's Platonic Love for Cecchino Bracci, who died in 1544 at a young age, and for Tommaso de' Cavalieri dates from this period and in both cases is documented in a number of drawings and poems from the *Rime*. Further evidence of the mystical tendencies that were becoming more firmly established in Michelangelo's character is found in the *Rime*, which shows that his passion for the beautiful, noble young Roman both exalts the ennobling power of Platonic Love and also sparks a mystic impulse perhaps reminiscent of Saint Paul, who saw married love as "two bodies in one skin" ("Se un'anima in duo corpi e fatta etterna" [if one soul in two bodies is made eternal]). The poet wishes to die like the serpent and the silkworm:

Così volesse al mio signor mio fato
Vestir sua viva di mia morta spoglia
Che, come serpe al sasso si discoglia
pur per morte potra cangiar suo stato.
(Thus, I should like my fate to clothe my lord's living body with my dead remains, as a serpent loses its skin against a rock and can through death change its state.)

Vil bruco che con pena e con doglia
l'altrui man veste e la sua scorza spoglia
e sol per morte si puo dir ben nato.
(The lowly silkworm, which, with pain and suffering, clothes the hand of others and loses its skin, and only in death can it be said to be fully born.)

The similes of the serpent and the silkworm suggest a desire for dissolution and death tinged with sarcastic humor, which seems a prelude to the extremely bitter self-portrait that the artist included in Saint Bartholomew's empty skin in the *Last Judgment*.

The first drawings for the composition as a whole (unfortunately, the artist's habit of destroying his own drawings means that we do not have enough material to reconstruct the progress of the definitive version) show that the artist initially tried to retain the status quo of the wall and leave in existence both his own two lunettes and Perugino's fresco as an imitation altarpiece above the altar. In the end, he swept away all constraints and even destroyed his own work because of the new concept of space that he had developed. This concept of space bore no relation to fifteenth-century perspective; it was an image of space as the opposite of volume, as some indeterminate and immense thing that could not possibly have been fitted into the "Albertian window." The mere presence of a frame around the enormous wall would have required a synthesizing view at a fixed distance

THE LAST JUDGMENT: Detail with Christ and the Virgin
Christ the Judge is at the center of the composition near the top. The whole fresco can be schematically divided into four horizontal bands: at the top, in the lunettes, are the angels bearing the symbols of the Passion—the cross on the left and the pillar on the right; immediately below, on either side of Christ and the Madonna, are the apostles and the patriarchs and then the saints, the martyrs, the virgins, and the confessors; lower down are the souls who have been judged, the blessed rising to heaven on the left, and the damned falling down into hell on the right, while in the center the angels sound their trumpets to awaken from death those who have not yet been judged; finally, at the bottom, on the right, Charon ferries the damned to hell, while the left side shows the Resurrection of the dead.

Pages 128–129: THE LAST JUDGMENT: Detail with figures of the blessed
In the more than four centuries of its existence, Michelangelo's fresco has suffered various outrages. The most serious damage was done when a broad strip along the lower edge of the painting was destroyed in order to raise the floor level of the chapel. In the detail illustrated, the face immediately above the figure's hand has sometimes been identified as a portrait of Dante Alighieri.

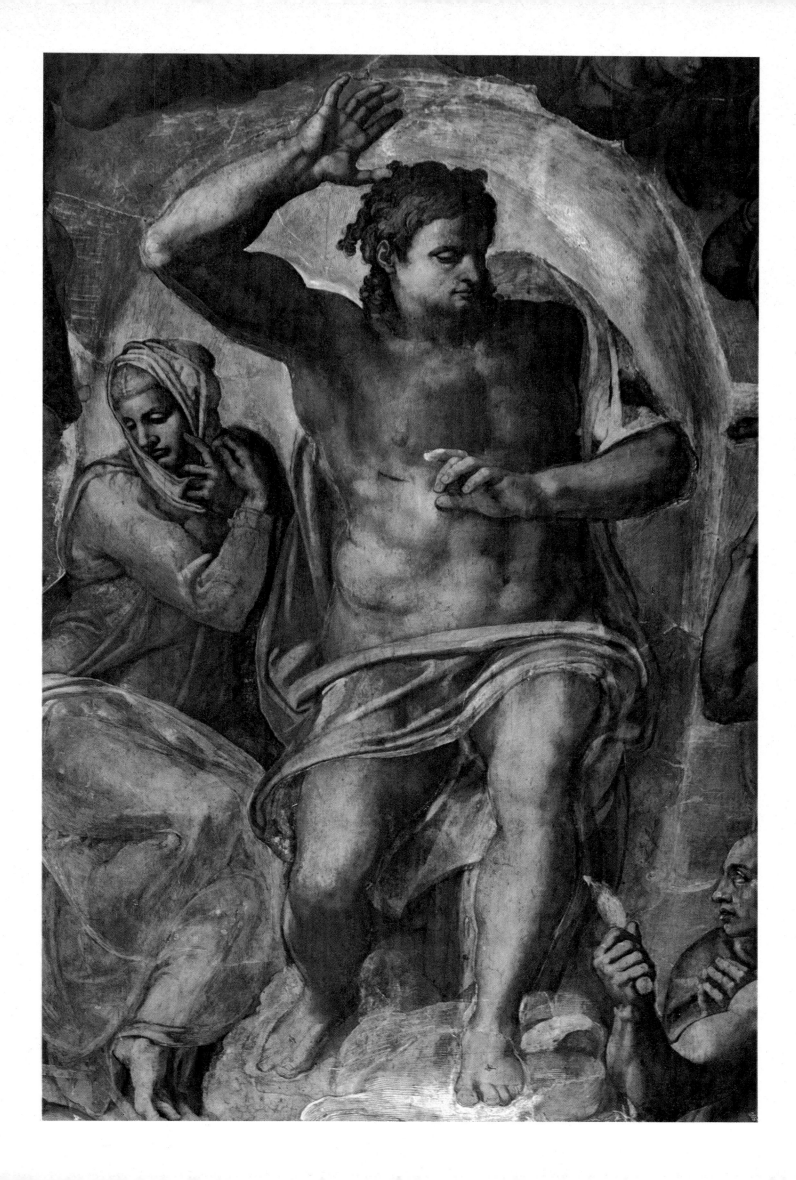

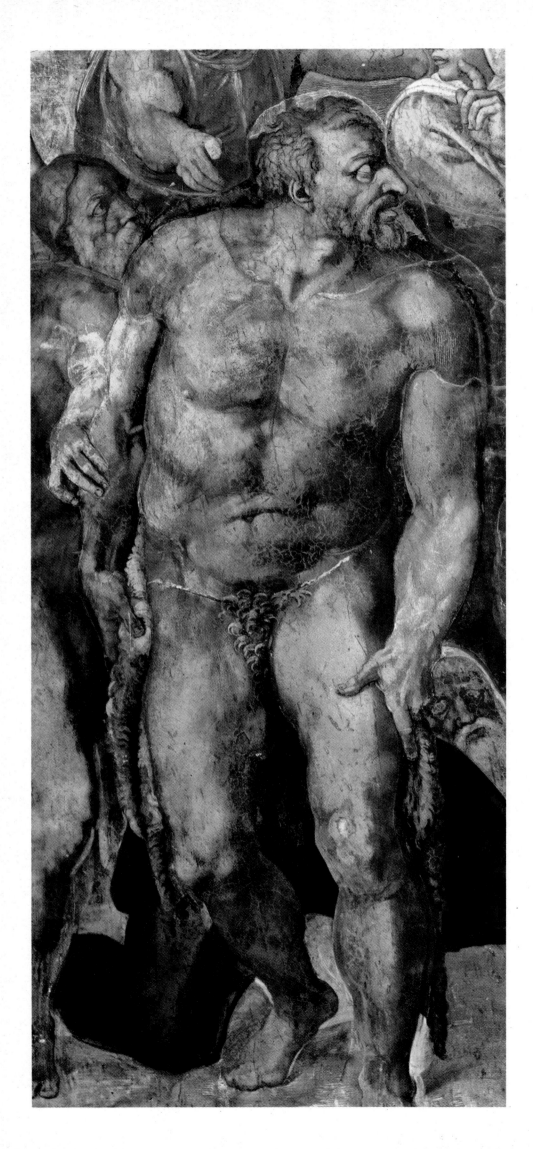

THE LAST JUDGMENT: Detail with Adam (or Saint John the Baptist)
The partial or total nudity of many of Michelangelo's figures was strongly criticized from the years immediately following the unveiling of the fresco. On several occasions, particularly after the Council of Trent had condemned unseemly images in churches, there were moralizing attempts to make Michelangelo's nudes more decorous by clothing them. Even a talented painter like Daniele da Volterra was employed in this task and earned himself the nickname "Breeches maker."

with a fixed viewpoint. But this would have created an illusionistic effect, as if the space represented, however large, was of necessity limited and a continuation of the chapel, which although sacred, was still earthbound space. There would have been no sense of movement bursting out of the void, the creation of a vast disturbed space that was obviously what the artist intended. Only by rejecting any relationship of size with the figures and flooding the entire vast wall with a sense of open and boundless space could the superhuman scale and transcendental nature of the terrible event be clearly expressed. The figures, grouped in separate, three-dimensional formations, float isolated and desperately alone in the awe-inspiring, infinite void. The streams of figures from the heavenly court pressing around Christ, the fall of the damned on the onlooker's right, and the ascent of the blessed on the left unfold in a cosmic cataclysm against the background of an abyss of space suggested by the bold, complex foreshortening of the figures. The controlled, terrible gesture of Christ the Judge seems to unleash a cosmic force that throws the universe into turmoil.

Despite the imperfect state of preservation and the clumsily painted additions, which were demanded by the narrow-minded moralists of the Counter-Reformation and which have not all been removed by recent restoration work, the hundreds of figures have lost none of their impact. Scholars have sometimes regarded them as isolated images and groups, in which Michelangelo gave free rein to his already baroque imagination in his search for the widest possible range of foreshortening, or as three-dimensional groupings of masses with no spatial relationships in keeping with the already Manneristic inclination that resulted from his work as a sculptor. In fact, in Michelangelo's unifying vision, the isolation of three-dimensional forms has a conscious and dialectical relation to the concept of unlimited space. The magnificent synthesis of the *Last Judgment* can be understood only if due regard is paid to the antithesis of space as well as to the thesis of three-dimensional form.

As with the ceiling frescoes, the question is whether or not Michelangelo meant to attach a mystical significance to the composition's literal meaning. Tolnay believes that the work has an allegorical meaning—the spiritual life under the reign of the Sun of Justice. Taking as his starting point the Apollo-like appearance of Christ the Judge, Tolnay sees the image as a symbol of the sun. (In antiquity, Apollo was identified with the sun, and in Christianity Christ was identified with the sun; the *sol invictus* of the ancients became the *sol justitiae*.) Around Him "revolve the constellations of souls both magically attracted and repelled in the infinite space of the universe." The whirling composition of the *Last Judgment* is ultimately a heliocentric vision of the universe "which strangely anticipates that of his contemporary Copernicus," just as "in his conception of limitless space, he anticipates the infinite universe of Giordano Bruno." Thus, man as "son of the earth and fashioned out of mud obeys new forces after death. A new age begins for him: freed from matter and weight, he comes under the sun's domination. It is the end of Tellus's reign and the start of Uranus's, the pure and direct revelation of cosmic fatality" (Tolnay).

This ingenious suggestion is based on many references to Pythagorean myths and other ancient astral myths and, for this reason, is less than convincing. Accepting it would mean assuming that Michelangelo had a great many, well-thought-out mythological and philosophical notions, but there are no signs of these in his writings, not even in the *Rime*, which is so interwoven with Neoplatonist themes. Moreover, while we have seen that Neoplatonist interpretations of the scenes depicted on the ceiling contribute to a better understanding of the work's tone so long as they are kept in proportion and related to a single, general idea, the fundamental idea implicit in this cosmological interpretation seems to conflict rather than harmonize with what the fresco expresses. If the composition was really

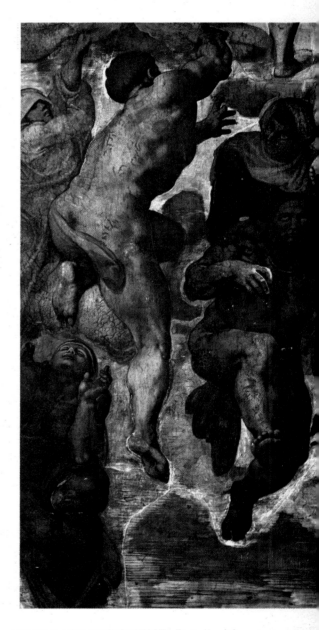

THE LAST JUDGMENT: Detail with the Blessed rising to heaven
Page 133: Detail of a damned soul

meant to represent the life of souls under the reign of the Sun of Justice, the figures rotating around Christ's Apollo-like gesture should move at a regular, serene pace, not in this frightening whirl, which recalls Dante's "bufera infernal che mai non resta" (infernal storm that never ceases) rather than any ordered movement of stars. It is difficult to interpret the dark, desperate atmosphere of the *Last Judgment* in terms of any solar myth.

From the Bayonne study of the upper section and especially from the study of the whole composition now in Casa Buonarroti, it is moreover clear that Michelangelo conceived the vision of this supreme event of human history as the unleashing of an irresistible and tremendous force that set the universe in a circular motion that cannot be stopped. This force is not a calm, regular phenomenon of universal gravitation but the uncontrolled fury of a cosmic catastrophe. This study still reflects the original plan to paint the *Last Judgment* without affecting the status quo of the chapel decoration, that is, preserving the two lunettes and the imitation altarpiece.

Apart from this, the main difference between the final version as it appeared in the completed work and the earlier drawing is that in the drawing the motif of ascent is stronger than the motif of descent. The fall of the wicked is still conceived as a struggle between angels and the damned and is similar to the fall of the rebel angels that in an early scheme, not implemented by the pope, Michelangelo was to have painted at the other end of the chapel. On the other hand, in the fresco, the theme of struggle, while not completely disappearing, is lost in the headlong downward fall of the souls into hell.

The main difference between the drawing and the fresco is one of degree. In the final composition, we find more clearly defined, developed, and multiplied the main ideas that had remained at an earlier stage in the Florence sketch while the ideas fermented in the artist's imagination. From the idea of the ogival arch pointing towards Christ, there then developed the idea of an elliptical movement of saints and patriarchs around the Judge and of a second outer, elongated ellipse, consisting at the top of the furthermost figures of the heavenly court pushing towards Christ and, at the bottom, of the blessed ascending and the damned falling. The contrapuntal motif of the angels struggling with the rebellious damned and the way the damned are falling obliquely from the center towards the right made room for the new motif of the group of trumpet-blowing angels in the center of the composition at the bottom. The two oblique downward lines of trumpets link the group with the horizontal strip of land along the lower edge, which shows the resurrection of the dead, Charon's boat, and the mouths of hell. (This strip of land is somewhat reduced in size at the bottom by later alterations, as is apparent from Venusti's copy in Naples.) Here some of the resurrected figures on the left and the damned descending into hell on the right establish further links with the ascending and descending vertical motion of the blessed and the damned above, creating a crisscrossing network of lines, directions, and forces that is resolved in the extraordinary, dynamic power of the composition as a whole. This effect is enhanced by the groups of angels in the two lunettes. Dramatically struggling to raise the cross and the pillar as they fly, the angels describe at the top of the fresco two diagonal lines that are immediately interrupted by the whirling composition of figures below and are then echoed in the two oblique lines that link the vertex of the trumpet-blowing angels to the base formed by the resurrection of the dead and Charon's boat.

The groups in the lunettes have often presented particular difficulties to both early and recent exegetes of the *Last Judgment*. Not only were the moralizing critics of the Counter-Reformation decidely disconcerted by these wingless angels, who were mainly, as Gilio wrote, in attitudes that made them look like "jesters or jugglers," but also some recent critics have reservations. Mariani considered them an "intrusion," which spoiled the

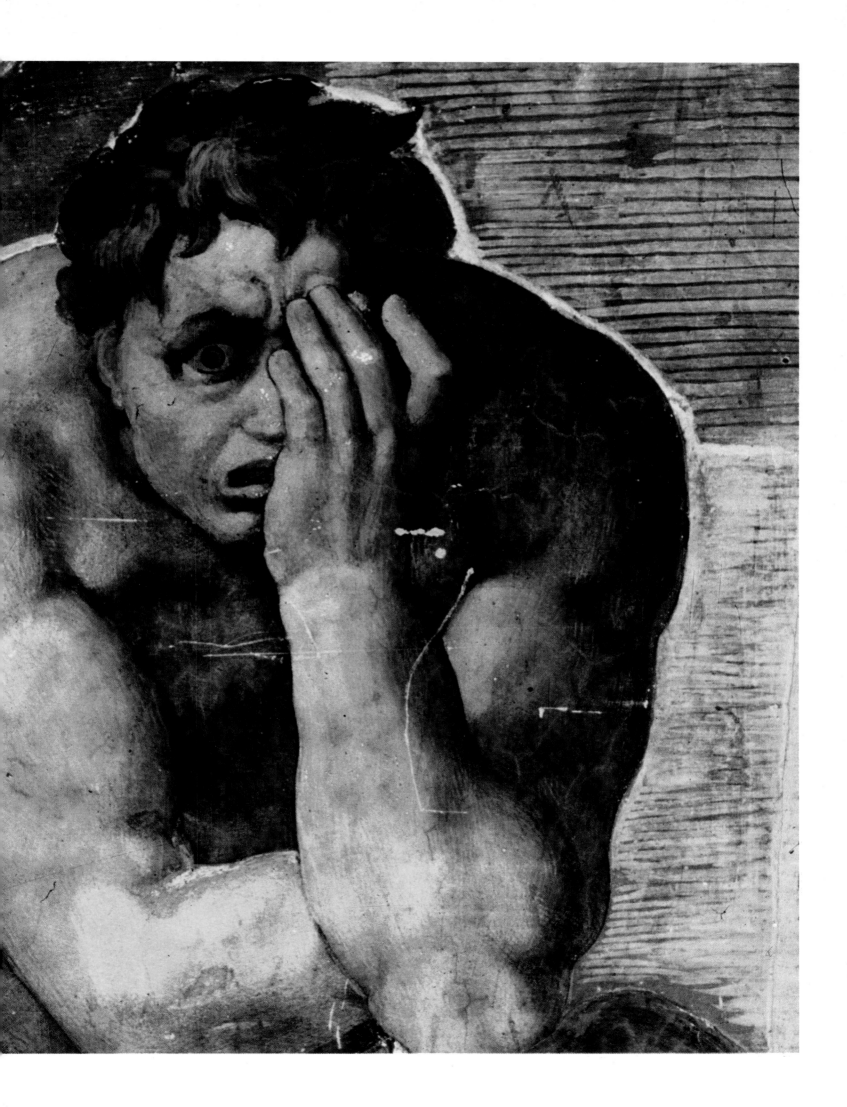

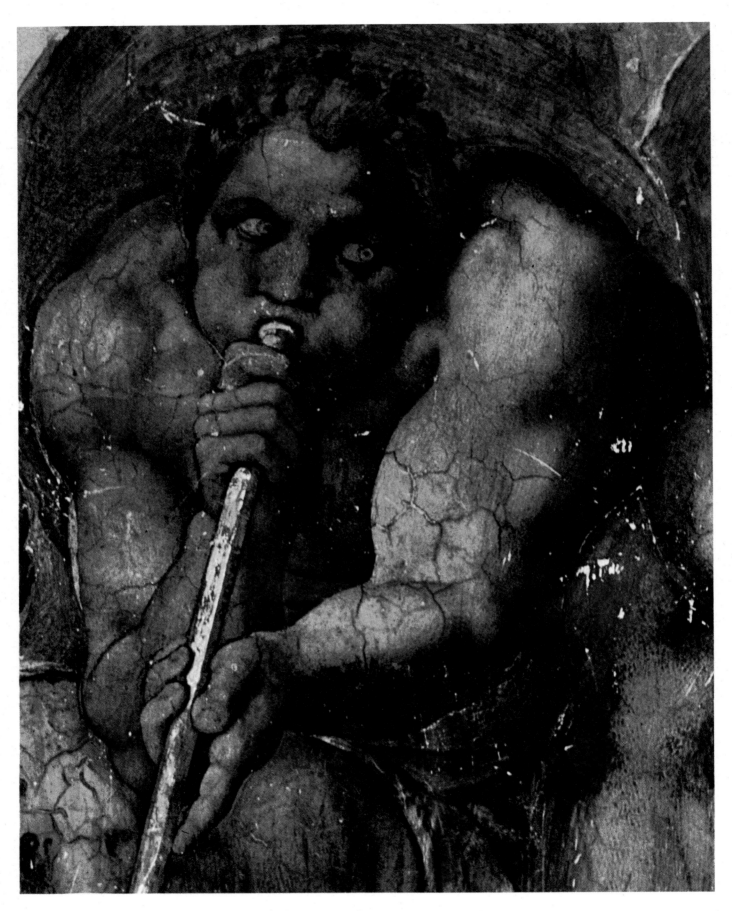

unity of the fresco, and De Campos finds "between them and the zone below . . . a harsh break." However, von Einem rightly remarks that the inclusion of the two lunettes in the enormous fresco area makes the figure of Christ far more imposing, because "All the lines of the architecture converge on it, giving back to it what it might have seemed to have lost." This consideration, together with the close compositional relationship that

THE LAST
JUDGMENT, Detail with angel
blowing a trumpet.
Below and page 136:
Two details showing souls just awak-
ened from death. These are some of the
last figures Michelangelo painted, as he
worked in the long-established, tradi-
tional manner from the top downwards
to avoid splashing finished work with
paint.

connects the top of the enormous fresco with its base, shows that including the two lunettes in the composition answers not only the need to increase the area as much as possible, given the monumental scale of the images and their actions, but also a more complex search for tension in the composition in general. The search for tension is evidenced by an unparalleled counterpoint of straight trajectories that crisscross the turbulent rotating movement of the large central section of the composition. This counterpoint is also part of a more general dialectic between the unrestrained movement and the details expressing regularity or immobility that include the hint of a return to the division of the scene into three zones—celestial glory, the blessed and the damned, and earth with the resurrection of the flesh—in the manner of traditional iconography and in the marvelous classical beauty of the Apollonian Christ, the almost immobile mover of so much movement. In this anticlassical setting, the inspiration of antiquity shines bright and clear in the Apollonian Christ. The figure is certainly dynamic, more in the manner of Scopas than of Phidias, but it is very finely balanced between a seated and a standing pose. The powerful form is caught and held forever as he rises and lifts his right arm to condemn while he draws the elect towards him with his left. The circle described by the movement of his two arms gives the figure equilibrium and majesty, far more so than a large halo. The equilibrium is quietly stated by the unaccentuated *contrapposto* of the arms and legs. The frightening strength of this crowded world is concentrated in the controlled tension of this figure.

The dialectic mentioned between unrestrained movement and immobility and balance is seen in individual figures and in the relationship between different parts of the composition or between individual groups. The lunettes, for example, are certainly two of the most dramatic, exciting parts of the work; in the struggles of the athletic angels, visually expressed by the exceptionally complex foreshortening and use of *contrapposto*, it is difficult to see whether they really are trying to erect the pillar and cross rather than pull them down. In fact, their attempts to straighten them seem to be severely hampered by their flimsy cloud support and by the stormy wind that blows them through the air and sweeps away these two huge instruments of Christ's passion. The composition of the two lunettes becomes part of the solid structure of the whole through the symmetry— however free—that links them. This convergent symmetry not only makes the figure of Christ more dominant but also relates these two furthest corners to the area below. The distinct break, which is not apparent in Venusti's copy, is caused by changes of color in the blue of the sky and the warm terra-cotta tones of the small figures of the heavenly crowds that have become increasingly dense. This gives the impression of a clear-cut, slightly curved line separating the two that was certainly not intended by the artist.

Although the tight group of apostles (on the right) and patriarchs (on the left) that form a close circle around Christ and the Virgin consists of figures in flight or running along paths of cloud in obvious excitement, as a whole it seems very calm and composed. The serenity is due to the comparatively restrained use of *contrapposto* effects in the individual images and the roughly symmetrical parallels between the figures on either side, culminating in the balanced pair of martyrs, Saints Lawrence and Bartholomew. But the figure of the Virgin, full of emotion, turns away and not imploring but, as Condivi puts it, "timorous of aspect," breaks the symmetry. In fact, she creates a second center next to the main center, and the sharp colors of her clothes and her sinuous form introduce an effective dissonant note that seems to underline the predominance of the dynamic element in the nearby figure of Christ. The movements and actions of the figures that populate the outer circle—on the right, the prophets, confessors, and martyrs and on the left, the Old Testament heroines, sibyls, and holy virgins—are freer and more obviously excited. This is shown by their more

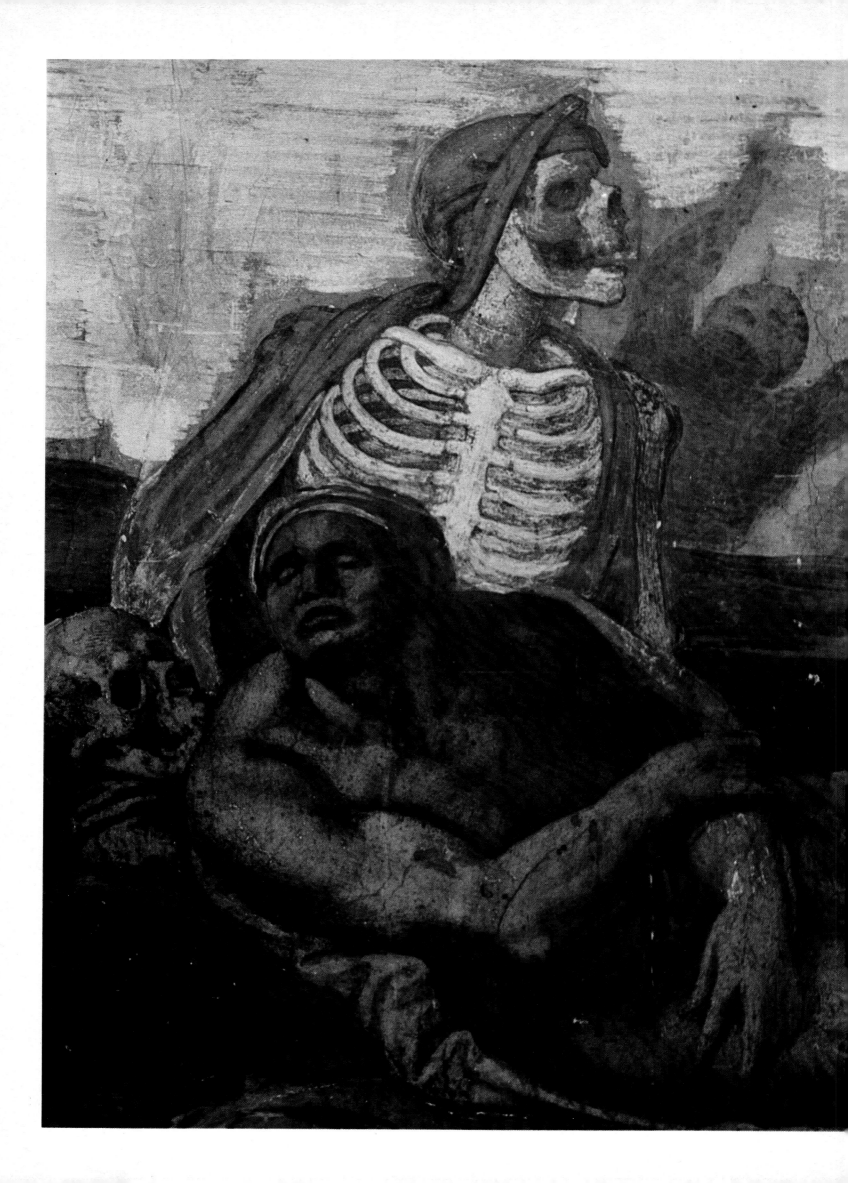

complex *contrapposto* and foreshortening. But here again, one can see a network of distant correspondences between the two groups and a rhythmic relation that links the figures on the two outer wings to those in the circle around Christ.

In the lower part of the fresco, with the ascent of the blessed and the fall of the damned, there is a greater variety of situations, but there is, nonetheless, an interplay of correspondences between the two sides. But here, they are inverse relationships that sometimes occur on different levels. On the left, the blessed ascend to fill a space that on the other side is still firmly occupied by the ranks of martyrs, who weigh down more heavily on the fall of the damned. It is this deliberate imbalance that makes the ascent of the blessed and the headlong fall of the damned stand out so clearly (as recent critics have noticed). Without this unusual impact of the composition on the left, which overbalances the weight of the composition on the right, only the presence on the right of a few upside-down figures would show the direction of movement. This disequilibrium accounts for the immediate impact of the real driving power of the vast forces that burst out and interact all over the surface of the immense fresco. The powerful thrust from the bottom left-hand edge of the composition is made effective by the initial introduction of the slow, lethargic movements and then by the lighter, swifter movements that embody the resurrection of the dead.

This section ultimately derives its impetus from the oblique movement and foreshortening of the two couples rising from the dead and clasping each other. One figure, already resurrected by the divine call, laboriously pulls up the other, still lifeless in the sleep of death. In the couple on the right, the risen figure pushes away a demon. The sense of the gradual liberation of ascending forces is made more evident by the contrast with the corresponding section on the right in which the damned are disembarking under the blows of Charon's oars and the judgment of Minos. This is a crowded, compact scene that is given weight by the three-dimensional nude forms and the deep, rather uniform color.

Dante's inspiration is very evident here, and it would be pedantic to deny it (as has been done) because of a few inaccuracies (Charon is shown beating the souls with his oar while they disembark. But in Dante's work, they embark, and Minos "giudica e manda secondo ch'avvinghia" [judges and sentences as he girds himself], using a serpent's tail rather than one of human flesh). Michelangelo was a dedicated reader of Dante, and it may be that the idea of the flight of the elect drawn by the force of divine love originated in Dante. There are no earlier figurative representations of it, except in Hieronymus Bosch's small panel in the Doge's Palace, Venice, which Michelangelo is unlikely to have known. In fact, the starting point for this new iconography is perhaps to be found in the merging of two themes from the *Divine Comedy*: Dante and Beatrice flying from heaven to heaven in Paradise by the power of divine attraction and the image of "que' due che insieme vanno/e paion sí al vento esser leggieri" (those two that go together and seem so light in the wind), in the fifth canto of the *Inferno*. Above all, there is a Dantesque flavor in the inexorable figurative power of the representation; the pure, bare language; the lack of moral prudery (in the great "stew of nudes," condemned by the work's detractors, and in the way the devils are holding some of the damned by the genitals); and in the high moral tone of the conception.

It has often been commented that each figure reflects the quality of an isolated three-dimensional block; that is, each one is like a statue that is perfectly defined by its own outline, while still keeping some sense of the marble block from which one can imagine it was carved. Sometimes this sense of a compact block is so strong that it creates quite a rugged impression. This is seen in the group with a damned soul shown seated on a reef of cloud and shrinking back and covering half his face, while two demons

drag him down to the abyss by his legs and feet. Even in the slenderest figures, the *contrapposto* (dynamic pose) or turning movements follow the same laws as the unfinished *Captives*, struggling to free themselves from the matter that envelopes them.

Other details prefigure the late marble *Pietàs*, for example, on the left, in the group with the woman supporting a man by his arms. However, all these details must be seen in their mutual relationships, dictated by the needs of expression and drama. The linking of figures and the three-dimensional development of masses are not flat but occur in depth by means of foreshortening and the network of oblique lines pointing into the depths of the fresco as much as on the surface.

I do not, therefore, share the widespread view that the *Last Judgment* is some kind of enormous tapestry or a painted imitation of a bas-relief. It has even been written that Michelangelo used a type of inverted perspective that makes more distant images larger. This is one of the not-infrequent errors that arise from the onlookers' misinterpretation of the literal significance of the pictorial text. It is a view derived from interpreting the composition in terms of fifteenth-century perspective. This leads one to suppose that everything placed higher in the picture is farther away in space. It should be remembered, however, that here the narrative takes place on different levels—from earth at the bottom to the highest regions of heaven. Within each zone—earthly, intermediate, and celestial—the figures farthest away in space are represented as smaller in size, although since there is no measurable architecture or landscape element, there is no clear unit of measurement (and there are some exceptions to the rules because of the expressive demands of the drama).

Michelangelo depicted the figures of Christ and the heavenly court as larger and more imposing than the figures of humanity rising from the grave or the wicked driven into hell by Charon's oar because he disregarded the onlooker on the ground and fixed his viewpoint on an ideal, distant spot from which it was possible to embrace the universe. He gave greater weight to heavenly figures and events in order to accentuate the overhanging weight of the masses in the upper part and to make the effect of universal ruin more inevitable and imposing. The onlooker cannot help feeling that he is watching the destruction of universal order. Although the blessed poised in flight balance the fall of the wicked, there is a sense of universal dismay that arises from the realization that everything is occurring by virtue of mysterious, irresistible forces. To achieve this effect, Michelangelo did not merely reject the Brunelleschian concept of space and also Bramante's and Raphael's spherical, universal sense of space; he had to accentuate the effects of vast, confused space, so immense as to be immeasurable (which he had already conveyed on a smaller scale in the scene of the *Great Flood* and elsewhere on the ceiling). Michelangelo's tragic pessimism finds expression in this combination of his vision of undefined, limitless space with images of confused suffering humanity. The artist himself is symbolized in the self-portrait already mentioned, grotesquely imprinted on Saint Bartholomew's skin. Apart from the warm embraces of some figures in the heavenly court, the blessed flying towards paradise appear astonished and absorbed in their upward struggle rather than being radiant with joy, as if they had suddenly been dragged half-conscious towards beatitude by some obscure and tremendous force.

There is some justification for the theory that the conception of the *Last Judgment* shows the influence of the Protestant idea of justification through Faith rather than good works. This is suggested, on the one hand, by the ostentatious way many of the saints are holding out the instruments of their martyrdom (martyrdom being the supreme testimony of Faith) and, on the other, by the fact that neither the saints in paradise nor the Virgin herself appear to be pleading on behalf of the sinners, although in Catholic doctrine

THE CONVERSION OF SAUL
Wall fresco
20 ft. 6 in. × 21 ft. 8 in. (6.25 × 6.61 m)
1542–1545
Vatican City, Vatican Palace, Pauline Chapel
This fresco and the one which followed in the sequence are Michelangelo's last known paintings. They have been seen as an indication of the painter's failing powers, as a development of the ideas that had matured in the Sistine Chapel, or as evidence of his new religious ideas, seen in relation to his "conversion." The fresco was painted between late 1542 and the middle of 1545, with an interruption in 1544, when Michelangelo was ill.

they are regarded as mankind's intercessors. It is unlikely that Michelangelo meant to refer to current controversies about justification, since when he planned the *Last Judgment* he did not yet know Vittoria Colonna or the circle of Catholic reformers who gathered around her. Furthermore, he certainly would not have intended to bring polemics into the pope's own house. The fact remains, however, that the terrible sense of doom that breathes from its vision of humanity in the grip of irresistible forces is more compatible with a Pauline or Augustinian conception based on the idea of Grace than on the rationalist Thomist idea of free will prevalent in the Catholic Church. Pope Paul III himself was not deaf to the ferment of reform. From what we know of Michelangelo's personality, it is easy to believe that his high moral sense, educated in youth by the preaching of Savonarola on the sacred dread of divine punishment, gave him a natural inclination to reject the opportunist attitude that, in practice, lay beneath the doctrine of works (the "works" most popular with the hierarchy were the ostentatious giving of alms to convents, the buying of indulgences, and the establishment of magnificent foundations) and eagerly seek ways of making faith a more interior affair.

In the early 1540s, while Michelangelo was finishing the fresco, a madrigal

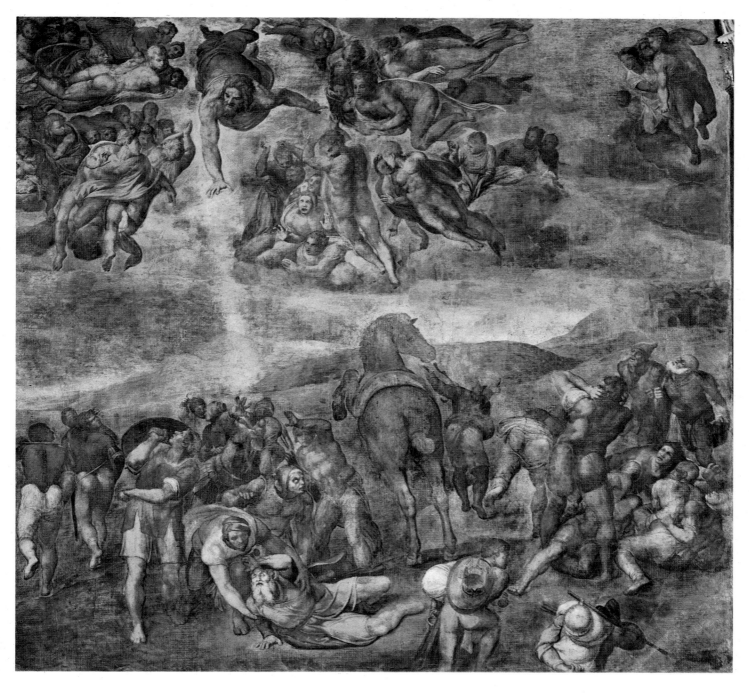

for Vittoria Colonna that opened with a Neoplatonist-type statement about art ("Per fido esemplo alla mia vocazione/Nel parto mi fu data la bellezza / Che d'ambo l'arti m'è lucerna e specchio" [As a faithful example to my vocation, beauty was given me at birth that is for me the lantern and mirror of both arts]) ends with an epigrammatic reference to the frailty of human works compared with the omnipotence of Grace ("Ascender senza Grazia è pensier vano" [To ascend without Grace is a vain thought]). Savonarola had already expressed this idea, and it was resolutely taken up again by Juan de Valdés, whom Vittoria Colonna may have met in Naples (before she met Michelangelo, apparently in 1536 or 1538).

When Michelangelo had finished the *Last Judgment*, he applied the finishing touches to the *Moses* and, with the help of assistants, carved the statues of *Leah*, symbol of the active life, and *Rachel*, symbol of the contemplative life, for the final version of Julius II's tomb in San Pietro in Vincoli, which was unveiled in 1545. The torsion of Rachel is to some extent reminiscent of the figure of the Virgin in the *Last Judgment*; but it mainly emphasizes the upward movement, which is a clear statement, rather than a poetic expression, of the soul rising in contemplation. *Leah*, on the other hand, is tranquil and introspective; she is shown in a peaceful, balanced pose. On the whole, the two figures show waning inspiration.

STUDY FOR A RESURRECTION
OF CHRIST
Red chalk drawing on paper
6 × 6¾ in. (15.5 × 17 cm)
Circa 1530
Paris, Louvre
One of Michelangelo's many surviving studies on the theme of the Resurrection. It has not yet been related satisfactorily to any of Michelangelo's works, but the most convincing suggestion is that it was executed for Sebastiano del Piombo when Michelangelo was commissioned to do a painting for the Chigi Chapel in Santa Maria della Pace in Rome. Michelangelo probably supplied his friend with a preparatory drawing for his important commission. Popp, however, suggests that the drawing relates to a fresco planned for one of the lunettes in the Sagrestia Nuova of San Lorenzo.

THE CONVERSION OF SAUL:
Detail with Saint Paul thrown from his horse
The prostrate figure of the saint is sometimes thought to represent Michelangelo himself.

Paul III soon commissioned Michelangelo to paint two frescoes for the Pauline Chapel, recently built by Antonio da Sangallo the Younger to vie with Nicholas V's chapel, which had been decorated with frescoes by Fra Angelico about a hundred years before. The artist was engaged in this work from the end of 1542. The first fresco was finished by July 1545, when the pope went to see the fresco. Michelangelo had become seriously ill, and the second fresco was not started before the spring of 1546. The work was again interrupted several times due to his illnesses between the end of 1548 and April 1549. It was not yet finished in October of the same year, when the elderly pope climbed "a ladder with ten or twelve rungs" to view the fresco.

Documents and sources do not reveal which of the two compositions was done first. But Vasari, who in 1550 published the first edition of his *Lives*, talks about the two paintings in the present tense as if they were still incomplete: "He is painting two histories, one of Saint Peter, the other of Saint Paul." Vasari also describes one of them as depicting the handing over of the keys: "one in which Christ gives the keys to Saint Peter, the other, the awesome conversion of Paul." In fact, Saint Peter is shown suffering his martyrdom. Whether this was a slip on the biographer's part or whether there was a subsequent change of plan, the fact that the subject matter of one fresco was wrongly described means that it had not yet been painted when Vasari composed the *Lives*. Moreover, the episode of Paul's conversion is stylistically much closer than the other to the *Last Judgment*, so that there is almost unanimous agreement that it is the earlier of the two. But unless Vasari, who duly corrected his error in the second edition of the *Lives*, was originally mistaken, there must have been a change of plan. This is very probable since the two frescoes in the chapel show surprisingly few parallels between the two episodes. The *Conversion of Saul* should logically have been matched by the handing over of the keys to Peter, portraying the triumph of Faith and the founding of the Church. The change of subject from the handing over of the keys to the *Crucifixion of Saint Peter* profoundly alters the work's ideological assumption, which now becomes the exaltation of Grace and Faith: the conversion (of Saul) through the sudden descent of Grace and the martyrdom (of Peter) as the supreme testimony of Faith. This change was certainly suggested by Michelangelo himself, who had previously managed to make Julius II accept his program for the Sistine Chapel ceiling.

This brings us to the ideas and sentiments that must have occupied the artist during these years. Every Sunday, Michelangelo met Vittoria Colonna and other lay and clerical figures in the convent of San Silvestro on Monte Cavallo. Vittoria Colonna also frequented the circle of Valdés's disciples, with Cardinal Reginald Pole, Pietro Carnesecchi, and others. Their meeting place was the convent of Santa Caterina at Viterbo.

References to the frailty of human virtue and human works compared with the omnipotence of Grace frequently occur in the letters and verses that Michelangelo wrote to the poetess: "having recognized and seen that the Grace of God cannot be bought [with one's own works]" states a letter of uncertain date, written between 1540 and 1545. In a madrigal addressed to the lady, Michelangelo asks, almost in an echo of Luther's "pecca fortiter," "saper, se in ciel men grado tiene/L'umil peccato che'l soverchio bene" (to know if in heaven humble sin holds lower rank than excessive good). In his late poetry, there are increasingly frequent calls to God to remedy his own inability to do good: "I' te sol chiamo e invoco/contro l'inutil mio cieco tormento" (I call and invoke you alone against my futile, blind torment); "Ogni ben, senza te, Signor, mi manca;/Il cangiar sorte e sol poter divino" (Without you, Lord, all good fails me; only divine power can change my lot); "I' t'amo con la lingua e poi mi doglio/ch'amor non giunge al cor; ne so ben onde/Apra l'uscio alla Grazia" (I love you with the tongue and then sorrow that love does not reach the heart; nor do I know where the door to Grace opens); "Io parlo a te Signor, c'ogni mia prova/Fuor del tuo sangue non fa l'uomo beato" (I speak to you, Lord, with all my powers/Without your blood man cannot be blessed).

The extent to which Michelangelo was concerned with the problem of Grace is shown by the incomplete sonnet, of Dantean inspiration, on the various ways in which Grace works: "Se sempre e solo è un quel che sol move/Non sempre a no' si mostra per un verso/Ma più e men quanto sua grazia piove" (If always alone is he who moves everything. . . . He never reveals himself to us in any way except as he rains down more or less of his Grace). The idea of the weakness of human action and the need for Grace that cannot be bought and can only be attained by the soul's intimate union

THE CRUCIFIXION OF SAINT PETER
Wall fresco
20 ft. 6 in. × 21 ft. 8 in. (6.25 × 6.61 m)
1546-1550
Vatican City, Vatican Palace, Pauline Chapel
The start of work on this fresco was probably somewhat delayed by the fire that broke out in the chapel in 1545. (Fortunately, it caused only slight damage to the *Conversion of Saul*.) The *Crucifixion of Saint Peter* was begun in 1546 and was completed in 1550.
Pages 144–145: Detail with Saint Peter and executioners

with God preoccupied and troubled the artist ("Vorrei voler, Signor, quel ch'io non voglio/Tra'l foco e 'l cor di ghiaccio un vel s'asconde/Che'l foco ammorza" [I would like to want, Lord, what I do not want/A veil of ice is hidden between the fire and the heart/which extinguishes the fire]) and made him afraid lest his devotion should remain formal and insincere ("onde non corrisponde/La penna all'opre, e fa bugiardo il foglio" [when the pen does not match the deeds and makes the page a liar]). This anxious concern is apparent in the troubled dismay of the figures in the bleak landscape of the *Conversion of Saul* (page 139).

In fact, the episode of the *Conversion of Saul*, in which Saul falls to the ground bathed in supernatural light as he hears the Lord's call, is portrayed not as an historical event, fixed in space and time, but as a mystical experience of contact between man and God. The onlooker is drawn into the picture by the absence of precise suggestions of perspective and even of a fixed viewpoint, combined with the virtual abolition of the picture's lower edge that is intersected by the two soldiers who are seen from behind and who are climbing up to the scene of action (they do not yet seem aware of what is happening). The viewer is put into immediate contact with Saul's mystical experience and with the emotion Saul arouses in the bystanders.

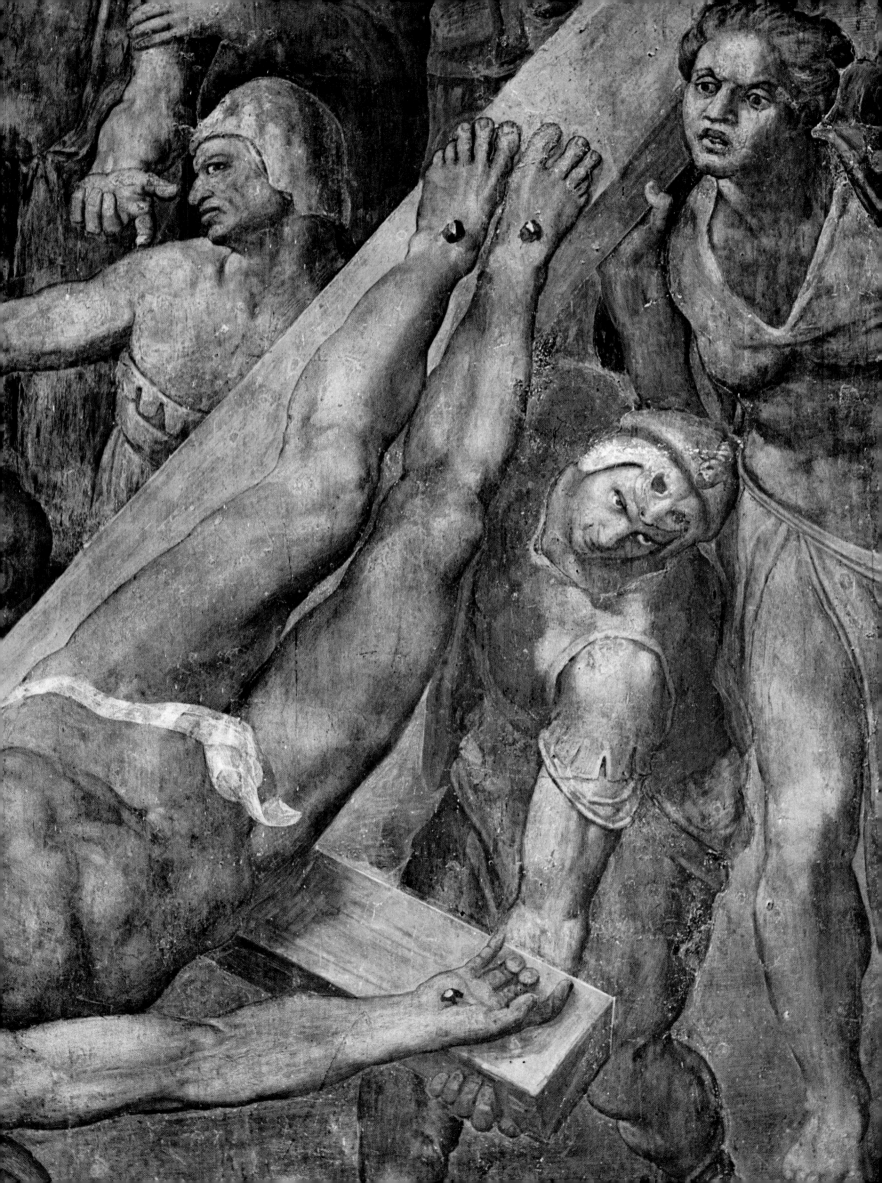

The lightning suddenness and force of the miracle are effectively expressed in the composition's centrifugal structure, with the two groups fanning out on the surface and in depth to form an arc around the central axis of the bolting horse, slanting upwards and to the left. The divergence between the figure of the animal and the man who is trying to restrain it both emphasizes and epitomizes the divergence between the two main lines of direction. The centrifugal movement of the lower part is matched inversely by the centripetal motion of the scene in the sky in which the nude angels (much of the clothing was added later) converge in a circle around Christ.

There are also effective links created by the *contrapposto* effects of the two parts. First, there is the relationship between the horse and Christ—one pointing upwards, the other downwards, one slanting to the left, the other to the right. This is not in any way irreverent since it is demanded by the requirements of form or expression. Other correspondences reinforce the link—for example, the relation between the soldier, below right, covering his ears and the large angel flying just above the horse's head.

Some scholars have found this fresco guilty of Mannerist indulgences or even stylistically incoherent with its unsuccessful experiments with space and sculptural tendencies. However, my interpretation of the work recognizes its fundamental coherence and unity. It is true that it consists of two parts that could exist separately: if one removed the scene in the sky, the portrayal of Saul's fall and his companions' alarm would in itself be perfect and self-contained. Yet the action in the sky harmonizes perfectly with the event on earth and thus brings out its full effect.

In painting this fresco, the artist's state of mind must still have been much as it was when he created the *Last Judgment*. The most obvious echo of the

THE CRUCIFIXION OF SAINT PETER: Detail
A group of grief-stricken Christians watch Saint Peter's martyrdom on the cross.

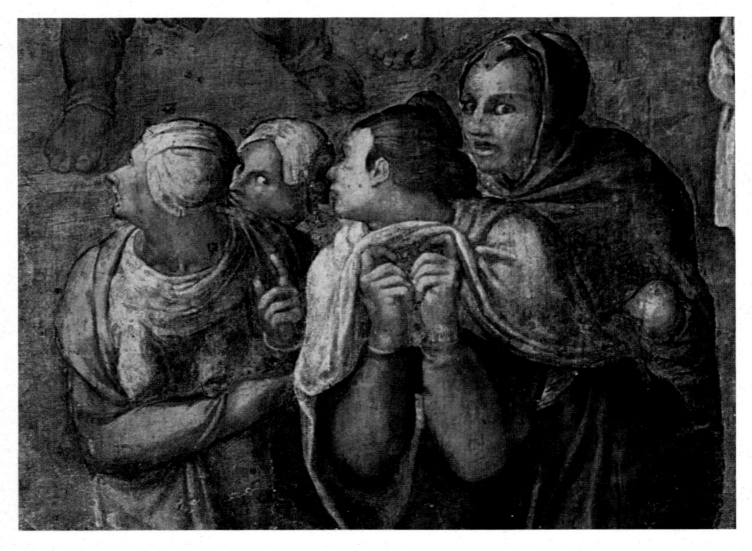

Last Judgment is the downward-pointing figure of God appearing in the sky, with his headlong flight being broken by placing his arm on a bank of cloud and ardent crowds of naked angels surrounding him. The swift movement and range of foreshortening recall both the restless flow of the blessed and damned and the patriarchs and saints eagerly thronging around Christ the Judge. In this fresco, there is the same juxtaposition of an earthly scene and a heavenly one; they are in the same relation to one another, although on a much smaller scale. Here, as in the lower part of the *Last Judgment*, the ground recedes and slips away in an unlikely, distant perspective, while the heavenly band floats above. The compact heavenly group rests on a plane with the boundless expanse of the sky, which is suggested simply by the use of foreshortening and the transparent color.

Apart from similarities of detail in composition, this vision of a vast, empty space with stunned, awe-struck human figures has the same note of deep pessimism as in the *Last Judgment*. This is intensified by the bare and indeterminate landscape, with its few broad, rolling undulations that look more like a stormy sea. The city in the background, confined to a small corner on the right, is compact and stylized, like the symbolic views in medieval paintings. However, the mystical element is more pronounced than in the *Last Judgment*. The onlooker is more deliberately drawn into the action, and the sense of tragic grief is replaced by an expression of anxiety and anguish. In the *Last Judgment*, the whirling movement of the masses took place mainly on one plane beyond which there was only an expanse of boundless space; but here the figures, which take the form of fully three-dimensional masses, extend right into the desolate, open space.

The *Crucifixion of Saint Peter* (page 143), which has generally been rated more highly than the other fresco, corresponds directly and inversely to the *Conversion of Saul*. There is the same sense of immensely deep space that is not related to the onlooker by any fixed viewpoint. The viewer is drawn in by the way the lower edge is here again intersected by the bottom figures in the foreground. The deserted landscape has the same broad, rolling rhythm; the main directrix of the composition—here, the cross and in the other fresco, the horse—is slanted in a similar way. But the figures of the bystanders are arranged around the fulcrum in a quite different and opposite way— centrifugal and divergent in the other fresco and here centripetal and circular. The figures of the soldiers and the groups of mourners take on a strong, spacious, rotating movement; they form a large arc around the center, which the painter has established as the saint's head. These converging figures are reinforced by the group of mounted soldiers arriving from the left and by the crowd hurrying from the right, while the movements of the two executioners form a smaller circle.

Besides the rotating movement on the plane, there is a suggestion of vertical rotation in the position of the cross, which is depicted as it is being raised. This hints at a spherical, universal view of space—Michelangelo's great innovation in iconography from which all the novel features of style follow. Traditional representations always showed the cross already in its upright position with Peter upside down. Here the cross is at an angle, raised from the ground at one end by the executioners, so that the crucified martyr's body is drawn around by the cross's movement. Peter's head and his fierce stare thus become the fulcrum of the composition, and the artist presents the scene dynamically, as the tragedy takes place, without losing the fixed element of the martyr's spiritual triumph.

While in the *Conversion of Saul*, the sense of the miraculous is conveyed by the lightning suddenness of the event, here the slow regularity of the multiple rotating movement creates a sense of destiny that is equally miraculous. This rotation is echoed and extended, as already noted, by the figures of the bystanders—soldiers and silent groups slowly passing by and looking on. They are powerful figures, forming compact, self-contained

three-dimensional masses (as the ultimate expression of a kind of "metaphysical painting"), and their faces express inhuman and horror-struck grief. The visionary tone and "expressionistic" elements have become more marked, while the greater range and delicacy of color (the artist here learned something from Venetian painting) make the pressing silence of the scene more vibrant.

Even more than the *Last Judgment*, the two frescoes of the Pauline Chapel show Michelangelo's painful involvement in the great crisis of his age. In 1545, while he was starting the second fresco, Vittoria Colonna, intimidated by the Inquisition's threats, broke off relations with her reforming friends, some of whom, like Ochino himself, had actually become Protestants. In 1547, she died. Michelangelo was left on his own, clinging to the idea of salvation by Faith alone, with a growing sense of dissatisfaction and isolation from the world. This may explain the feeling of mystery and grief that emerges from the two frescoes, particularly the second, the *Crucifixion of Saint Peter*. Here mankind seems to have lost all faith in itself and waits apprehensively for salvation, which can only be achieved by mystical union with God.

From Michelangelo's biographers and from his letters, we learn that he made some drawings for Vittoria Colonna. According to Vasari, they included "an admirable *Pietà* in the lap of our Lady, with two little angels; and a Christ crucified, raising his head and commending his soul to the Father—a divine work; and also a Christ and the Samaritan woman." The *Pietà* is known from an engraving by Giulio Bonasone; but it seems that Michelangelo never did a painting of it, although various copies by another hand survived. The same is true of *Christ and the Samaritan Woman*, which is known mainly from an engraving by Béatrizet and from Vittoria Colonna's comments on it in one of her sonnets that show that Michelangelo's interpretation of the Gospel passage was not so much concerned with charity and the equality of men and races as with affirming the value of private prayer, without the Church's mediation. This is further proof of the reforming tendency of the circle Michelangelo frequented in about 1541.

Two of Vittoria Colonna's letters, dating from about 1539–40, show that the *Crucifixion* was not just a drawing but that Michelangelo himself did a painting of it. Many copies have survived (the most famous is Marcello Venusti's), but the original has not been convincingly identified. Although it is impossible to make an assessment of their artistic worth because the originals have disappeared, these minor works for Vittoria Colonna are interesting because they show how Michelangelo, in pursuing new modes of iconography, attempted to go more deeply into the meaning of the themes that express an intimate and troubled religious feeling. The *Pietà* also contained interesting echoes of northern European iconography.

The reign of the Farnese Pope Paul III marked the beginning of Michelangelo's great Roman work in the field of architecture. When he finished the frescoes of the Pauline Chapel, he finally gave up painting, which he felt, as he often declared, never was his art. From now on, the firm clear language of his favorite art—sculpture—seemed to him inadequate to express his yearning for union with God in Faith and Grace. He committed his deepest and most tormenting thoughts to his sculpture, and this explains the changes of mind that can be seen in his last works and their unfinished state.

When he began work as an architect again in Rome at the height of his fame, after his great achievements in Florence, certain constant elements of his personality and way of thought found their supreme expression. To begin with a comparatively minor work—the completion of the Farnese palace (pages 156–58)—we can say that, as Ackerman and De Angelis in particular have shown, Michelangelo's final intervention brought new majesty and power to it.

FAÇADE OF SAN LORENZO
Wooden model
1517
Florence, Casa Buonarroti

STUDY FOR THE FAÇADE OF SAN LORENZO
Drawing in pen, black pencil, and red chalk on paper
$8\frac{1}{4} \times 5\frac{3}{4}$ in. (21.2×14.3 cm)
Circa 1520
Florence, Casa Buonarroti
This is probably the last of the preparatory sketches for the San Lorenzo façade and so represents the final project. On the *verso*, there is a sketch of a dead man wearing a miter, this is perhaps connected with the third project for Julius II's tomb (Barocchi).

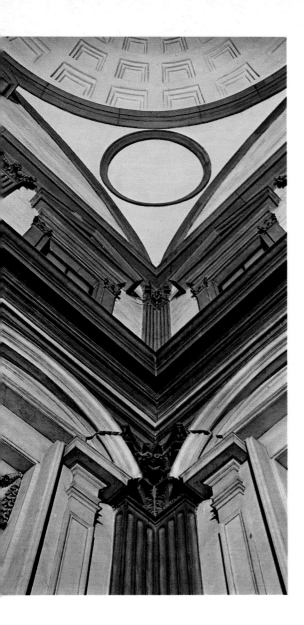

Work on the palace had started in about 1517 under the direction of Antonio da Sangallo the Younger. But when Sangallo died in October 1546, all that was standing was the ground floor, the first order of the courtyard, and the section of the *piano nobile* overlooking the piazza. It seems certain that Michelangelo designed the cornice and the large central window of the façade. More importantly, he gave the building new majesty and power by making the second story higher than in Sangallo's design and also by increasing the height of the already completed *piano nobile* by raising the cornice between the stories.

Below each window of the top story (which followed the design and forms that Sangallo had had prepared), Michelangelo added a recessed panel; and above the large middle window of the *piano nobile*, he placed a large, very prominent shield bearing the pope's coat of arms. A socle consisting of a band of emblems, a denticulate frieze, and a small cornice of ovolos provide a base for the elastic brackets that support the cornice (page 157). The powerfully projecting cornice (which was criticized by the Sangallo faction as being out of proportion and top heavy) is the culmination of the crescendo of three-dimensional tension that animates the palace frontage. Vasari wrote that Michelangelo "remade the palace almost in another form."

Michelangelo also left his mark on the courtyard, where above the already completed arcades of the ground floor he placed two stories with an increasing upward emphasis of line and three-dimensional tension. Some of the arches—both on the ground floor and on the *piano nobile*, opposite the entrance—were intended to open onto a view of gardens. According to Vasari, "Michelangelo proposed the building of a bridge at that point across the river Tiber, so that one could go from the palace to another garden and palace belonging to the family in Trastevere, in order that from the main doorway leading to Campo dei Fiori, one could see at a glance the courtyard, the fountain, via Giulia, the bridge, and the beauty of the other garden, as far as the other gate that opened onto the road of Trastevere: an outstanding plan, worthy of the pope, and of Michelangelo's talent,

judgment, and design''; the scheme, however, was never implemented. Michelangelo's ideas were certainly at the root of the Manneristic theatrical effects so skillfully achieved in Florence by Vasari, Ammannati, Buontalenti, and, on a larger scale, by the Roman planners of Sixtus V's reign; but for Michelangelo, the essence lay in the dramatic contrast between an enclosed space full of tensions and the sudden release of these forces into open, unlimited space.

The same concept is expressed in Michelangelo's design for the Piazza del Campidoglio (pages 152–55), which he worked on from early 1539, when funds were allocated to set up "secundum judicium domini Michaelis Angeli sculptoris" the equestrian statue of *Marcus Aurelius*, which two years

before had been moved from Saint John Lateran to the Capitol (against Michelangelo's advice at the time), and to build certain walls around the open space. The piazza was really no more than a clearing—a bumpy, unpaved, uneven space, roughly bounded on only two sides and dominated by the hill and church of Aracoeli. On the southeast side stood the Senator's Palace, built in the twelfth century up against the ruins of the *tabularium* to create a sense of continuity with the ancient Roman republic at the dawning of the short-lived communal government. The palace was enlarged and altered on several occasions during the fourteenth and fifteenth centuries and later.

On the southwest side, the little palace of the Banderesi (troop commanders) was built in about 1400 and was altered, during the reign of Pope Nicholas V in the middle of the fifteenth century, by the addition of a porticoed front. This was the palace of the gonfaloniers of the Roman *rioni* (the captains of the civic militia) and also the seat of the corporations and, apparently from 1453, of the magistrature of the Conservators.

A drawing by the Dutchman Marten van Heemskerk (page 153) shows that before the statue of *Marcus Aurelius* was moved to the Capitol, an obelisk stood beside the Senator's Palace and the church of Aracoeli, and a tall column bearing an antique statue stood beside the Conservators' Palace towards the northern end of the open space. Two antique statues of *River*

THE BIBLIOTECA
LAURENZIANA: View of the staircase
Circa 1524–1570
Florence
This work, commissioned from Michelangelo in 1523 when he was already engaged on the Sagrestia Nuova and on Julius II's tomb, was begun the following year. However, it made slow progress and was interrupted in 1527, the year of the sack of Rome, or earlier. Work was resumed in 1533 but was not finished when Michelangelo left Florence permanently in 1534. Vasari and Ammannati, following detailed instructions that Michelangelo sent them from Rome, continued the scheme almost to its completion.

THE BIBLIOTECA
LAURENZIANA: View of the
reading room
Circa 1524–1570
Florence

Gods were placed in front of the central span of the loggia of the Conservators' Palace, while the Capitoline *Wolf* was fixed to the wall above the entrance.

From 1535–36, in anticipation of Emperor Charles V's triumphal visit, the city authorities began to think about a new layout for the hill; but the scheme really got under way with Pope Paul's decision at the end of 1537 to move the statue of the *Marcus Aurelius*. This was carried out (against Michelangelo's better judgment) in January the following year. A contemporary document that refers vaguely to the person "who has the task of making the new base" and an engraving by Hieronymus Cock, dating from 1547, suggest that the equestrian statue of *Marcus Aurelius* was first placed on a rectangular base not very different from the base on which it had stood in its old position in front of Saint John Lateran. The date 1538 inscribed at the end of the epigraph on the present base and a 1538–39 drawing by Francisco de Hollanda, in which the rectangular base already has two curved ends, have made some scholars think that after 1561 Michelangelo only made a few, though not insignificant, alterations to the earlier base that had already been built.

However, it does not much matter whether the present base is the 1538 base (and Michelangelo simply added the four small pillars that mark the transition between the main faces and the curved ends in 1561 or soon after, when he started laying out the piazza's oval floor pattern) or whether it was not made until 1561 or soon after. Béatrizet's 1548 engraving shows that before that year, and so probably as early as 1538 (when there is documentary evidence that Michelangelo was in charge of arrangements for

the statue), he had at least planned the oval base and decided to close off the piazza on the northeast. He also planned to build a long wall with a large central niche below the Aracoeli, as is shown by the two anonymous drawings in Braunschweig and Paris relating to the contemporary document mentioned above.

The implementation of Michelangelo's scheme, which we know from Dupérac's two engravings of 1567 and 1569 (page 152) proceeded very slowly because of financial difficulties. The transformation of the Senator's Palace started in 1547, continued under Michelangelo's direction until about 1559, and was resumed with some alterations after his death. The Conservators' Palace, or rather the portico on the piazza that replaced the fifteenth-century portico and gave the old building a new frontage, was only started in 1563, shortly before Michelangelo's death. The layout of the piazza's floor design, an essential detail that gives life to the whole, was begun in 1561, but the pattern around the *Marcus Aurelius* was not completed until 1940. The Palazzo Nuovo, facing the Conservators' Palace, was built during the first half of the seventeenth century and later. The balustrade and *cordonata* were begun but not completed during Michelangelo's lifetime.

Many alterations were made to the scheme while it was being built. Tommaso dei Cavalieri was faithful to Michelangelo's intentions; but many changes were made by Giacomo della Porta, who was given the job of finishing the Senator's Palace and building much of the Conservators' Palace, and by seventeenth-century architects, including Girolamo

PERSPECTIVE OF THE PIAZZA DEL CAMPIDOGLIO
E. Dupérac's 1569 engraving, based on Michelangelo's project

PLAN OF THE PIAZZA DEL CAMPIDOGLIO
1567 engraving by Dupérac. It was used as a model when the pavement was laid out in 1940.

Rainaldi, who built the Palazzo Nuovo (now also known as the Capitoline Museum). However, in spite of these alterations, the Piazza del Campidoglio, in terms of architecture and more particularly as the creation of an architectural setting and as an example of town planning, may rightly be considered Michelangelo's work and one of his finest masterpieces. The objective constraints and limitations imposed by the shape of the hill and by the existing buildings and statues (which for various financial or ideological reasons had to be left) were an incentive to the artist's imagination. The orientation of the old Conservators' Palace, set at an angle to the Senator's Palace, suggested the piazza's trapezoid form far more than Rossellini's illustrious precedent, the piazza in Pienza. From 1539, Michelangelo had, by his positioning of the *Marcus Aurelius*, fixed the center once and for all and, in relation to the middle of the Senator's Palace, the future piazza's longitudinal axis.

He had also started to build a massive supporting wall against the slope of the Aracoeli. He planned to have a niche in the middle of the wall, which would be on a transverse axis to the equestrian monument of *Marcus*

THE CAPITOLINE HILL

Drawing by Marten van Heemskerk from about 1535 showing the Capitoline area before Michelangelo's intervention. In the background is the palazzo nuovo where the Conservators' Palace was later built. In front of the central span, the two statues of *River Gods* can be seen with the Capitoline *Wolf* above them.

PIAZZA DEL CAMPIDOGLIO
Rome

The original decision to redesign the Piazza del Campidoglio dates from 1537, when the hill was simply a semi-derelict open space. It contained some archaeological remains, two dilapidated palaces, the twelfth-century Senator's Palace and the Conservators' Palace facing the Aracoeli. Michelangelo's first action, in 1539, was to raise the statue of *Marcus Aurelius* on a base oriented as it still is today.

In the foreground, at the entrance to the piazza, are the two statues of the *Dioscuri*. The first was placed there before 1585 and the second at the beginning of the seventeenth century. But they are not in the position suggested by Michelangelo.

Aurelius. Although this wall stands farther back than the front of the future Palazzo Nuovo (which Michelangelo was probably already planning to build as soon as possible), it is placed obliquely to the Senator's Palace and at the same angle as the small Conservators' Palace. Given the financial limitations of the civic administration, Michelangelo probably adopted this solution as being the most economical way of achieving two preliminary results: the clear separation of the communal area from the ecclesiastical area of the Aracoeli hill, almost as if using a town-planning statement to underline the separation of Church and State, while at the same time satisfying an elementary requirement of symmetry. But he must immediately have grasped the aesthetic significance of the lines diverging towards the back of the piazza and thus formed by the lateral masses. This created an effect of inverse perspective. As soon as the visitor neared the top of the new uphill approach—the *cordonata* that Michelangelo had designed on an axis with the center of the piazza—he would think the palace was at a shorter distance than really existed. This optical illusion made the Senator's Palace seem more imposing. But to be fully effective, not only did the two sides have to be

symmetrical and divergent, but they also had to be at an equal distance from the axis of the piazza and be—or appear to be—of equal weight. This is why Michelangelo insisted that the wall should be replaced by a building that repeated the mass and forms of the building opposite (the Palazzo Nuovo that appears in the scheme reproduced in Dupérac's famous engravings but was built during the seventeenth century).

The potentially more majestic appearance of the Senator's Palace had to be made fully effective by an appropriate use of dynamic and vigorous three-dimensional forms. As far as one can tell from a brief series of not-very-comprehensive drawings and engravings, the old building, before Michelangelo started work on it, seems to have consisted in front of a rectangular body flanked by two projecting towers of very different sizes. It was medieval in origin but was altered during the fifteenth century. Between the two towers, the front, as it appeared in the fifteenth century during Nicholas V's reign and especially in about 1451, presented on the onlooker's left a surface divided by three large windows of Guelph cross form. On the right, at the top of a wide flight of steps divided into several stairways, there rose a handsome loggia with two orders of five spans each. The entrance was behind the last arch on the right. The recent authors of a model reconstruction of the palace as it appeared in the early years of the sixteenth century have suggested that this loggia, built by Senator Pietro Squarcialupi in 1520, stood out from the front and consisted of two orders of arches. In the Berlin drawing by Marten van Heemskerk, however, it seems to open flush with the façade, while in the later engraving by Hieronymus Cock, it is shown as recessed between the façade and the tower. In both these views, it seems to consist of one order of arches and one architraved order (placed in reverse order in the two sheets). In this respect, I do not think Cock's engraving is reliable. It shows that the right-hand tower no longer stands out from the whole front, and I think it is more likely that the loggia was flush with the front. Michelangelo preserved and reinforced the projection of the two lateral towers but made them the same size by removing their tops and reducing them to the height of the front of the rest of the building, treating them as the projecting masses of a civil palace.

He also designed two orders of large windows above a high base and the division of the whole width of the front, including the lateral projections, with a single colossal order of pilasters. This created on the façade a tension of planes resulting from the close succession of architectural membering and elements and from the interplay of projections and recessions starting with the two lateral projections.

The dramatic interplay of three-dimensional masses culminates in the stairway, with its two flights sloping across the front of the building and meeting in a central loggia of two orders that in turn projects well beyond the stairs. Michelangelo's transformation of the building seems to have begun, just before 1547, with the building of the double staircase that was started on the onlooker's left and completed in 1554, when the doorway on the balcony at the top was also built. From certain discrepancies between Cock's engraving and the scheme as reproduced by Dupérac and compared with a sketch by Michelangelo himself in Casa Buonarroti, De Angelis has rightly inferred that the design was gradually modified by Michelangelo in order to make the three-dimensional intensity of his forms ever more powerful. In particular, the staircase had a central projection, in which later, in 1588 at Sixtus V's request, a fountain was placed (according to De Angelis, this detracted somewhat from the "impulse of the masses" and the "obviousness of the projecting body") and two lateral projections at the sides corresponding to the two projecting bodies brought forward at the ends of the façade. Michelangelo's design also envisaged a loggia at the top of the two flights, and if this had been built, it would certainly have strengthened the building's three-dimensional rhythm.

CONSERVATORS' PALACE
Rome, Piazza del Campidoglio
Although Michelangelo's directions for the piazza, consisting of a comprehensive series of drawings and projects, were to some extent altered or ignored, this did not greatly weaken the impact of his highly imaginative scheme. After Michelangelo's death, Guidetto Guidetti, Giacomo della Porta, and Girolamo Rainaldi took charge of the work.

The doorway on the balcony was refashioned in a more solemn style by Giacomo della Porta, who, after Michelangelo's death, was responsible for the implementation of the scheme that was altered for various reasons. Among other things, the second order of windows was finally built in a more modest form, with a series of small, square windows at a respectful distance from those of the *piano nobile*, instead of repeating the same windows close to the first order. This certainly weakened the three-dimensional tensions and dramatic accents of the whole front. But the artist found a way to express his own vision of architecture as an art closely related to sculpture by placing the two Roman *River Gods*, which had previously been in front of

the fifteenth-century loggia of the Conservators' Palace under the staircase, in the space between the central and side projections.

The Conservators' Palace, which preceded the present building, was rebuilt during Nicholas V's reign on the site of an older palace sometimes referred to in documents as "palazzo nuovo" (new palace as compared with the Senator's Palace). This was the seat not only of the Banderesi (troop commanders) mentioned above but also of other of the city's magisterial offices and of the Consiglio Speciale that, during certain periods and on certain occasions, existed beside the Consiglio Generale (which held its sittings in the Senator's Palace).

As far as one can tell from the 1535 Berlin drawing of Marten van Heemskerk and from the anonymous Louvre drawing of some twenty years later, the palace was a roughly square building with a loggia, apparently composed of eleven round arches resting on columns, at ground level on the front, giving onto the open space of the Capitol (the three central arches were

FARNESE PALACE: Main façade
Rome
After the death in 1546 of Antonio da
Sangallo the Younger, who started the
work on the palace in 1517, the building
was completed by Michelangelo. He
was responsible for raising the height of
the *piano nobile*, designing the second
story with the massive cornice, and
altering the large central window with
the arms of the Farnese Pope Paul III
above it; he was also responsible for the
façades of both *piano nobile* and second
floor overlooking the court.
Right: Detail of the cornice

reduced to a single lower arch to mark the entrance to the main doorway,
presumably in preparation for Charles V's visit, although the imperial
procession was eventually diverted to the side of the hill, since the top was
not yet fit to receive him). The *piano nobile* had a series of large windows of
Guelph cross form flanked by two high mullioned loggias; and in the top
story, there was a row of small square windows. The other sides appear to
have had a central loggia opening on the *piano nobile*.

Although the restoration of the palace had been planned since 1537,
Michelangelo's design only began to be implemented in early 1563, under the
direction of Guidetto Guidetti (who is specifically mentioned in documents
as executor of the scheme and of Michelangelo's wishes). After
Michelangelo's death (and after Guidetti's which occurred at about the same
time), Giacomo Della Porta was put in charge of the work. Although Della
Porta made some changes and clarifications of his own, especially in relation
to the central doorway and the large window above, he was on the whole
faithful to Michelangelo's scheme that, during the last months of his life, had
been turned into working drawings under Guidetti's guidance and under
Michelangelo's own control.

The reason so much time elapsed between the decision to proceed with
restoration and the start of work was that the Capitoline administration had
started with modest plans to restore the old buildings, while Michelangelo
was drawing up grandiose plans involving the complete renewal of the
architectural structures around the sides of the piazza—using the existing
façades—and the addition of a third palace to be built from scratch.

The municipal authorities, fascinated by the grandiose scale of
Michelangelo's ideas, did not dare either to reject his designs or, in their
financial circumstances, to carry them out; so they could only wait in hope

of better times. These came between the end of 1561 and the spring of 1563, when Pope Pius IV spurred the communal authorities to action by suggesting a decrease of the debt caused by a loan that was guaranteed by the tax on wine. Meanwhile, some piecemeal works of rearrangement and restoration had been carried out.

Mention should be made of Michelangelo's work in rearranging plaques of marble, with the lists of victorious consuls, Roman magistrates, and military leaders' triumphs. These were previously inside the Arch of Augustus, and when they were discovered in 1546, it was decided to transfer them from the Roman forum below to the Capitoline hill. Thanks to De Angelis, attention has been drawn to this almost-forgotten minor work of Michelangelo that is documented in a contemporary print by Panvinio (page 164). Michelangelo's scheme, which was seriously disfigured in 1586, when the tympanum was removed from the top so that it could be moved to the Sala dei Fasti, consisted of four smooth pilasters, in which the fragmentary

FARNESE PALACE
The courtyard.
Shown is the detail of the façade of the two upper stories designed by Michelangelo.

marble inscriptions were placed, enclosing in the wider middle opening an architraved aedicula between two fluted pilaster strips, raised on a base and surmounted by a plaque. Above the pilasters and against the wall ran an architrave with a cornice and central tympanum. The whole arrangement only projects very slightly, as if to prevent the architecture from overwhelming the plain documentary element. De Angelis writes: "The solemnity of the task and finally the constraints, including the spiritual constraints, of archaeological restoration held in check but did not crush Buonarroti's genius. . . . Michelangelo simply wanted to introduce these glorious texts in an exalted, evocative, linguistic setting, presenting them with slow, grave phrasing. But the formal frame did not conceal at all the compressed energy of such a personal interpretation."

Michelangelo's scheme for the palace front was implemented substantially unchanged by Guidetti, who lived long enough to build the first span, and by Della Porta. He designed a façade with a single colossal order of

PLANS FOR SAINT PETER'S
From left to right are the plans following the projects of Bramante (1506), Peruzzi (1515–1520), Antonio da Sangallo the Younger (1538), and Michelangelo (from a 1569 engraving by Dupérac).

pilasters in high relief, resting on strong, high pedestals, with between each pair the openings of an architraved loggia resting on columns built close against the pilasters. The shadow that gathers in the spans of the ground-floor loggia seems to support the light travertine stone front of the upper story, scanned by windows with columns and tympanums. Over the architrave that links the pilasters, there is a slightly recessed band, above which the cornice projects, supporting in turn the balustrade of a terrace ornamented with statues. This noble, eloquent architecture is inspired by memories of ancient Rome, recreated in a highly dramatic atmosphere.

The Palazzo Nuovo (the Capitoline Museum) was built during the next century as a copy of the one facing it, in accordance with the posthumous wishes of Michelangelo, who had intended to make the piazza into a magnificent chamber open to the sky. Therefore, the wall that he himself had built at an earlier stage would not have served his purpose.

Thus, the prompting of the layout of the two preexisting buildings determined the piazza's trapezoidal form: a piazza enclosed on each side, with four normal entries to the main axis beside the two longitudinal palaces, and a main entry from the direction of the city center that was to connect with the planned Via Capitolina and that Michelangelo designed as a *cordonata*, a broad pathway with parapets on either side and long shallow steps. The *cordonata* started its climb up to the middle of the hill from the same point as the stairway to the Aracoeli, diverging from the stairway to emphasize once again the autonomy of the seat of civic government. In practice, the *cordonata* had to be lengthened slightly beyond the point where it joined the Aracoeli stairway and beyond the start of the piazza to make the otherwise rather steep ascent easier.

The balustrade of the piazza towards the *cordonata* was also begun during

Michelangelo's lifetime. The four statues of emperors that can be seen in the first edition of the Dupérac engraving were replaced by two *Dioscuri* (sons of Jupiter). This was not the pair from Monte Cavallo (the Quirinal) as the pope had wished but an inferior pair that had been discovered in 1560. Castor and Pollux, as Ackerman has explained, had from time immemorial been regarded as a symbol of the struggle for freedom from tyranny and these two figures seem to have been featured on the ancient Capitol with the same significance. (Their presence in defense of the piazza must have pleased Michelangelo.) However, when Charles V was crowned by Clement VII in Bologna in 1532, the pair had also been viewed as symbolizing the brotherhood of papal and imperial power, and this is perhaps why Paul III was so eager to raise their images on the balustrade of the Capitoline piazza.

Besides the orientation of the two old palaces, another element played a large part in firing Michelangelo's imagination: the arrival of the equestrian statue of *Marcus Aurelius* in the still-rough and unkempt open space of the Campidoglio. Since throughout the Middle Ages, the statue was thought to represent Constantine, it was carefully kept in the place of honor in the piazza del Laterano. When it was moved, it was believed to be a portrait of Antoninus Pius, and so it became a symbol of the Roman spirit not hostile to Christianity. Michelangelo placed it, with its face turned towards the city center below, in the center of the future piazza, on an axis with the center of the Senator's Palace. He designed and probably immediately began to build a roughly oval pedestal placed along the axis of the piazza.

In 1561, to implement a scheme prepared by the architect since 1539, work started on digging out and shaping the three steps (now only two) forming an ellipsis along the same axis as the *Marcus Aurelius* and the piazza that make a slightly sunken area around the monument. Inside this sunken area, the pavement that the artist designed and that Dupérac scrupulously reproduced was divided by a stellar pattern, inspired by medieval cosmographic designs, and intended to imply that the *umbilicus mundi* was there, at the center of the piazza, where the mounted emperor stood. Recent research has rightly recognized that the pavement design is as important a part of the piazza's architecture as the three majestic palaces and the *Marcus Aurelius*. The design has exceptional, dynamic force that produces a release of centrifugal energies, setting up a dramatic dialogue with the piazza's trapezoidal outline. This confirms that in Michelangelo's plans the piazza was meant to be seen first from the slow approach up the *cordonata*. From a distance, the divergent lines of the two palaces are not apparent, and they seem to be parallel and at right angles to the front of the Senator's Palace. Similarly, the lengthwise pavement oval is foreshortened and looks circular. But gradually, as one advances, the divergent lines of the two buildings are revealed, pushing the mass of the Senator's Palace towards us, while the pavement gradually reveals its oval form and seems to push towards the back of the piazza. This creates a slow rotation of powerful masses and an interplay of contraction and expansion at ground level in relation to the volumes that surround or, rather, contain it. The whole space is imbued with this dramatic tension that is underlined by the tense, contrasting forms of the buildings.

Michelangelo's layout of the Campidoglio represents a vision of contrast, and of dramatic effect, between open and enclosed space, which is here expressed in two ways: in the dialectic between the appearance the piazza has of being a noble chamber and the conception of it as a terrace (De Angelis writes: "We are aware of a hilltop light around us, breaking from the long balustrade overlooking the city and from the gaps between the buildings, that confirms the effect of height and that makes us feel the throb of nature") and in the presence of the four secondary side exits to which one is drawn by the short radial routes of the oval pavement design. The visitor is thus driven to seek relief in the scenographic views of the exits (the

DOME OF SAINT PETER'S
Polychrome wooden model
Vatican City, Basilica Vaticana, Sala
dell'Immacolata

SAINT PETER'S
Vatican City
The dome that Michelangelo designed between 1557 and 1561 was begun and built as far as the drum before his death. Work then continued under Giacomo della Porta, and the dome was finished in 1593.

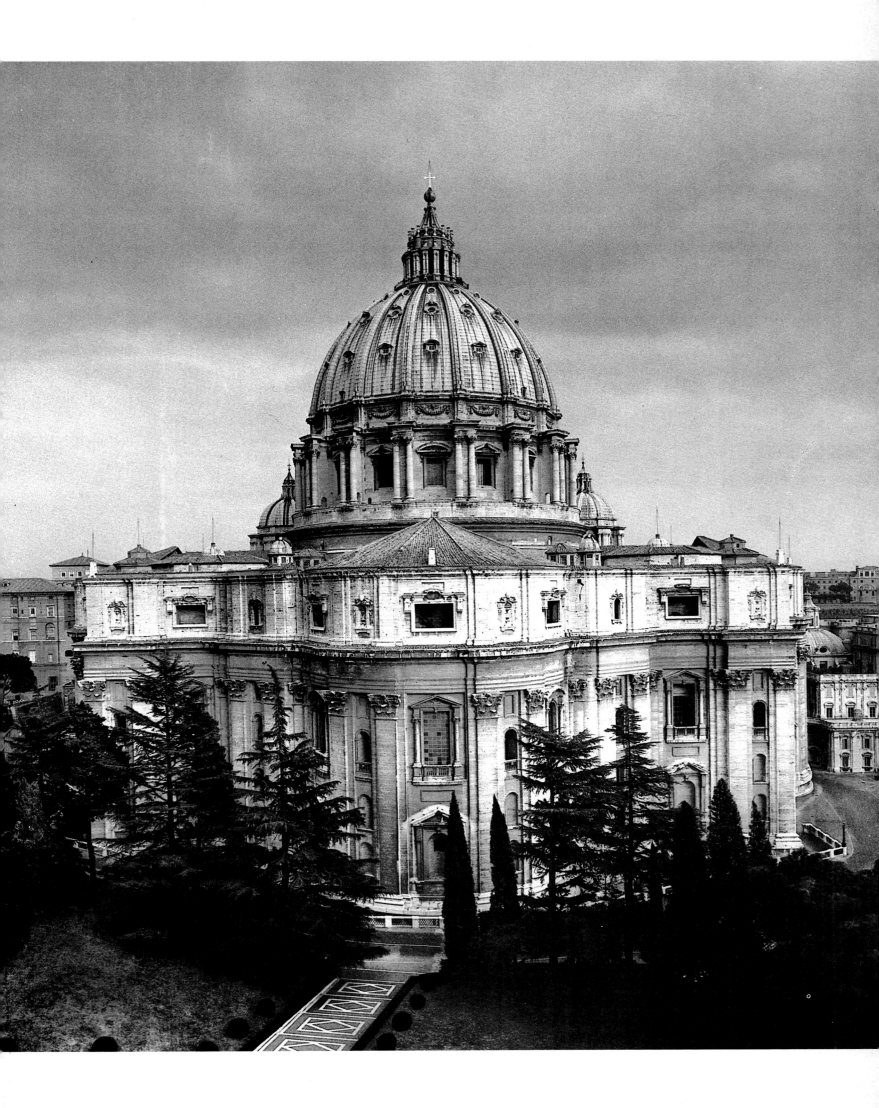

two near the Senator's Palace end in stairways leading to two symmetrical loggias, rather skimpily executed by other architects), as if to release the tension that accumulates during his presence in the piazza.

The oval pavement was never completed at the time; and views dating from the mid-seventeenth century, when the scheme as planned by Michelangelo was finally completed with the building of the Palazzo Nuovo, show only radial lines inside the oval. The pavement design was not carried out until 1940, under Antonio Muñoz, but the third step was not restored, and, as De Angelis has pointed out, there are some inaccuracies, the most serious being the circular rather than oval perimeter of the paved star around *Marcus Aurelius*. The failure to build the loggia at the top of the Senator's Palace staircase, together with the reduction of the building's top story, helped to weaken the three-dimensional harmony with the pavement

STUDY FOR THE DOME OF
SAINT PETER'S
Black chalk and pen drawing
$10 \times 10\frac{1}{8}$ in. $(25.5 \times 25.7$ cm)
1546
Lille (France), Musée des Beaux Arts
The drawing shows a section of the dome and a view of the drum. There is some disagreement about the authenticity of this drawing; Dussler attributes it to Giuliano da Sangallo or an assistant.

APSE OF SAINT PETER'S: Detail
Vatican City
The story of the modern Saint Peter's begins in the early sixteenth century, when Julius II decided to commit himself to rebuilding the basilica. Bramante, Raphael, Antonio da Sangallo the Younger, and Baldassarre Peruzzi then produced a succession of projects and contributed to the scheme. Michelangelo first became involved with the basilica in 1546; in 1547, he was appointed architect of the Fabbrica of Saint Peter's and devoted himself to this task until his death. The outer wall of the apsidal complex and the dome are the parts in which Michelangelo's contribution is most notable.

of the piazza, and this was not adequately counterbalanced, when in 1578–83 Martino Lunghi built a new Torre Civile to replace the previous one which was not on the same axis as the piazza. Despite this and other departures from the original scheme, such as the gentler slope of the *cordonata* that reaches slightly into the piazza itself, the Capitoline hill today still proudly bears the mark of Michelangelo's genius as architect and planner.

From the end of 1546, immediately after the death of Antonio da Sangallo the Younger, Michelangelo began to devote himself to the building of Saint Peter's with a fervor that lasted until the end of his life. But this work, too, remained unfinished; and the dome itself, the fulcrum of the entire architectural concept, was built by others. The whole basilica, except for the front nave and the façade, fulfills in its general lines and in many particulars Michelangelo's magnificent vision. Here again, the constraints imposed by what had been designed and built over the previous forty years acted at least in part as a stimulus to his imagination.

In his famous letter to Ammannati, Michelangelo praises the talents of Bramante: "One cannot deny that Bramante was as worthy an architect as any from ancient times onwards. He laid down the first plan for Saint Peter's, not full of confusion, but clear and pure, full of light and set apart ... and it was regarded as beautiful, as can still be seen." This should not perhaps be taken too literally, since on this occasion it was intended to justify the criticism leveled at Sangallo ("anyone who has departed from Bramante's said order, as Sangallo has done, has departed from truth"). But certainly in Bramante's scheme, Michelangelo found a magnificent unity of space, sonorous and universal, in his clear, tranquil coordination of spaces that, in a dynamic and dramatic manner, had to be modified to subordinate all the lateral spaces to the dominant central space of the dome. The outer perimeter, as Bramante envisaged it, although quite in keeping with the distribution of space inside, must have provoked a reaction in Michelangelo and set him in search of forms as plastic and full of movement as his predecessor's had been volumetric and crystalline.

Baldassare Peruzzi had already tried to loosen Bramante's firm volumetric and spatial fabric by projecting the curved apses and square towers outside the perimeter, adding an ambulatory around each apse on the inside. This resulted in an undoubtedly light and elegant design. However, Sangallo kept the projecting apses and the ambulatory but brought the towers inside the main perimeter again; and he planned to lengthen the east arm of the cross, adding two more towers and dividing the whole up inside into different spaces by the use of large-shaped pilasters. As a result, the building would have been complicated and very dark, because the ambulatories would have been much more closed in than in Peruzzi's plan. Michelangelo was able to demolish the south arm that Sangallo had built. For the time being, he preserved the tribune of the west apse that Rossellino had built (now almost a prehistoric part of the monument), which was in fact demolished after Michelangelo's death to be rebuilt exactly on the model of the south and north arms Michelangelo had built.

Michelangelo, however, learned something from the much-despised Sangallo, although he gave it new significance: the idea of having an east arm ending in a façade instead of a fourth apse and the use of the colossal order that Sangallo had used inside and that Michelangelo transferred to the exterior to make it the dominant note of the vertical thrust of the masses and their complex horizontal plastic development. Bramante, inspired by the architecture of the Byzantine *martyrium*, had conceived a building perfectly equal and symmetrical in the four arms of the inscribed Greek cross and in the four sides of the circumscribed square. This would have given a solemn, abstract, immobile quality to the volumes and spaces. Michelangelo accepted Bramante's layout because he realized that he could transform this completely static quality into dynamic intensity, changing the immobile coordination of volumes and spaces into a dramatic concentration. By making the end of the east arm of the Greek cross rectangular rather than semicircular without making it longer in relation to the opposite arm and the two side arms and by eliminating as a result the two oblique linking sections between the semicircle of the eliminated apse and the straight lines of the square, Michelangelo introduced a suggestion of a longitudinal axis, in antithesis to the dominant thesis of the central plan, and thus created a tension. Instead of Bramante's arrangement of small lateral spaces beside the large central Greek cross, which created an effect of tranquil, coordinated space in the interior and of crystalline volumes on the outside, Michelangelo contracted spaces and masses, gathering them closely around the dominant space and mass of the dome. As Ackerman puts it: "He surpassed the clarity that he admired in Bramante's plan in substituting for the concept of major and minor crosses a more unified one of an integrated cross-and-square, so that all circulation within the basilica should bring the

PORTA PIA: View from via Pia (now via XX Settembre) 1561–1565. Rome
In 1561, "Mastro Michelagnolo" was commissioned to design a new gate for the Aurelian Walls, between Porta Salaria and Porta Nomentana, to connect with via Pia. The work made rapid progress and was probably completed in 1565. Some plans of Rome in the 1570s show the gate already finished, including the attic at the top that was later destroyed and not rebuilt until the nineteenth century.

visitor back to its core. Unity was Michelangelo's contribution to Saint Peter's; he transformed the interior into a continuum of space, the exterior into a cohesive body. The structural technique—a revival of the heavy, plastic wall-masses of Roman and Byzantine architecture—permitted Michelangelo to treat the body of the basilica as a sculptural block and left him free in the choice of surface articulation; the exterior orders were to be exclusively expressive."

The colossal order of powerful pilasters with strips behind them expresses the theme of vertical upward movement and at the same time (since they almost completely hide the wall behind which survives only around the window and niche openings) shapes the great mass horizontally so that in the end it seems to be molded by a sculptor's thumb rather than measured and designed with an architect's set square.

An engraving by Vincenzo Luchino, dates 1564, and other graphic records have led many scholars to believe that Michelangelo first adopted a very simple, bare solution for the attic, consisting of a series of arches in the solid wall. But Gioseffi has remarked that "these arches do not in any way belong to the external covering of the attics; they were not visible except in one place during a long but temporary suspension of the works"; they in fact open "in the middle of the thickness of the final wall." They belong not to the exterior but to the interior of the apses and were intended, right from the start, to be masked by the attic facing. There seems to be no doubt that the solution later put into effect (partly during Michelangelo's lifetime, as is shown by Dupérac's engraving of the 1565 tournament at the Belvedere) was the one conceived by Michelangelo: the horizontal windows (similar to those of Porta Pia), which are between double pilaster strips that, after the interruption of the cornice, take up the rhythm of the pilasters of the colossal order, introduce a dialectic of horizontal and vertical elements (dramatized by the projecting frames) that provides an element of contrast and elasticity before the final thrust of the dome.

The present dome both is and is not the one Michelangelo designed. It was built by Giacomo Della Porta from 1588 to 1593. But much of the drum was built during Michelangelo's lifetime and to his design. In both the interior and the exterior, the basic motif is supplied by pairs of projecting members with windows between them; but in the interior, they are relatively flat pilaster strips that provide interest without detracting from the majesty of space, whereas on the exterior, they are pairs of separate columns attached to solid wall-projections and bear cornices that project still farther. This creates an intensely three-dimensional effect. The base of the dome was meant to be linked by volutes, which were never realized. The precise form of the dome as Michelangelo conceived it during the course of the fifteen years he spent designing the scheme and directing work on the building is still a subject for discussion. Della Porta made alterations to the large wooden model, and there are discrepancies among various undated sketches by the artist, drawings by his followers, and engravings that claim to reproduce his project. The one thing that is certain is that Michelangelo, inspired by Brunelleschi's dome in Florence, designed his dome with a double-shell construction, with an elevated curve of the outer shell in relation to the inner. But since the curve of the present dome, which already figures in the Vatican model following the changes Della Porta made to it, seems more ogival than the curves conceived by Michelangelo at any time, discussion centers around the angle of the ogive as designed by Michelangelo and the chronological sequence of the different projects.

In general, it has seemed reasonable to assume that the progression was from hemispherical or almost hemispherical solutions to the ogival solutions that finally culminated in the form adopted by Della Porta. Michelangelo was interested in the dome of Florence cathedral at an early stage, as is shown by his letter of July 30, 1547, in which he asks his nephew Lionardo to

CONSULAR AND TRIUMPHAL FASTI
Panvinio's engraving shows the setting Michelangelo designed on the Capitoline Hill for the Roman marble fragments bearing lists of names of magistrates and military triumphs that were found in the Roman forum in 1546.

measure for him "the height of the dome of Santa Maria del Fiore, from where the lantern begins to the ground, and then the height of the whole lantern." He was, however, concerned with the proportional relationship between the lantern and the height of the dome and not with the shape of the dome itself. But probably even before this, Michelangelo had in mind the Florentine dome—the emblem of his native city and the monument that was closest in size to the dome that was to be built in Rome. The use of external ribs, derived from Brunelleschi's masterpiece, was an initial and lasting feature of Michelangelo's design for the dome. This makes Ackerman's thesis attractive; he suggests a progression in the opposite direction, from the ogival solutions of the Haarlem and Lille drawings to the solution recorded in about 1569 in Dupérac's engraving, which shows the dome as

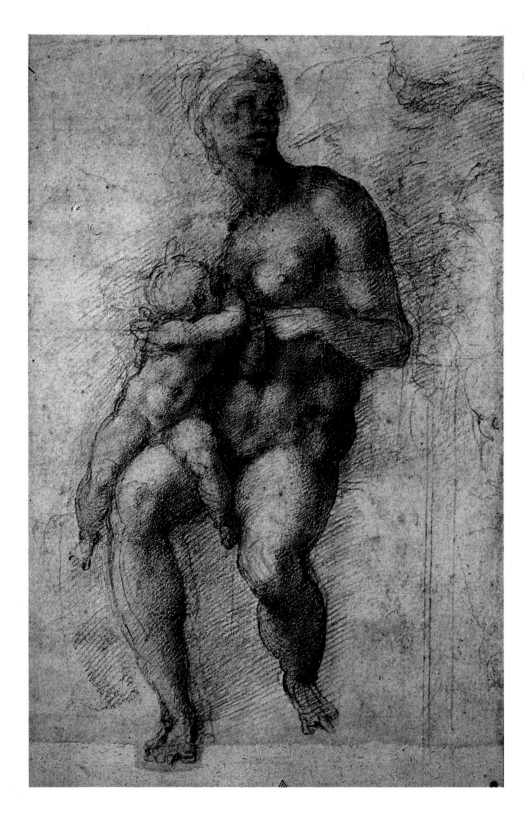

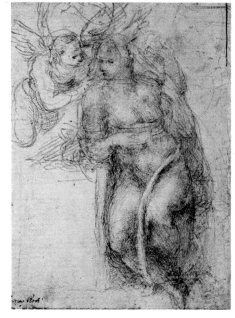

STUDY FOR AN ANNUNCIATION
Black chalk drawing on paper
$11\frac{1}{4} \times 7\frac{3}{4}$ in. (28.3 × 19.6 cm)
Circa 1547
London, British Museum
A copy by Marcello Venusti shows Michelangelo's interest in this theme; on the *verso* of the drawing, there is an annunciation angel. According to Berti, "The chiaroscuro is ... vibrant, the realization of form pictorial, as if commenting upon the message whispered by the angel so close to the Virgin Mary."

MADONNA AND CHILD
Black chalk drawing on paper
$12\frac{1}{2} \times 7\frac{1}{2}$ in. (31.7 × 19.1 cm)
Circa 1533
London, British Museum
Although sometimes thought to be related to the *Medici Madonna* in the Sagrestia Nuova of San Lorenzo, this drawing may be an independent, later work exploring further the conception of the earlier statue.

CRUCIFIXION
Black chalk on paper
$14\frac{1}{2} \times 10\frac{3}{4}$ in. (37×27 cm)
Circa 1540
London, British Museum
This is probably the drawing mentioned in correspondence between Michelangelo and Vittoria Colonna or is a copy of the lost original.

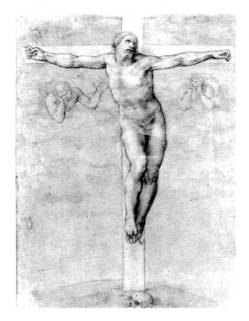

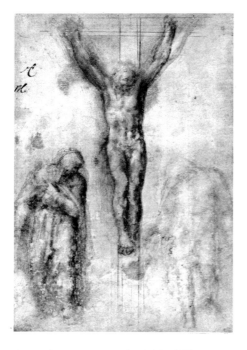

CHRIST ON THE CROSS WITH THE VIRGIN AND SAINT JOHN
Black chalk and white lead
$17 \times 11\frac{1}{2}$ in. (43.2×29 cm)
Circa 1540–1557
Paris, Musée du Louvre

Facing page: CHRIST ON THE CROSS BETWEEN THE VIRGIN AND SAINT JOHN
Black chalk and white lead
$16\frac{1}{4} \times 11$ in. (41.2×27.9 cm)
Circa 1550–1557
London, British Museum

hemispherical or almost so. However, the argument advanced by Gioseffi is even more convincing and is cleverly supported by mathematical calculations. He claims that the dome of the famous Vatican model, on which the building was based, reproduces the form and curve conceived by Michelangelo. Della Porta must, therefore, have simply raised the outer shell by a height equivalent to that of the attic. This "involved inserting, between drum and shell, an additional ringlike structure, decorated with the same cornices and moldings that had previously qualified the lower part of the wooden shell as an attic in the original version." On the basis of his inspection of the model, Gioseffi continues, "The additional structure is revealed on the front of the section by the two inset pieces that are seen to be inserted below the horseshoe center."

To get an impression of the dome as Michelangelo designed it, the outer shell simply has to be lowered to its original level. This gives a dome with a semicircular section inside, covered by an outer shell with a lowered, ogival profile. It differs from the outer shell of the model as altered by Della Porta not because it has an acute curve but because it is lower and so fits more closely over the powerful movement of masses of the bulk of Saint Peter's. The solemn space of the dome interior, animated three-dimensionally by the pilaster strips of the drum, resolves the dialectic of opposing forces by reconciling and submerging them in a divine immensity. On the exterior, the ogival dome, with its double raised ribs, crowned by a high lantern that repeats the motif of the paired columns of the drum, gathers together the dramatically interacting apsidal masses in an upward surge full of tension yet with a sense of repose and fullness that seems to mark the peaceful resolution of the human drama in which earlier laborious effort is not forgotten.

Della Porta, anticipating that the basilica would be completed as a Latin cross, raised the outer shell. This proposal, which was already starting to be discussed in about 1580, would prevent the dome from being lost behind the east arm when seen from the front. When he built the dome, he raised the angle of the profile a little more, so that the present dome, particularly when seen from the Vatican gardens, has a vertical surge that Michelangelo had not foreseen and that to some extent weakens the impact of the compact interplay of the building's masses. Yet even in Della Porta's not-very-faithful realization of the scheme, the tense, elastic form of the dome, despite the unforeseen element of its greater upward thrust and lightness, unites and exalts the drama and torment of the vigorously molded masses of the apsidal complex, in a total state of spiritual yearning. Unfortunately, the excessive length of the east arm, with its façade and deep atrium built by Maderna and extending much farther than the front of the old palaeo-Christian basilica, meant that Della Porta's precautionary measures were inadequate. From the center of the piazza, built by Bernini with such incomparable theatrical skill, the dome is not the dominant feature that Michelangelo's dome, although not as high, would have been at the center of the Greek cross, or as Della Porta's would have been if the arm of the Latin cross that he had foreseen had not been longer than the naves of old Saint Peter's.

Michelangelo's feverish activity in Rome also involved the church of the Florentine colony, San Giovanni; the scheme for the Sforza chapel in Santa Maria Maggiore; the conversion of the *tepidarium* of the Baths of Diocletian into the church of Santa Maria degli Angeli; some work on the city fortifications; and the partial construction of Porta Pia to complete a fine scheme of urban design commissioned by Pope Pius IV —the straight linking road between the Quirinal and Sant'Agnese fuori le Mura on the via Nomentana. Porta Pia (page 163), built from 1561 to 1565 at the edge of the city, fits perfectly into the scheme of urban design that can probably be attributed to Michelangelo's inspiration, although there is no documentary evidence of this. Ackerman and De Angelis both emphasize the scenographic

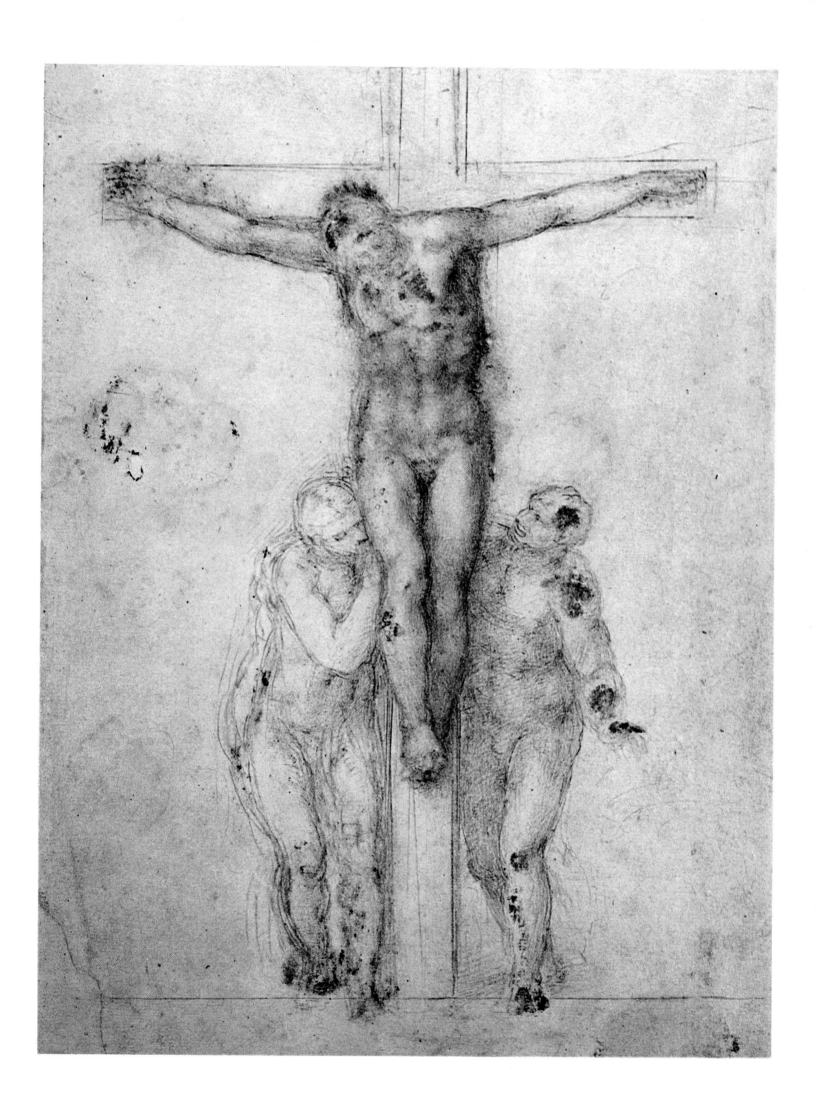

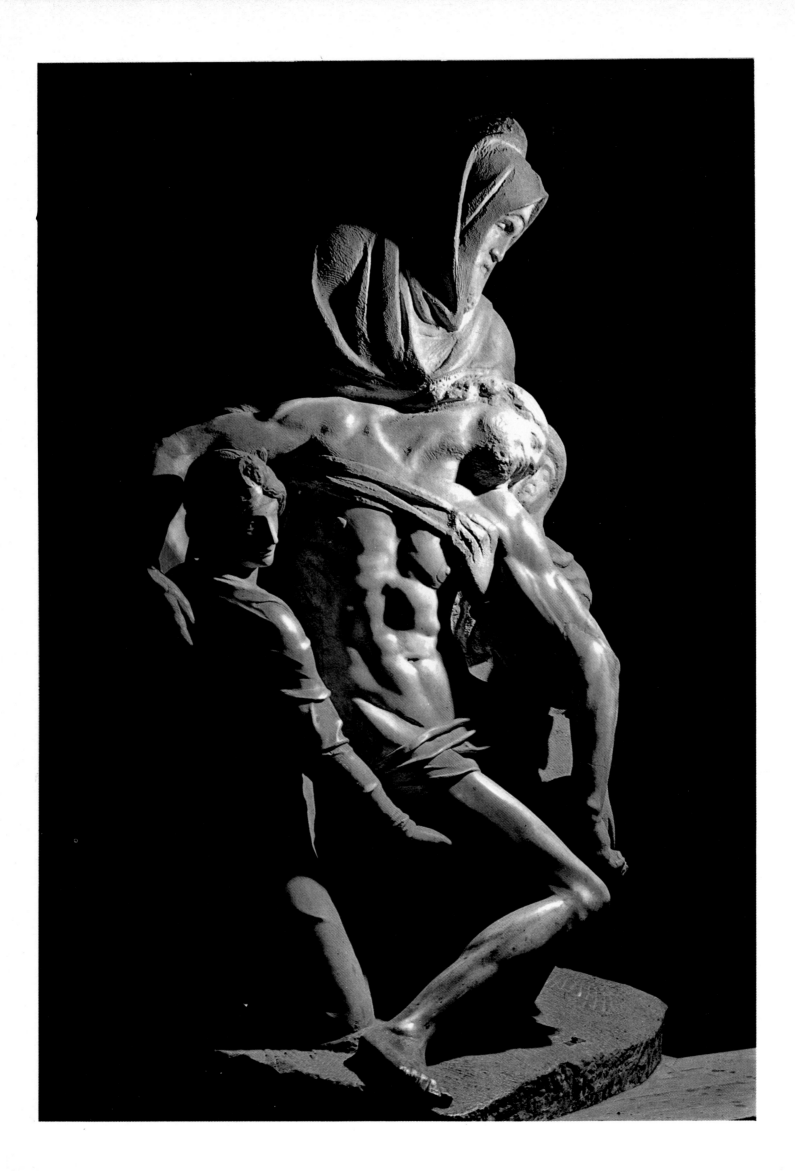

STUDY FOR A DEPOSITION
Red chalk drawing on paper
14¾ × 11 in. (37.5 × 28 cm)
Circa 1555
Oxford, Ashmolean Museum
The suggested dating is simply a guideline, as there are indications that the drawing may belong to a much earlier period. It is perhaps a preparatory drawing for a cartoon mentioned in the inventory of Michelangelo's possessions as portraying "a *Pietà* with nine unfinished figures." The drawing is not universally accepted as Michelangelo's work, and Sebastiano del Piombo and Rosso Fiorentino among others have been suggested as possible authors.

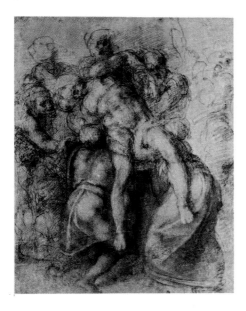

PIETÀ
Marble
Height, 89 in. (226 cm)
Circa 1546–1555
Florence, Cathedral
Michelangelo left the group unfinished after flaws in the marble had caused it to break in several places, damaging Christ's left leg, left arm, and torso. He gave the work to Francesco Bandini, and it remained in the possession of his heirs until 1674, when it was transferred to San Lorenzo in Florence. During the next century, it was moved to Florence Cathedral and was placed first behind the high altar and then in its present position in the first chapel on the right in the north tribune. While Michelangelo was still alive, Tiberio Calcagni worked to finish the group, but he died in 1565 before he had completed the work.

Pages 170–171: Detail

character of Michelangelo's building, designed to be seen from a distance as a backdrop to a long street bordered by occasional noble buildings (like the customary stage-settings for tragic drama in the late Renaissance). The solemn gate has the usual three-dimensional qualities and power of Michelangelo's architecture. This is particularly seen in the architect's intentions to have the free-standing central attic act as one of the four faces of a tower. The present gateway differs from Michelangelo's conception (reproduced in a 1568 engraving by Faletti) by the absence of the two lateral obelisks that were perhaps never erected and by the different form of the attic, which was originally a simple tympanum but collapsed a few years later and was rebuilt in its present form in 1853.

It is important to note that on the city side the gate stands well out from the line of the Aurelian Walls; and instead of being part of the walls, the gateway, with its own volume and three-dimensional values, is an independent building. The portal, which consists of a flattened rustic arch, flanked by two fluted pilasters and surmounted by a sturdy, prominent tympanum projecting beyond the doorway at the sides, expresses the theme of contrast between upward forces and downward traction that is resolved in the elastic form of the flattened arch. With a slight shifting of emphasis to the vertical movement, the theme is echoed in the two sets of three real and fictive windows that become progressively lighter towards the top. These tensions are united and resolved in the upward surge of the high attic, completed by its classic tympanum. The gateway to the countryside, projecting slightly from the walls, was not built until 1853; but as De Angelis claims, two medals struck by Federico Bonzagni in 1561 suggest that its appearance followed those of Michelangelo's ideas that had not been carried out. "The contrast between the large portal and the small openings on either side of it was to provide a glorious measure of the gate's freedom and great majesty. It would appear set in the magnificent turreted city wall to anyone coming up the straight road of via Nomentana (De Angelis)."

This is not the place to discuss Michelangelo's scheme for Santa Maria degli Angeli since the parts built by him or according to his design were radically altered by Vanvitelli during the eighteenth century. But some reference must be made to what was probably Michelangelo's last gift to his native city, the Ponte Santa Trínita. Over thirty years ago, Kriegbaum drew attention to a passage in a letter from Vasari (then in Rome) to Duke Cosimo in 1560. Vasari writes: "I have visited Michelangelo every day, and we have dealt with the drawings of the Ponte Santa Trínita; he has discussed it with us a great deal, so that I will remember the writings and drawings according to his intentions, with the measurements I took from the site."

The bridge was eventually built by Bartolomeo Ammannati from 1567 to 1569, but it seems very likely, as Kriegbaum and Ragghianti claim, that Michelangelo's suggestions and drawings, brought to Florence by Vasari, supplied the masterly idea of the succession of three flattened arches. The dramatic tension of the arches, the extended elastic arch of the footway and the parapets, and the way the bridge fits into the city's structure and layout seem to bear the mark of Michelangelo's genius. Kriegbaum wrote: "The raising of the level of the bridge above the level of the banks was a common feature of all medieval bridges in Florence. But the Ponte Santa Trínita is raised so much that anyone crossing it really seems to be climbing a hillside, while the bridge ends, which slope down a long way into the adjoining quarters, establish an intimate relationship with the inhabited area, giving the impression that, with this marvelous extended arch, the street makes a vigorous bound and then continues on its peaceful way between the houses of the city."

It is true that the profiles of the cornices have a quality of ingeniousness that betrays Ammannati's subtle Mannerist taste, and the elegant cartouches must also have been conceived by him. The slightly later

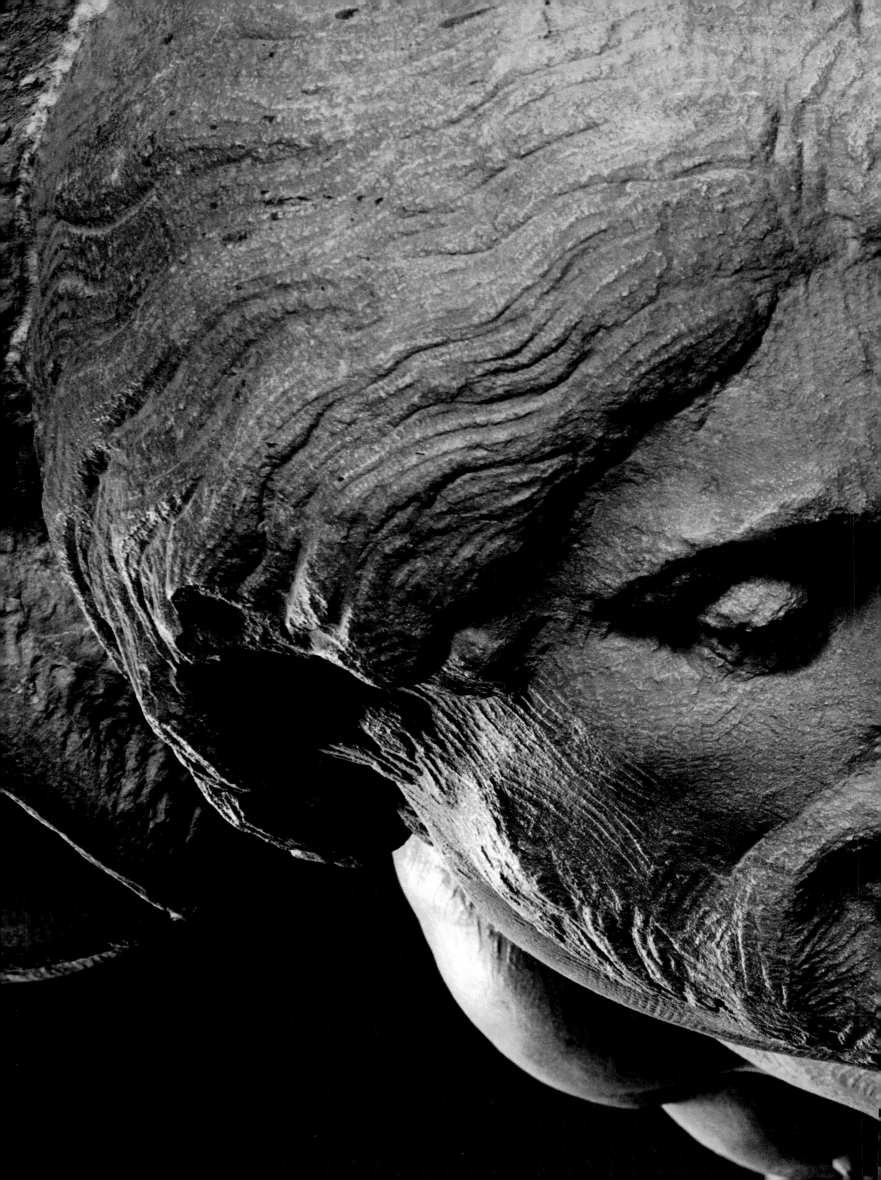

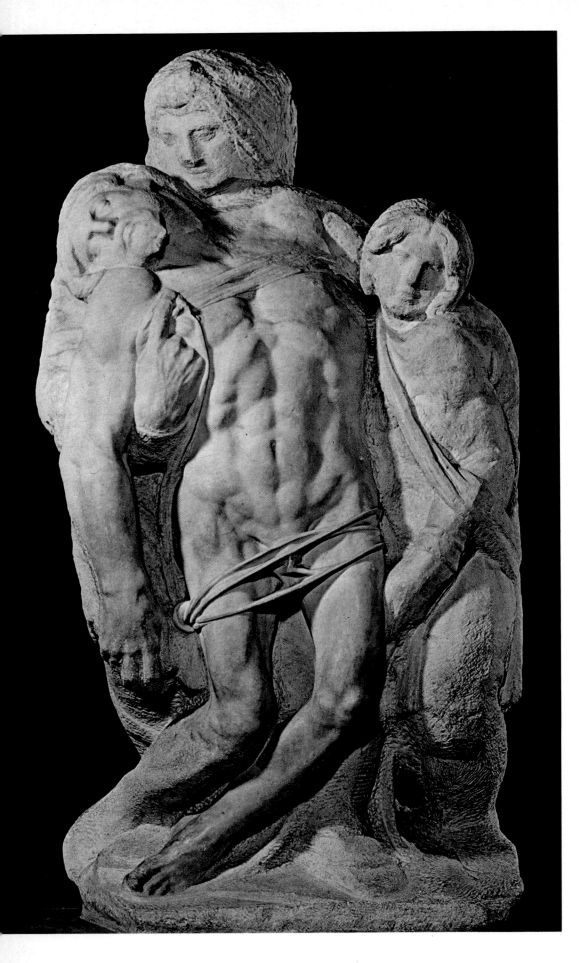

THE PALESTRINA PIETÀ
Marble
Height, 100 in. (253 cm)
1550–1560
Florence, Galleria dell'Accademia
There are widely varying opinions about the authorship and date of this group. The work is not mentioned in sources and is not recorded as Michelangelo's until the eighteenth century. The date is generally thought to be somewhere in the 1550s, although there are suggestions that it may belong to the previous decade. Most critics believe the group is by Michelangelo, although Tolnay among others does not accept this attribution Some scholars think that only the original idea is Michelangelo's and that the group was executed by other hands. The *Pietà* is named after Palestrina, where it stood in the Barberini chapel in Santa Rosalia for many years, until it was transferred to the Accademia in 1940.

Page 173: Side view

addition of the four statues of the *Seasons* also provides an idyllic note that underlines the subtly Mannerist tone of the work. But the main lines of this elegant structure are those that sprang from Michelangelo's imagination.

We must now end with a brief examination of Michelangelo's sporadic private activity as a sculptor, which, with his heavy commitments in

architecture and town planning, involved him wholeheartedly in ceaseless activity right up to his death. The works in question are three *Pietà*s and three meditations, several times interrupted and begun again on a fresh note, on the theme of sacrifice, Faith, and death. The *Pietà* that Grand Duke Cosimo III had moved to Florence in the second half of the seventeenth century and that after a long period in the vaults of San Lorenzo was finally placed in the cathedral in 1721 (although it has since been moved a number of times) was already mentioned in the first edition of Vasari's *Lives*. The work must have been begun in the 1540s, at the time of the Pauline Chapel and the start of Michelangelo's work on Saint Peter's. But in 1553, it was still unfinished and Michelangelo himself damaged Christ's left leg and broke off other segments that were scrupulously gathered up and mended by Tiberio Calcagni. Calcagni later completed the figure of *Mary Magdalen* that Michelangelo had only rough-hewn. This figure is necessary to the iconography and is an external justification for the position of Christ's body as it is lowered from the imagined cross. However, it stands too much apart from the other three figures that Michelangelo conceived as a composite unit. The slow, unbroken torsion of Nicodemus's hooded head runs down through the S-shape of Christ's body to his knee, where the long, thin leg bends to form a right angle. From here, one can follow up the Mother's body, which closes the composition on the right. Her head, close to Christ's and set against the curve of Nicodemus's shoulder, marks a tender, sorrowful pause in the unbroken, downward movement. This is a sublime image of grief that is tinged with tenderness and a gentle, almost Leopardian, profound stillness. It is the counterpart in terms of the microcosm of the individual soul of the universal peace that is the culmination of man's troubled, spiritual life in the dome of Saint Peter's.

The *Palestrina Pietà* (page 172), which used to be in the chapel of the Barberini Palace in Palestrina and since 1939 has been, together with the *David, Saint Matthew*, and the *Captives* for Julius's tomb, in the Accademia Gallery in Florence, is a work initiated by Michelangelo but largely executed or retouched by a pupil or later imitator. However, much of the original idea survives in the close interpenetration of the three bodies. The lengthening of

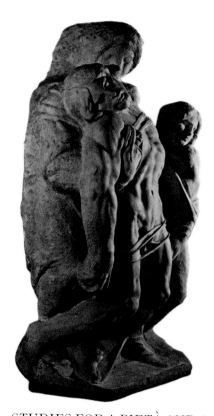

STUDIES FOR A PIETÀ AND A DEPOSITION
Black chalk drawing on paper
$4\frac{1}{4} \times 11$ in. (10.8×28.1 cm)
Circa 1542–1550
Oxford, Ashmolean Museum
On these two combined sheets, there is a series of five studies for a *Deposition*. The two on the left show an early idea for the *Rondanini Pietà*, while the last one on the right is related to the *Palestrina Pietà*.

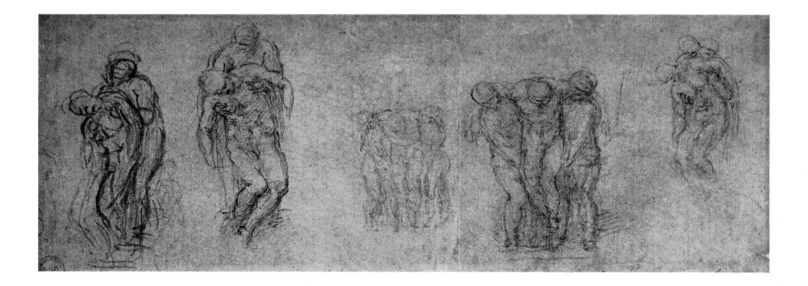

the figures is a prelude to the *Rondanini Pietà* (page 175), now in Milan, which shows signs of continual changes of mind on the part of the artist. According to some theories, the *Rondanini Pietà* was begun before the *Pietà* now in Florence cathedral and underwent a change in 1555, Christ's detached arm on the onlooker's left being a survival of the first version.

According to another very recent and attractive, though not fully

documented, hypothesis, the group was begun even earlier as a gift for Vittoria Colonna, but because of some obstacle to the work, this intention was never carried out. In the second version, Christ, supported by his Mother, had his head and shoulders bent forward, so that the figure, in keeping with the way the legs are bent, was still the sad, tender, lifeless body of the dead Christ. But in the last days of his life, Michelangelo decided to change the work's form and meaning: he cut Christ's head and shoulders

 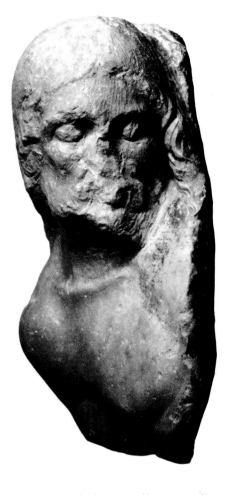 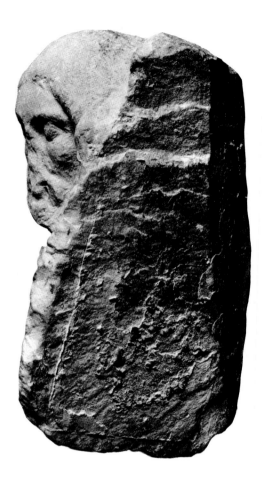

away from the block (the precious fragment has recently been rediscovered), turned the Madonna's head the other way, and carved Christ's new head from her shoulder. The two figures were thus even more closely united and, as Tolnay remarks, the Redeemer's body now seems to be rising rather than falling, "braving the laws of gravity and becomes a support for the figure of Mary, who leans against him and seems to draw the warmth of life from his inert form. . . . Once again, Michelangelo has subordinated physical beauty to the irradiation of the soul." The forms become longer, more slender, and ghostlike; the painful torsion is weakened but does not disappear; and the sculptor makes increasing play on the contrast between smooth surfaces and the rough texture of the unfinished parts, in a muted vision of deep, twilight meditation.

As he neared his end, Michelangelo feverishly pursued images that could express his wish for annihilation in "quell'amor divino/Ch'aperse a prender noi in croce la braccia" (that divine love, who opened his arms on the cross to receive us). The broken rhythm of the verse again suggests the pain and suffering the soul must undergo before being united with God. This thought is also expressed in the roughness and residual tensions of this *Pietà*, in which he struggles to attain the utmost spirituality of form.

In conclusion to this brief account of the life and works of the most extraordinary artist of all time, it can perhaps be said that every one of his

THE FIRST CHRIST FOR THE RONDANINI PIETÀ
Three Views
Marble
Frontal height, 23½ in. (59 cm)
Michelangelo's first rendering of the head of Christ for the *Rondanini Pietà*. When found, it was part of a seventeenth-century wall near the church of Santa Maria in Trastevere in Rome, and was recognized in a Roman collection by Bruno Mantura in 1973; it was recovered in Switzerland in 1976. Mantura has given a detailed description of the marble in the account of his find written for the *Bollettino d'Arte* 4, 1973.

THE RONDANINI PIETÀ
Two views
Marble
Height, 77 in. (195 cm)
Circa 1546–1564
Milan, Museo del Castello Sforzesco
This work was started just before or just after the *Pietà* in Florence Cathedral. Vasari claims that Michelangelo was still working on it a few days before his death. After an uncertain history, the work was placed in the Palazzo Rondanini. It was then bought by the city of Milan and moved to the Castello Sforzesco in 1952.

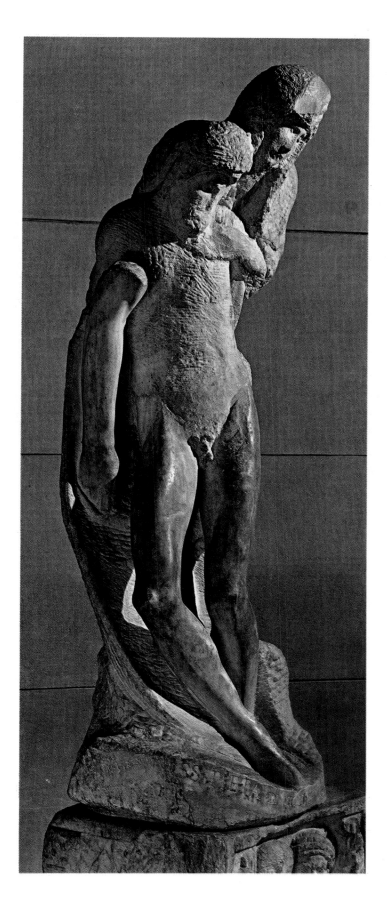 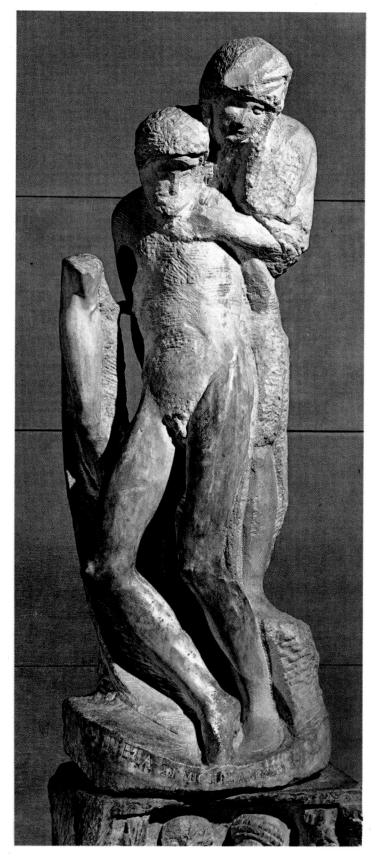

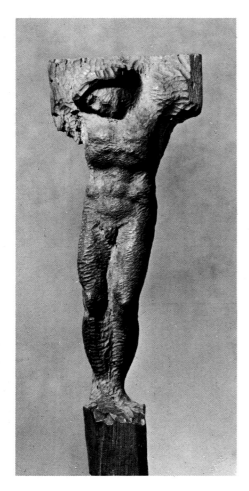

CRUCIFIX
Wood
Height, 8in. (20.5 cm)
1562
Florence, Casa Buonarroti
First attributed to Michelangelo by
Tolnay in 1965.

works, whether in carved marble, in line and color, in the elevation of masses and spaces, or composed in words, reveals beneath the light of the artistic image the shadow of a confession. This man, described as "divine" by his contemporaries, was on the one hand passionately attached to the world and to life, yet on the other driven by a troubled moral consciousness and a continual longing for heaven. He was solitary and difficult because his haughty, painful morality inevitably brought him into conflict with the trouble of the world. Although he shared in the conviction of humanist and Renaissance thinkers that art was a mental exercise involving spiritual and intellectual powers, he did not scorn the humble workmanship of its manual side: he revived the medieval idea that the sweat the artisan's labor brings to his brow is noble.

Replying in 1547 to Benedetto Varchi on the problem of the comparison of the arts, he admits that the arguments of his learned interlocutor have swayed him and that painting and sculpture, both daughters of drawing and aiming at the same end, are the same thing. But he cannot help commenting that "I used to think that sculpture was the lantern of painting and that, between one and the other, there was the same difference as between sun and moon." He agrees to accept Varchi's point of view only "if greater judgment and difficulty, obstacles and effort, do not make for greater nobility."

These words sum up the essence of Michelangelo's moral and artistic theory: his concept of life and art as a struggle to discover "in pietra alpestra e dura/Una viva figura" (in hard alpine stone a living figure), an image of beauty that raises man up to God. This sense of morality inspired the unequalled masterpieces of an art that, at the height of the Renaissance, could return to the strongest values of the medieval tradition. But this meant plunging a great civilization into crisis at the very moment when it reached its peak, showing up the futility of the dream of perfect equilibrium between matter and spirit that civilization had so eagerly pursued, turning away from the stately progress of the Renaissance, and setting art on more rocky and perilous paths.

Catalog of extant works

All the known extant works of Michelangelo are reproduced below. Not included, for obvious reasons, are works and projects that are now lost or that cannot be correctly attributed because of major modifications carried out by others. These, however, are referred to elsewhere in the book.

1

4

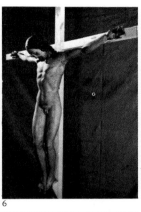

6

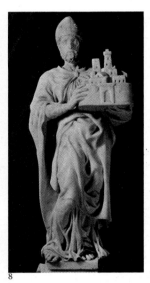

8

−2

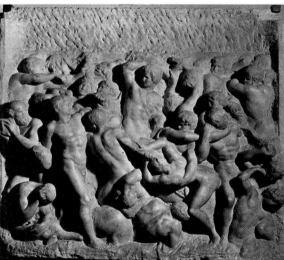

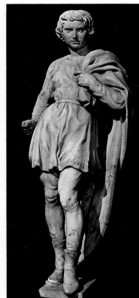

9

3

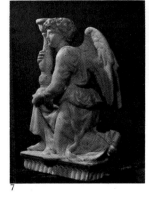

7

Domenico Ghirlandaio
1. Baptism of Christ
Wall fresco
1486–1490
Florence, Church of Santa Maria Novella, Choir
The nude kneeling figure of the young man on the right of the lunette and the two figures behind him are probably the work of Michelangelo.

Domenico Ghirlandaio
2. Assumption of the Virgin
Wall fresco
Circa 1486–1490
Florence, Church of Santa Maria Novella, Choir
The figure facing inwards on the left of the lunette is probably the work of Michelangelo.

3. Saint John the Evangelist
Fragment of panel
Circa 1488
Canonica (Florence), Church of San Cristoforo
Part of a frontal, with the *Lamentation of Christ*, of the school of Ghirlandaio, missing since 1900

4. Madonna of the Stairs
Marble;
$22 \times 15\frac{3}{4}$ in. $(55.5 \times 40 \, \text{cm})$
1489–1492
Florence, Casa Buonarroti

5. Battle of the Centaurs
Marble;
$33\frac{1}{4} \times 35\frac{3}{4}$ in. $(84.5 \times 90.5 \, \text{cm})$
1492
Florence, Casa Buonarroti

6. Crucifix
Polychrome wood;
$53\frac{1}{4} \times 53\frac{1}{4}$ in. $(135 \times 135 \, \text{cm})$
Circa 1494
Florence, Casa Buonarroti

7. Angel with Candlestick
Marble; height,
$20\frac{1}{4}$ in. $(51.5 \, \text{cm})$
1494–1495
Bologna, Basilica of San Domenico

8. Saint Petronius
Marble; height,
$25\frac{1}{4}$ in. $(64 \, \text{cm})$
1494–1495
Bologna, Basilica of San Domenico

9. Saint Proculus
Marble; height,
23 in. $(58.5 \, \text{cm})$
1494–1495
Bologna, Basilica of San Domenico

177

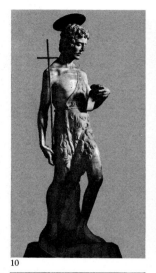

10

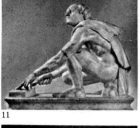

11

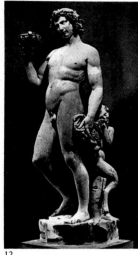

12

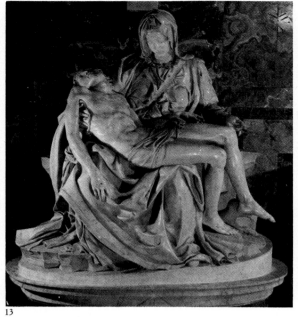

13

14

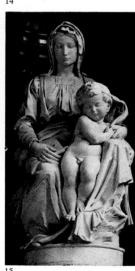

15

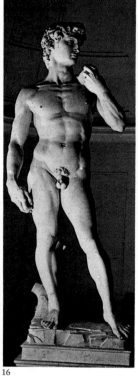

16

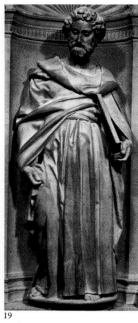

17

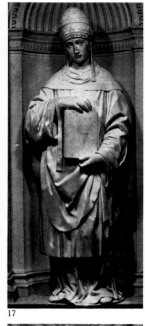

19

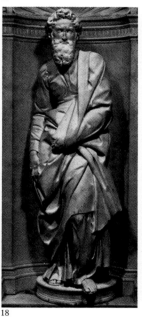

18

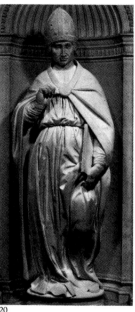

20

10. Saint John the Baptist
Marble; height with base,
68 in. (172.5 cm)
Circa 1495–1496
Florence, Museo Nazionale
del Bargello
Not universally accepted as
authentic. Attributed to
Michelangelo by Parronchi;
for a long time held to be by
Donatello.

**11. Arrotino (Knife
Grinder)**
Marble
Circa 1496
Florence, Uffizi Gallery
Once held to be a Greek
work, it was first attributed
to Michelangelo by
Sandrart in 1675 and again,
recently, by Parronchi.

12. Bacchus
Marble; height with base,
80 in. (203 cm)
1496–1497
Florence, Museo Nazionale
del Bargello

13. Pietà
Marble; height,
69 in. (174 cm)
1498–1499
Vatican, St. Peter's

14. The Crouching Boy
Marble; height,
22 in. (54 cm)
1500–1530
Leningrad, Hermitage
Museum
It is extremely doubtful
whether this is the work
of Michelangelo; it has
been attributed to
Tribolo and to Pierino da
Vinci.

15. Bruges Madonna
Marble; height with base,
50½ in. (128 cm)
1501–1504
Bruges, Church of Notre-
Dame

16. David
Marble; height with base,
14 ft. 3 in.. (434 cm)
1501–1504
Florence, Galleria
dell'Accademia

17. Saint Gregory
Marble; height,
53½ in. (136 cm)
Circa 1501–1504
Siena, Cathedral
Mainly the work of Baccio
da Montelupo

18. Saint Paul
Marble; height,
50 in. (127 cm)
Circa 1501–1504
Siena, Cathedral
By Baccio da Montelupo,
completed by Michelangelo

19. Saint Peter
Marble; height,
49 in. (124 cm)
Circa 1501–1504
Siena, Cathedral
By Baccio da Montelupo,
completed by Michelangelo

20. Saint Pius
Marble; height,
53 in. (134 cm)
Circa 1501–1504
Siena, Cathedral
Mainly the work of Baccio
da Montelupo, completed
by Michelangelo

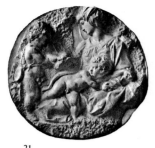

21

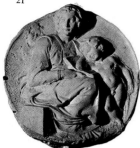

22

23

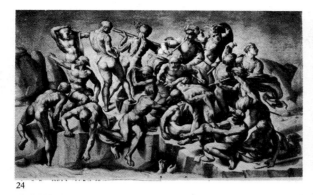

24

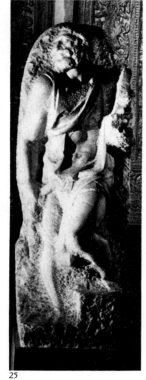

25

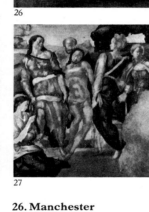

26

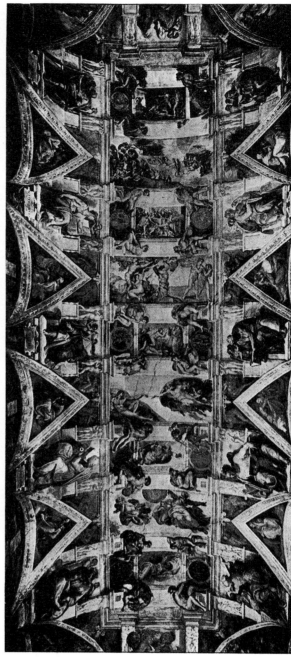

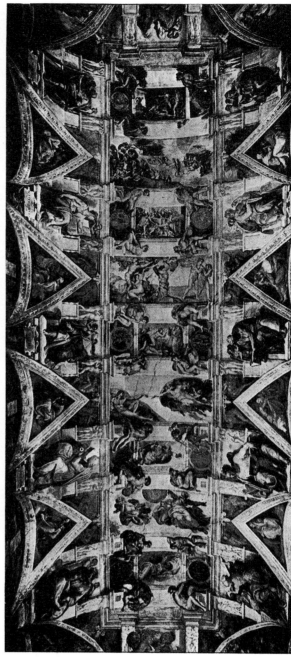

27

**21. Taddeo Taddei
Madonna**
Marble; diameter,
43 in. (109 cm)
1502–1504
London, Royal Academy of
Arts

22. Pitti Madonna
Marble;
$33\frac{1}{2} \times 32\frac{1}{2}$ in. (85.5 × 82 cm)
1503–1504
Florence, Museo Nazionale
del Bargello

**23. Doni Madonna (The
Holy Family)**
Tempera on wood;
diameter,
$47\frac{1}{4}$ in. (120 cm)
1503–1504
Florence, Uffizi Gallery

Aristotile da Sangallo
24. The Battle of Càscina
Chiaroscuro drawing
(*grisaille*)
Circa 1542
Holkham Hall, Norfolk,
Earl of Leicester Collection
Copy of Michelangelo's lost
cartoon, circa 1505

25. Saint Matthew
Marble; height,
7 ft. 1 in. (216 cm)
1505–1506
Florence, Galleria
dell'Accademia

**26. Manchester
Madonna**
Tempera on wood;
40 × 30 in. (102 × 76 cm)
Circa 1510
London, National Gallery
Probably not by
Michelangelo but by a pupil
or collaborator.

27. Entombment
Tempera and oil on wood;
$62\frac{3}{4} \times 58\frac{3}{4}$ in. (159 × 149 cm)
Circa 1511
London, National Gallery
Probably not by
Michelangelo but inspired
by one of his drawings.

The Sistine Chapel
Wall fresco;
43 × 118 ft. (13 × 36 m)
1508–1512
Vatican City, Vatican
Palace

179

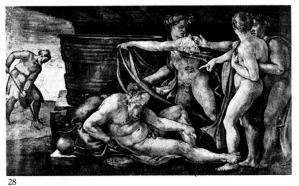

28

29

30

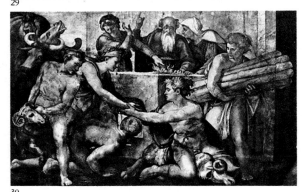

31

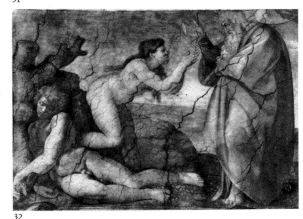

32

Central Scenes:

28. The Drunkenness of Noah
Wall fresco;
5 ft. 7 in. × 8 ft. 6 in.
(170 × 260 cm)
Circa 1508–1509

29. The Great Flood
Wall fresco;
9 ft. 2 in. × 18 ft. 8 in.
(280 × 570 cm)
1508–1509

30. Noah's Offering
Wall fresco;
5 ft 7 in. × 8 ft. 6 in.
(170 × 260 cm)
1508–1509

31. The Fall; The Expulsion from Eden
Wall fresco;
9 ft. 2 in. × 18 ft. 8 in.
(280 × 570 cm)
1509–1510

32. The Creation of Eve
Wall fresco;
5 ft. 7 in. × 8 ft. 6 in.
(170 × 260 cm)
Circa 1510

33. The Creation of Man
Wall fresco;
9 ft. 2 in. × 18 ft. 8 in.
(280 × 570 cm)
1511 or 1511–1512

34. God Dividing the Waters from the Earth
Wall fresco;
5 ft. 1 in. × 8 ft. 10 in.
(155 × 270 cm)
1511 or 1511–1512

35. The Creation of the Sun and the Moon
Wall fresco;
9 ft. 2 in. × 18 ft. 8 in.
(280 × 570 cm)
1511 or 1511–1512

36. God Dividing the Light from the Darkness
Wall fresco;
5 ft. 11 in. × 8 ft. 6 in.
(180 × 260 cm)
1511 or 1511–1512

IGNUDI AND BRONZE
MEDALLIONS:
Surrounding the
Drunkenness of Noah:
37. Delphic Sibyl Couple
Wall fresco;
6 ft. 3 in. × 12 ft. 8 in.
(190 × 385 cm)
1508

In the medallion:
Joab Killing Abner

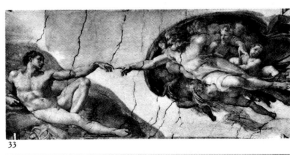

33

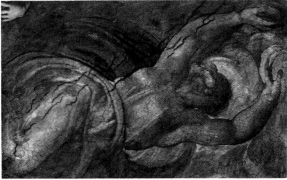

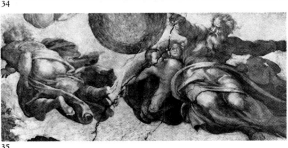

34

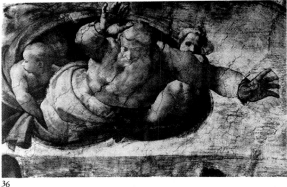

35

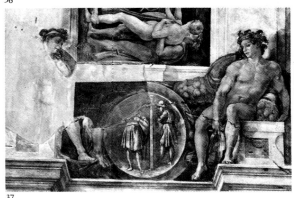

36

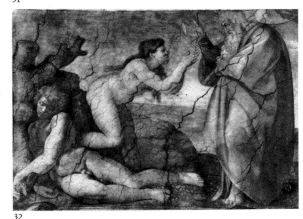

37

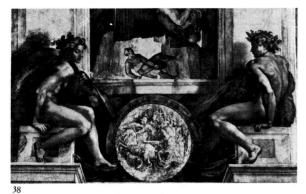

38

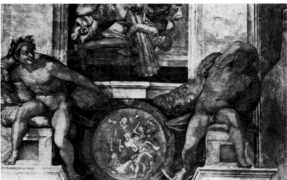

39

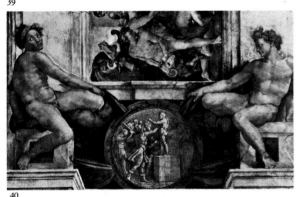

40

41

42

38. Joel Couple
Wall fresco; about
6 ft. 3 in. × 12 ft. 8 in.
(190 × 385 cm) 1508

In the medallion:
Jehu Killing Joram

Surrounding Noah's
Offering
39. Isaiah Couple
Wall fresco; about
6 ft. 3 in. × 13 ft. 1 in.
(190 × 395 cm) 1509

In the medallion:
The Death of Uriah

**40. Erythraean Sibyl
Couple**
Wall fresco;
6 ft. 3 in. × 12 ft. 10 in.
(190 × 390 cm) 1509

In the medallion:
**The Destruction of the
Statue of Baal**

Surrounding the Creation of
Eve
**41. Cumaean Sibyl
Couple**
Wall fresco;
6 ft. 5 in. × 12 ft. 8 in.
(195 × 385 cm)
1509–1510

In the medallion:
**The Penitence of David
Before Nathan**

42. Ezechiel Couple
Wall fresco;
6 ft. 5 in. × 12 ft. 8 in.
(195 × 385 cm)
1509–1510

In the medallion:
**The Destruction of the
Tribe of Achab**

Surrounding God Dividing
the Waters from the Earth:
43. Daniel Couple
Wall fresco; about
6 ft. 5 in. × 12 ft. 8 in.
(195 × 385 cm)
1511–1512

In the medallion:
The Death of Absalom

44. Persian Sibyl Couple
Wall fresco; about
6 ft. 7 in. × 13 ft. 1 in.
(200 × 395 cm)
1511–1512

Medallion: blank

Surrounding God Dividing
the Light from the
Darkness
45. Libyan Sibyl Couple
Wall fresco; about
6 ft. 5 in. × 12 ft. 8 in.
(195 × 385 cm)
1511–1512

In the medallion:
**The Sacrifice of
Abraham**

46. Jeremiah Couple
Wall fresco;
6 ft. 7 in. × 13 ft. 1 in.
(200 × 395 cm)
1511–1512

In the medallion:
The Ascension of Elijah

SEERS, PROPHETS,
SIBYLS AND PUTTI
CARYATIDS:

47. Zacharias
Wall fresco;
11 ft. 10 in. × 12 ft. 10 in.
(360 × 390 cm)
1509

43

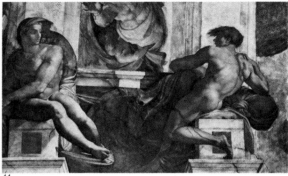

44

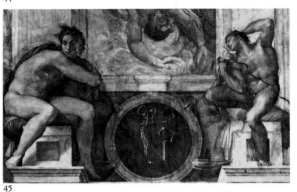

45

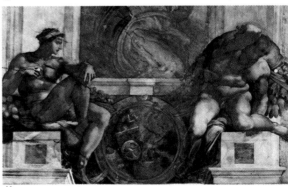

46

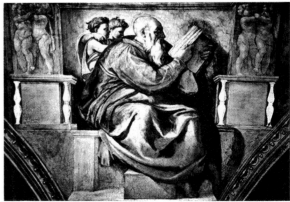

47

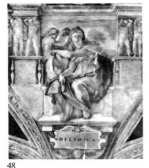
48

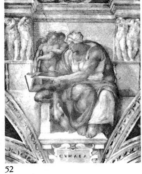
52

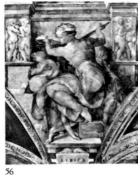
56

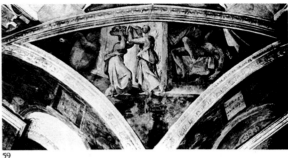
59

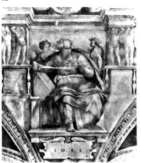
49

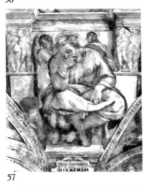
53

57

60

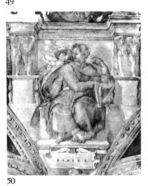
50

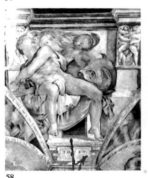
54

58

61

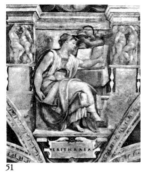
51

55

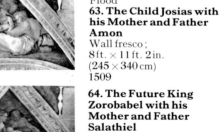
62

48. Delphic Sibyl
Wall fresco;
11 ft. 6 in. × 12 ft. 6 in.
(350 × 380 cm)
Circa 1509

49. Joel
Wall fresco;
11 ft. 8 in. × 12 ft. 6 in.
(355 × 380 cm)
1509

50. Isaiah
Wall fresco;
12 ft. × 12 ft. 6 in.
(365 × 380 cm)
Circa 1509

51. Erythraean Sibyl
Wall fresco;
11 ft. 10 in. × 12 ft. 6 in.
(360 × 380 cm)
Circa 1509

52. Cumaean Sibyl
Wall fresco;
12 ft. 4 in. × 12 ft. 6 in.
(375 × 380 cm)
Circa 1510

53. Ezechiel
Wall fresco;
11 ft. 8 in. × 12 ft. 6 in.
(355 × 380 cm)
Circa 1510

54. Daniel
Wall fresco;
13 ft. 1 in. × 12 ft. 6 in.
(395 × 380 cm)
1511

55. Persian Sibyl
Wall fresco;
13 ft. 2 in. × 12 ft. 6 in..
(400 × 380 cm)
1511

56. Libyan Sibyl
Wall fresco;
13 ft. 1 in. × 12 ft. 6 in.
(395 × 380 cm)
1511–1512

57. Jeremiah
Wall fresco;
12 ft. 10 in. × 12 ft. 6 in.
(390 × 380 cm)
1511

58. Jonah
Wall fresco;
13 ft. 2 in. × 12 ft. 6 in.
(400 × 380 cm)) 1511

SPANDRELS

59. Judith and Holofernes
Wall fresco;
18 ft. 8 in. × 31 ft. 10 in..
(570 × 970 cm)
1509

60. David's Victory over Goliath
Wall fresco;
18 ft. 8 in. × 31 ft. 10 in.
(570 × 970 cm)
1509

61. The Brazen Serpent
Wall fresco;
19 ft. 3 in. × 32 ft. 4 in.
(585 × 985 cm)
1511–1512

62. Haman Crucified
Wall fresco;
19 ft. 3 in. × 32 ft. 4 in.
(585 × 985 cm)
1511–1512

63

64

65

At the sides of the Great Flood
63. The Child Josias with his Mother and Father Amon
Wall fresco;
8 ft. × 11 ft. 2 in.
(245 × 340 cm)
1509

64. The Future King Zorobabel with his Mother and Father Salathiel
Wall fresco;
8 ft. × 11 ft. 2 in.
(245 × 340 cm)
1509

At sides of the Fall *and the* Expulsion from Eden
65. Achaz with the Young Ezechias
Wall fresco;
8 ft. × 11 ft. 2 in.
(245 × 340 cm)
1510

66

67

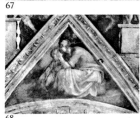

68

69

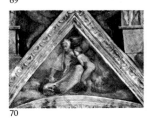

70

71

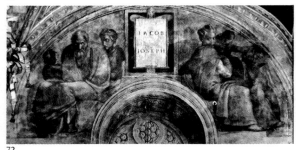

72

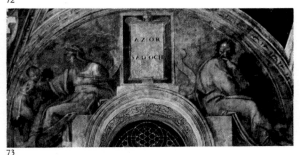

73

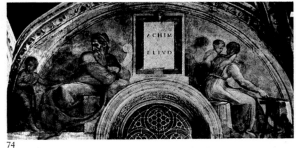

74

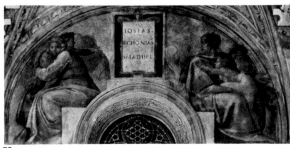

75

76

77

78

79

80

66. The Future King Ozias with his Mother; Joram with Another Son
Wall fresco;
8 ft. × 11 ft. 2 in.
(245 × 340 cm)
1510

At the sides of the Creation of Man
67. The Mother of the Future King Asa
Wall fresco;
7 ft. 10 in. × 11 ft. 2 in.
(240 × 340 cm)
1511–1512

68. The Mother of the Future King Roboam and Salomon
Wall fresco;
7 ft. 10 in. × 11 ft. 2 in.
(240 × 340 cm)
1511–1512

At the sides of the Creation of the Sun and the Moon
69. The Future King Jesse with his Parents
Wall fresco;
8 ft. × 11 ft. 2 in.
(245 × 340 cm)
1511–1512

70. The Future King Salomon with his Mother
Wall fresco;
8 ft. × 11 ft. 2 in.
(245 × 340 cm)
1511–1512

LUNETTES:
71. Eleazar/Mathan
Wall fresco;
7 ft. 1 in. × 14 ft. 1 in.
(215 × 430 cm)
1511–1512

72. Jacob/Joseph
Wall fresco;
7 ft. 1 in. × 14 ft. 1 in.
(215 × 430 cm)
1511–1512

73. Azor/Sadoch
Wall fresco;
7 ft. 1 in. × 14 ft. 1 in.
(215 × 430 cm)
1511–1512

74. Achim/Elivd
Wall fresco;
7 ft. 1 in. × 14 ft. 1 in.
(215 × 430 cm)
1511–1512

75. Josias/Jechonias/Salathiel
Wall fresco;
7 ft. 1 in. × 14 ft. 1 in.
(215 × 430 cm)
1511–1512

76. Zorobabel/Abivd/Eliachim
Wall fresco;
7 ft. 1 in. × 14 ft. 1 in.
(215 × 430 cm)
1511–1512

77. Ezechias/Manasses/Amon
Wall fresco;
7 ft. 1 in. × 14 ft. 1 in.
(215 × 430 cm)
1511–1512

78. Ozias/Ioatham/Achaz
Wall fresco;
7 ft. 1 in. × 14 ft. 1 in.
(215 × 430 cm)
1511–12

79. Asa/Josaphat/Joram
Wall fresco;
7 ft. 1 in. × 14 ft. 1 in.
(215 × 430 cm)
1511–1512

80. Roboam/Abias
Wall fresco;
7 ft. 1 in. × 14 ft. 1 in.
(215 × 430 cm)
1511–1512

81

82

83

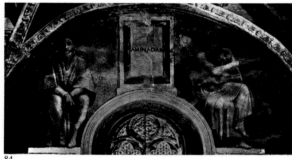

84

85

86

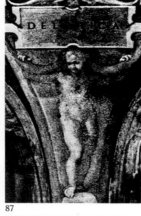

87

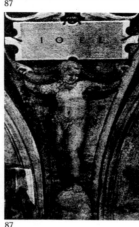

87

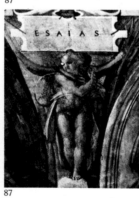

87

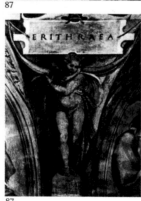

87

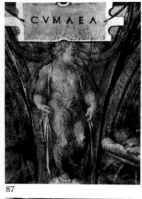

87

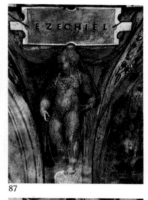

87

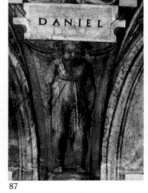

87

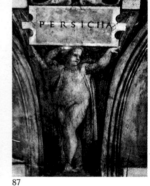

87

87

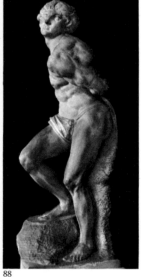

87

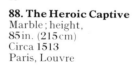

87

88

88. The Heroic Captive
Marble; height,
85 in. (215 cm)
Circa 1513
Paris, Louvre

81. Jesse/David/Salomon
Wall fresco;
7 ft. 1 in. × 14 ft. 1 in.
(215 × 430 cm)
1511–1512

82. Salomon/Booz/Obeth
Wall fresco;
7 ft. 1 in. × 14 ft. 1 in.
(215 × 430 cm)
1511–1512

83. Naason
Wall fresco;
7 ft. 1 in. × 14 ft. 1 in.
(215 × 430 cm)
1511–1512

84. Aminadab
Wall fresco;
7 ft. 1 in. × 14 ft. 1 in.
(215 × 430 cm)
1511–1512

85. Phares/Esron/Aram
Drawing of the lunette
erased by Michelangelo to
accommodate the *Last
Judgment.*

**86. Abraam/Isaac/Jacob
Judas**
Drawing of the lunette also
erased to accommodate the
Last Judgment.

**87. Ten Putti Scroll-
bearers**
1511–1512
Placed between spandrels,
each *putto* holds aloft a
scroll with the name of the
prophet or sibyl above.

**Delphica/Joel/Esaias/
Erithraea/Cvmaea/
Ezechiel/Daniel/
Persicha/Libica/Hieremias/**

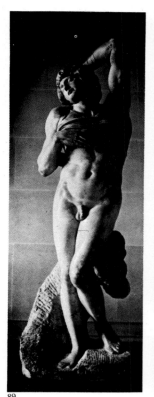

89

90

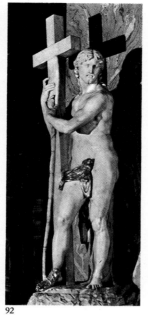

92

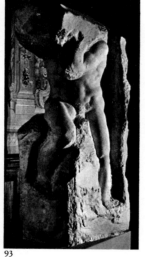

93

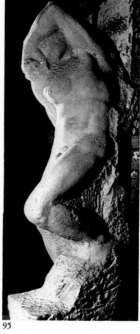

95

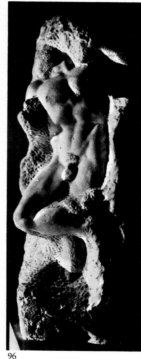

96

97,a

97,b

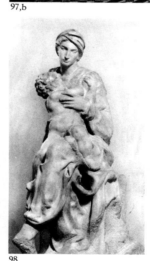

98

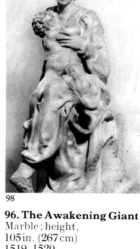

99

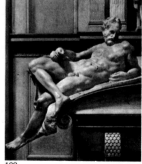

100

91

94

89. The Dying Captive
Marble; height,
90 in. (229 cm)
Circa 1513
Paris, Louvre

**90. Chapel of Saints
Cosmas and Damian
(Chapel of Leo X)**
1514
Rome, Castel Sant'Angelo,
Cortile delle Palle

91. "Kneeling" Window
Circa 1517
Florence, Palazzo Medici

92. The Risen Christ
Marble; height,
80¾ in. (205 cm)
Circa 1518–1520
Rome, Church of Santa
Maria sopra Minerva

The Four Captives:

**93. The So-called Atlas
Captive**
Marble; height,
109 in. (277 cm)
1519–1520
Florence, Galleria
dell'Accademia

94. The Bearded Giant
Marble; height,
104 in. (263 cm)
1519–1520
Florence, Galleria
dell'Accademia

95. The Young Giant
Marble; height,
101 in. (256 cm)
1519–1520
Florence, Galleria
dell'Accademia

96. The Awakening Giant
Marble; height,
105 in. (267 cm)
1519–1520
Florence, Galleria
dell'Accademia

SAGRESTIA NUOVA,
SAN LORENZO, AND
THE MEDICI TOMBS:

**97. a, b. Sagrestia Nuova,
San Lorenzo**
Architecture
Circa 1520–1523
Florence

98. Medici Madonna
Marble; height,
89 in. (226 cm)
1521–1534
Florence, San Lorenzo

99. Dawn
Marble; length,
81 in. (206 cm)
Circa 1524–1527
Florence, San Lorenzo

100. Evening
Marble; length, 77 in.
(195 cm)
1524–1531
Florence, San Lorenzo

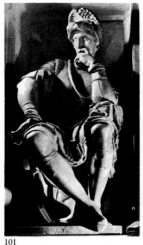

101

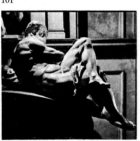

102

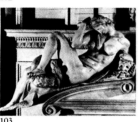

103

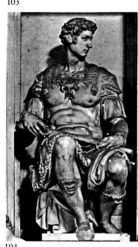

104

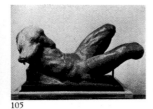

105

106,a

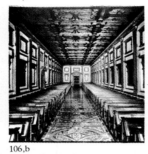

106,b

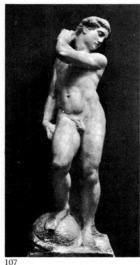

107

108

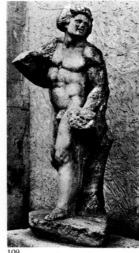

109

110

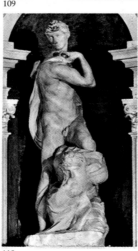

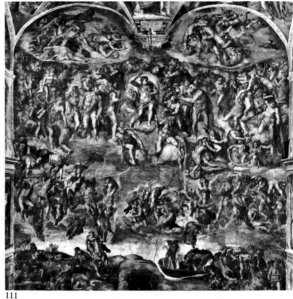

111

112

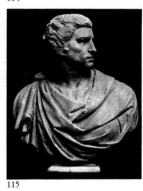

113

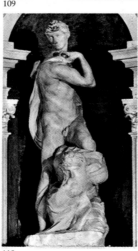

114

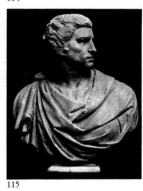

115

101. Lorenzo de' Medici, Duke of Urbino
Marble; height,
70 in. (178 cm)
1524–1531
Florence, San Lorenzo

102. Day
Marble; length,
73 in. (185 cm)
1526–1531
Florence, San Lorenzo

103. Night
Marble; length,
76 in. (194 cm)
1526–1531
Florence, San Lorenzo

104. Giuliano de' Medici, Duke of Nemours
Marble; height,
68 in. (173 cm)
1526–1534
Florence, San Lorenzo

105. River God
Wood, clay, wool, and oakum; length,
71 in. (180 cm)
Circa 1524
Florence, Casa Buonarroti
Nonauthenticated work

106. Biblioteca Laurenziana:
a. Staircase;
b. Reading Room
1524–1570
Florence

107. David – Apollo
Marble; height,
57½ in. (146 cm)
1525–1526; 1530–1531
Florence, Museo Nazionale del Bargello

108. Hercules and Cacus
Clay; height,
16½ in. (41 cm)
Circa 1528
Florence, Casa Buonarroti

109. The Fifth Captive
Marble; height with base,
92 in. (234 cm)
Circa 1532
Florence, Casa Buonarroti
In all probability, largely the work of pupils

110. The Victory
Marble; height,
103 in. (261 cm)
Circa 1532
Florence, Palazzo Vecchio

111. The Last Judgment
Wall fresco;
45 × 40 ft. (13.7 × 12.2 m)
1536–1541
Vatican City, Vatican Palace, Sistine Chapel

112. Gallery of the Reliquaries
Florence
Executed in 1531–1532, after Michelangelo prevailed upon the pope to accept his design in place of the pontiff's own preference for a canopy-ciborium above the high altar.

113. Portal
Circa 1530–1535
Florence, Santa Apollonia
The traditional attribution, later abandoned, has recently been revived by Tolnay and proved to be correct by Charles Davis. Some alterations were carried out in the eighteenth century and again later.

114. Piazza del Campidoglio
1537–1940
Rome
Michelangelo, responsible for the architectural layout of the piazza, was involved with the actual construction from 1539 until his death in 1564.

115. Brutus
Marble; height,
29¼ in. (74 cm)
Circa 1538
Florence, Museo Nazionale del Bargello

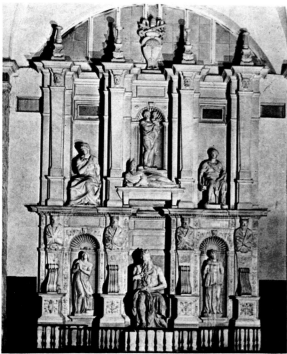

116

120

121

127

128

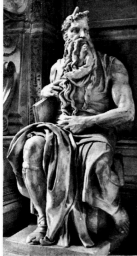

117

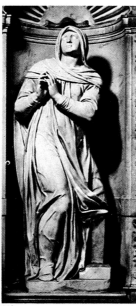

118

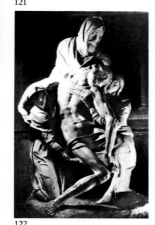

122

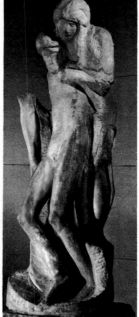

125

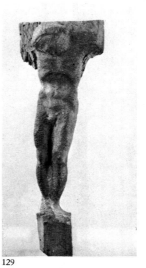

129

123

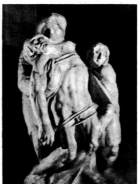

126

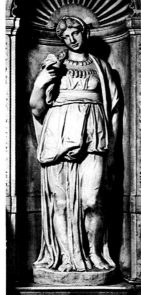

119

TOMB OF JULIUS II:

116. Tomb of Julius II
General view of the sixth
and final version

117. Moses
Marble; height,
93 in. (235 cm)
1513–1515 (completed
in 1542)
Rome, San Pietro in Vincoli

118. Lea
Marble; height,
77½ in. (197 cm)
Circa 1542
Rome, San Pietro in Vincoli

119. Rachel
Marble; height,
82 in. (209 cm)
Circa 1542
Rome, San Pietro in Vincoli

**120. The Conversion of
Saul**
Wall fresco;
20 ft. 6 in. × 21 ft. 8 in.
(6.25 × 6.61 m)
1542–1545
Vatican City, Vatican
Palace, Pauline Chapel

**121. The Crucifixion of
Saint Peter**
Wall fresco;
20 ft. 6 in. × 21 ft. 8 in.
(6.25 × 6.61 m)
1546–1550
Vatican City, Vatican
Palace, Pauline Chapel

122. Pietà
Marble; height,
89 in. (226 cm)
Circa 1546–1555
Florence, Cathedral

123. Farnese Palace
1517–1549
Rome
Michelangelo took over on
the death of Antonio da
Sangallo the Younger in
1546.

**124. Building of Saint
Peter's**
1546–1564 ((intervention
of Michelangelo)
Vatican City
Michelangelo is particularly
associated with the design
of the apse and cupola.

125. The Rondanini Pietà
Marble; height,
77 in. (195 cm)
Circa 1546–1564
Milan, Museo del Castello
Sforzesco

**126. The Palestrina
Pietà**
Marble; height,
100 in. (253 cm)
1550–1560
Florence, Galleria
dell'Accademia

127. Santa Trinita Bridge
1567–1569
Florence
The bridge was built by
Bartolomeo Ammannati,
probably from
Michelangelo's design
(1560) for the three
flattened arches.

128. Porta Pia
1561–1565
Rome

129. Crucifix
Wood; height,
8 in. (20.5 cm)
1562
Florence, Casa Buonarroti

Bibliographical Notes

The enormous literature on Michelangelo is fully listed in E. Steinmann and R. Wittkower, *Michelangelo 1510–1926*, Leipzig 1927, revised by H. W. Schmidt in an appendix to E. Steinmann, *Michelangelo im Spiegel seiner Zeit*, Leipzig 1930, by P Cherubelli, "Supplemento alla Bibliografia Michelangiolesca," 1931–42, in *Centenario del Giudizio*, Florence 1942, by P. Barocchi in her explanatory notes to *Vita di Michelangelo* (by G. Vasari, 1550 and 1568 editions, Milan–Naples 1962), by P. Meller, "Aggiornamenti Bibliografici" in *Michelangelo Artista Pensatore Scrittore*, II, Novara 1965. Some new items, up to 1969, are listed in the concise bibliography to be found in Ch. de Tolnay, *Michelange*, Paris 1970.

Apart from the main sixteenth-century sources, in the bibliography below we have listed only a few of the most important recent works, some collections of illustrations, as well as some essays we think particularly important or which we have referred to implicitly or explicitly in this book. We apologize for unavoidable omissions.

SOURCES
Buonarroti, Michelangelo *Le Lettere*, edited by G. Papini. Lanciano: 1910.
Buonarroti, Michelangelo *Le Rime*, edited by D. Redig di Campos. Florence: 1939.
Condivi, A. *Vita di Michelangelo Buonarroti*, edited by E. Spina Barelli, Milan: 1964.
Giannotti, D. *Dialoghi*, edited by D. Redig di Campos. Florence: 1939.
Hollanda, F. de *Dialoghi romani con Michelangelo*, edited by E. Spina Barelli. Milan: 1964.
Poggi, G., Barocchi, P. and Ristori, R. *Carteggio di Michelangelo*, 6 vols. Florence: 1965.
Vasari, G. *Vita di Michelangelo*, 4 vols, edited by P. Barocchi (with full explanatory notes). Milan–Naples: 1962.

PHILOSOPHY AND POETRY
Clements, R. J. *Michelangelo. A Self Portrait*. New York: 1963.
Clements, R. J. *Michelangelo's Theory of Art*. New York–Zurich: 1961.
Feo, F. de "Nota Biografica." *Michelangelo Artista, Pensatore, Scrittore*. Novara: 1965.
Garin, E. "Il Pensiero." *Michelangelo Artista, Pensatore, Scrittore*. Novara: 1965.
Salmi, M. "Michelangelo," a lecture held at the Accademia dei Lincei. Rome: 14th March, 1965.
Salvini, R. "Michelangelo nel suo tempo."*Atti dell' Accademia Petrarca*, Arezzo; 1976.
Sanminiatelli, R. *Vita di Michelangelo*. Rome: 1964.
Spini, G. "Politicità di Michelangelo." *Rivista Storica Italiana*. 1964.
Tolnay, Ch. de "Personalità storica ed artistica di Michelangelo." *Michelangelo Artista, Pensatore, Scrittore*. Novara: 1965.

MONOGRAPHS AND ESSAY COLLECTIONS
Atti del Convegno di Studi Michelangioleschi. Florence–Rome 1964. Florence: 1966.
Bertini, A. *Michelangelo fino alla Sistina*. Turin: 1945.
Carli, E. *Michelangelo*. Bergamo: 1941, 1946, 1948.
Einem, H. von *Michelangelo*. Stuttgart: 1959.
Goldscheider, L. *Michelangelo*. London: 1964
Mariani, V. *Michelangelo*. Turin: 1942.
Mariani, V. *Michelangelo*. Naples: 1964.
Michelangelo Artista, Pensatore, Scrittore, 2 vols. (with essays by U. Baldini, L. Berti, G. De Angelis d'Ossat, F. de Feo, Ch. de Tolnay, E. Garin, E. N. Girardi, P. Meller, G. Nencioni, R. Salvini), Istituto Geografico De Agostini. Novara: 1965.
Michelangelo Buonarroti (with essays by L. Dussler, M. Gosebruch, E. Hubala, F. Karlinger, F. Rauhut, Ch. de Tolnay). Würzburg: 1964.
Toesca, P. "Michelangelo." *Enciclopedia Italiana*, 13th ed. Rome–Milan: 1934.
Tolnay, Ch. de *Michelangelo*, 5 vols. Princeton: 1943–1960.
Tolnay, Ch. de *Michelangelo* (abridged version). Florence 1951.

SCULPTURE
Baldini, U. "La scultura." *Michelangelo Artista, Pensatore, Scrittore*. Novara: 1965.
Carli, E. *Michelangelo a Siena*. Rome: 1965.
Kriegbaum, F. *Michelangelo. Die Bildwerke*. Berlin: 1940.
Kriegbaum, F. "Le statue di Michelangelo nell'altare dei Piccolomini." *Michelangelo Buonarroti nel IV Centenario del Giudizio Universale*. Florence: 1942.
Lisner, M. *Il Crocefisso di Michelangelo in Santo Spirito*. Florence: 1965.
Mantura, B. "Il primo Cristo della Pietà Rondanini," *Bollettino d'Arte LVIII*, 1973.
Michelangelo scultore (with essays by G. C. Argan, E. Battisti, R. J. Clements, F. Negri Arnoldi). Rome: 1964.
Parronchi, A. *Opere Giovanili di Michelangelo*, 2 vols. Florence: 1968, 1975.
Parronchi, A. "Ricostruzione della Pietà Rondanini." *Michelangelo*, 4 vols. Florence: 1975.
Pope-Hennessy, J. "Michelangelo." *Italian Sculpture of the High Renaissance and Baroque*. London: 1964.
Russoli, F. *Tutta la scultura di Michelangelo*, 3rd ed. Milan: 1964.
Weinberger, M. *Michelangelo the Sculptor*. New York: 1967.

PAINTINGS
Baumgart, F. and Biagetti, B. *Gli affreschi di Michelangelo nella Cappella Paolina*. Vatican City: 1934.
Grohn, W. "die Schule der Welt." *Il Vasari*, XXIV, 1965.
Hartt, F. *Michelangelo Pittore*. Milan–New York: 1964.
Isermeyer, Ch. A. "Die Arbeiten Leonardos und Michelangelos für den grossen Ratsaal in Florenz." *Studien zur Toskanischen Kunst, Festschrift Heydenreich*. Munich: 1963.
Mariani, V. *Michelangelo Pittore*.

Naples: 1964.

Redig de Campos, D. and Biagetti, B. *Il Giudizio Universale di Michelangelo*. Vatican City: 1934.

Redig de Campos, D. *Il Giudizio Universale di Michelangelo*. Milan: 1964.

Salvini, R. "La Pittura." *Michelangelo Artista, Pensatore, Scrittore*. Novara: 1965.

Salvini, R. *La Cappella Sistina in Vaticano* (annotated by E. Camesasca and with an appendix by C. L. Ragghianti). Milan: 1968.

Salvini, R. "La Battaglia di Cascina. Saggio di Critica delle Varianti." *Studi di Storia dell'Arte in Onore di V. Mariani*. Naples: 1970.

ARCHITECTURE

Ackerman, J. S. *The Architecture of Michelangelo*. London: 1961; Lutherville: 1971.

Angelis d'Ossat, G. de "L'Architettura." *Michelangelo Artista, Pensatore, Scrittore*. Novara: 1965.

Angelis d'Ossat, G. de, and Pietrangeli, C. *Il Campidoglio di Michelangelo*. Milan: 1965.

Barbieri, F. and Puppi, L. *Tutta l'architettura di Michelangelo*. Milan: 1962.

Bonelli, R. *Da Bramante a Michelangelo*. Venice: 1960.

Gioseffi, D. *La cupola vaticana. Un'ipotesi michelangiolesca*, Istituto di Storia dell'Arte, Facoltà di Lettere e Filosofia, Trieste University. Trieste: 1960.

Kriegbaum, F. "*Michelangelo e il Ponte a Santa Trinita*." *Rivista d'Arte* XIII. 1941.

Portoghesi, P. and Zevi, B. *Michelangelo architetto* (with essays by C. G. Argan, F. Barbieri, L. Puppi, A. Bertini, S. Bettini, R. Bonelli, D. Gioseffi, R. Pane, P. Portoghesi and B. Zevi). Turin: 1964.

Ragghianti, C. L. *Il Ponte a Santa Trinita*. Florence: 1947.

Schiavo, A. *Michelangelo architetto*. Rome: 1949.

Schiavo, A. *La vita e le opere architettoniche di Michelangelo*. Rome: 1952.

Siebenhüner, H. *Das Kapitol in Rom. Idee und Gestalt*. Munich: 1954.

DRAWINGS

Barocchi, P. *Michelangelo e la sua scuola: i disegni di Casa Buonarroti e degli Uffizi*. Florence: 1962.

Berenson, B. *The Drawings of the Florentine Painters*. 1903, 1938.

Berti, L. "I Disegni." *Michelangelo Artista, Pensatore, Scrittore*. Novara: 1965.

Brugnoli, M. V. *Michelangelo. I Disegni*. Milan: 1964.

Goldscheider, L. *Michelangelo's Drawings*. London: 1951.

Parker, K. T. *Catalogue of the Collection of Drawings in the Ashmolean Museum*, III. Oxford: 1956.

Popham, A. E. and Wilde, J. *The Italian Drawings of the 15th and 16th centuries in the collection of H.M. the King at Windsor Castle*. London: 1949.

Salmi, M., Tolnay, Ch. de and Barocchi, P. *Disegni di Michelangelo (103 disegni in fac-simile)*. Florence–Milan: 1964.

Tolnay, Ch. de *Corpus dei disegni di Michelangelo*, I. Florence: 1975.

Wilde, J. *Italian Drawings in the British Museum: Michelangelo and his Studio*. London: 1933.

POETRY AND LETTERS

Binni, W. *Michelangelo scrittore*. Bari: 1975.

Binni. W. "Michelangelo scrittore." *Rassegna della Letteratura Italiana*. 1964.

Girardi, E. N. "Le Lettere, Le Rime." *Michelangelo Artista, Pensatore, Scrittore*. Novara: 1965.

Girardi, E. N. *Studi sulle Rime di Michelangelo*. Milan: 1964.

Mariani, V. *La Poesia di Michelangelo*. Rome: 1940.

Nencioni, G. "La Lingua." *Michelangelo Artista, Pensatore, Scrittore*. Novara: 1965.

Index